CLARENDON STUDIES IN THE HISTORY OF ART

General Editor: Dennis Farr

LIGHT AND COLOUR

IN

BYZANTINE ART

LIZ JAMES

CLARENDON PRESS · OXFORD

1996

Oxford University Press, Walton Street, Oxford OX2 6DP

Oxford New York
Athens Auckland Bangkok Bombay
Calcutta Cape Town Dar es Salaam Delhi
Florence Hong Kong Istanbul Karachi
Kuala Lumpur Madras Madrid Melbourne
Mexico City Nairobi Paris Singapore
Taipei Tokyo Toronto
and associated companies in
Berlin Ibadan

Oxford is a trade mark of Oxford University Press

Published in the United States
by Oxford University Press Inc., New York

British Library Cataloguing in Publication Data
Data available

Library of Congress Cataloging in Publication Data
James, Liz.
Light and colour in Byzantine art / Liz James.
— (Clarendon studies in the history of art)
Includes bibliographical references.
1. Art, Byzantine. 2. Color in art. I. Title. II. Series.
N6250.J36 1995
709'.02'14—dc20 95-18920
ISBN 0-19-817518-3

1 3 5 7 9 10 8 6 4 2

Typeset by Regent Typesetting, London
Printed in Great Britain on acid-free paper by
Butler & Tanner Ltd,
Frome and London

Acknowledgements

THIS book has grown out of my doctoral thesis. A British Academy Postdoctoral Fellowship, held at the Courtauld Institute, has enabled me to develop and rework the themes of the original.

As is common in such a case, thanks are owing to the many people who have experienced my work at both stages. First and foremost has been Robin Cormack who supervised the original work and kept an eye on this, its successor. Without him, there would have been no book. My debt to the late Ernest Hawkins will be apparent throughout, not only in the illustrations but also in the benefit I gained from his unrivalled knowledge of the practicalities of Byzantine art. John Gage, my external examiner, has raised the profile of many of the issues discussed in this book. David Buckton of the British Museum has answered many questions and always been ready with information. John Lowden has offered many constructive comments and much encouragement. The late Professor Doula Mouriki was always willing to offer advice and encouragement: her good offices and the help of Kyria A. Kyriakopoulou of the Chios Ephorate enabled me to work at and photograph Nea Moni, where I am grateful to the nuns for their tolerance. I owe much to Henry Maguire who, as one of the readers for Oxford University Press, offered many useful suggestions and remarks. My thanks too to my editor at Oxford University Press, Anne Ashby.

My friends at the Courtauld and Warburg Institutes, Henri Franses, Katrina Kavan, Barbara Zeitler, and especially Charles Barber and Jaš Elsner, who were forced to read and comment on bits at regular intervals, have helped me all the way. Martin Kauffmann was the only person strong-willed enough to read the whole thing—I owe him one for this. Ruth Webb rescued me on many occasions and gave me the benefit of her experience with scholia and, of course, with ekphrasis. Antony Eastmond took many of the photos whilst dealing with conflicting streams of advice from an anxious colleague.

Others who have offered advice and encouragement are Jill Storer, Zaga Gavrilović, and Valerie Nunn; Anthony Bryer, Margaret Mullett, and Judith Herrin have always been ready to help. And without Peter Rhodes of the University of Durham and Margaret Mallender who taught me Greek, the whole process would never have begun.

I must also thank the staff of the Warburg Institute Library, the best library in

Britain for the Byzantine art historian, and, above all, Mira Hudson, whose assistance went beyond the call of duty.

Finally, without Mary Pullen, the computer would have defeated me, and I would have given up long since; Karen Dodd and Carol Merrett have always been there. And my mother has supported my efforts without once suggesting that accountancy might be a more useful profession in the modern world. To her and the memory of my father, this book is dedicated.

Contents

List of Plates

UNLESS otherwise stated, all photographs are by Ernest J. W. Hawkins and generously deposited by him in the Courtauld Institute of Art. I am grateful both to Ernest Hawkins and to the Courtauld Institute for permission to use these reproductions. I would also like to thank Robin Cormack for his assistance with the photographic material, the staff of the Courtauld Institute Slide Library, Ron Baxter, Nicholas Orchard, Nicola Lambourne and David Crellin, and Antony Eastmond and Charles Barber.

ix

Photo Credits

List of Abbreviations

ActaIRNorv	*Acta ad Archaeologiam et Artium Historiam pertinenta, Institutum Romanum Norvegiae*
AJA	*American Journal of Archaeology*
AmAnth	*American Anthropologist*
AntAb	*Antike und Abendland*
ArtB	*Art Bulletin*
BAR	British Archaeological Reports
BBBS	*British Bulletin of Byzantine Studies*
BMGS	*Byzantine and Modern Greek Studies*
Bonn edn.	Corpus Scriptorum Historiae Byzantinae, ed. B. G. Niebuhr *et al.* (Bonn, 1828–97)
BSA	*The Annual of the British School at Athens*
CahArch	*Cahiers archéologiques*
CahCM	*Cahiers de civilisation médiévale*
ClMed	*Classica et Medievalia*
CQ	*Classical Quarterly*
CR	*Classical Review*
DACL	F. Cabriol and H. Leclercq (eds.), *Dictionnaire d'archéologie chrétienne et de liturgie* (Paris, 1907–53)
DOP	*Dumbarton Oaks Papers*
DOS	*Dumbarton Oaks Studies*
ErYb	*Eranos Yearbook*
GBA	*Gazette des Beaux-Arts*
GRBS	*Greek, Roman and Byzantine Studies*
JGS	*Journal of Glass Studies*
JHS	*Journal of Hellenic Studies*
JÖB	*Jahrbuch der Österreichischen Byzantinistik*
JWarb	*Journal of the Warburg and Courtauld Institutes*
LSJ	H. G. Liddell, R. Scott, and H. S. Jones, *A Greek–English Lexicon* (9th edn., Oxford, 1968)
Mansi	G. D. Mansi, *Sacrorum Conciliorum Nova et Amplissima Collectio*, 53 vols. in 58 parts (Paris–Leipzig, 1901–27, facsimile of Florence, 1859–98), vol. xiii

MonPiot	*Monuments et mémoires*, Académie des Inscriptions et Belles-Lettres, Fondation E. Piot
OrChrP	*Orientalia Christiana Periodica*
MunchJb	*Münchner Jahrbuch der bildenden Kunst*
PG	*Patrologiae Cursus Completus, Series Graeca,* ed. J. P. Migne
REB	*Revue des études byzantines*
RevEtArm	*Revue des études arméniennes*
SCon	*Studies in Conservation*
SemKond	*Seminarium Kondakovianum*

CHAPTER 1
Colour in Art

THE mosaic of the Anastasis at Nea Moni on Chios is a powerful medieval image (Plate 1). Centre stage, Christ, having burst asunder the gates of Hades, tramples them as he reaches to grasp Adam by the wrist, pulling the Father of Mankind bodily out from his sarcophagus. Behind Adam, the standing figure of Eve provides a vivid shadow, her hands uplifted under her robes in supplication, whilst behind her a muted group of the saved look on and worship. Behind Christ, the prophet kings, David and Solomon, acclaim the fulfilment of their prophecies. A group of mountains rise up, sketched in behind each waiting group, but the gold background behind Christ is clear, silhouetting the figure of Christ, cross uplifted, robe streaming out behind with the force of his passage.

This scene, the Anastasis, is a key scene in Byzantine church decoration. It is the scene used to represent the Resurrection of Christ, his victory over death shown through his raising of the dead from Hades. For the Byzantine, it was the scene synonymous with Easter and the triumph of Christ.[1] In the church of Nea Moni, it occupies a key place in the north conch of the nave, the culminating episode in a cycle of scenes from the life of Christ. It is made of mosaic, thousands of small cubes of coloured glass set together on a curved plaster background.

Conventionally, a description of this scene might stop here: that is what we see in looking at this particular representation. But this book is about describing art. What do we see in looking at Byzantine art? How far do modern frames of seeing and of writing of that seeing help or hinder the eye? Once asked, the question goes far beyond 'description' to the domain of what guides the hand and eye in the perceptual process. The aspect I will focus on is a very obvious one. It is the aspect which dominates art but which we do not always notice, an aspect perhaps conspicuously absent from my opening description of the Nea Moni Anastasis, the aspect of colour.[2] What part do coloured materials, does colour itself, play in any viewing of a picture? To answer this question, this book will demonstrate just how complicated are the artistic results of an

[1] A. D. Kartsonis, *Anastasis: The Making of an Image* (Princeton, NJ, 1986), provides a detailed study of the history of the image and its iconography.

[2] On the theme of colour in art, see now J. Gage, *Colour and Culture* (London, 1993), the first attempt in English to devote an entire book to the role of colour in art.

apparently simple choice of coloured materials. It will go beyond merely adding colour words to a description of the Anastasis scene to consider the options available to the artist, the meanings of colours in the medieval world, and the distinction between modern and medieval viewing.

COLOUR AND MOSAIC ART

Byzantine art is acclaimed for its mastery of mosaic. For the Byzantines, mosaic was the material *par excellence* of art, its use a claim to skill, artistry, and prestige. But what does it mean to make a mosaic? Coloured glass is not a flexible medium. The mosaicist is in the position of modelling and building up the picture with small blocks of pure colour. Colours cannot be mixed; to change colour, the artist can only pick up the next set of coloured cubes. Blending is virtually impossible. Strips of pure colour have to be laid down next to each other; consequently, in photographs, mosaics often look crude, two-dimensional, unmodelled (Plates 2, 3, and 4). Ugly, jarring colours, greens and oranges especially, are juxtaposed in creating textures, faces, and details (Plates 5 and 6). Yet this is only a problem in close up. The trick Byzantine mosaicists employed to overcome it was that of distance. Mosaics were designed to be seen from a distance and at an angle: those in Nea Moni are perhaps ten metres above ground; the Virgin in the apse of Hagia Sophia, Istanbul, is some thirty metres up.[3] Very simply, mosaic art is a monumental art. What looks clumsy, artificial, flat, and coarse from close to or head on springs into focus from afar. The techniques and skills of Byzantine mosaicists lay in manipulating optical artifices to get the best out of their medium and to turn the apparently intractable nature of pure colour into a flexible, fluid medium—even to the extent of creating three-dimensional effects if so desired (Plates 7 and 8). The mosaicist's work was in two dimensions, creating from close up a work designed only to be seen from far away (Plates 9 and 10).

It is the lack of flexibility in the use of colour which forms the key element in understanding the artistic construction of a mosaic. Within a mosaic, colour must be used in blocks defined and bound by contours, the lines around each colour plane. These lines may actually exist, as where, in the Nea Moni Anastasis, Adam's left arm crosses his body, or they may be formed by the juxtaposition of different colours, as with the meeting of Adam's outer and inner garments (Plate 11). Modelling and form is revealed

[3] Mango and Hawkins suggest that the Virgin was not perfectly designed to be seen from the floor, but rather drawn from a point directly below the crown of the semidome: C. Mango and E. J. W. Hawkins, 'The Apse Mosaics of Saint Sophia at Istanbul', *DOP* 19 (1965), 117. Nevertheless, the proportions of the figure are still more convincing from the floor of the church than from close up and head on.

through colour changes, apparent in the black and white illustration as nuances of black, white, and grey (Plate 12).

It may have been that normal procedure in laying out a mosaic was to set the out‑lines of the figure first and then to fill in the surrounding areas.[4] In the Late Antique period, the illusion of three‑dimensional form was created by the juxtaposition of tesserae of contrasting colour values, which merged into a recognizable shape only when seen from a distance. In mosaics in Rome in the late sixth and early seventh centuries, each form is clearly defined with dark outlines, tightly set with tesserae of a single colour, resulting in a flat unified surface. This is apparent, for example, in the churches of Sta Agnese and San Lorenzo fuori le Mura and in the Oratory of Pope John VII at St Peter's. Dark lines are used to indicate basic form: contours, facial features, drapery folds; colour is used within this framework to create a glittering effect.

However, the great mosaic restorer, Ernest Hawkins, has always argued that, certainly in later mosaics, work was begun from the top with the gold background, which was laid down as far as the figures, which were then inserted. This can be seen, for example, in the ninth‑century apse mosaic of Hagia Sophia, where concentric gold lines come down from the crown of the apse to the head of the Virgin and then resume around her (Plate 35). In the mosaics of Nea Moni, and in those of the churches at Hosios Loukas and Daphni, which belong to the same eleventh‑century period, there does not appear to be any consistent pattern of use of dark outlines. They are not used extensively in the creation of form: to return to the Nea Moni Anastasis mosaic, there is no outline, for example, around Adam's head, though there is between part of his forehead and ear, running down to divide his neck from his robe. Instead, his head is delineated in a single line of gold tesserae, which blend in with the general colouring of Eve's robe, and in a single black line along his right shoulder. It may be that the basic layout of the scene, rather than the detail, is marked out in outlines of different colours, but certainly things have moved some distance from the clear definition of each form in dark outline. At Nea Moni, and in other monuments from this period, modelling and drapery folds are executed by modulations of colour as well as by outlining. Both line and colour are consequently an intrinsic part of form, through elements which can be manipulated in different ways to create different visual effects.

As mosaic does not allow for subtle modelling, the representation of faces presents particular problems in the use of colour (as Plates 3 and 5 illustrate). Here optical tricks were combined most effectively with the advantage of distance. The most common of

[4] As E. Kitzinger, 'Technique', in the mosaic section of the *Encyclopaedia of World Art*, 10 (1965), cols. 325–7, and 'Stylistic Development', in the same, cols. 344–6, suggests.

these devices were the so-called 'chequerboard' and 'neo-impressionistic' techniques.[5] The chequerboard effect alternates light and dark cubes with no attempt at continuity, in a bid to achieve a rapid transition from light to dark: the viewer's eye automatically fills in the intervening shades. Given the impossibility of more subtle modelling, this technique avoids the problem of striping or of large expanses of one colour. It is particularly effective in the modelling of faces, as can be seen at Nea Moni[6] and, as illustrated here (Plate 13), in the face of the Virgin in the mosaic of the Crucifixion from Daphni, or, from some three centuries later, the face of Christ in the Isaac and Melane panel at the Kariye Camii (Plate 14). The second device, 'neo-impressionism', seems to have been an attempt to mix optically tones that could not have been gained through the use of individually coloured cubes. It works on the optical phenomenon employed in pointillism but known in Antiquity, that the light reflected from two adjoining patches of colour will mix on the retina and form a third. In the face of the Virgin in the thirteenth-century Deesis panel in Hagia Sophia, Istanbul, the heavy blues of an apparent 'five o'clock' shadow seen in close up disappear from a distance, creating an effect of soft, natural shading (Plates 15 and 16). Highlighting, another method employed on both faces and garments, was also used to great effect in modelling (Plate 5).

Other tricks to manipulate colour included creating the illusion of space through darkening colour to represent increasing depth or through increasing the saturation of the horizontal and vertical planes. In Sta Maria Maggiore in Rome, the reverse, the lightening of tone towards the rear of the picture, also serves to produce a feeling of depth.

THE MANIPULATION OF LIGHT

Optical devices are employed with the other crucial factor in the use of colour, that of light. Light plays a double role in art. It is a natural phenomenon, subject to the laws of physics and manipulable through these laws, by which we see the work of art; it is also an element of that work of art, an aspect of what is represented. Paul Hills has argued that with the development of narrative as action in art, a range of problems arose associated with the manipulation of colour in relation to directional light and to the spectator. Real and decorative effects had to be balanced through an understanding of the effects of external light.[7] He focuses on early Italian art; here, I intend to extend his study back to the Middle Ages.

[5] O. Demus, *Byzantine Mosaic Decoration* (London, 1948), 38; J. Gage, 'Colour in History: Relative and Absolute', *Art History*, 1 (1978), 112.

[6] D. Mouriki, *The Mosaics of Nea Moni on Chios* (Athens, 1985), 239.

[7] P. Hills, *The Light of Early Italian Painting* (New Haven,

External light—real light—affects the internal structure of a work of art and the way in which light is represented within that work. But the Byzantines also conceived their art, above all their mosaic art, as a painting with light. It was the glittering, sparkling effect of mosaic that was most admired, as was light created by space as well as by colour. The sixth-century Byzantine historian, Procopios, wrote of Hagia Sophia in Constantinople: 'it was singularly full of light and sunshine; you would declare that the place was not lighted by the sun from without, but that the rays are produced within itself, such an abundance of light is poured into this church'[8] (Plate 17). Mosaic is a medium above all designed to interact with external light. The Byzantines conceived of it as a sheathing for the walls, a skin lying over the masonry; as such, light brought it to life.

Mosaic is subservient to the shape of the building and affected by a variety of factors: the different inclinations of surfaces, the degree of reflectance of surfaces in white light, the changes in external illumination reaching the surfaces. Consequently, light striking the mosaic acts as a dynamic force, a force which has to be carefully and deliberately employed by the mosaicist to create the desired effect. Each tessera, each cube of glass, is itself a mirror, reflecting light back. To exploit this asset to the full, the Byzantines combined geodesy, the art of measuring volume and surface, with optics to work on a careful planning and placing of mosaics. They experimented with devices for the reflection and refraction of light: mosaics were placed in carefully constructed squinches and pendentifs, in curved apses, in domes; even on flat surfaces, curved setting beds for mosaics were employed (Plate 18). The deliberate use of an uneven surface allows for the greater play of light.

Two domes from the Kariye Camii, one in the narthex, the other in the parecclesion, demonstrate how the medium also affected the lighting. The dome in the narthex (Plate 19) is mosaic and lit by eight windows, one for every other section; light runs up the flutes to the centre. The other dome is painted and lit by twelve windows, one for each segment, so that the dome appears to stand on a circle of light (Plate 20). In this way, the light-reflectant quality of mosaic is emphasized through the distribution of light, in contrast with the more uniform illumination of the paintings.

This concern with the manipulation of external light to create visual effects can be

Conn., and London, 1987), based on his Ph.D. thesis, J. G. P. Hills, 'Studies in the Use of Light in Central Italian Paintings: Cavallini to Masaccio' (University of London, 1976). Also on the theme of the nature and role of light in art, see W. Schöne, *Über das Licht in der Malerei* (Berlin, 1954), and the review of this by A. Neumayer in *ArtB* 37 (1955), 302–3.

[8] Procopios, *Buildings*, I 1 28–31, especially 30. φαίης ἂν οὐκ ἔξωθεν καταλάμπεσθαι ἡλίῳ τὸν χῶρον, ἀλλὰ τὴν αἴγλην ἐν αὐτῷ φύεσθαι, τοσαύτη τις φωτὸς περιουσία ἐς τοῦτο δὴ τὸ ἱερὸν περικέχυται. Similar sentiments are expressed by a multitude of Byzantine authors including Paul the Silentiary in his account of Hagia Sophia (in P. Friedländer, *Johannes von Gaza und Paulus Silentarius* (Leipzig, 1912), e.g. lines 489–94) and the Patriarch Photios (*Homily*, X 5, in Φωτίου Ὁμιλίαι, ed. B. Laourda (Thessaloniki, 1959), 100).

seen very clearly in the setting of gold mosaic backgrounds. The solid background of the Byzantine mosaic forms the most obvious colour mass, against which the figures in a scene are set, but this gold background is clearly not conceived of as a solid, static sheet.[9] Rather, it is the site for creating light effects, scattering light, creating glitter.

In the late ninth-century narthex panel of Hagia Sophia in Istanbul, above the great west door, the background is not laid as a solid mass but as alternating rows of tesserae and plaster bed. The tesserae are angled so that for the viewer below, and this panel can only be seen from below, the background appears solid (Plates 21 and 22). The apse mosaic of the Virgin and Child in the same church, dated to the early ninth century (Plate 23), is illuminated from below. Here, gold and silver tesserae are used in the background to create movement. Different colours are frequently used to provide variation in an otherwise monochrome surface. Gold tesserae can be set in reverse, plain glass used to create a translucent effect, yellows and greens mixed in with gold.[10] The mosaic is curved to obtain different angles of reflectance of light. The gold and silver tesserae of the background have their surfaces angled forward, whilst those of the border are set vertically.[11] All of these devices serve to vary the light effect of the gold background. In the thirteenth-century Deesis mosaic, again in Hagia Sophia, Istanbul, the background gold tesserae are laid in a ripple trefoil pattern (Plate 24). This background serves to diffuse the light and alters as the light itself changes and moves, creating a shimmering effect.

Light from outside a work of art also affects the internal structure of that art and the ways in which light is represented within the work. The direction of external light influences the positioning of figures and the use of colours. Shadows cast by real light can reveal surface orientation; the scattering of light can cause mutations of colours and confuse the scene. Real light is used therefore in combination with an awareness of its effect in the space between viewer and picture. In Byzantine art, light tends to be projected from in front and above the picture. This real light is then represented in pictorial terms. In the Deesis panel from Hagia Sophia, Istanbul, where real light comes from windows to the viewer's left and above, the direction of this light is represented pictorially: a shadow line runs across Christ's neck, from the right-hand side of his jaw, the shadow cast by a real jaw in real light from this direction (Plate 25). Similarly, in the Nativity at Hosios Loukas, the left half of the scene is brightened with strong white highlights, representing starlight (Plate 26).

[9] Hills, *Early Italian Painting*, 29–31, sees the gold background as the negative space of a patterned backdrop: it should be seen as the setting for the scene, a setting designed to manipulate light within that scene.

[10] As at Nea Moni where clear glass is used in the Trans-figuration mosaic, where it outlines the beams of light outside Christ's mandorla.

[11] For more on the intricacies of the setting of this mosaic, see G. Mathew, *Byzantine Aesthetics* (London, 1963), 29.

In this same scene, real light is collected in the focal region of the mosaic, the centre of the curve of the squinch. This concentration is echoed by the representation of light, the star and its rays, striking the baby. Consequently, the Christ-child becomes the focus of both external and pictorial light, emphasizing his position as the iconographic focus of the scene. In the representation of the Annunciation at Daphni (Plate 27), light is collected in the niche between the Virgin and the Archangel. They stand either side of a pool of light, which can be read as iconographically significant.[12] The two fourteenth-century mosaic domes showing the ancestors of Christ at the Kariye Camii are fluted in such a way that external light is channelled up each dome to the central figure, which is thus literally highlighted (Plate 19).

Light within a picture is represented predominantly through highlighting, both in white and gold. In the case of mosaics, sharp contrasts between dark and light are necessary to avoid creating a silhouetted effect. Increasingly, highlighting becomes stylized; rather than conforming to body shapes, it has a patterning effect. This seems partly a result of using and directing real light through the internal highlights. At Nea Moni, chrysography, gold highlighting, serves to illuminate the bust of St Anne, the mother of the Virgin (Plate 28). In the Anastasis at the same church, the two most heavily highlighted figures, webbed in chrysography, are Christ and Eve (Plate 29).[13] The extensive use of gold here serves to focus external light on Christ in the centre of the scene and to throw both Adam and Eve into high relief, offering a dynamic horizontal axis to the composition. The place of highlighting in the composition as a whole should not be overlooked in understanding other roles in art of this nature. Similarly, gold highlighting is apparent in the hair of the Christ-child in the apse mosaic of Hagia Sophia, Istanbul (Plate 30). This increases the brightness around the child's head, emphasizing his importance against the dark robes of his mother.

The Byzantine emphasis on light and glitter serves to highlight two problems inherent in the study of colour, one practical and one theoretical. The practical issue is that of dirt and discoloration; the theoretical, that of perception, of how a particular culture conceives of colour.

Dirt, cleaning, and restoration all affect the appearance of a work of art, especially of its colours, as I have illustrated with examples from mosaic and wall-painting (Plates 31 and 32).[14] Otto Demus perceived a feature he described as 'reverse highlighting' in the mosaics of Hosios Loukas. Here, faces were highlighted in the places where one

[12] E. A. James, 'Colour Perception in Byzantium', Ph.D. thesis (University of London, 1989), 32; Gage, *Colour and Culture*, 58–9.

[13] Mouriki, *Nea Moni*, 241, comments on the extensive use of chrysography in the church. It should be noted that the chrysography of Christ's robe in this scene carries a particular iconographic significance.

[14] As the disputes over the cleaning of the Sistine Chapel have also shown.

would expect to find shadows, the grooves of facial relief, in a bid, according to Demus, to deal with the particularly bright lighting of the vault in which these mosaics were placed.[15] However, this mysterious effect turns out to have been the result of dirt; now that the mosaics have been cleaned, there is no trace of reverse highlighting (Plates 33 and 34).[16]

Lighting, however, does have an effect on colours. Although it is not known under what conditions Byzantine monumental art was set up, we do know that it was illuminated by candles, oil lamps, and windows, not by the steady, bright, focused light that is now usually the case. This has a significant influence on the colour balance of the picture, with the potential to alter it in such a way as to disturb the overall compositional balance. For example, in purely physical terms, the decrease in illumination on a complete colour scale results in a shift of emphasis or relative intensity from the red end of the scale to the blue. In dark surrounds, blue is the last colour to shine out, but is very intense. In well-lit surrounds, red and yellow are stimulated (the Purkinje phenomenon). Complementary colours, red and yellow, green and blue, play off each other; colours are affected by the proximity of different colours. The same mosaic seen from two different positions may appear very different in its colours (Plates 35 and 36). All of these factors influence the viewer's perception of colour.

COLOUR AND STYLE

A further issue is that of style: the ways in which these colours are used. In looking at the way in which colour is used within a picture, the fundamental question is that of what does the colour do. A twofold use of colour is most obvious: its role as a balancing and as a unifying agent within a scene.[17]

Colour is used to balance a scene by its use in creating symmetry and in creating counterpoint. Symmetry is used to correlate colour planes. In the Pantocrator mosaic at Daphni, the gospel book held by the Pantocrator is balanced by a pale patch, matching the book in colour, on the shoulder of his garment, a patch which has no other reason for being there (Plate 37). Counterpoint on the other hand consists of a system of exchanging or of offsetting colours within the composition: the right shoulder of the bust of Theodore Studites at Nea Moni is in pink, offset by the red and gold colour of the book he holds. Both symmetry and counterpoint affect the axis of pictorial composition. The eye may be concentrated on the centre or encouraged to move evenly

[15] Demus, *Byzantine Mosaic Decoration*, 36 and plates 26 and 27a. [16] I owe this observation to Ernest Hawkins. [17] J. K. G. Shearman, 'Developments in the Use of Colour in Tuscan Painting of the Early Sixteenth Century',

Ph.D. thesis (University of London, 1957). P. A. Underwood, *The Kariye Djamii*, i (New York, 1966), also records colour changes in modelling but does not seek to develop a vocabulary for it.

from side to side to the centre. Counterpoint tends to have a distributive rhythm at variance with the centre and encourages the eye to wander. The strong dark colours of the Theodora panel at San Vitale in Ravenna (sixth century) pull the eye to Theodora and to the darkened doorway to her right, away from the attendant women, offset by their pale, lighter colours (Plate 38). Symmetry, however, balances the picture around a central point and tends to stress the vertical axis of composition. In the Zoe panel in Hagia Sophia in Istanbul (1028–42), the gold robes of emperor and empress on either side of Christ blend with the gold background and balance each other, leaving Christ's blue robe as the colouristic and iconographic focus of the composition (Plate 39).

Colour can be used to unite a scene through colour chains and sequences. The repetition of contrasting or complementary colours links together areas of a picture. In the Nativity at Hosios Loukas (Plate 26), two colour chains unify the picture. Vivid red runs along the bottom from one of the kings to the Virgin's mattress, the woman giving the baby his first bath, a shepherd, and a seated figure. From this same seated figure, a chain of blue is developed across the top of the scene, ending in the Magus wearing red.

By using techniques such as these, emphases in a scene can be created through the use of colours. Colour and the rhythms of colour can also be employed to create variety in a scene. Byzantine art consists of the repetition of a fairly limited repertoire of scenes; by varying the colours within each scene, variety in the art itself is created. In this way, each patch of colour has a place in the overall surface pattern and a stylistic significance.

THE DESCRIPTION OF COLOUR IN ART

To return to the Nea Moni Anastasis, an additional level of description can now be added, a level which takes into account the ways in which colours are used in pictorial composition. Christ is the focus and pivot of the scene in terms of colour: his blue and gold robe in the centre of the conch forms the focal point for the collection of external light and the reflection of internal light. Adam in grey and blue is thrown into sharp relief by the striking red and gold of Eve's robes, whilst the righteous dead behind them provide a dark foil, offering a descending colour scale of increasing light. Eve's very bright garments frame Adam, serving to throw him into sharper definition between the two areas of gold, herself and Christ. A counterbalance to these colours is provided by the two vivid, solid blocks of colour of the kings' haloes to the left, reinforced by the odd patch of green between the two haloes, a patch of colour which seems to bear no relation to figures behind the kings. Along the bottom of the scene runs a chain of red and blue from David's robes to Adam, a chain which links these two figures and helps

to unify the scene. Similarly, Solomon and John the Baptist with his accompanying figures balance each other in form and colour.

At Hosios Loukas, the same scene is shown in a much less detailed fashion (Plate 40). Only five figures appear against the solid gold ground. Christ, this time in white and gold, is again the dominant figure in colour terms. His white himation blowing to the viewer's right is echoed by Adam's garments in two shades of white. Again, the solid red of Eve's clothing is balanced by the kings, this time in their dress rather than their haloes, whilst their gold tablia echo the gold in Christ's robes. In the representation of the Anastasis at Daphni (Plate 41), the gold of Christ's dress provides a strong vertical axis. On either side are balanced Adam and Eve and John the Baptist. The strong blue in the garments of John link him colouristically across the bottom of the scene with the kings, Adam, and the figure of Hades. The paler figures behind the Baptist provide a counter to the white robe of Adam. All three scenes offer variations on the basic theme of the Anastasis, both in composition and in use of colours. However, though the colours are varied, the ways in which they are used, providing balance and unity within the picture, remain similar.

Such descriptions of colour cover only part of the story. The usual way in which colour has been described by historians of Byzantine art concentrates on a very different aspect of colour: not its overall use in pictorial composition but a detailed study of tones and shades. For example, excerpts from the full-length study of the mosaics of Nea Moni reveal that in the Anastasis

Christ is clad in a chiton of the two deepest shades of purple, and in a himation of the two deepest shades of dark blue, with purple-black for the outline and black for the shadow lines. Both the chiton and the himation have rich gold striations . . .

Adam . . . has hair of grey-blue glass and white marble. Glass of the same colour but combined with white limestone is used for his beard. The usual flesh tones [*pinks and whites*] with dark olive shading have been used in the face. The tone of Adam's right arm and hand are different from those of his left. His right arm and hand . . . appear almost completely white in two tones of white and the lightest tone of pink. The shading consists of a single row of brown tesserae . . . Adam's chiton is grey-blue in three tones. The clavus consists of a double row of red tesserae. The himation is white in the usual combination of materials with shading in two tones of olive and one of grey-blue . . .'[18] (See Plates 29 and 11)

Such a description of colours is important. It offers a baseline, a point from where the style of colour use can be explored, both within a picture and across pictures, a place where it is established what colours are used within the scene, opening up a space to describe how these colours are used.

[18] Mouriki, *Nea Moni*, 61–2. The descriptions of mosaics throughout this publication are of high quality. Mouriki's text contains an excellent chapter (in collaboration with Ernest Hawkins) on technique, a section on colour and style, and outstanding colour illustrations.

In her analysis of the mosaics at Nea Moni, Mouriki provides a colour chart listing fifty-seven different colours and their various shades.[19] She evaluates the palette and notes the ways in which colours are used within the mosaics. Red, for example, is found in two shades, deep and bright, and used essentially for drapery, contours of hands and feet, outlines of nimbi, clavi, jewels, and ornamentation.

She then endeavours to compare the palette at Nea Moni with that of other churches from the same period.[20] For two of these churches, Hosios Loukas and Daphni, no lists or charts of colours exist. This reduced Mouriki to generalizations; she could only conclude that the mosaics at Daphni obviously possess a greater variety of materials and colours than Nea Moni, with, for example, three types of red glass to Nea Moni's two.

For the church of St Sophia in Kiev, a different problem arises. Of the two Russian scholars who have described the church, one, Logvin, states that there are eighteen groups of colours with 129 gradations, 143 tonal shades, and twenty-five variants of gold and silver.[21] The other, Lazarev, describes 177 different tints, including twenty-one blues (the same figure as Logvin), twenty-three yellows (to Logvin's forty-four yellow-brown shades) and nineteen reds (Logvin has thirty-one).[22]

Similarly, one description of the imperial panel in the narthex of Hagia Sophia in Istanbul describes thirty-four shades of nine basic colours; another account has fifty-three colours.[23] To return to Nea Moni, an earlier study of the church asserted that twelve colours were employed there.[24]

A tabulation of colours by hue and material is clearly very useful. However, those that exist at present serve only to highlight the major defect of this system: it is not clear to which colour each colour word refers. Without knowing this, it is impossible to compare colours within monuments, never mind across them. Each account of colour works in the context of the individual report of which it forms a part, but no further.

Such a standardization of colour terms can be achieved relatively easily and at several levels of complexity. Within archaeology, the Munsell colour chart provides the basic reference point for describing the colour of an object.[25] The Munsell colour chart, and similar colour charts, arrange colours in a continuous line and in three

[19] Ibid., 102–3. [20] Ibid., 238–45.
[21] G. N. Logvin, *Kiev's Hagia Sophia* (Kiev, 1971, in English), 16.
[22] V. N. Lazarev, *Mosaiki Sofii Kievskoj* (Moscow, 1960, in Russian), 144–51. Lazarev's analysis of the colours of the mosaics of the church of St Sophia in Kiev is even more detailed. See V. N. Lazarev, *Michajlovskie Mosaiki* (Moscow, 1966, with French summary), 120–1.
[23] The first is E. J. W. Hawkins, 'Further Observations on the Narthex Mosaic in St. Sophia at Istanbul', *DOP* 22

(1968), 153–68; the second, T. Whittemore, *The Mosaics of St. Sophia at Istanbul* (Oxford, 1933), 24 and table IV. See also Whittemore's appendix, 'Particulars of Colour, Meaning etc.' Whittemore provided similar details for all the mosaics of Hagia Sophia in whose rediscovery he was involved.
[24] E. Diez and O. Demus, *Byzantine Mosaics in Greece* (Cambridge, Mass., 1931), 84.
[25] A. H. Munsell, *A Grammar of Color* (New York, 1900).

dimensions, hue, saturation, and brilliance. Consequently, a colour can be plotted in three dimensions and given a Munsell rating or number expressing this, marked by a coloured chip on the colour chart. A standard nomenclature, the Universal Color Language, has been devised, based on a division of the three-dimensional Munsell colour space into 267 blocks which are denominated according to a standard schedule of hue names with modifications for saturation and brilliance.[26]

These references are used in the description and analysis of pigments; there is no reason why they should not be used in the description of the colours of a work of art. Each shade of colour in the wall paintings of the cave church of Tokalı Kilise in Cappadocia has been given a Munsell rating.[27] However, the Munsell system does present several problems. Differences in media affect the appearance of a colour: a piece of blue glass and a Munsell colour chip are some distance apart (Plate 42). In addition, a single colour does not have a consistent value but is seen in the context of its neighbours and changes both according to that context and with different light, the phenomenon known as simultaneous colour contrast.

More useful is the chroma meter. This instrument records colour in all three dimensions simultaneously. Placed on a colour, it emits its own, measured light and records the reflection of light back. The reflectance curve of the colour can then be plotted, the pigment identified from its place on that curve and then recorded on a CIE chart or a Munsell chart through the conversion of the colours to a numerical code.[28]

The Byzantinist Ernest Hawkins has always advocated identifying pigments by pigment name according to artists' conventions: such a system would provide a relatively straightforward standardization.[29] A full colour chart, in which colour words were matched to the actual colour, could then become a basic tool of description. Once colours are recorded in a standardized way, then a new set of issues can be confronted: issues about the development of palettes, the range of colours available at any one period, the standard pigments employed; economic issues about the acquisition and manufacture of pigments; stylistic and iconographic questions about patterns of colour use, and comparisons across cultures and time. Style is used to date art: why not colour

[26] This is the nomenclature used in R. L. Feller (ed.), *Artist's Pigments. A Handbook of their History and Characteristics* (Cambridge and the National Gallery of Art, 1986), together with the Colour Index (CI) generic name and number. These are described, together with the method for calculating the Universal Color Name, by R. Johnstone-Feller as an appendix to Feller (ed.), *Artist's Pigments*, 299–300.

[27] App. 2 to A. Epstein, *Tokalı Kilise: Tenth Century Metropolitan Art in Byzantine Cappadocia, DOS* 22 (Washington, DC, 1986), 58–9.

[28] I would like to express my gratitude to the late Gerry Hedley for his advice on colour and the chroma meter. For its use in archaeology and the recording of tomb paintings, see N. Strudwick, 'An Objective Colour-measuring System for the Recording of Egyptian Tomb Paintings', *Journal of Egyptian Archaeology*, 77 (1991), 43–56.

[29] P. J. Nordhagen is another who has advocated a systematic recording of colour. See e.g. his 'The Mosaics of John VII (705AD–707AD)', *ActaIRNorv* 7 (1965), 121–66, and, with H. P. L'Orange, *Mosaics*, trans. A. E. Keep (London, 1966).

and patterns of colour use? Different colours are emphasized in different periods. In fifth- and sixth-century mosaics, blues and greens predominate, as in the Mausoleum of Galla Placidia and the apse of Sant' Apollinare in Classe, both in Ravenna. Coloured backgrounds are superseded by gold ones; blues and especially greens in figural composition by gold also. What further comparisons and conclusions remain to be drawn?

THE PERCEPTION OF COLOUR

I opened this book by posing a very simple question. What do we see in looking at Byzantine art? This far, I have answered it in the terms of the art historian looking only at the object: what colours are there, how are they made, how are they used within the particular picture. I want now to begin to open it out beyond the 'traditional' frame of scholarly writing, to move beyond description and into perception.

This issue of the perception of colour is the theme that will dominate the remainder of this book. Rather than simply 'what do we see in looking at Byzantine art?', I will rephrase the question as 'what is there to see in looking at Byzantine art?' Is there a difference between our perceptions of something so obvious as colour and Byzantine perceptions? To assess this, I will look at colour vocabulary, the actual words used to describe colours by the Byzantines, and the use of such words. Do the Byzantines describe colours in the same sort of ways as we do? What does this use of colour vocabulary say about Byzantine perceptions—and about our perceptions? In describing the Anastasis, what would a Byzantine say? In answering such questions, I shall discuss Byzantine writings about art and concentrate on one image in particular, the rainbow, an image whose colours are so familiar to us as to need no discussion. I shall examine Byzantine theories of vision and the workings of vision to see how these affect Byzantine beliefs about the nature of colour and I shall conclude with a study of how Byzantine ideas about colour influenced their ideas about the nature of pictorial representation itself.

Colour offers the scope to examine Byzantine perceptions of art because 'we know what we think' about colour and we know how colour and vision work. We have a model for our own perceptions (in my case, white, middle-class, European, woman) to set against the Byzantine. This is my model.

Modern scholars characterize colour as being made up of three components:[30] hue;

[30] e.g. R. M. Evans, *An Introduction to Color* (New York, 1948); J. J. Gibson, *The Senses Considered as Perceptual Systems* (London, 1968); R. B. MacLeod and H. L. Pick (eds.), *Perception: Essays in Honor of James J. Gibson* (London and Ithaca, NY, 1974).

saturation; brightness. Hue is conveyed by words such as 'red' and often described as the main quality factor in colour, the most noticeable aspect of the spectrum, changing as the wavelength of light changes; saturation is defined as the percentage of hue in a colour, or the perception of the apparent concentration of a hue, conveyed by terms such as 'pale'; and brightness describes the relative lightness or brightness of a colour. A direct judgement of brightness can be made without reference to hue or saturation, and the brightness of one part of an object can differ sharply from that of another. In answer to the question 'what colour is it?', hue answers with a word such as 'red' or 'blue', saturation with 'deep red' or 'green-blue', brightness with 'bright red' or 'dark green'.

Our understanding of colour and the relationship between light and colour derives essentially from Isaac Newton's discovery of the composite nature of light. Each colour in the spectrum corresponds to a given electromagnetic frequency and, as Newton observed, objects 'become colour'd by reflecting the Light of their own Colours more copiously, and that of other Colours more sparingly'.[31] If white light falls on a red object, the surface modifies the light by taking in all of the spectrum except red which is reflected out.[32]

Our understanding of vision is also well developed. We know that objects are seen usually only because light falls on them and is diffusely reflected. Light enters the eye through the pupil and passes through the lens and the humours, which serve to refract it on to the retina and optical nerve. From the stimulus of light, the receptors in the eye, the rods and cones, pass back neural signals in the form of electronic pulses into the brain.[33] It is on these bases that we think about colour.

COLOUR NAMING

There are about 7,295,000 visible differences in a colour solid; the eye can discern perhaps 120–50 different hues. The English language, however, can subsume these into four basic categories, the so-called primary colours of red, yellow, green, and blue.[34] We recognize that the interaction between colour impression or sensation and linguistic

[31] I. Newton, *Opticks: or a Treatise of the Reflection, Refraction, Inflections and Colours of Light* (New York, 1952, based on 4th edn., London, 1730). H. Gipper, 'Purpur', *Glotta*, 42 (1964), 65, mentions that the inclusion of indigo in the spectrum was influenced by Newton's partiality to this colour. Newton also seems to have wished to link colour intervals to the intervals of the musical scale, hence seven spectral colours.

[32] All objects absorb light. However, light from the source and from the object are different in colour. Further, two light sources with completely different energy distributions may look identical to an observer but can produce very different colours if the light from them falls on the same object.

[33] R. L. Gregory, *Eye and Brain* (3rd edn., London, 1979).

[34] Seven million is the figure in C. E. Padgham and J. E. Saunders, *The Perception of Light and Colour* (London, 1975), 104. It varies from 10 million cited by K. Nassau, *The Physics and Chemistry of Color* (New York, 1983), 7, to 1 million in H. Terstiege, 'The CIE Colour-coding System', in J. D.

expression is not close enough for lack of precision and clarity to be avoided. Consequently, colour naming and the development of colour terms within cultures is a complex issue, extending into anthropology, psychology, and psychobiology.[35] Colour terms serve to map out the space of colour in a particular society and are of vital significance for the understanding of perceptions. Our own post-Newtonian perception of colour is immediately apparent: when asked to describe the colour of an object, our response is typically a term such as 'red' or 'blue'. We relate colour to hue, to the extent that 'colour' and 'hue' are virtually synonymous. Even language is constructed with this bias. Hue words generally serve as adjectives—'the green leaves'—and other qualities of colour qualify this description by being applied as verbs or adverbs—'the green leaves glistened'. Writing about colour concerns itself primarily, though not exclusively, with these aspects; these biases affect our analysis of colour.

Other attributes of visual sensation and perceptual patterning modify the perception of colour: what one expects to see, what one remembers as the appropriate response to the particular colour stimulus. Consequent to individual observation is the form of linguistic description employed, however restricted by language it might be. When the colour of an object rises above the norm in brightness or saturation, then language tends to exaggerate the overstepping; often colour effects are emphasized by reference to those attributes most striking in perception—blood-red, snow-white. In the imagination and memory, the tendency is also towards exaggeration. It is very hard to retain an accurate memory of a specific colour: usually the generic or heightened version is preferred. Colour may also change with different forms of illumination or with the proximity of other colours, as artists such as Delacroix realized, through their reading of scientific works.[36]

Colour sensations result not only from the physical qualities of light and physiological processes in the brain and retina, but also in the psychological interpretation of

Mollon and L. T. Sharpe (eds.), *Colour-vision: Physiology and Psychophysics* (London, 1983), 563. For primary colours and the differences between the primary colours of art, psychology, and physics, see H. Rossotti, *Colour* (London, 1983). Also, T. Young, 'On the Theory of Light and Colours', *Transactions of the Royal Philosophical Society* (1802), 12–48, and refined by Helmholtz, a major figure in work on colour and light. See H. von Helmholtz, *Helmholtz on Perception: Its Physiology and Development*, trans. and ed. R. and R. Warren (New York, 1968).

[35] The standard study on 'basic colour terms' and the issues around colour naming is B. Berlin and P. Kay, *Basic Color Terms* (Berkeley, Calif., 1969). Also useful are V. F. Ray, 'Techniques and Problems in the Study of Human Color Vision', *South-Western Journal of Anthropology*, 8 (1952), 251–60; H. Conklin, 'Hanunoo Color Categories', *South-Western Journal of Anthropology*, 11 (1955), 339–44; reviews of Berlin and Kay, *Basic Color Terms*, by N. P. Hickerson in *International Journal of American Linguistics*, 37 (1971), 257–70 and by P. Newcomer and J. Fairs in *International Journal of American Linguistics*, 37 (1971), 270–5; N. B. McNeill, 'Color and Color Terminology', *Journal of Linguistics*, 8 (1972), 21–33; H. Conklin, 'Color Categorization', *AmAnth* 75 (1973), 931–42; D. Turton, 'There's No Such Beast: Cattle and Cattle-naming among the Mursi', *Man*, 15 (1980), 320–38.

[36] M. E. Chevreul, *De la loi du contraste simultané des couleurs* (Paris, 1889). For Delacroix's colour triangle, see M. Kemp, *The Science of Art* (London and New Haven, Conn., 1990), 308.

these. These are of great complexity since other sensory attributes besides those of hue, saturation and brightness are present and need to be taken into account. These include texture, lustre, and transparency.[37] That we perceive these as secondary reflects our own concerns, rather than the 'intrinsic' nature of colours. The perception of object colour can be changed by any one of a number of significant factors—hue, brightness, saturation, size, shape, location, flicker, sparkle, transparency, glossiness, lustre, so that no one of these attributes can be considered independently of any of the others, and all must be assessed when colour is examined.

It is apparent even in such a brief account that we place our emphases in the study of colour on hue and changes in hue and that this is based on our modern understanding of the nature of vision and the physics of light. This indeed is the emphasis placed on colour by art historians generally. The strongest modern school of colour study is that followed in Germany, a school which depends upon a tradition of aesthetic formalism and philosophic phenomenology. The study of colour in Western art has focused on areas such as the gendering of colours, the cognitive status of colour, and the search for the 'meaning' of colours; it is especially concerned with the particular artist's use of colours, together with the theory behind such a use.[38]

Both Marcia Hall in *Color and Meaning: Practice and Theory in Renaissance Painting* and Paul Hills in *The Light of Early Italian Painting* adopt a teleological perspective.[39] They aim to trace the development in the use of colour from one Italian artist to another, aiming towards some sort of culmination—in Masaccio for Hills and Leonardo for Hall. For both these scholars, the significance of colour in art is in its development within the context of named artists of identified pieces of work. There are few known, named artists in Byzantium, indeed, in medieval art as a whole. Consequently, an alternative approach to that offered by Renaissance art historians is required. My approach is synchronic. I have begun, and will continue, to juxtapose both works of art and texts from different periods. In this way, it will become clear that while some attitudes to colour remained constant, others were flexible and shifted. I have been more concerned to consider shifts in colour use in terms of the subject-matter of the particular image than questions of how exactly attitudes to colour changed over time: there is not sufficient

[37] Conklin, 'Color Categorization', 933.

[38] J. Gage, 'Color in Western Art: an Issue?', *ArtB* 72 (1990), 518–41, discusses fully the treatment of colour by art historians. It is noteworthy that, in his survey, the bulk of research relates to the Renaissance and after, with particular reference to Impressionist painters. Gage's conclusion is that 'the study of color in Western art must proceed along broadly anthropological lines' (539), but that a diachronic

overview is necessary to overcome standard misunderstandings of local and period-specific aspects of colour in art.

[39] M. B. Hall, *Color and Meaning: Practice and Theory in Renaissance Painting* (Cambridge, 1992). In contrast to both Hall and Hills, John Gage in his important article 'Colour in History', 104–30, begins the task of looking at colour without the artist.

evidence to trace this last issue. By juxtaposing material from different centuries, both continuity and change become apparent.

My illustrations of the Nea Moni Anastasis and the 'gap' between colour and black-and-white offer a springboard into the question of how was colour used and further, of how was it perceived. How did the conception and perception of colour affect its use in art? To answer such a question, I shall have to move further than is traditionally allowed to art historians into looking at colour vocabulary, the words used to describe colours, to see what these words tell us about attitudes towards colours. I shall also consider how the influence of the past, the previous traditions of colour use, affected the Byzantines' perception of colour in art—though without seeking a teleological fulfilment.

CHAPTER 2
The Materials of Colour

THOUGH the principal stress in this book lies on the issue of the perception of colour, questions of technical production methods cannot be ignored. The use of colours in art depends on the availability of pigments: a colour which cannot be made cannot be used. Consequently, the materials of colour are important. What the actual colours were, how they were made, and how easy they were to make are all fundamental issues in understanding colour and art. Economic and trade considerations become significant in understanding the manufacture of colour: were colours made locally or imported? It then becomes possible to determine which colours were rare and difficult to obtain, and whether they were valued accordingly, and to judge how these factors may have influenced the composition and use of colour in a work of art.

THE COLOUR OF MOSAICS

Glass tesserae are the normal material of a Byzantine mosaic, though stone, brick, shell, and other such materials were also employed (Plates 43 and 44). Mosaic glass is essentially of the type known as soda-lime glass, a compound of sand, soda acting as a flux (the substance mixed to ensure fusion of the components), a lime stabilizer, and a small admixture of impurities.[1] It was the standard form employed in the Roman world. It tends to be bluish-green, coloured by the iron present in all sand. Other colouring depends upon the nature of the impurities present in the mix. Different metallic oxides were added when specific colours were required or to decolour the glass. However, even where old, proven recipes were used, wildly differing results could be obtained depending on the materials and proportions employed and the temperature of the furnace.[2]

[1] Very little analysis has been done of Byzantine glass mosaic tesserae, so evidence consists mainly of hypotheses based on Roman glass. However, for a study noting the composition of Byzantine glass, see I. C. Freestone, M. Bimson, and D. Buckton, 'Compositional Categories of Byzantine Glass Tesserae', *Actes du 11 congrès (Basle, 1988) de l'association internationale pour l'histoire du verre* (Amsterdam, 1990), 271–80. I am grateful to David Buckton who allowed me to see this report prior to publication.

[2] R. G. Newton, 'Colouring Agents Used by Medieval Glass Makers', *Glass Technology* 19: 3 (1978), 59–60, argues, from Western evidence only, that colours were obtained less through the addition of colouring oxides and more through controlling the temperature of the furnace, and through the nature of the wood burnt and the cullet used. He suggests that perhaps each glass-maker could only make a particular colour/range of colours, which was claimed as a secret process.

Roman and Byzantine chemical knowledge was not always equal to removing the impurities in raw materials; the range of colouration in glass often indicates the uncertain outcome of the attempt to produce a fixed hue, an important factor in the study of Byzantine colour.

Manganese and antimony, together or separately, were used in the manufacture of colourless glass (that is, glass which is not deliberately coloured): depending on the quantity added, yellowish or purple glass could be obtained. Between the sixth century BC and the fourth century AD, glass was characterized by a low potassium and manganese content and a high antimony concentration, whereas fourth- to ninth-century glass contains less antimony and more manganese. Although a variety of metal ores were used to make colours, the same ore could produce a range of hues. Pale blue was obtained by using copper oxide or even iron; dark blue could also result from copper oxide and additionally from cobalt. Copper oxide was further employed in the making of deep green glass. Bottle green came from ferrous (reduced) oxide, FeO. Lead was also used in the making of greens. Oxidized iron, Fe_2O_3, produces transparent amber. Purple came from manganese, yellow from antimony or manganese, and black from large quantities of mixed iron and manganese. Sealing-wax red was obtained from a suspension of cuprous oxide in a vitreous matrix, and other shades of red, invariably opaque, could be employed by the manipulation of furnace conditions.[3] In the Byzantine period, opaque red glass is not common, and may even have been imported from the West.[4]

Alexandria and Syria were the glass-making centres of the Roman world. Glass was also produced in Italy, particularly Rome itself. Evidence from the East in this period suggests that practically every area possessed glasshouses; by the first century AD it seems that glass was a common material of everyday use for all kinds of domestic purposes, practical and ornamental, at most levels of society. Although it is not clear what happened to the glass-making industry in the West in the fifth century and after, in the East, Roman traditions continued.[5] Glass remained essentially natural green, bluish-green, yellow, brown, or deep blue, this last probably the only case where a special colouring material had to be added. The Arab conquests inevitably led to a shift in centres of glass manufacture within the empire. The three major production areas of Egypt, Syria-Palestine, and Mesopotamia continued the manufacture of glass and by

[3] C. Singer, E. J. Holmyard, A. R. Hall, and T. I. Williams (eds.), *A History of Technology*, ii (Oxford, 1956), 312–14; R. J. Forbes, *Studies in Ancient Technology* v. *Glass* (Leiden, 1957).

[4] Suggested by D. Buckton, 'Theophilus and the Techniques of the Medieval Enameller', paper given at the 12th British Museum Medieval Enamel Colloquium, 1991.

[5] The most technically innovative glasshouses of the Roman empire were on the east shores of the Mediterranean, at Tyre and Sidon, for example, and continued production after the Arab conquests. Islamic glass-making is indebted to Roman. See M. Jenkins, *Islamic Glass: A Brief History*, Metropolitan Museum of Art Bulletin (Fall 1986).

the time of the establishment of the Abbasids in Baghdad, a distinct Islamic style was apparent. Very high quality colourless glass was made, as were painted and gilt and enamelled vessels.

In the Byzantine empire, it is not at all clear what glass was made, where it was made, and what quality it was. Fourth- to sixth-century sources mention glass-making occasionally, and do so in such a way as to indicate that craftsmen were involved in the production and decoration of glass. The *Theodosian Code* mentions glass-makers in its list of those practitioners of the arts exempt from public services, together with mosaicists.[6] John Chrysostom in the fourth century expresses astonishment at the work of glass-makers in transforming sand into a cohesive, transparent substance.[7] Evagrius tells a story of a Jewish glass-maker in Constantinople during the sixth century.[8] John the Geometrician, writing in the ninth century, composed an epigram on a vase[9] and the tenth-century *Book of Ceremonies* refers to seventeen glass vessels sent with an envoy to Italy by Romanos I.[10] There is no mention, however, of glass or glass-makers in the tenth-century *Book of the Eparch* or in later sources generally.[11] However, this lack of information is similar to the general uninterest Byzantine authors display towards most forms of Byzantine craft work.

It has been suggested that the craft of glass-making was lost during the so-called 'dark ages' of the seventh and eighth centuries, since there appears to be no evidence of sites for its manufacture. The same could be said of the bulk of crafts in Byzantium, for which the only remaining evidence is the finished pieces. A more likely explanation is the lack of serious excavations of Byzantine sites. The quantity of glass tesserae in existence indicates that the manufacture of glass continued. In addition, high quality enamels continued to be made, employing the same basic techniques of manufacture and colourants as mosaic glass. The practicalities of putting up a mosaic and the quantities of tesserae involved suggest that the empire needed to provide its own tesserae. It has been proposed that instead of manufacturing glass, the Byzantines imported all their needs from the Arab world, combining this with a continual reuse of tesserae.[12]

[6] *Codex Theodosianus*, XIII. 4. 2.

[7] John Chrysostom, *In Epist. 1 ad Cor. Homil.*, PG 61, 142, 24–6.

[8] Evagrius, *Ecclesiastical History*, ed. J. Bidez and L. Parmentier (Amsterdam, 1964; repr. of London, 1898), iv. 36. John Moschos also tells of a Jewish glass-maker in Constantinople: E. Mioni, 'Il Pratum Spirituale di Giovanni Mosco. Gli episodi inediti del Cod. Marciano greco II, 21', *OrChrP* 17 (1951), ch. 12, p. 93. Is there any significance in the fact that these are both Jewish craftsmen? ὑαλουργός and ὑαλοψός are the terms used for 'glass-maker'.

[9] John the Geometrician, *Epigram 76*, PG 106, 938A.

[10] *De Ceremoniis Constantini Porphyrogeniti*, ed. I. I. Reiske (Bonn, 1829), 661, 13–16.

[11] Michael Glykas writing in the 12th cent. mentions a glass-maker from the reign of Justin II: *Annales*, ed. I. Bekker (Bonn, 1836), 506.7.

[12] Evidence for reuse comes largely from Western manuals such as the *De Diversis Artibus* of Theophilus and that of Heraclius. This does not mean the Byzantines were forced to reuse tesserae; it is more likely they exported to the West as they did to the Islamic world and Kiev. See also the discussion in D. Mouriki, *The Mosaics of Nea Moni on Chios* (Athens, 1985), 102–4.

Certainly, unrefined glass was shipped all over the Roman empire. However, as it seems that Byzantine craftsmen were imported for the construction of the Great Mosque in Damascus and the Dome of the Rock, Jerusalem, and that tesserae went with them and later to Kiev, there seems little reason to suppose that the Byzantines lacked the skill to make their own materials.

The only glass-making site so far excavated in the empire is in Greece, an area which historians had never previously considered to be a centre of glass-making. The two small factories in Corinth probably date from the eleventh century.[13] They are situated in the medieval agora, on a part of the classical site which was primarily used by various factories. Previous finds of medieval glass from Corinth are meagre, making the discovery of glass factories here even more surprising. Though the furnace here is less complicated than that described by Theophilus in *De Diversis Artibus*,[14] the fragments of glass are of high quality, consisting essentially of tag-ends and vessels accidentally broken, not failed pieces. All the glass is blown, and the excavators remarked upon the amazing range of colours. The close stylistic links of the glass with Egyptian glass led to the suggestion by the excavators that one factory may have been established by Greek craftsmen escaping eleventh-century persecutions in Egypt. Very little glass later than the twelfth century was found at Corinth, and it is unlikely that any was ever manu-factured there after the conquest and pillaging of the city by Roger II of Sicily in 1147. Analysis of glass panels from Greece shows that the reds and yellows are so significantly different in composition from the other glass as to come from differing sources apart from Greece. This supports belief that Greece was not a glass-producing area and that the workers in the Corinth factory were refugees.[15]

[13] G. Davidson, 'A Medieval Glass Factory at Corinth', *AJA* 44 (1940), 297–324; G. Davidson Weinberg, 'A Medieval Mystery: Byzantine Glass Production', *JGS* 17 (1975), 127–41; G. Davidson Weinberg, 'The Importance of Greece in Byzantine Glass Manufacture', *15th International Congress of Byzantine Studies 2B* (Athens, 1981), 915–18. Laiou somewhat misleadingly seems to cite Corinth as a centre of glass-making which may have exported its wares to Venice, thus building up what is essentially a small site into something considerably more significant: A. E. Laiou, 'Venice as a Centre of Trade and Artistic Production in the Thirteenth Century', in H. Belting (ed.), *Il medio oriente e l'occidente nell'arte del XIII secolo*, Atti del XXIV congresso internazionale di storia dell'arte, 2 (Bologna, 1982), 14–15. Susan Young has suggested that glass was produced on Cyprus in the pre-7th cent. period: see S. H. Young, 'A Pre-view of Seventh Century Glass from the Kourion Basilica, Cyprus', *JGS* 35 (1993), 39–47.

[14] *De Diversis Artibus*, II 1–3, ed. and trans. C. R. Dodwell (London, 1961), 37–9. The *De Diversis Artibus* of Theophilus is a 12th-cent. Western book describing how artistic crafts are carried out. One of these is the making of glass. It is often suggested that Theophilus is talking about Byzantine practices, using a Byzantine technical manual. However, the sort of glass he describes is a potash not a soda-lime glass, and therefore not Byzantine. What is more likely is that his description concentrates on Western techniques with some reference to Byzantium (perhaps with regard to blue glass, which he calls 'saphirus graecus'), a natural consequence of the increased 9th- and 10th-cent. contacts between West and East. On Theophilus' glass, see D. Buckton, '"Necessity the Mother of Invention" in Early Medieval Enamel', *Transactions of the Canadian Conference of Art Historians*, 3, 1982 (London, Ont., 1985), 1–6.

[15] R. H. Brill, 'The Scientific Investigation of Ancient Glasses', *Eighth International Congress on Glass, 1968*, (Sheffield, 1969), 47–68.

The fragments from Corinth show a wide range of colours.[16] Green is the prevailing hue, in shades ranging from blue-green to olive-green and yellow-green. There is also a wide range of blues, light, turquoise, and dark, some violets, and colourless glass with a yellow tinge. These colours are all transparent. Opaque fragments were also found, mainly red but some pale green shades of blue and turquoise. Most of the glass contained iron and manganese, yellow tinges being the result of oxidization and green-blues of reduction. There is no evidence for the use of cobalt, though copper seems to have been used in some of the blues and in red with iron and manganese. The glass is soda-lime. The analysis carried out on the glass indicated no major change in the manner of producing various colours; this glass is closer to Egyptian and Roman wares than Islamic.

It is unclear, however, what glass of what quality was made in Constantinople.[17] Glass found *in situ* there consists primarily of painted windows from the Pantocrator monastery (Zeyrek Camii) and the Kariye Camii, which have been dated to the twelfth century (Plate 45).[18] No glass factories have been found in the city itself yet.

The bulk of surviving Byzantine glass is found in the enormous numbers of mosaic tesserae still in existence. In addition to this, Byzantine glass vessels consist of ordinary undecorated ware, the common glass of the Aegean from the sixth century. There are several gilt and enamelled vessels, including the small purple glass cup from the Treasury of San Marco, which perhaps dates from the tenth century. This has been related to glass found at Corinth, Novgorod, and Dvina in Armenia.[19] There also exist some bottles in dark blue and goblets with gilt or gilt and enamel designs that have been found in Russia, the Corinth factory, and Cyprus.[20] They are thought to be Russian, Corinthian, or Constantinopolitan in origin, which does not advance matters very far. The San Marco Treasury also contains some examples of clear glassware in the form of lamps and bowls.[21]

Recent work on the composition of tesserae supports the idea of Byzantine glass manufacture, and suggests an extensive localization of glass-making.[22] Analysis has

[16] F. Matson, 'Technological Study of the Glass from the Corinth Factory', *AJA* 44 (1940), 325–7.

[17] D. B. Harden, 'Ancient Glass III: Post-Roman', *Archaeological Journal*, 128 (1971), 78–117.

[18] A. H. S. Megaw, 'A Note on Recent Work of the Byzantine Institute in Istanbul', *DOP* 17 (1963), 333–72. Glass from both sites is dated to the 12th cent., and in the case of the Kariye, also to the 14th cent. Megaw tries to show that Western stained glass thus originated from Byzantium. On this debate, see also J. Lafond, 'Découverte de vitraux histoires du moyen âge à Constantinople', *CahArch* 18 (1968), 231–8. M. Vickers, 'A Painted Window in St. Sophia at Istanbul', *DOP* 37 (1983), 165–7, provides some evidence for decorated windows in Hagia Sophia.

[19] This bowl is gilded and painted with medallions containing mythological figures and with rosettes and pseudo-Kufic decorations; it may have been a 'whimsical commission' on the part of Constantine VII Porphyrogenitus. See A. Cutler, 'The Mythological Bowl in the Treasury of San Marco at Venice', in D. Kouymjian (ed.), *Near Eastern Numismatics, Iconography, Epigraphy and History: Studies in Honor of George C. Miles* (Beirut, 1974), 235–54, esp. 254.

[20] See Davidson, 'A Medieval Glass Factory at Corinth', esp. 308–10.

[21] *The Treasury of San Marco, Venice* (Milan, 1984), 181–99, nos. 21–7, describes these.

[22] Freestone, Bimson, and Buckton, 'Compositional Categories'; Brill, 'Scientific Investigation'.

shown that Byzantine tesserae are composed of a soda-lime glass with the addition of calcium and potassium to form calcium phosphate, which acts as an opacifying agent. Metal oxides are mixed in: where these have been analysed, they have been shown to be similar to those used in Roman glass.[23] Tesserae from Shikmona in Israel (fifth century), Hosios Loukas (tenth century), and from San Marco (eleventh to thirteenth century) have been tied tightly to each site on the grounds of their composition, suggesting if not necessarily a local industry for each, then at least a single, separate source for each group.[24] The British Museum analysis describes the colourants of the tesserae analysed in some detail, but the lack of comparative evidence makes it virtually impossible to draw any conclusions from it.[25]

It may be that more than one source was needed to provide the full range of colours available. At Orvieto, documentary evidence about the mosaics of 1321–c.1390 shows that much glass was made on site or locally, but that some was imported, notably from the glass-making centre of Venice. Some colourants were also brought in, and special reference is made to blue, as is the case elsewhere in Italy for painters and other craft-workers.[26] Certainly the only way that mosaic colour could be controlled and organized in any practical sense would be in its manufacture on site or within the empire rather than in its import. The mosaicist's ability to obtain colours, and the availability of certain types of glass, is a further significant factor in the colour composition of the mosaic. Studies of compositional characteristics will prove invaluable in clarifying the colour charts described in the first chapter. They may also offer evidence for dating purposes.

Though the method of colouring glass tesserae is identical to that of colouring glassware, the means of production of the glass itself are somewhat different.[27] Mosaic glass seems to have been made in a variety of ways. The muff technique involved molten glass being blown and then shaped on a marvering slab (the flat slab on which molten

[23] Though David Buckton, in conversation, has mentioned a red potash glass used in tesserae dating to the 9th to 12th cents. which seems to be an import from the West. See above, n. 14.

[24] Freestone, Bimson, and Buckton, 'Compositional Categories'. The colourants are given as manganese (purple, fawn, honey) at Shikmona and Hosios Loukas; copper oxide and cobalt (blue) at Shikmona, Hosios Loukas, and San Marco; cuprite (red) at all three; copper oxide and iron oxide (green) at Hosios Loukas; tin and lead oxides (green) at Shikmona and San Marco; tin as an opacifier at Shikmona and San Marco, but no trace of tin at Hosios Loukas. This glass reflects the compositional characteristics of contemporary vessel glass.

[25] An account of the colourants in the glass of St George's Rotunda in Thessaloniki (5th cent.) in *DACL* 12. 1, cols. 70–5, 'Mosaique', esp. sects. IV–VI, col. 71, offers some comparative material. Here, cobalt and copper oxide (blue); iron oxide or silica, potassium and copper oxide (red); manganese (violet); copper oxide (green); antimony and white tin (yellow) are given as the colourants. The source for this is cited as C. Texier, *Architecture Byzantine* (Paris, 1864), 149, which does not, in fact, seem to provide this information.

[26] C. Harding, 'The Production of Medieval Mosaics: The Orvieto Evidence', *DOP* 43 (1989), 73–102, esp. 76–7, 79–80 on the different colours brought in from Venice.

[27] See Harding, 'Production of Medieval Mosaics', and P. A. Underwood, *The Kariye Djami*, i. Text (New York, 1966), 172–83.

glass is rolled). It was then reheated, formed into cylindrical shapes, cut lengthways, and opened up into sheets of glass. In the annealing chamber, these were heated very slowly and allowed to flatten under their own weight, with the aid of a smoothing block. These sheets were of varying thickness and unconfined by moulds at the edges—a rounded edge on one side of a tessera indicates that it came from the side of a plate. The glass was then cut into the required shapes and sizes in a way similar to scoring and cutting toffee. Alternatively, glass could be drawn into tubes, cut lengthways, and laid out; or it could be cast as thin cakes which were then subdivided.[28] The evidence from Orvieto also provides evidence of the tools used in mosaic making, ranging from hammers, anvils, and a variety of cutting tools to blowpipes, shears, and ladles on the glass-making side.[29]

The sizes of the tesserae depend on the thickness of the plate and also where they were to be used in the mosaic. Different surfaces could be obtained: the fractured side is the most glossy; the top and bottom create different effects. Tesserae of mixed colour could be obtained by using several metals in the making of the glass plates. Metallic tesserae were made by overlaying a plate of transparent (usually pale green) glass perhaps 6 mm. thick with the gold or silver leaf, and then coating this with a thin (1 mm.) layer of clear glass. This was then heated until the elements fused. Where this fusion did not occur, layers have since been lost. A variety of effects can be achieved through the use of gold tesserae. They create an amber effect when set on their sides, as can be seen at the Kariye Camii. Also at the Kariye, molten glass for the manufacture of gold tesserae was apparently poured on a surface covered with a red substance. This has given the under-surface of these tesserae a red colour and pebbled texture. When set in reverse, they can be mistaken for red tesserae. Such tesserae are found at other sites beyond the Kariye Camii.[30]

How much control the craftsman had over the range of shading is unclear; it is likely that this was dictated by the range of coloured tesserae available. The evidence of Nea Moni, the Kariye Camii, and Orvieto suggests that a fairly narrow range of shades may have been preferred. Documents from Orvieto record that buyers in Venice were instructed to buy three to five shades of each colour, and Harding notes that the range of shading at Orvieto is identical to that described by Mouriki for Nea Moni.[31] The tesserae of the darkest values are most glossy, and free from the air holes, which become larger and more numerous the lighter the tesserae.

[28] At Orvieto, the muff technique was employed (Harding, 'Production of Medieval Mosaics', 78), but the stained glass from the Zeyrek Camii was cast in rectangular pans (Megaw, 'Recent Work of the Byzantine Institute', 350).

[29] Harding, 'Production of Medieval Mosaics', 77–8.
[30] Underwood, *Kariye Djami*, i. 181.
[31] Colours: blue, red, violet, green, vermillion, white, yellow, plus 3 lbs. weight of flesh, green, black, silver (Harding, 'Production of Medieval Mosaics', 80).

Glass tesserae were standard in wall mosaics from about the time of the Roman emperor Tiberius.[32] Glass was preferred because of its light-catching properties; the effect of glass tesserae in a mosaic is to create brilliance and richness through the changing effect of the refraction of light. The insertion of single tesserae produced a non-uniform surface picking up light through the angling and aligning of tesserae for the creation of particular optical effects (as discussed above in Chapter 1). Other substances might be employed if they provided the colour more easily and cheaply, depending on the resources available. Stone, especially marble, terracotta, and shells could also be used, offering more stable sources of colour (Plate 46). For floor mosaics, stone remained the dominant material. Before the fourth century, there appears to have been little use of gold tesserae.

Until the late 1950s, it was believed that mosaics were made in sections in a workshop, tesserae being attached to cartoons, and then transferred to the wall. However, such a method is inherently impractical. It is now generally accepted that artists painted preliminary drawings straight on to the plaster of the walls and then set the tesserae directly. Mosaic setting beds consist of two or three layers of mortar. Plaster is laid on top of this, occasionally reinforced with iron clamps (Plates 47 and 48). Two kinds of preliminary sketches seem to exist: those painted on to the masonry itself or on early layers of plaster, and those painted directly on to the setting beds. These act as guides for the mosaicist, though they need not always be followed. At the Kariye Camii, the plaster beneath the mosaics seems to have been painted in considerable detail, including shading (Plate 49). It is suggested that this acted as a detailed guide to the mosaicists in the delineation not only of form and drapery folds, but also in the indication of colours and the values of these colours. It also concealed the white interstices of the tesserae.[33]

As for workshops, the Orvieto evidence suggests the existence of mosaic workshops, but, for Byzantium, little evidence of actual working practices exists, beyond the division in the *Theodosian Code* between floor and wall mosaicists.[34]

COLOUR IN PAINTING

The roles of painter and mosaicist seem to have been very closely linked. As mentioned above, below the mosaics of the Kariye Camii there are fully developed paintings in colour on the setting beds. In other cases, sketches exist, at varying levels of sophistica-

[32] D. Strong and D. Brown (eds.), *Roman Crafts* (London, 1976), 'Glass', 111–26.

[33] See E. Kitzinger, 'Mosaic Technique', *Encyclopaedia of World Art*, 10 (New York and Toronto, 1972), cols. 325–7; E. Kitzinger, *Mosaics of Monreale* (Palermo, 1960), 64–8;

C. Mango and E. J. W. Hawkins, 'The Apse Mosaic of St. Sophia at Istanbul', *DOP* 19 (1965), 124; Mouriki (with Ernest Hawkins), *Nea Moni*, 95–7; Underwood, *Kariye Djami*, i. 172–80.

[34] See Harding, 'Production of Medieval Mosaics', 82–3.

tion (Plates 50–3). One of the inscriptions of the twelfth-century Church of the Nativity, Bethlehem, speaks of the artist as 'painter and mosaicist'.[35] A Latin inscription relating to a sixth-century mosaic talks of the Transfiguration being pictured or painted (*depinxit*) in mosaic, using the same vocabulary as for a painting.[36] On occasion, wall-paintings went so far as to imitate mosaic. In the apse and iconostasis of the Church of the Virgin, Studenica (twelfth century), the background of the wall-paintings is coloured yellow, in imitation of the gold background of mosaics. This imitation is even clearer at Sopoćani and Gradac, where in the bema, naos, and narthex, gold leaf has been attached as background to the paintings, and tiny squares drawn on the gold (Plate 54).[37]

As with mosaics, there is little information about the methods of colouring employed in Byzantine painting. On the whole, the Western medieval accounts given by texts such as the *Mappae Clavicula*, Heraclius, and Theophilus, together with the Eastern *Painter's Manual* of Dionysius of Fourna, which dates to the eighteenth century, are used by scholars to provide a general account to fit both East and West. As regards the question of what the colours were made of, these texts, together with the writings of Pliny[38] and Vitruvius,[39] and such analysis as has been carried out, provide a framework for deduction.[40] There are problems in this use of evidence, but it seems to coincide with such analysis of Byzantine wall-paintings as has been carried out.

Each class of painting, on walls, in manuscripts, and of icons, had its own grade and range of pigments. Wall-paintings used bold and coarse colours rather than fine costly pigments, both because of the amount of paint needed and the nature of wall-paintings, with regard to durability. The pigments of wall-paintings need to remain unaffected by the alkalinity of lime plaster, and by exposure to atmosphere, light, and damp. Icons are better protected by the impervious nature of the oil-based medium and often by a coat of varnish, whilst, in manuscripts, delicate vegetable dyes will survive if protected from light and atmosphere much of the time by the book remaining closed. Lakes (organic dyestuffs absorbed on to an inorganic base, such as chalk or aluminium hydroxide, to

[35] ἡστοριογράφου καὶ μουσιάτορος. H. Vincent and F.-M. Abel, *Bethléem, le sanctuaire de la Nativité* (Paris, 1914), 158 n. 1.

[36] Quoted in J. Elsner, 'Image and Iconoclasm in Byzantium', *Art History*, 11 (1988), 487 n. 19. On the theme of the parallels between mosaics and wall-paintings, see also S. H. Young, 'Relations between Byzantine Mosaic and Fresco Techniques: A Stylistic Analysis', *JÖB* 25 (1976), 269–78. Young attempts a stylistic comparison between mosaics and wall-paintings from decorative programmes which mix the two media.

[37] V. J. Djurić, 'La Peinture murale serbe au XIIIe siècle',

in *L'Art byzantin du XIIIe siècle*, Symposium de Sopoćani 1965 (Belgrade, 1967), 145–68, esp. 151–2. I am grateful to Zaga Gavrilović for advice on the Serbian material.

[38] Pliny, *Natural History*, XXXIII–XXXV.

[39] Vitruvius, *De Architectura*, VII, esp. 5–14.

[40] These are summarized in D. V. Thompson, *The Materials and Techniques of Medieval Painting* (London, 1936); Strong and Brown (eds.), *Roman Crafts*, 'Wall-painting,' 223–9; Singer *et al.* (eds.), *A History of Technology*, ii. 359–62; R. J. Forbes, *Studies in Ancient Technology*, iii. *Cosmetics and Paints* (Leiden, 1955) and iv. *Dyes and Dyeing* (Leiden, 1955).

produce an insoluble powder pigment) provide brilliant, fugitive colours affected by light and by the alkalinity of plaster, and so tend to be reserved for manuscript illumi-nation. Mineral colours on the other hand make up the bulk of the wall-painting palette.

THE PALETTE

Medieval Western writers on pigments follow Pliny in dividing pigments into natural and artificial colours. Natural pigments include certain elements, compound minerals, and vegetable extracts; the artificial ones include all manufactured salts, including lake pigments (made from organic dyes on an inert metallic oxide base), which owe their colour to vegetable or insect dyestuffs.

Black

Ink is the chief form of black used in manuscripts. For wall-painting, forms of carbon (e.g. charcoal) or iron salts in suspension are used.

White

White lead (*psimithium*) is the most commonly used substance. The recipe books abound in details about its manufacture: essentially it seems that wood chips soaked in vinegar were put with lead in an enclosed vessel.[41] This produced a very thick white, ideal for highlighting. Lead white, however, is unsuitable for wall-paintings as sulphurous impurities in the air react with it to form a black lead sulphide on the surface. Instead, lime whites dominate, produced by a suspension of lime. Similarly, chalk, eggshells, and bone could be employed.

Brown

The medieval palette in East and West contains very few drab dark pigments. Brown ochre seems to have been the basic material.

Red

Iron ore ochres make up the basic reds, particularly in wall-paintings. These vary greatly in colour depending on the iron concentrate. They are made by drying and

[41] R. J. Gettens, H. Kuhn, and W. T. Chase, 'Lead White', *SCon* 12 (1967), 125–39, describe the manufacturing process in some detail.

grinding the ochre; the finer ground it was, the purer the red. More brilliant reds, used in manuscript illumination, could be obtained from red lead (*minium*), by roasting it. These were cheap to produce, though they tended towards an orange shade. Other bright reds were obtained from cinnabar (also known as *minium*) or red mercury sulphide, obtained in the Classical period chiefly from Spain, and the only really bright red pigment known; and from vermillion.[42] This was a mixture of mercury and sulphur which was heated and then ground, becoming increasingly red the longer it was ground. In western Europe, vermillion was regarded as rare and mysterious in its manufacture until the twelfth century, and therefore costly—the earliest reference seems to be in the *Compositiones Variae* (Lucca, Biblioteca Capitolare, Cod. 490), a Latin manuscript which may be of Greek origin and is dated to the eighth century.[43] Its origins and costliness in the East is unknown. Vermillion has one serious flaw: it can unpredictably turn black through the rearrangement of the internal structure of mercury sulphide; this and its cost meant that it was generally avoided in wall-paintings.

For deep saturated reds, red lakes created through lac (an encrustation of insect resin from India, which was imported into Spain and Provence as early as 1220), brazil wood, and grain or the κόκκος or kermes were used. This was made from the bodies of insects (specifically, the *coccus ilicus*) which sting the oak tree *quercus coccifera*, and then die on it, forming clusters like berries. This dye was said to have originated with the Phoenicians.[44] Also used were madder and 'dragon's blood', so-called by Pliny, but actually the sap of an Indian shrub. It was used extensively in the medieval period particularly for the colouring of metals, especially gold.

Blue

The purest, brightest, and most costly form of blue was ultramarine, produced from lapis lazuli.[45] Lapis can differ widely in quality and appearance. Unless it is of very high quality, simply grinding and washing it produces only a pale greyish-blue powder, lacking purity and depth of colour.[46] This is found in Byzantine manuscripts as far apart as the sixth and twelfth centuries. As a mineral, lapis is characterized by a scattering or veining of small bright metallic looking golden or silver particles of pyrites.

[42] R. J. Gettens, R. L. Feller, and W. T. Chase, 'Vermillion and Cinnabar', *SCon* 17 (1972), 45–69, describe the manufacture of these colours, and also endeavour to disentangle the Classical confusion of terms for red pigments.

[43] For the *Compositiones Variae* (also known as the *Compositiones ad tingenda*), see below, n. 70.

[44] H. Schwepe and H. Roosen-Runge, 'Carmine—cochineal carmine and kermes carmine', in R. L. Feller (ed.), *Artists' Pigments: A Handbook of their History and Characteristics* (Cambridge and National Gallery of Art, 1986), 255–83.

[45] J. Plesters, 'Ultramarine Blue, Natural and Artificial', *SCon* 11 (1966), 62–91.

[46] Plesters details a technique known in Renaissance Europe for producing pure ultramarine blue, but it is unclear how the Byzantines produced their blue from lapis lazuli.

These were likened by Classical authors to stars in a blue sky, and sometimes mistaken for gold—probably another reason for the mineral's popularity. The only known source of this material in the Classical period seems to have been in Afghanistan.

The Egyptians, Classical Greeks, and Romans used a synthetic copper silicate pigment, known as Egyptian blue, but the knowledge of the manufacture of this seems to have been lost in Late Antiquity. Other blues could be obtained from indigo and azurite (copper carbonate). Azurite, powdered copper carbonate which was washed, levigated, and sieved, could create a greenish tinge if malachite was present.[47] If coated thickly, the crust created a rich effect, especially as each particle glittered. Smalt, a dark blue cobalt glass,[48] and woad, a plant dye, were also used. Often a mixture of carbon black and lime white was used to create a blue effect.[49] Even the trick of leaving grey patches between warm colours to create blue through simultaneous colour contrast might be employed. Indigo, a vegetable lake pigment, provides the exception to the rule about fugitive lake colours, and is used in some wall-paintings.

Purple

There are problems in identifying purples as such since reds and blues often tend towards these shades. The most expensive purple dye was murex, used on cloth and in manuscripts.[50] Purple could also be obtained from the plant, folium.

Green

The wall-painter's palette seems to have been relatively weak in greens, unlike the manuscript painter's. Green copper carbonate, malachite, closely associated with azurite, was an expensive green, but one which tended towards blue. Terre verte, a natural earth pigment containing iron, manganese, aluminium, and potassium hydro-silicates, gave a light greeny-grey tending towards dark olive, which was particularly used in the underpainting of flesh areas. Verdigris, ($\grave{\iota}\grave{o}\varsigma$ $\chi\alpha\lambda\kappa o\hat{v}$ in the Classical period) was the only manufactured green known to the ancient world and was used

[47] R. J. Gettens and E. W. Fitzhugh, 'Azurite and Blue Verditer', *SCon* 11 (1966), 54–61.

[48] B. Muhlethaler and J. Thissen, 'Smalt', *SCon* 14 (1969), 47–61. Contrary to what they say, smalt was used in Byzantium, since a trace of it was detected at the Kariye Camii, but to what extent is unknown. See R. J. Gettens and G. L. Stout, 'A Monument of Byzantine Wall-painting: The Method of Construction', *SCon* 3 (1957–8), 110 and 113.

[49] As at Hagia Sophia, Trebizond, and the Kariye Camii.

[50] J. H. Munro, 'The Medieval Scarlet and the Economics of Sartorial Splendour', in N. B. Harte and K. G. Ponting (eds.), *Cloth and Clothing in Medieval Europe* (London, 1983), 13–70. I regret not having the space to deal with colour and clothing in Byzantium, but any such study should await the publication of Anna Muthesius's research into Byzantine silks, forthcoming from Vienna. In the interim, see A. Muthesius, 'Crossing Traditional Boundaries: Grub to Glamour in Byzantine Silk Weaving', *BMGS* 15 (1991), 326–65.

extensively. It consists of copper acetate—little more is known of the medieval version than that. It has a great and somewhat overstressed reputation for general instability, though it is particularly destructive of parchment, both staining and destroying it. Verdigris readily blackens. It also can react unfavourably with other pigments, notably white lead and orpiment.[51] Vegetable greens were also employed.

Yellow

Gold was the most important yellow pigment; one of the most crucial functions of other yellows was to imitate the metal gold. Yellows were used also to modify the qualities of green and red. Yellow objects tend not to be portrayed. Yellow ochres were quite adequate for walls, though, as with red ochre, no standard hue could be obtained. Orpiment, a sulphide of arsenic, resembled gold very closely, whilst realgar, another form of arsenic sulphide, was orange-yellow and rarely used. Orpiment was incompatible with several other colours, notably white lead and verdigris, and also acted as a corroding agent. To replace this, bile could be used, white metals could be lacquered to look like gold and, most important, saffron was available. This was used primarily in manuscripts since it lacked durability, but it was an indispensable element in compounds imitating gold and in toning other colours.

Metals

Gold, thanks to its lustre and disinclination to tarnish, was the most significant metal (Plate 56). Silver could be used in a similar way as both powder and leaf, though silver in manuscripts seems always to have oxidized and tarnished.

These pigments comprise the basic range of hues found in Byzantine wall-painting and manuscript illumination, and almost certainly icon painting as well.[52] Western medieval recipe books describe essentially the same range of basic materials. Laurie's examination of a handful of seventh- to fourteenth-century Byzantine manuscripts indicates a similar consistency of palette despite variations in manufacture.[53] In the case of wall-paintings, rather more analysis has been carried out.

[51] H. Kuhn, 'Verdigris and Copper Resinates', SCon 15 (1970), 12–36.

[52] Carolyn L. Connor has begun work on the colouring of ivory in Byzantium. See C. L. Connor, 'New Perspectives on Byzantine Ivories', Gesta, 30 (1991), 100–11, for her preliminary findings.

[53] A. P. Laurie, The Pigments and Mediums of the Old Masters (London, 1914), 62–70; R. Nelson, 'Pigment

Analysis of some Byzantine Manuscripts at the University of Chicago', Tenth Annual Byzantine Studies Conference, Abstracts (1984), 30; D. E. Cabelli and T. Mathews, 'Pigments in Armenian Manuscripts of the Tenth and Eleventh Centuries', RevEtArm 18 (1984), 33–47. I am grateful to Henry Maguire for these last two references. See also articles in Pigments et colorants de l'antiquité et du moyen âge: Colloque internationale de CNRS (Paris, 1990), describing

At the Kariye Camii, the palette used in the fourteenth-century wall-paintings consists essentially of blue (azurite and, sparingly, lapis lazuli), white (lime), black (charcoal), red (red ochre), yellow (yellow ochre), green (terre verte), brown (ferric oxide), and dull purples (iron oxide). There is only a very limited amount of mixing of the pigments. All the paintings have an azurite background, which is now black in places, though part of the conch of the apse had turned to a brilliant green when uncovered. Unusually, this was not the result of azurite changing to malachite, as often happens. Only areas whitewashed were affected by this colour change, and analysis suggested that this was caused by salt (sodium chloride) present in the wash which caused the azurite to alter from a carbonate to a chloride, paratacamite.[54]

At Hagia Sophia, Trebizond, analysis of the thirteenth century wall-paintings revealed a very similar palette.[55] Again, earth colours were the most frequent, yellow and red ochres (haematite), green earth, together with a local blackish-green colour, obtained from Trebizond sand, which is rather gritty, but indicates the willingness of artists to use local resources. Other colours at Hagia Sophia are lime white, charcoal black, touches of vermillion for occasional brilliant splashes of colour, which have now turned black, and both ultramarine and azurite. Ultramarine is used for considerable areas of blue background, but it is of poor quality, and Plesters suggests that it may have been pigment left over from work on manuscripts and icon painting.

In the church of the Panagia Amasgou at Monagri in Cyprus where the wall-paintings are dated between the twelfth and sixteenth centuries, the samples taken indicate a fairly consistent technique and choice of materials over time.[56] The same pigments—charcoal, terre verte, haematite (red ochre), minium (red lead) with vermillion as an admixture, azurite—were noted in each century although the mixture and sequence of application varies. Here again, earth colours are consistently the most frequent. At the Panagia Amasgou, yellow ochre alone or with charcoal is used as an undercoat. Variants in shading are achieved by mixing hues: haematite with lime and charcoal, with vermillion admixed.

These pigments are repeated in the analysis of materials from the twelfth-century wall-paintings of the Chrysostomos monastery at Koutsovendis in Cyprus. Ochres

methods of analysing the pigments of manuscripts. In the case of both manuscript illumination and icon painting, the lack of information about actual pigments presents major problems in analysing the use of colour in these media.

[54] Underwood, *Kariye Djami.* i. 300–8, esp. 308. Underwood took it upon himself to remove this green colour and does not seem to have recorded it in any detail. Gettens and Stout, 'Monument of Byzantine Wall-painting', 107–19. Ernest Hawkins recalled the bright green streaks in

the conch of the apse, which looked as if they were caused by the point of a stick (letter, May 1991).

[55] J. Plesters, 'The Materials of the Wall-paintings', in D. Talbot Rice (ed.), *The Church of Hagia Sophia at Trebizond* (Edinburgh, 1968), 225–34.

[56] V. Jenssen and L. Majewski, Appendix to S. Boyd, 'The Church of the Panagia Amasgou, Monagri, Cyprus, and Its Wall-paintings', *DOP* 28 (1974), 329–45.

again form the dominant pigment. Umber is used for the brown colours and terre verte for the greens. Blues are created by a thin white wash over black, except for one example of ultramarine.[57]

Of the pigments described above, the ochres were virtually ready for use. Others of the metal ores found as stones had to be reduced to powder and levigated to grade them and to remove impurities. This last operation was less than straightforward, and various ingenious methods were devised for speeding up the process. Colour was obtained from vegetables either by drying them and then soaking parts in water or glair, as was the case with saffron, or more generally by combining the plant juices with acids or alkalis to develop the colour or convert them to lake pigments. Salts can be manufactured by the direct combination of elements (as in the case of vermillion), from the action of acid on metal (as with verdigris), or from the double decomposition of salts in solution, the lakes. Production of a lake depends on the power of alkaline reagents to cause the precipitation of alumina hydroxide from a solution of alum. Alumina has no value as a pigment, being colourless and generally transparent. But if any vegetable or insect dye is present when the alumina is precipitated, the alumina takes up the colour like a sponge and forms a colour compound, often different in colour to the natural dyestuff and usually more powerful.

The unstable nature of colours meant that it was difficult to establish a standard hue even within the same picture—hence the range of hues we find detailed in modern descriptions of them. Evidence from the pigments, however, suggests that standardization is not a primary concern. For example, in the analysis of lapis, it is often noted that the hue produced is not particularly blue. But the effect produced is one of sparkle and glitter, qualities far more highly regarded. Similarly, gold was less valued for its hue than for its radiance and the effect this created (Plate 55). It is also plausible that the thickness and effect of the pigment on the wall was more highly considered than its specific hue. Thin dark colours and thick light colours are often found, playing on the tendency of light hues to stand out and dark ones to recede. The technique of simultaneous colour contrast and the polishing of plaster, and possibly of paint were other tricks to emphasize brightness and reflectance rather than hue.

There is very little information available about how colours were applied to a drawing. The first sixteen chapters of Theophilus may comprise a confused general account of Byzantine and Western painting processes which apply with equal validity to manuscripts, icons, and walls.[58] The technique described by Theophilus at its simplest seems

[57] C. Mango, 'The Monastery of St. Chrysostomos at Koutsovendis (Cyprus) and Its Wall Paintings. Part 1: Description with the collaboration of E. J. W. Hawkins and S. Boyd', *DOP* 44 (1990), 63–94. Ernest Hawkins's technical observations are pp. 93–4.

[58] D. C. Winfield, 'Middle and Later Byzantine Wall

to have involved the use of a single colour as ground, then different colours to build up the object. This method was capable of elaboration at the discretion of the painter, through the use of a greater number of dishes in which different quantities of black and white were mixed with the basic colour to achieve more tones[59]—something clearly reminiscent of Platonic colour theories.

Elsewhere, Winfield's study of Byzantine wall-painting methods is based on his own observations.[60] He notes that lime plaster is almost invariably used as the base for pigments, and that Byzantine wall-paintings are frequently true fresco, painted while the plaster is still damp (Plate 57). Painting seems to have taken place in a series of stages, beginning with an overall planning to fit figures and scenes into the available spaces. Then preliminary sketches were drawn on the walls, usually in red or yellow ochres. Incising of lines, as described by Cennini, is also fairly common. These underpaintings acted as a guide and are not always followed. Colours are applied in a definite order, beginning with background colours, usually monochrome, then the colours of background objects, clothing of figures, faces, and flesh areas, and finally the trimmings—inscriptions and the like (Plates 50–53). This contrasts with the Italian method of fresco painting, which involved the complete painting of small areas of plaster from the top of the scene downwards.

In the case of Byzantine wall-painting, Winfield's observations suggested that outlines were drawn first, then fields of undifferentiated colour applied, and, on top of these, lines of other tones of the same colour or of different colours to create the effect of garment folds, for example. In this way, colours were built up by layering, rather than by mixing on the walls. Form was built up by using tones of each colour, a dark tone, a medium, and a light, in that order, using the optical trick whereby light colours seem to stand out while dark colours recede. In some cases, overlays and drips suggest that one pot of colour was finished before the artist moved on to the next.[61] Colours were never mixed on the walls; opacity and hatching were used to achieve subtle gradations of colour, or colours were overlaid. The ancient world seems to have known methods of building colours in layers on top of each other: Roman painters were aware of the

Painting Methods: A Comparative Study', *DOP* 22 (1968), 63–139. A contrasting study of colour in Byzantine wall-painting is U. M. Rüth, *Die Farbgebung in der Byzantinischen Wandmalerei der spätpaläologischen Epoche*, Inaugural-Dissertation zur Erlangung der Doktorwurde, 2 vols. (Bonn, 1977), which concentrates on the period 1341–1453. The author's aim is to examine the 'meaning' of colour through a structural analysis of the use of colour in monumental painting. He overcomes the problem of imprecise terminology of colour words by devising his own system which he claims

combines plasticity, vividness, and graphic qualities with precise colour tonal definition. Unfortunately, it is so complex and highly organized as to be virtually impossible either to follow or to apply. Further, in his psychological analysis, Rüth appears to quote modern colour-emotion responses as concrete, valid data for examining expressionism in colour.

[59] Winfield, 'Wall Painting', 124.　　　　[60] Ibid.

[61] As Didron noticed with Father Joseph: A. Didron, *Manuel d'iconographie chrétienne* (Paris, 1845), 65, which describes the early 19th cent. monk, Father Joseph, at work.

means of manipulating colour to achieve the effects of opacity and transparency, light and shade.[62] The Byzantines took the technique of line from the Romans but abandoned most of their complex optical effects and developed a layer system of predominantly opaque colours, well adapted to the rapid painting of large areas. Winfield also notes some evidence, notably from Asinou, suggesting that the polishing of plaster for brighter, more shiny surfaces, was practised in Byzantium.[63]

THE ECONOMICS OF COLOUR

A further practical consideration in the making of colours is the question of where the raw materials for pigments were obtained. Pliny notes that red lead, cinnabar, mineral dyes, gold, silver, lead, tin, iron, copper, mercury, and marble were all obtained from Spain,[64] though for how long the Byzantines continued to import from Spain is unknown. The Arab conquests must have affected trade to some degree, though this seems to have been less damaging than has been thought. Alluvial gold could be obtained from Macedonia and Thrace, silver from Laurion near Athens. Spain was always the great centre of copper mining, but in the Classical period copper was also found in Cyprus, Asia Minor, Macedonia, and Tuscany. Iron ores were mined in the Pontic, Taurus, and Phrygian regions of Asia Minor. Tin, important for arsenic and antimony, could be imported from central Europe. Between the fourth and thirteenth centuries, there are, in fact, few surviving references to mining activities. Those that exist indicate the production of gold, silver, copper, iron, and lead in Asia Minor and the continuation of mining in the Balkans. It is improbable that the Byzantines let their mining skills fall into extinction, but equally unlikely that they would write about them.[65] Asia Minor was the centre *par excellence* for alum. Cochineal could be obtained from the Peloponnese and the Levant (as could saffron), madder from Arabia and Syria, and indigo from India, with Egyptian indigo vastly inferior.[66] Lapis, as already described, was obtained only from Afghanistan.

Constantinople was recognized by the Byzantines as a centre for the concentration of wealth and consumption of produce. Its position as a great trading port situated on the junction of sea routes, on the Europe–Asia land bridge, and the exit from the Black Sea, ensured that the import of materials was unlikely to be any real problem. It seems that the bulk of materials for painting could be obtained within the empire. While earth

[62] As detailed below, Chapter 3.
[63] Winfield, 'Wall Painting', 71–4. See also R. Ling, *Roman Painting* (Cambridge, 1991), 204, for the polishing of Roman wall-paintings.
[64] Pliny, *Natural History*, XXXIII, deals with mines.

[65] S. Vryonis, 'The Question of the Byzantine Mines', *Speculum*, 37 (1962), 1–17.
[66] W. Heyd, *Histoire du commerce du Levant au moyen-âge* (Leipzig, 1885–6).

colours and vegetable dyes were always going to be locally available, metallic ores would tend to have to be shipped in, and the corresponding increase in price only enhanced their value. It was unsurprising that lapis lazuli was so highly regarded.

From sixth-century accounts, however, a picture can be gained of acute problems regarding transport and its costs in areas more than minimally remote from the coast or navigable rivers.[67] The Byzantine navy did not really exist until the sixth century, when Justinian began to build it up as the only real means of communication between Constantinople and the more remote provinces. Until the Arab invasions, Byzantium was in command of the seas and evidence from wrecks suggests that goods were shipped to all parts of the empire.[68] Though maritime commerce was important in the economy of the empire, the volume of goods shipped appears to have decreased in the seventh century. However, the existence of texts like the *Rhodian Sea Laws* of this period and the details provided of foreign travel in saints' lives in particular, indicates that shipping was still important.

The Arab wars diminished Byzantine control and the empire never regained all the provinces it lost. It turned to economic warfare, blockading Arab coastlines and restricting trade to the Black Sea and Italy. During the eighth century, more and more trade was taken over by non-Greek middlemen, notably Italians and Arabs. In the eleventh century, the Latin West became increasingly dominant in trade; by 1100 the Italian maritime states controlled much of the Mediterranean except that held by the Arabs.[69]

So the import of the materials needed for making colours was not necessarily straight-forward, though a study of significant changes in pigment apparent at any particular time, and a tracing of the relationship between colour availability, ease of trade, and the replacement of pigments are beyond the scope of this work. In addition, economic developments influence the amount of money available to be spent on art, affecting materials, methods of production, and quantity.

RECIPE BOOKS AND ARTISTS' HANDBOOKS

Evidence for the making of colours and their use can also be obtained from a study of recipe books and artists' handbooks. The creation of pigments from raw materials seems to have been a popular occupation. Where texts like the treatise of Theophilus deal with

[67] See e.g. Procopius, *Secret History*, XXX 11; John Lydus, *De Magistratibus*, III 61.

[68] F. Van Doorninck, 'Byzantium, Mistress of the Seas; 330–641', in G. F. Bass (ed.), *A History of Seafaring* (London, 1972), 133–58, describes the 6th-cent. wreck off

Marzameni in Sicily containing prefabricated church fittings.

[69] A. R. Lewis, *Naval Power and Trade in the Mediterranean AD 500–1100* (Princeton, NJ, 1951); R. W. Unger, *The Ship in the Medieval Economy 600–1600* (London, 1980), 96–103.

colour, it is in providing recipes for the making of colours from the same basic group of raw materials. There is a whole group of Western manuscripts which fit into this category of colour recipe books. Of these, the earliest appears to be the so-called *Compositiones Variae* (Lucca, Biblioteca Capitolare, Cod. 490, fos. 211ᵛ, 217–31ʳ) which is dated *c.*787–816.[70] Like the rest of the recipe books, this is essentially a compilation of several treatises into one body, and, in tracing its sources, it is possible to go back to seventh-century BC cuneiform, as well as Egyptian, Graeco-Byzantine, Arabic, Spanish, and Italian works.

The *Mappae Clavicula*[71] is second only to Theophilus' *De Diversis Artibus* as a source for medieval Western artistic technology and shares several recipes with the *Compositiones Variae*. A version of the text exists from the ninth century, but its most complete form is a twelfth-century edition. It shares similar sources with the *Compositiones Variae* and incorporates details from Dioscurides, Theophrastus, Olympiodorus, Oribasius, Pliny, and Vitruvius. Throughout it there is a use of Latinized Greek words which may indicate ancient Classical sources and Byzantine links. In addition, almost all the places mentioned are Classical: indeed, recipe 131 has been identified as an obvious transliteration of a Greek source by an artist fleeing from Iconoclasm![72] Parallels are drawn also with the Graeco-Egyptian alchemical papyrus, Leyden Papyrus X, notably with regard to the *Mappae*'s recipe 43.

The *Mappae Clavicula* is interpreted as a compilation which does not reflect ninth-century knowledge, but instead consists of a variety of older sources grouped together. No attempt is made by its compilers to update it, to remove discrepancies, or to bring the recipes together. It may be that this is in no way an artist's handbook but was perhaps produced to delight the uninformed with the description of strange materials, changing colours, and the atmosphere of the Classical past—hence the stress on magical and alchemical details, possibly with little understanding of them.

Another text in this series is that of Heraclius, who may, despite the name, have been an Italian.[73] His work consists of three books, though the nature of these is unclear. Various scholars have suggested either that the last three chapters of the third book formed part of a Byzantine manuscript,[74] or that the first two books were the work of a

[70] Text in A. Pellizzari, *I trattati attorno le arti figurative in Italia e nella Penisola Iberica dall'Antichistà' classica al riniscimente e al secolo XVIII* (Naples, 1915), 459–502; or H. Hedfors (ed.), *Compositiones ad tingenda* (Uppsala, 1932), with German trans. Commentary in R. P. Johnson, 'Compositiones Variae from Cod. 490, Biblioteca Capitolare, Lucca', *Illinois Studies in Language and Literature*, 23:3 (1939).

[71] C. S. Smith and J. G. Hawthorne (trans.), 'Mappae Clavicula', *Transactions of the American Philosophical Society*, 64 (1974), part 4. On the colours in the *Mappae Clavicula*, see H. Roosen-Runge, *Farbgebung und Technik frühmittelalterlicher Buchmalerei. Studien zur den Traktaten 'Mappae Clavicula' und Heraklius* (Munich, 1967).

[72] Claimed by Johnson, 'Compositiones Variae', 88–9.

[73] M. P. Merrifield (trans.), *Original Treatises in the Art of Painting*, 2 vols. (London, 1849), 183–257.

[74] Merrifield, *Original Treatises*, 174.

tenth-century Italian monk working under Byzantine influences and that the third book is a later, probably French addition;[75] or that the work is closer to Lucretius than to any other source.[76]

The best known of the recipe books is the *De Diversis Artibus* of Theophilus. This is generally accepted as twelfth-century in date, and there is much debate still as to the identity of its author who wrote under the name of Theophilos, but was most probably a Western monk. The text consists of a treatise in three books, each describing different forms of artworks, with emphasis on the means of manufacture. Scholars have drawn parallels in the colour recipes with the *Mappae Clavicula*, Heraclius, and others of the recipe texts, but Theophilus' account may be extensively based on Byzantine accounts. Thompson suggested that Book 1 represents a garbled version of a Byzantine painter's manual, similar to the eighteenth-century Greek text of Dionysius of Fourna, the *Hermenia* or *Painter's Manual*.[77] The range of colours dealt with by Theophilus far exceeds in range the palette in use in Byzantium, but this may of course represent an ideal range of colours which, it is supposed, might have been evolved in a Byzantine workshop.

There are other texts of this nature, including three fourteenth- and fifteenth-century Italian texts on the making of mosaics,[78] and many more Latin colour recipes which follow a very similar pattern. All of these books contain a range of recipes for making colour, though the *De Diversis Artibus* and the *Hermenia* go further, Theophilus in describing how to make art objects, and Dionysius of Fourna in detailing artistic prac-tices. It is this last aspect of the *Hermenia* which has concerned art historians the most. From Dionysius, Byzantinists have been eager to extrapolate backwards, in a series of lost models, to the concept of artists' handbooks. Western recipe books have been accepted somewhat unthinkingly as reliable guides to Byzantine techniques and prac-tices, since these Western examples do contain Byzantinizing elements.

It is not known what a Byzantine recipe book, if indeed such things ever existed, looked like. None survives, and although this may reflect the survival patterns of expen-sive Byzantine manuscripts, it is nevertheless suggestive, in view of both Greek and Western survivals, that there is nothing from Byzantium. Even Byzantine alchemical texts pay very little attention to recipes for making colours, implying perhaps that this

[75] Johnson, 'Compositiones Variae', 102.

[76] L. Thorndike, *A History of Magic and Experimental Science*, i (New York, 1923), 772.

[77] D. V. Thompson in a review of W. Theobald's edition of Theophilus, *Speculum*, 10 (1935), 438. Dionysius of Fourna, Ἑρμηνεία τῆς ζωγραφικῆς τέχνης, ed. A. Papadopoulos-Kerameus (St Petersburg, 1909). English

trans. P. A. Hetherington, *The 'Painter's Manual' of Dionysius of Fourna* (London, 1974).

[78] *Dell'arte del vetro per mosaico tre trattatelli dei secole XIV e XV*, ed. G. Milanesi (Bologna, 1968). The three treatises are colour recipe books rather than descriptions of how to make a mosaic.

was less regarded in the East than the West. Western recipe books such as the *Compositiones Variae* and the *Mappae Clavicula* seem to relate to alchemical practice rather than to artistic practice, and to represent the views of patrons of art, rather than actual artists.[79] On the other hand, Western pattern books such as the Wolfenbüttel manuscript and Villard de Honnecourt's drawing-book exist as probable evidence for a tradition of artists' pattern books, though again the purpose of these is not at all clear.[80] Examples of sixteenth-century working drawings from the East exist in collections made in the eighteenth century. It is not clear whether drawings on paper existed earlier than this: in view of the presence of sketches under mosaics and frescoes, it is highly plausible.[81] Working drawings are sketches from which the final drawings were made; recipe books, on the other hand, describe how the colours were made. The *Painter's Manual* in combining elements of both, may create some confusion, but this is an eighteenth-century work and its uncertain relation to actual Byzantine artistic practices cannot be overstressed. Its nearest link with Byzantium is the tenth-century text of Ulpius, *On Bodily Characteristics*, which consists of a brief description of the facial characteristics of prophets and other figures. This however, seems not so much an iconographic guide (since, even with its use, it is impossible to identify many figures without inscriptions), as a descriptive piece, similar to descriptions found in histories.[82] In reality, figures in art tend to be treated in more diverse ways than the text of Ulpius allows for.[83]

Two issues are present here: the relation of texts to artistic practices; and the relation of surviving Western treatises to hypothetical Byzantine texts. Western recipe texts seem to represent outside interests rather than artists' techniques, a mixture of the fabulous, the

[79] As Smith and Hawthorne, 'Mappae Clavicula', 18, suggest. See also R. Halleux, 'Pigments et colorants dans la *Mappae Clavicula*', in *Pigments et colorants de l'antiquité et du moyen âge*, 173–80.

[80] H. Buchthal, *The 'Musterbuch' of Wolfenbüttel, and Its Position in the Art of the Thirteenth Century* (Vienna, 1979); H. R. Hahnloser, *Villard de Honnecourt* (Graz, 1972). C. Dauphin, 'Byzantine Pattern Books: A Re-examination of the Problem in Light of the "Inhabited Scroll"', *Art History*, 1 (1978), 400–23, starts from the somewhat dubious assumption that Byzantine pattern books did exist.

[81] L. Bouras, 'Working Drawings of Painters in Greece after the Fall of Constantinople', in *From Byzantium to El Greco*, catalogue of an exhibition of Greek frescoes and icons (London, 1987), 54–6. Kitzinger, *Monreale*, 63, argues the case for 'motif' books and 'pictorial guides' rather than 'model books' prefiguring in miniature the finished product in all its aspects. On this theme, see also E. Kitzinger, 'The Role of Miniature Painting in Mural Decoration', in K.

Weitzmann *et al.*, *The Place of Book Illumination in Byzantine Art* (Princeton, NJ, 1975), 109–21.

[82] See e.g. the descriptions in the 6th cent. *Chronicle* of John Malalas of both historical and biblical figures: John Malalas, *Chronicle*, PG 97. 9–790, e.g. 389*B* (St Paul), 393*A* (the emperor Vitellius).

[83] For Ulpius see M. Chatzidakis, 'Ek ton Elpiou tou Romaiou', in *Studies in Byzantine Art and Archaeology*, Variorum reprints (London, 1972), no. 3; J. Lowden, 'Did Byzantine Artists Use an Iconographic Guide?', *17th International Byzantine Congress, Washington 1986*, Abstracts of shorter papers (Dumbarton Oaks, 1987), 201; J. Lowden, *Illuminated Prophet Books* (London, 1988), 51–5 and 61–2. In this last, Lowden concludes that only by ignoring the art historical evidence is it possible to maintain that Ulpius is part of a tradition of iconographic guides stipulating what the prophets ought to look like. What the purpose of Ulpius' text actually was remains unclear.

part-understood, and the genuine. Recipe 43 of the *Mappae Clavicula* is said to be a direct translation of Recipe 74 of Leyden Papyrus X:

Making inscriptions with gold, according to the first method.

1 part of *elidrium*, 1 part of broken resin, the white of five eggs by number, 1 part of gum, 1 part of gold-coloured orpiment, 1 part of tortoise gall, 1 part of *carcale* scrapings. The weight of them all, after they have been pounded, should be about 20 denarii. Then add 2 drams of saffron. This works not only on papyrus and leaves of vellum, but also on marble and on glass. (*Mappae Clavicula*)[84]

To write in letters of gold, without gold. Celandine, 1 part; pure resin, 1 part; golden-coloured arsenic, of the fragile kind, 1 part; pure gum; bile of tortoise, 1 part; the liquid part of eggs, 5 parts; take 20 staters by weight of all these materials dried; then throw in 4 staters of saffron of Cilicia. Can be used not only on papyrus or parchment, but also upon highly-polished marble, or as well when you wish to make a beautiful design upon some other object and give it the appearance of gold. (Leyden Papyrus X)[85]

This sounds feasible. On the other hand, Recipe 126 of the *Compositiones Variae* (which is supposedly the same as Recipe 130*A* in the *Mappae Clavicula*) reads like a transliteration from Greek:

De crisorantista. Crisotantista. Crisorcatarios sana, megminos meta idroscirgiros, et chetei, cinion chetis, chete yspureorum, ipsinicon, ydrosargyros, chethmata, aut abaletis, sceugnasias, dauffira, hecrisamixsam, chismon, per diati thereu pulea ribule.[86]

Whether this would have benefited any artist as a recipe for making colours is a different issue.

Since there are no Byzantine sources, the so-called 'Byzantine' element of Western texts may be derived from extrapolation from earlier works such as Graeco-Egyptian papyri and from oral tradition. How much of Theophilus' work is based on Byzantine sources is dubious. It has been suggested that for a twelfth-century writer, Theophilus is unduly concerned with tenth-century Western techniques in his account of enamelling, and that the glass he describes is a potash not soda-lime glass and consequently cannot be Byzantine.[87] In addition to this, parts of Theophilus are as confused as anything in the *Mappae Clavicula*. It is plausible that Theophilus was not the master-craftsman he has been made out to be, describing techniques accurately and with understanding, but another compiler of sources. What is clear is that assumptions about the relationship

[84] Text in 'Letter from Sir Thomas Phillips, Bart., FRS, FSA, addressed to Albert Way, Esq., Director, communicating a transcript of a manuscript treatise on the preparation of pigments, and on various processes of the Decorative Arts practised during the Middle Ages, written in the twelfth century, and entitled *Mappae Clavicula*', *Archaeologia* 32 (1847), 183–244; trans. in Smith and Hawthorne, 'Mappae Clavicula', 35.

[85] Text of Leyden papyrus in M. Berthelot, *Collection des anciens alchimistes grecs*, i. Introduction (Paris, 1888), 19–50; or ed. and trans. R. Halleux, *Les Alchimistes grecs* (Paris, 1981), 84–108. English trans. E. R. Caley, 'The Leyden Papyrus X: An English Translation with Brief Notes', *Journal of Chemical Education*, 3: 10 (1926), 1149–66. The quotation is Recipe 74, p. 1159 in Caley.

[86] Text from Pellizzari, *I trattati attorno le arti figurative*, 499.

[87] This is the argument of David Buckton.

between Western recipe books and lost Byzantine texts are considerably less straight-forward than has been made out in the past. Where it was once assumed that texts like the *Compositiones Variae* and the *Mappae Clavicula* were utilizing all available sources, the time has come to ask where these sources came from and who in the West was reading them.

ALCHEMY AND COLOUR

The recipe books may have even less to do with actual instructions for colour manufacture than has been realized. They all show some links with alchemical science. In them, alchemy and colour perception are linked through the parallels between alchemical methodology and the artist's preparation of colours, and through the thought-world of alchemy with its emphasis on the use of colour and colour symbol-ism. The recipe books, with their claims to provide information which is never quite forthcoming or which proves too garbled to be of much use, are an echo of alchemical texts, where the meaning is always obscure. This perhaps derives from a belief that admitting the uninitiated to the secrets of the art was to render the art, and the individual's position in it, less exclusive; or perhaps it was that the craft of making colours became more mysterious and prestigious, like alchemy. Certainly it is alchemy rather than artistic practice which makes sense of these texts.

Alchemy in its origins in Egypt was a practical skill combined with mysticism, a part of craftsmanship and technology which gradually grew into an imitative art, faking expensive materials, gold, silver, dyes, and stones, by reproducing their colour. This fourfold division of tincture is perhaps significant. It is from this heritage that the key alchemical belief seems to have developed that base metals were considered impure or unripe forms of a single metallic substance which in its pure or ripe form appeared as gold. The purpose of alchemy became the purification or ripening of other metals. Apart from this practical aspect, in both Classical and medieval alchemy, endless theorizing and speculation about metallic metamorphoses could be, and was, linked with similar philosophizing about the nature of people (specifically men) and their relation to God. Depending on the bent of the alchemist, emphasis could be placed on the practical or the spiritual and metaphysical aspects. How much of an élite concern it was is not known for sure. The esoteric aspects were certainly for the initiated only, but the skills of imitation may well have been a craft divorced from the mystical approach. What does seem apparent, and significant from the angle of colour perception, is that the conception of the nature of colour held by the alchemists and artisans is also apparent in theological and more general accounts of colour use.

Alchemical science picked up and adapted a variety of scattered notions. These included a diluted, syncretic form of Greek philosophy.[88] Plato and Aristotle were very influential in this respect; alchemy recognized a primary material, a substratum without qualities on to which these could be transplanted to create diversity. This is seen in the concept of the four elements which have no individual character, but are all different appearances of the substratum matter, an idea found in Plato's *Timaeus*.[89] This particular dialogue seems to have wielded great influence over medieval thought through its emphasis on universals and stress on the nature of matter. Aristotle's belief in qualities was gradually transformed via the Stoics into a theory of transmutation. In the earliest alchemical texts, colour seems to have fulfilled a magical and practical function, for it was seen to indicate not only the appearance but also the inner nature of the metal or compound—a concept with clear significance for views on art. There were four stages of transmutation from the base to the pure, known as *kerotakis* to Greek alchemists, and present even in the early Egyptian texts.[90] This process of change was indicated through a series of changes in colour, indicating the alteration of matter. These progressed from *melanosis* (blackening), through *leukosis* (whitening), and *xanthosis* (yellowing), to *iosis* (purpling), the culmination when the substance had been changed through and through.

The early alchemical texts such as the Leyden and Stockholm papyri[91] consist almost entirely of apparently practical recipes for the faking of precious metals, stones, and dyes, with the colouring of metal seen as analogous to the dyeing of cloth. Recipe 69 of the Leyden Papyrus X describes the colouring of gold:

Roasted misy, 3 parts; lamellose alum [and] celandine, about one part; grind to the consistency of honey with the urine of a small child and color the object; heat and immerse in cold water.[92]

Another recipe records dyeing with purple:

Grind lime with water and let it stand overnight. Having decanted, deposit the wool in the liquid for a day; take it out [and] dry it; having sprinkled the alkanet with some vinegar, put it to boiling and throw the wool in it and it will come out dyed in purple.[93]

These early alchemical texts seem to be manuals for artists and dyers or books of instruction for forgers rather than philosophical works concerned with the transforma-

[88] A. J. Hopkins, *Alchemy, Child of Greek Philosophy* (New York, 1934).

[89] *Timaeus*, 50 C–E.

[90] A. J. Hopkins, 'A Study of the *Kerotakis* Process as Given by Zosimus and Later Alchemical Writers', *Isis*, 29 (1938), 326–54; C. A. Wilson, 'Philosophers, *Iosis*, and Water of Life', *Proceedings of the Leeds Philosophical and Literary Society, Literary and Historical Section*, 19: 5 (1984), 101–219.

[91] Stockholm papyrus ed. O. Lagercrantz, *Papyrus Graecus Holmiensis: Recepte für Silber, Steine und Purpur* (Uppsala, 1913); and also Halleux, *Les Alchimistes grecs*, 110–151. English trans. E. R. Caley, 'The Stockholm Papyrus: An English Translation with Brief Notes', *Journal of Chemical Education*, 5: 4 (1927), 979–1002.

[92] Caley, 'Leyden Papyrus X', Recipe 69, 1159.

[93] Ibid. Recipe 96, 1162.

tion of matter, as is the case with later works.[94] They deal with the dyes—indigo, madder—that fix colours, and those that are modified by acid or alkali. That these techniques are then shifted without any alteration to the other spheres, glass, metal, and precious stones, suggests a lack of practical experience.

However, the existence of these imitative arts suggests that apparently costly articles could be owned and worn by those who could not afford the real article. The important issue was colour: if the substance looked right, then it was what it seemed to be. This appears to be a fundamental tenet of alchemy, overriding the differences between practical and theoretical texts. The principal aim of all surviving texts is to modify the properties of a substance by its colour. Colour is the key element in defining visible form.

By the period of Zosimus (third–fourth century AD),[95] concern was more with philosophy and deliberate obscurity of expression, influenced by Christianity, rather than practical method. Tertullian and Clement of Alexandria both employ alchemical symbolism.[96] The third century saw the development of alchemy as a religio-philosophic quest of a soteriological nature. In the East, under the patronage of the Byzantine emperor Heraclius, the seventh-century Alexandrian philosopher Stephanos completed the transformation of the 'sacred art' from a mixture of shop recipes of metal-workers, Egyptian magic, Greek philosophy, gnosticism, Chaldean astrology, Christian theology, and pagan myth into a theme for rhetorical, poetical, and religious composition, subordinating the physical act of transmutation to the allegorical symbol.[97] Stephanos used the transformation of metals as a symbol for the regenerating force of religion in transforming the human soul:

Copper, like a man, has both soul and spirit. For these melted and metallic bodies when they are reduced to ashes, being joined to the fire, are again made spirits, the fire giving freely to them its spirit. For as they manifestly take it from the air that makes all things, just as it also makes men and all things, thence is given them a vital spirit and soul.[98]

In Byzantium, interest in alchemy flourished beyond Stephanos. Archelaos, c.715, wrote in his poems about the amalgam of metals with mercury in terms of light and dark. He too was more concerned with morals than experiments:

[94] Caley, 'Leyden Papyrus X', Commentary, 1163–4; R. Pfister, 'Teinture et alchimie dans l'Orient hellénistique', SemKond 7 (1935), 1–59.

[95] Berthelot, Collection, ii. Texte grec, part 3.

[96] Clement in e.g. Stromates, VI 4; Tertullian in De Idolatria, IX, and De Cultu Feminarum, II 10. See also M. Berthelot, Les Origines de l'alchimie (Paris, 1885), 9.

[97] Other important figures earlier in this process include Aeneas of Gaza (5th cent.) who brings Platonism and

alchemy together in his Theophrastus, Olympiodoros (5th cent.), and the anonymous works of the so-called Christian and the Philosopher (6th cent.).

[98] F. S. Taylor, 'The Alchemical Works of Stephanos of Alexandria', Ambix, 1 (1937), 116–39, Ambix, 2 (1938), 39–49. This quotation is taken from The Same Stephanos on the Material World: Lecture III with the Help of God, trans. Taylor in Ambix, 2, 41.

> . . . A heavy nature cannot change
> To what is buoyant, volatile and light
> Unless its nature thou do first transform.
> Refined in fire it undergoes a change
> To spirit, being joined to what is light.[99]

The story of John Isthmeos who claimed to be able to make gold is told by the sixth-century historian, John Malalas, who describes him as an 'alchemist and great impostor'.[100] The *Acts* of St Procopios refer to alchemy.[101] Alchemical imagery seems to become a standard form of reference. In the sixth century, Evagrius quotes Zosimus, as does George the Synkellos, writing in the late eighth century, and who seems to know all the major alchemical authors.[102] Passages in John of Damascus's three treatises *On the Divine Images* (eighth century again) carry alchemical imagery and the ninth-century patriarch Photios cites Zosimus and Olympiodorus. The tenth-century *Souda* lexicon similarly carries alchemical overtones as does the twelfth-century romance *Dosikles and Rhodanthe* where a life-giving herb is described as being white, rosy, and purple. The interest of the eleventh-century polymath, Michael Psellos, in alchemy is well known, though his work is as theoretical as that of Stephanos. In the *Chrysopoeia*,[103] he bases his theory on Pseudo-Democritus and cites Zonarus and Theophrastus, refers to practical metallurgy and technology, and gives the impression of going nowhere near a practical experiment. He summarizes much alchemical doctrine and literature, employing a strong religious basis by saying that salvation can be achieved through the Great Work.

It seems that alchemical thought and symbolism were as much a part of Byzantine educated literary culture as Classical Greek philosophy, and as appealing—to the Byzantines. A manuscript, Venice, Biblioteca Marciana, MS 299, a collection of alchemical texts, was copied in the tenth or eleventh century, and is possibly based on a seventh- or eighth-century version. Paris, BN MSS Gr. 2325 and Gr. 2327, are manuscripts of a form of alchemical encyclopaedia where the copyist seems to have gathered together whatever material was available, including works of the early alchemists, Democritus, Cleopatra, and Zosimus, and many recipes for faking and colouring substances, an expansion of the Marciana manuscript. It is even suggested that the so-called Pseudo-Democritian texts were a tenth-century compilation.[104] More remains to be done on the topic of alchemical influences in Byzantine literature and art.

[99] Lines 132–6, trans. C. A. Browne, 'Rhetorical and Religious Aspects of Greek Alchemy', *Ambix*, 2 (1938), 129–37, these lines on pp. 133–4; *Ambix*, 3 (1948), 15–25. Archelaos' style is compared to George of Pisidia and Psellos.

[100] Malalas, *Chronicle*, XVI 5.

[101] *Analecta Bollandiana*, Julii II 557A.

[102] J. Lindsay, *The Origins of Alchemy in Graeco-Roman Egypt* (London, 1970), 65.

[103] Other alchemical works of Psellos including his letter to Xiphilinus are collected in *Catalogue des manuscrits alchimiques grecs*, ed. J. Bidez, vi. *Michel Psellus* (Brussels, 1928).

[104] G. Loumeyer, *Les Traditions techniques de la peinture médiévale*, (Brussels and Paris, 1920), 112.

From the earliest surviving examples of alchemical texts, especially the Greek ones and onwards, there is an insistence on the colour changes and their correct sequence. From these texts, it is clear that colour is the key characteristic of a substance, the sign of its real nature. Plato said that matter had no qualities but served as a passive recipient of ideas and forms. So the properties which distinguished the individual object were believed not to be caused by matter. The colour of a metal was considered to be its spirit ($\pi\nu\epsilon\hat{\nu}\mu\alpha$), independent of the inactive body matter which merely supported it, and therefore it could be removed from one substance and infused into another.[105] The individuality of the metal was due to its spirit. In *iosis*, the spiritual colour was so concentrated that it was almost free from the retarding influence of the body. Blackening was an important first step, not because black represented an absence of colour, but because, as a primary colour, it left no room for other interfering colours.[106] At times, the black–white–yellow–purple sequence of *iosis* was altered by the introduction of red, but this does not appear to have been of any significance.[107] 'It is evident that, at first, the metals were spiritual because they had found nothing that could fix them; but when they had reached complete stability, the indelible nature of the tincture brought them to the present state.'[108]

Why *ios* was seen as the final colour is an intriguing question. The range of colours that could be obtained from purple dye, colours from purple to red, blue, green, and even yellow, re-emphasizes the irrelevance of a fixed colour and of the need to find one.[109]

The *kerotakis* process may also be linked to the four primaries and the elements. Empedocles, Heraclitus, and Democritus listed black, white, red, and yellow as the primaries.[110] Plato gave 'shining' instead of yellow. The second-century Athenian astrologer, Antiochos, appears to have been the first to link four colours to the four elements: black and earth, white and water, yellow and air, red and fire.[111] He associates them also with the seasons, as does Tertullian. According to Aetius, Empedocles noted a correspondence between the four primaries and the elements, but Theophrastus'

[105] Lindsay, *Origins of Alchemy*, 112 and refs.

[106] Hopkins, 'A Study of the Kerotakis Process', calls black the absence of all colour. This was not how it was seen in the Classical world, where it acted as a primary colour and therefore a basic component of other colours. See below, Chapter 3.

[107] There is some debate over this aspect between Hopkins, 'A Study of the Kerotakis Process', and Lindsay, *Origins of Alchemy*, 111–14.

[108] Olympiodoros, quoted in Berthelot, *Collections*, ii, iv, 5.

[109] Modern technology has been able to produce a violet bronze, sometimes iridescent, on alloys containing a small fraction of gold. Though the Golden Fleece is apparently sometimes described as purple (see J. Gage, 'Colour in History: Relative and Absolute', *Art History*, 1 (1978), 124 n. 30) and the two colours subsequently linked, purple is frequently used for fleeces and animals, e.g. by Libanius describing bulls, who uses φοῖνιξ (*Encomium* 8, D391, Teubner vol. viii (Leipzig, 1915), 268–9.

[110] For Empedocles and Democritus on the primaries see below, Ch. 3.

[111] P. Dronke, 'Tradition and Innovation in Medieval Western Colour Imagery', *ErYb* 41 (1972), 61.

version makes this dubious. Malalas links blue with water, green with earth, red with fire, and white with air.[112] Colours were also linked variously to the four stages of life, the humours and temperaments, bearing a medical and cosmological significance, though the more formal conventions were a Western tradition, rather than Eastern. This sort of symbolism fits with metaphorical accounts of *iosis* and adds an extra layer of significance, though it is not one that is made explicit. The yellow spirit of gold was also the spirit of air or of fire.

Alchemical recipes were originally concerned with the creation of colour to make one substance look like another. This same idea can be seen in the making of colours for painting, the emphasis on gold-like yellows and lapis-style blues. The recipes make it very clear that colour is an important aspect in defining visible forms and changes. The Classical world had no very fixed concept of definite, unchanging species with unvarying characteristics, which explains why substances are referred to in a multiplicity of ways. Colour changes are taken as indicating a change in the nature of matter; it seems that a dyed-to-look-like murex garment carried the same weight in the minds of those wearing and seeing it as a genuine one. Colour had a practical significance and revealed the inner nature of a substance; it defined visible forms and changes. But hue is unstable and difficult to reproduce, as is apparent in the numerous technical accounts describing the manufacture of pigments and in the relative ease with which it could be faked. So a paradox exists around colour, but one that can be partially explained by a perception of colour less as hue than as other qualities, and where hue usually means a set of related shades.

Alchemy and its relationship with colour is also significant in a spiritual way. The willingness of Christian writers to use alchemical images has already been noted and, on one level, Christian art can be read in alchemical terms. The church is the site where colours are used to represent the true nature and spirituality, and the true colours combine to produce the 'gold' of true faith. The colour of a material is seen as its spirit, πνεῦμα, and changes with its refinement—as the soul changes as it progresses along the Heavenly Ladder. Within the church, the true elements are transmuted: alchemists are purified by their elements.

[112] Malalas, *Chronicle*, VII 176.

CHAPTER 3

Colour and the Byzantine Inheritance

STYLE analysis and the study of pigments are only the beginning of the story. My aim here is to move the study of colour on into the realm of perception, to look at how colour was seen. To do this, it is necessary to explore how the awareness of colour affected descriptions of works of art. Our perception of colour is dominated by an interest in the hue and definition of hue of an object. But what seems most obvious to us need not necessarily be so: what we regard as 'colour' may not always have been so perceived.[1] It is at this point that I will turn to look at Byzantine perceptions of colour, beginning with the examination of an alternative model to our perceptions: the model of the Classical world. The language and outlook of the Classical world provided a heritage for the Byzantine world, which developed from it.

I shall make no attempt to examine Latin colour terms. This may seem illogical given the important contribution of Latin writers to the Classical foundations of the emergent Byzantine empire. However, in general, my argument depends upon the philosophical proposition that we can only comprehend colour in Byzantium in terms of the linguistic categories available to describe it; there are two universally recognized facts that effectively remove the colour terminology of Latin from my discussion. First, that the Classical Greeks and Byzantines shared a common language and, secondly, that Latin ceased to be used in the Eastern empire in any meaningful way much after the sixth century.[2]

COLOUR IN LANGUAGE

What words were used to talk about colour in the Classical and Byzantine worlds? What did those words mean? The system of colour naming is difficult and contro-versial, as anthropological studies on the topic have demonstrated.[3] Even avoiding the

[1] Present English colour terms are significantly different in meaning from Anglo-Saxon ones, for example. See N. F. Barley, 'Old English Colour Classification: Where Do Matters Stand?', *Anglo-Saxon England,* 3 (1974), 15–28; J. J. G. Alexander, 'Some Aesthetic Principles in the Use of Colour in Anglo-Saxon Art', *Anglo-Saxon England,* 4 (1975), 145–54. It is interesting how few English colour words are derived from Greek or Latin.

[2] On Latin colour words, see J. André, *Étude sur les termes*

de couleur dans la langue Latine (Paris, 1949); R. F. Newbold, 'Perception and Sensory Awareness among Latin Writers in Late Antiquity', *ClMed* 33 (1981–2), 169–90; M. Roberts, *The Jeweled Style* (London and Ithaca, NY, 1989); R. J. Edgeworth, *The Colours of the 'Aeneid'* (New York, 1991). I am grateful to Dion Smythe for this last reference.

[3] See K. Goldstein in *Language and Language Disturbances* (New York, 1948), 167.

issue of whether a perceived colour must have a name, and the question of the inter-action of perception and sensation in linguistic development, a host of problems remain.

It is the apparent imprecision of Greek colour words which has been perceived by scholars as problematic. The study of Greek colour names began with the work of W. E. Gladstone who, in his analysis of Homer, noted a paucity and confusion in Greek colour terms when compared to Newton's differentiation of the seven primaries.[4] Gladstone criticized Homer for his 'crude and elemental' use of colours and, in the tradition of nineteenth-century rationalism, bewailed a system in which colour words were not fixed and constant.[5] He believed that as a result of the Mediterranean environ-ment where colour was less defined, painting unknown and few artificial colours existed, 'the organs of colour and its impression were but partially developed among the Greeks of the heroic age'.[6] In other words, because the Greeks failed to differentiate colours to the degree that Gladstone felt was appropriate, they were colour blind. Gladstone's solution was to propose a biological evolutionary view of colour designa-tion, a line of argument later applied to other languages including Hebrew and Old Norse.[7]

However, it is no longer believed that the Classical Greeks were colour blind, rather that they described colours in a different way from ours. This is the difference which I shall now illustrate through a glossary of Classical Greek colour words.[8] It will serve as a guide to the definition of terms used in this book, and as a comparison with the glossary of Byzantine colour terms in Chapter 4. The fifteen words used are those given by Plato and Aristotle as the major colours, together with those words that I have found to be most commonly employed in Greek texts; the glossary is not meant to be either exclusive or exhaustive.

In this glossary, I have collected a range of contexts for colour words, rather than a single colour term or hue definition for each. The themes which unite the colour words are suggestive; whatever else they may do, colour words tend to echo the prevalent

[4] W. E. Gladstone, *Studies on Homer and the Heroic Age*, iii (Oxford, 1858).

[5] Ibid. M. Platnauer, 'Greek Colour Perception', *CQ* 15 (1921), 153–62, comes to the same conclusion.

[6] Gladstone, *Studies in Homer*, iii. 488.

[7] See A. Brenner, *Colour Terms in the Old Testament* (Sheffield, 1982), esp. ch. 1, for a discussion and critique of this.

[8] Detail provided in A. E. Kober, *The Use of Color Terms in the Greek Poets to 146 BC* (New York, 1932); F. E. Wallace, 'Color in Homer and in Ancient Art', *Smith College Classical Studies*, 9 (1927); E. Irwin, *Color Terms in Greek Poetry* (Toronto, 1974). See also E. Veckenstedt,

Geschichte der griechischen Farbenlehre (Paderborn, 1888); K. Müller-Bore, 'Stilistische Untersuchungen zum Farbwort und zur Verwendung der Farbe in der älteren griechischen Poesie', *Klassische-Philologische Studien*, 3 (Berlin, 1922), 5–126; E. Handschur, *Die Farb- und Glanzwörter bei Homer und Hesiod, in den homerischen Hymnen und den Fragmenten des epischen Kyklos* (Vienna, 1970), which list words and their definitions in a variety of ways. H. Stulz, *Die Farbe Purpur im frühen Griechentum* (Stuttgart, 1990), examines purple and red in great detail. Roberts, *The Jeweled Style*, provides an approach to Late Antique poetry which stresses the diverse nature of colour terms.

perceptions of their culture.[9] Rather than providing an English hue word equivalent for the Greek, I have preferred to list the qualities which Greek colour words seek to convey.

GLOSSARY

Χροιά is the term applied to coloured surfaces or colour in general, χρῶμα describes the colour of objects or beings, ἄνθος is the name given to colours which are particularly bright.

ἁλουργός	LSJ[10] 'wrought by the sea', therefore taken to mean 'sea-purple', the genuine purple dye used of cloth. M[11] sees it as synonymous with πορφύρεος and φοῖνιξ. He translates it as 'le lilas', lilac.
γλαυκός	Translated as a range of shades in the grey, blue-grey, blue-green range. Used of eyes, vines, olives, the sea, suggesting a meaning beyond that simply of hue. LSJ suggests 'gleaming' and 'bright'.[12]
ἐρυθρός	Red. Used in Homer invariably in the context of blood (*Iliad*, X. 482–4) from which the wider meaning seems derived. M's references make the role of red as a primary elemental colour clear.
κυάνεος	Perhaps the most unclear of the colour words. Homer uses it as a substantive (for example in *Iliad*, XI. 24–7, 34–5) and this use has been taken to mean 'dark blue enamel' or 'lapis lazuli', with blue taken as the colour reference. Homer also uses it of hair, clouds, groups of warriors. The fifth- to sixth-century BC poet Simonides provides the first reference to the sea as κυάνεος; Irwin says[13] that, apart from colour theorists and geographers, the word is confined to poetry and acts as a synonym for μέλας, thus meaning 'dark' rather than 'blue', conveying lustre and glossiness. It is used of the swallow, of the skin of porpoises, of clouds, Africans, the brows of Zeus, massed ranks of warriors, and the mourning veil of Thetis. LSJ translates κυάνεος as 'dark' when used with a noun.

[9] On this relationship, see V. W. Turner, 'Colour Classi-fication in Ndembu Ritual', in M. Banton (ed.), *Anthropological Approaches to the Study of Religion* (London, 1966), 47–84; D. Turton, 'There's No Such Beast: Cattle and Colour-naming among the Mursi', *Man*, 15 (1980), 320–38, both of which provide additional valuable references.

[10] LSJ: H. G. Liddell, R. Scott, and H. S. Jones, *A Greek–English Lexicon* (9th edn., Oxford, 1968).

[11] M: C. Mugler, *Dictionnaire historique de la terminologie optique des grecs* (Paris, 1964). This provides references to colour terms and uses in optical contexts.

[12] Also P. G. Maxwell-Stuart, 'Studies in Greek Colour Terminology: 1, Glaucos; 2, Karopos', *Mnemosyne*, suppl. 65 (Leiden, 1981).

[13] Irwin, *Color Terms*, 79–110, provides a summary of the use of the word.

λευκός	White/light/bright, covering any shade from snow to dust. It has been suggested that it derives from the same root as *lux*,[14] and this meaning dominates in Homer (*Iliad*, X. 437, 547). Used of hair, stars, roots, and gold. M offers three readings: what an object emits or reflects of light; the transparency through which light passes; the object colour white.
μέλας	Black/dark. This meaning has not been questioned and remains constant from the Homeric period on. It is used of water, men's skin, clouds, death, and character, a reference to obscurity. M: something deprived of light.
ξανθός	LSJ suggests yellow, of various shades, often with a red or gold tinge. The range of objects so described includes hair (notably of heroes or divinities), flame, rivers, corn, fried food, some plants and animals. 'Fair' and 'bright' are suggested as alternatives.
πορφύρεος	Usually translated 'purple', the colour produced by the murex shell-fish. However, the word seems to have covered a wide range of colours from pink/red to green and purple, blue and black, which may be a result of the different shades it is possible to obtain from the dye of the murex. Equally, this diversity may suggest an original meaning beyond those of hue: Homeric usage can be translated as 'dark', and LSJ suggests 'gushing', 'surging', and 'heaving' as alternative meanings.[15] It is used of cloth, death (especially death in battle), the human complexion and cattle. M translates it as 'rouge sombre' or 'éclatant'.
πράσινος	Leek-coloured, i.e. green. A late term which seems to be first used by Plato.[16]
πυρρός	Derived from πῦρ, fire, and thus felt to cover almost any shade in the red–orange–yellow spectrum. On analogy with other colour words and considering other aspects of the nature of fire, it may also convey concepts such as motion, flicker, gleam. With the relationship to fire, a strong symbolic meaning is suggested. Used of hair, blushing.

[14] By L. Gernet, 'Dénominations et perceptions des couleurs chez les grecs', in I. Meyerson (ed.), *Problèmes de la couleur* (Paris, 1957), 313–26. This article examines the linguistic derivation of Greek colour words and looks at their symbolic aspect.

[15] I am reminded of the Anglo-Saxon use of *purpura*, interpreted by C. Dodwell, *Anglo-Saxon Art* (Manchester, 1982), 145–50, as shot-silk taffeta, with emphasis laid on its light-reflecting qualities. Dodwell notes how *purpura* is used in the Roman period to indicate brightness, the refulgence of the sun, the spectrum of the rainbow, the whiteness of snow, and general glittering effects.

[16] This derivative is quoted by e.g. LSJ.

ὑάκινθος	The flower name, hyacinth, which, like 'orange' in English, seems to have been transferred into a colour word.
φαιός	A mixture of black and white, therefore grey, and used in some cases as a negator of both black and white. Used to describe the mourning complexion and harsh sounds.
φοῖνιξ	Red, purple, according to LSJ and M which both derive it from ὁ Φοῖνιξ, Phoenician, the Phoenicians being considered the first users and discoverers of it. Possibly derived from φοινός, slaughter.[17] Used of cattle, fire, dates, the date-palm, and rye grass.
χλωρός	As a colour, it is translated as greenish-yellow though the range of contexts suggests pale and pallid in a negative sense, and also freshness, moisture, youth, and renewal.[18] The Presocratic philosopher Xenophanes seems the first to use it in a chromatic sense when commenting on the colours of the rainbow, though it is unclear whether he means a specific colour or a band of colours.[19] It is applied unambiguously in Hippocrates and Galen to the colour of bile, urine, etc., where it is invariably a negative symptom.[20] Used of grass, vegetation, tears, dew, honey, figs, wine, cheese, the complexion of fear and of those afraid. M sees it as having three distinct meanings: the colour of young leaves, i.e. green; pale grey with fear; freshness and youth.
ὠχρός	Another of the less than precise shades of the green–yellow band. Applied to complexions, and to egg yolks, indicating pale, sallow, wan. Where used in the context of colour theory, it is frequently translated as 'yellow ochre', which emphasizes pigment to the detriment of other characteristics.[21]

Greek definitions of colour words are clearly imprecise in their references to hue. Even when a word is used in a hue sense, the meaning covers a band of colours rather than a single specific hue, though this band remains constant within Classical Greek culture. Ἐρυθρός, for example, seems to be the equivalent of our 'red', but is used of colours from scarlet to maroon. Instead of hue, the glossary shows how emphasis is placed on contrast, especially between light and dark, shade, quality, movement, and the play of colours, a concept so alien to English that no single term or set of terms exists to describe it. They are best contained under one of the three modern terms used for

[17] C. Rowe, 'Conceptions of Colour and Colour Symbolism in the Ancient World', ErYb 41 (1972), 338.
[18] See Irwin, Color Terms, 31–78, for a justification of these shades of meaning.
[19] Fr. 28 D.
[20] See e.g. Hippocrates, Prognostic, II 10.
[21] As in the case of the 1929 Loeb Timaeus, 177, and V. J. Bruno, Form and Colour in Greek Painting (London, 1977), 91.

describing colour, brightness.[22] It is within this definition of colour that Greek colour words operate coherently.[23]

This conclusion is not a new one: it has been demonstrated in different ways by several Classical scholars. What I intend to do next, however, is to apply it to Greek writings on the subject of colour to illustrate how theories on the nature of colour and writings on colour in art are underpinned by this system of colour perception.

THE NATURE OF COLOUR IN THE CLASSICAL WORLD

The survey of colour words opens up the question of how the Classical world conceived of the nature of colour. Colour terms are used in a different way from that to which we are accustomed: how much of this is a result of alternative ideas of the very nature of colour and the workings of vision? In contrast to our knowledge about the ways in which the eye functions, the Greeks, as they expressed themselves in philosophical and scientific writings, saw things otherwise.

The writings of Greek philosophers reveal three basic conceptions of the nature of vision. Some argued that vision occurred through rays falling on an object, a belief hinted at by Aristotle and more strongly suggested by Theophrastus; others asserted that vision occurred through the stretching of the air—this was essentially the Stoic view; others believed that vision occurred through the impact of images streaming off from the object into the eye, a belief popular from Democritus through to Plato and Epicurus. All of these theories had a consequent influence on the understanding of the nature of colour and coloured vision.

It is with the third school of thought that I shall begin. Both Empedocles and Democritus held that vision came to the eye through images streaming off from the object of vision. Empedocles believed that the eye contained pores of fire and water and that white was perceived thanks to the fire, black thanks to the water.[24] An effluence from visible objects brought the colour to the eye, which could be seen in accordance with whichever pores it filled. For Empedocles, the primary colours, which he defined as white, black, red, and yellow (ὠχρός),[25] were related to the elements producing all

[22] Irwin, *Color Terms*, 201–3.

[23] In this context, though Homer has been criticized for using too few hue words, C. Rowe, 'Conceptions of Colour and Colour Symbolism in the Ancient World', 333–41, suggests that up to 30 can be found.

[24] Recorded by Theophrastus, though, obviously, it is

not at all certain how accurately Theophrastus repeats Empedocles or any other of his sources.

[25] According to Aetius in the 1st cent. AD. H. Diels and W. Krantz, *Die Fragmente der Vorsokratiker* (6th edn., Berlin, 1951–2), 31 A92. Theophrastus, *De Sensibus*, 37, gives only μέλας and λευκός.

other colours.[26] This emphasis on the elemental nature of colour later forms a link with alchemical theory where like elements perceive like, a tradition maintained in the Byzantine period.

For Democritus, colour seems to have been a subjective and secondary quality: sensations of colour were produced in the soul by the shape and position of atoms on the surface of objects and the amount of space between them. Colour was perceived as an attribute of touch, with white as the smoothest, caused by loose and friable surfaces of round, closely arranged particles, and black arising from rough, irregular, and dissimilar surfaces. Red, for example, consists of a configuration of atoms similar to those producing heat, but larger, and just as mobile: fire atoms move rapidly through the void spaces found in warm objects, so do red ones. Larger, slower atoms move less rapidly, producing colour sensations closer to black. Democritus argued that as colour exists in an object only through the order, figure, and position of the atom, it has no objective existence. He took the primary colours to be white, black, red, and green ($\chi\lambda\omega\rho\delta s$)[27] though he employed 'bright' and 'shining' ($\lambda\alpha\mu\pi\rho\delta s$ and $\delta\iota\alpha\nu\gamma\eta s$) as synonyms for white. All other colours were formed through combinations of these.[28] Gold and copper colours are produced by mixing white and red, the brightness of these colours being derived from the quantity of white present in the mixture; purple ($\pi o\rho\phi\upsilon\rho\epsilon os$) consists of red, white, and black. The imprecision of colour terms is immediately apparent: Democritus' colour combinations are not such as would be the product of mixing actual hues. Rather, in his account of the making of colours, he stresses their relative darkness, lightness, and brightness—two terms for 'bright' are significantly linked with white. He employs several terms like $\iota\sigma\dot{\alpha}\tau\iota s$ and $\kappa\alpha\rho\dot{\upsilon}\ddot{\iota}\nu os$ which are both secondary and seem unique to his writings.[29]

PLATO AND COLOUR

It was Plato, however, who refined these ideas on the nature of vision and colour most thoroughly.[30] Plato seems to have held that effluences from coloured bodies have an effect on the stream of usual particles so that these are either crowded or driven far apart;

[26] 'How by the mixture of water, earth, air and sun (fire) there came into being the shapes and colours of all mortal things that are now in being' (Theophrastus, *De Sensibus*, 37).

[27] There is some doubt as to the accuracy of this term as surviving versions of Democritus are not clear.

[28] The mechanics of colour vision are somewhat confusing, for Democritus explains dark colours as the result of shadows on a rough surface, but fails to describe how such shadows might be formed. It has been suggested that a rough surface is one from which effluences do not flow smoothly so that the observer is deprived of all or most of the vision-

producing effluence and therefore can only see shade or black. See D. Hahn, 'Early Hellenistic Theories of Vision and the Perception of Color', in P. K. Machamer and R. G. Turnbull (eds.), *Studies in Perception* (Ohio State Univ., 1978), 60–95, esp. 70.

[29] As quoted by Theophrastus, *De Sensibus*, 76–8.

[30] On Plato's colour theories, see also K. Gaiser, 'Platons Farbenlehre', in *Synusia: Festschrift für W. Schadewaldt* (Pfullingen, 1965), 173–222. Plato's theories on vision and colour are set out in most detail in the *Timaeus*, especially 45–6 and 67–8 with reference to colour.

the colour perceived will depend upon the alteration of the usual streams—though it is not made at all clear how this alteration is conveyed back to the eye. In the case of certain strong colours and lights such as 'red' or 'shining', motion is communicated by the effluences; in the perception of other coloured objects like black, the effluence never reaches the eye. Then sharper colours entering the eye spark off a reaction between the fire and water atoms of which the eye is composed. The various colours seen are then accounted for in terms of size, shape, arrangement, and motion of material particles from the object and the eye, and of the emissions of the eye. Primary colours from which the others derive in mixtures are explicable as quantitative variations of certain mechanical effects such as ease of approach, speed, and depth of penetration into the eye. Plato's underlying assumption seems to be that the higher the degree of access between the object and the eye, the brighter the colour: 'What separates the sight is white, and the opposite, black.'[31]

It is within this framework that different colours are made. Colour is essentially a flame or light emanating from the coloured body; colour differences correspond to differences in the result of the encounter between this flame and the ray of light issuing from the eye. The result depends on the balance between the visual stream and the particle of flame emitted by the coloured body. Colour is envisaged on a linear scale between white ($\lambda\epsilon\upsilon\kappa\acute{o}s$) and black ($\mu\acute{\epsilon}\lambda\alpha s$), with red ($\grave{\epsilon}\rho\upsilon\theta\rho\acute{o}s$) and 'shining' ($\lambda\alpha\mu\pi\rho\acute{o}s$) as the other two primaries. Plato then goes on to detail the effects of mixing:

Bright [$\lambda\alpha\mu\pi\rho\acute{o}s$] mixed with red and white produces orange [$\xi\alpha\nu\theta\acute{o}s$] . . . Red mixed with black and white gives purple [$\grave{\alpha}\lambda o\upsilon\rho\gamma\acute{o}s$] or deep blue [$\acute{o}\rho\phi\nu\iota\nu os$] when these ingredients are well-burnt and more black added. Tawny-yellow [$\pi\upsilon\rho\rho\acute{o}s$] is a mixture of orange and grey, grey [$\phi\alpha\iota\acute{o}s$] being a mixture of black and white, while pale yellow [$\grave{\omega}\chi\rho\acute{o}s$] is a mixture of orange and white. White combined with black and immersed in deep black [$\mu\acute{\epsilon}\lambda\alpha s$ $\kappa\alpha\tau\alpha\kappa o\rho\acute{\eta}s$] produces blue-black [$\kappa\upsilon\acute{\alpha}\nu\epsilon os$], which in turn produces blue-green [$\gamma\lambda\alpha\upsilon\kappa\acute{o}s$] when mixed with white, while tawny-yellow and black yield green [$\pi\rho\acute{\alpha}\sigma\iota\nu os$]. (*Timaeus*, 68 A–D)[32]

This passage has presented several problems. Not only does Plato appear to move away at this point from the concept of colour as light, but the mixtures he details seem incomprehensible: how can blue-black and white produce blue-green or yellow and black make green?[33] It has been suggested that Plato is merely playing with the ideas that he puts forward and acknowledges their weaknesses and the omnipotence of god—he states that: '. . . In what proportions the colours are blended it were foolish to declare, even if one knew, seeing that in such matters one could not properly adduce any ground

[31] *Timaeus*, 67D.
[32] The translation is that of D. Lee in the Penguin Classic (1983 edn.), which I quote to illustrate the problem of fitting an English hue term to the Greek colour word.

[33] 'This particular section of the dialogue is perhaps the one above all others we must never expect to understand fully' (A. E. Taylor, *A Commentary on Plato's Timaeus* (London, 1928), 479).

or probable reason';[34] and, further, that '. . . to try to apply an experimental test would be to show ignorance of the difference between human nature and divine; for god has the knowledge and power that makes him able to blend many constituents into one and to resolve the resulting unity again into its constituents, but no man can or will ever be able to do either'.[35] It has also been proposed that he is indulging in the commonplace of speculation and conjecture about colour combinations, apparently a favourite pastime of well-educated Athenians, or even that he is trying to indicate merely the resemblance of colour sensations, not to discuss the results of either mixing pigments or superimposing lights. In any case, so it has been said, the whole passage may be underlain by a touch of burlesque on the author's part.[36]

The apparent imprecision of Greek colour vocabulary adds to the problem. Plato's description of green (πράσινος) as a mixture of black and red-orange (πυρρός) is felt to be the most obscure.[37] The most ingenious solution to the problem of Plato's colours takes issue with this point.[38] Noting the apocryphal tradition of Plato's experiences as a painter and the knowledge of the techniques of art that he displays elsewhere in the dialogues, V. J. Bruno suggests a translation of Greek words into artist's colours.[39] Thus ξανθός becomes a pure yellow like deep cadmium, πυρρός an earth yellow like yellow ochre and μελάς a darkening agent capable of acting like a blue pigment. Consequently, πυρρός as a mixture of ξανθός and φαιός is the result of neutralising a bright yellow with grey to produce a more delicate shade, and then this combination together with blue-black can produce the much-maligned πράσινος.

What is problematic is Bruno's straightforward equation of changeable Greek colour words with the more consistent terminologies used by artists. Πυρρός defined as yellow ochre loses much of its force as a word applied to fire, to blushing and generally as an adjective conveying red as well as yellow; ξανθός seen simply as bright yellow also loses its red aspect. Plato states specifically that both of these colours include red in their make-up.

Further, in his emphasis on the painterly, practical nature of this passage, Bruno ignores the metaphysical aspect of the text. Just as the *Timaeus* can be understood as both a metaphysical and a physical explanation of the cosmos, so there is scope to deal with Plato's treatment of colour in abstract terms.

[34] *Timaeus*, 68B 6–8.

[36] Taylor, *Commentary*, 479–91.

[37] Plato's description of green comes in *Timaeus*, 68C. On the obscurity of the passage, see, again, Taylor, *Commentary*, 485, and also T.-H. Martin, *Études sur le Timée de Platon* (Paris, 1981: repr. of Paris, 1841), 294.

[38] V. J. Bruno, *Forms and Colour in Greek Painting* (London, 1977), ch. 10, 89–95.

[35] Ibid., 68D 2–7.

[39] On this theme, the *Anonymous Prolegomena to Platonic Philosophy*, 13, 13–15, ed. L. G. Westerink (Amsterdam, 1962) says, 'He [Plato] also went to painters to learn the mixing of colours in their manifold combinations; this enabled him to write a long passage on colours in the *Timaeus*' thus suggesting a tradition of Plato as practical artist. Also see *Republic*, X 602C–603A; *Philebus*, 51A–53B for examples.

Plato's theories on vision make it clear that he believed the eye saw colour as proportions of black and white. He suggests that all elements consist of geometrically shaped particles. The eye sends out a stream of fire which coalesces with the stream sent out from visible objects, and the particles impinge. The colour perceived depends on the relative size of the two sets of particles. These colours range from white and shining (λαμπρός) which penetrate deep into the eye, to black in which the effluence does not enter the stream at all. Intermediate colours penetrate to intermediate degrees. Black and white or dark and light (μέλας and λευκός) are the two poles of the scale, but red (ἐρυθρός) and shining are also primary colours. The rest of Plato's colours consist of mixtures in varying proportions of these four, within which context one has to ignore the hue involved and think only in terms of proportion. If drawn up and coloured, the scale would simply depict differing shades of grey, but this is because of the conceived polarity of colour between black and white, mediated by this graduation, but essentially a mixture of primaries. When Plato's mixtures are seen in terms of colours (hues), then the passage is fairly incomprehensible; when they are seen as points on a black–white linear scale, one concerned with relating colours through their proportions of light and dark, then a plausible colour scale can be constructed and sense made out of the mixtures. For Plato, as for Democritus, all colours fall as points on a black–white scale, running from decreasing whiteness/lightness towards increasing blackness/darkness. Colours are positioned on this scale by being broken down into their constituent parts of black, white, red and shining.

This is what Plato describes in his passage on the making of colours:

$$
\begin{aligned}
\xi\alpha\nu\theta\acute{o}s \quad &= \quad \lambda\alpha\mu\pi\rho\acute{o}s + \dot{\epsilon}\rho\upsilon\theta\rho\acute{o}s + \lambda\epsilon\upsilon\kappa\acute{o}s \\
\dot{\alpha}\lambda o\upsilon\rho\gamma\acute{o}s \quad &= \quad \dot{\epsilon}\rho\upsilon\theta\rho\acute{o}s + \mu\acute{\epsilon}\lambda\alpha s + \lambda\epsilon\upsilon\kappa\acute{o}s \\
\ddot{o}\rho\phi\nu\iota\nu os \quad &= \quad \dot{\epsilon}\rho\upsilon\theta\rho\acute{o}s + \mu\acute{\epsilon}\lambda\alpha s + \lambda\epsilon\upsilon\kappa\acute{o}s + \mu\acute{\epsilon}\lambda\alpha s \\
\pi\upsilon\rho\rho\acute{o}s \quad &= \quad \xi\alpha\nu\theta\acute{o}s + \phi\alpha\iota\acute{o}s \\
&= \quad [\lambda\alpha\mu\pi\rho\acute{o}s + \dot{\epsilon}\rho\upsilon\theta\rho\acute{o}s + \lambda\epsilon\upsilon\kappa\acute{o}s] + [\lambda\epsilon\upsilon\kappa\acute{o}s + \mu\acute{\epsilon}\lambda\alpha s] \\
\phi\alpha\iota\acute{o}s \quad &= \quad \lambda\epsilon\upsilon\kappa\acute{o}s + \mu\acute{\epsilon}\lambda\alpha s \\
\dot{\omega}\chi\rho\acute{o}s \quad &= \quad \lambda\epsilon\upsilon\kappa\acute{o}s + \xi\alpha\nu\theta\acute{o}s \\
&= \quad \lambda\epsilon\upsilon\kappa\acute{o}s + [\lambda\alpha\mu\pi\rho\acute{o}s + \dot{\epsilon}\rho\upsilon\theta\rho\acute{o}s + \lambda\epsilon\upsilon\kappa\acute{o}s] \\
\kappa\upsilon\acute{\alpha}\nu\epsilon os \quad &= \quad \lambda\alpha\mu\pi\rho\acute{o}s + \lambda\epsilon\upsilon\kappa\acute{o}s + \mu\acute{\epsilon}\lambda\alpha s \ \kappa\alpha\tau\alpha\kappa o\rho\acute{\eta}s \\
\gamma\lambda\alpha\upsilon\kappa\acute{o}s \quad &= \quad \kappa\upsilon\acute{\alpha}\nu\epsilon os + \lambda\epsilon\upsilon\kappa\acute{o}s \\
&= \quad [\lambda\alpha\mu\pi\rho\acute{o}s + \lambda\epsilon\upsilon\kappa\acute{o}s + \mu\acute{\epsilon}\lambda\alpha s \ \kappa\alpha\tau\alpha\kappa o\rho\acute{\eta}s] + \lambda\epsilon\upsilon\kappa\acute{o}s \\
\pi\rho\acute{\alpha}\sigma\iota\nu os \quad &= \quad \pi\upsilon\rho\rho\acute{o}s + \mu\acute{\epsilon}\lambda\alpha s \\
&= \quad [\xi\alpha\nu\theta\acute{o}s + \phi\alpha\iota\acute{o}s] + \mu\acute{\epsilon}\lambda\alpha s \\
&= \quad [(\lambda\alpha\mu\pi\rho\acute{o}s + \dot{\epsilon}\rho\upsilon\theta\rho\acute{o}s + \lambda\epsilon\upsilon\kappa\acute{o}s) + (\lambda\epsilon\upsilon\kappa\acute{o}s + \mu\acute{\epsilon}\lambda\alpha s)] + \mu\acute{\epsilon}\lambda\alpha s
\end{aligned}
$$

From this table, a scale can be constructed, ranking the colours between black and white through their constituent primaries.

λευκός
ὠχρός
ξανθός
πυρρός
φαιός
γλαυκός
ἁλουργός
πράσινος
κυάνεος
ὄρφνινος
μέλας

White is the brightest/palest colour. Ὠχρός is made up of λευκός + ξανθός and because of its constituents is brighter than ξανθός but not as bright as λευκός. Πυρρός is darker because it contains φαιός, but brighter than φαιός because it contains ξανθός, and so on, down the scale.

Plato does not place red and shining on the scale. As primary colours, they have no place in a scale of colours whose position is determined to a great extent by the constituents of black and white. From his account of how these two colours are made (68A), it is clear that as white penetrates the eye and as red and shining are found intermediate to and within the eye, they are both envisaged at the light/bright end of the scale. Every colour is made up from proportions of black and white, the cardinal poles of the scale; red and shining are employed not as points on this scale but as agents affecting and controlling the brightness or brilliance qualities of the colours.[40] Their presence in a colour mixture tips it towards the 'white end' of the scale and they act as a further scale running parallel to the basic one:

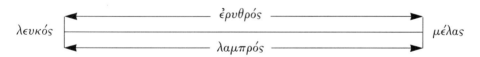

Plato's apparently qualifying comments at 68B and D suggest that, whilst the black/white poles of the scale remain consistent, as do the components of the colours, he does not believe that the proportions of these can be fixed. Although differing results within the same framework can be obtained, this depends upon the proportion of the primaries conceived of as making up each colour.

Though all this may seem ingenious, it is merely a way of illustrating a very simple point: that, for Plato, all colours are made up of proportions of the four primary

[40] See E. A. James, 'Colour Perception in Byzantium', Ph.D. thesis (University of London, 1989), 96–9; J. Gage, *Colour and Culture* (London, 1993), 31.

colours, black, white, red, and shining. The placing of colours on a light/dark scale is hardly unexpected. Considering the heritage of Democritus and the perception of colour displayed in literature from Homer onwards, Plato's statements can be perceived as both comprehensible and sensible. In his account of the mixing of colours, a constant principle is applied whereby a colour can be a mixture of two other colours as differing proportions of black and white, the basic constituents of any and every colour. This works only when the equivalence of colour and hue is ignored in favour of one of colour and brightness, and when Greek colour terms are accepted as imprecise with reference to hue. Moreover, Plato's colour scale is a concept which recurs in Byzantium.[41]

Elsewhere, Plato uses colour as a means of expressing both form and beauty. In the *Meno*, Socrates suggests 'Let this always be our definition of shape—the only thing which is always accompanied by colour'. He also cites Gorgias' definition, in the Empedoclean tradition, that colour is 'an effluence from shapes commensurate with sight and perceptible by it'.[42] In *Philebus*, Socrates is asked which pleasures can be considered true and replies 'Those arising from what are called beautiful colours, or from forms', defining these as geometry, 'the straight line and the circle and the plane and solid figures formed from these by turning lathes and rulers and patterns of angles' and 'colours which possess beauty and pleasures of this character'.[43] Colour adulterated by the admixture of other colours is no longer pure: the same is true of pleasures. In similar vein, in the *Republic*, Plato complains that man is in enough danger of being deceived by his own senses without surrounding himself with 'the illusions about colours to which we are all liable', though he is aware of the value of the proper colour in the right place rather than the indiscriminate application of the most beautiful colour.[44]

Plato seems to conceive of shape and colour as being closely related. However, he couples this with suspicion of the illusory nature of colour detracting from what is real, in a similar way to the concept of mimesis in poetry and drama. The same idea is applied to art with the same reservations. However, in *Phaedo* Plato actually displays a delight in colour; again, emphasis is on brightness, brilliance, and saturation rather than hue.[45]

[41] See below, Ch. 4.
[42] The first quotation is *Meno*, 95B, the second *Meno*, 76D.
[43] *Philebus*, 51B.

[44] *Republic*, X 602C–603B. Plato defines the most beautiful colour as ὄστρεον, purple derived from τὸ ὄστρεον, 'oyster', in *Republic*, IV 420C. [45] *Phaedo*, 110B–C.

ARISTOTLE AND COLOUR

Aristotle's work on colour makes up the single largest and most varied contribution to the topic in the ancient world and offers a very different perspective to that of Plato.

Aristotle believed that vision occurred through rays falling on an object. Vision is carried by movement from the object which moves the transparent medium (the so-called 'diaphanous') between the object and the eye, and this causes vision by an image of the object being transported. Colour is the surface limit of the transparent and is what sets the medium in motion. Because the transparent is colourless, colours can arise in it only by suitable modification of light, which is therefore, in a sense, the colour of the transparent. Light is not the contrary of darkness; instead, darkness is a removal from the transparent of the active condition, and light is the presence of this. What is visible in light is colour; colour is not visible without light.

Aristotle treats colour both as a philosophical issue and a topic for analytical observation. The object of sight is the visible, which is either colour or 'something which can be described in words but in fact has no name'.[46] However, 'the purpose of sight is colour',[47] a theme developed significantly further in Byzantium.

These themes are enlarged upon in *De Sensu* in which Aristotle describes sight as the most important sense because it informs us of 'many differences of all kinds'.[48] He suggests that colours may be made by the juxtaposition of dots of black and white, too small to be seen individually. Thus colour depends on the ratio of black to white, a concept similar to that of Plato in the *Timaeus*. In some cases there are definite ratios and strict numerical laws, like those of melodic procession, and the colours thus formed are the most beautiful, like purple (ἀλουργός) and red (φοῖνιξ); in others there is no definite ratio and the colour is analogous to a mere noise. Alternatively, Aristotle suggests that different colours may be formed by their superimposition, as when one colour is painted over another or sunlight is seen through mist. In Aristotle's view, a genuinely new colour, like a chemical substance, must be the product of a complete fusion of its constituents; it is only when the substances in which the colours are inherent are fused that a new colour is formed. This issue of mixing is one which recurs throughout Classical philosophy and has a role in alchemical thought: did the mixing of two substances destroy each and make a new one, or could the component parts be sorted out again? When colour was an essential element in the definition of form, its purity and simplicity were inevitably of consequence.

Colour itself is defined as a genus of which different shades are species. There are

[46] *De Anima*, 418ᵃ27.

[47] τὸ γὰρ ὁρατόν ἐστι χρῶμα (*De Anima*, 418ᵃ27).

[48] *De Sensu*, 437ᵃ–440ᵃ. This passage reiterates many of the points made in *De Anima*.

seven distinct colours according to *De Sensu*: black, white, green (πράσινος), blue (κυάνεος), red (φοῖνιξ), purple (ἁλουργός), and either yellow (ξανθός) or grey depending on whether yellow is seen as a variant of white or grey as a variant of black.[49] These seven basic colours are given by nature and the five intermediaries are formed from mixtures of black and white.

Where Plato employs an abstract approach, taking his colours to fit his general theory of vision with its emphasis on tone and brilliance, Aristotle, especially in the *Meteorologica*, deals far more with an analysis of observed phenomena and less with the abstract mixture of colour. Here, he treats colour in relation to light. Aristotle suggests that vision is due to rays emanating from the eye and reflected back from the object which are affected by distance, the colour of the media through which they pass, and of the surface from which they are reflected.[50] Nevertheless, he also places much emphasis on black and white, light and dark, and on the shading of colour.

Theophrastus also follows the Aristotelian line on vision and colour.[51] In his *De Sensibus*, he provides a summary of Empedocles and Democritus on colour, together with a suggestion of his own views. He appears to hold that colours themselves are a cause of seeing colour, that a colourless object cannot be seen—implying that form is defined by colour. The difference between colours is one of the quality, not quantity, of the mixture of black and white, which Theophrastus says are the only primaries.

The *De Coloribus*[52] does not examine the nature of colour perceptions directly but is rather a collection of observed facts about the physical basis of colour in plants and animals, and the effects of heat and moisture in this sphere.[53] The work begins by stating that primary colours are colours which belong to the elements; air and water are naturally white; fire and the sun yellow (ξανθός); black is the colour of elements in the process of change. Colours are fundamental properties of substances and the colour perceived by the observer arises from mixtures of the primary colours which derive from the mixture of elements. All colours vary in strength and purity depending on the concentration (brightness) of light; no colour is seen as absolutely pure. Light is treated as something material consisting of rays which may be rare or dense, and which move the object to the eye, transmitting colour. As an example of how light affects colour, the author cites the changing shades of a bird's feathers at different angles. Theories should not be based on the way in which pigments are mixed but on the observed effects of different sorts of illumination. This emphasis on observa-

[49] *De Sensu*, 442ᵃ21.

[51] G. M. Stratton, *Theophrastus and the Greek Physiological Psychology before Aristotle* (London and New York, 1917).

[52] This work is now generally accepted as part of the

[50] *Met.* 373.

Theophrastic-Peripatetic canon, if not actually by Theophrastus himself. See H. B. Gottschalk, 'The *De Coloribus* and Its Author', *Hermes*, 92 (1964), 59–85.

[53] *De Coloribus*, 791–2.

tion is at odds with the abstract reasoning of Plato, but ties in well with Aristotelian methodology.

THE STOICS AND COLOUR

Finally, the views of the Stoic philosophers offered a third analysis of vision and colour. Zeno defined colour as 'the primary shape of matter';[54] whilst Chrysippus seemed to hold the view that, in seeing colour, the tensed cone of air standing between the eye and the object experiences a change of state induced by the state of the object, which is communicated back to the eye.[55] This is yet another remodelling of the theory whereby colour depends on the accessibility of the sense organ, to fit the Stoic theories of matter and perception, which required that the visual cone be made of a continuous substance (i.e. tensed air). The Stoic idea postulates a state of density impressed on this cone and communicated back to the eye and soul: black and white are thus explained but nothing survives concerning other colours, which were perhaps explained in terms of intermediate degrees of tension.

All three of these basic theories display similar ideas and attitudes. All state in one way or another that form or matter is essentially defined by colour, though they differ as to how colour itself is seen. Black and white are defined as the fundamental primary colours, and tend to be seen as aspects of light and dark. That this is so is a significant indication of the difference between perceptions now and then. Colours are light and dark in different proportions, underlining the point made by the inconsistency in hue terms of colour words. It is their qualities of brilliance that are analysed and remarked upon. Theories on vision reflect these concepts. The significant differences between philosophers are not about colour and its nature, but over the mechanics of vision.

As far as colour vocabulary goes, these fourth- and fifth-century philosophers employ very few colour terms that are not to be found in Homer. The evidence of Plato and the introduction of words meaning 'colour of . . .' (like πράσινος) or compounds where the name comes from the object, like ἰοειδής, suggest that a shift away from Homeric usage is not as great or as conclusive as most scholars have made out.[56] The imprecision of Greek colour terms down into the Hellenistic period indicates that a once-for-all definition of colour as hue was still not considered of major importance and that other qualities were also considered significant. Clearly in attempting to understand colour in

[54] H. von Arnim, *Stoicorum Veterum Fragmentum*, i (Leipzig, 1903), no. 91: Aetius, I 15 6. Ζήνων ὁ Στωικὸς τὰ χρώματα πρώτους εἶναι σχηματισμοὺς τῆς ὕλης.

[55] Cited by Aetius, IV 15 3. (von Arnim, ii, nos. 866 and 869.

[56] Rowe, 'Conceptions of Colour', 342, expands on Plato's links with Homer's colour terms.

the ancient world, a very different set of preconceptions from our own as to the nature of colour is called for.

COLOUR IN ART

Greek colour vocabulary reveals the fluidity of Greek colour terms, above all their emphasis on qualities that we would not necessarily regard as colours. Writers on the nature of colour demonstrate similar concerns, explaining colours in terms of light and dark. How far was this translated into artistic terms? Here, evidence for the use of colour comes from two sources: writings about art and what they reveal about perceptions of art, and the works of art themselves.

'How right Phrynicus was' [Sophocles] said to his neighbour, 'when he wrote "on red ($\pi o\rho\phi\acute\upsilon\rho\epsilon os$) cheeks shines the light of love!"' The Eretrian, who was a schoolmaster, took this up. 'Of course, Sophocles, you are an expert in poetry. But Phrynicus was surely wrong in calling the boy's cheeks "red". If a painter were to use a red colour for them, the boy wouldn't be a beauty any more' . . . Sophocles laughed. 'Then I take it, sir,' he said, 'that you don't approve either of Simonides' much admired line, "the maid from red ($\pi o\rho\phi\acute\upsilon\rho\epsilon os$) lips speaking"—or of Homer's "golden-haired Apollo". For if the painter had made the god's hair gold and not black, the painting would have been worse. And what about "rosy-fingered"? If you dipped your hands in rose colour, the result would be a dye-worker's hands, not those of a beautiful woman.' (Told by Ion of Chios)[57]

It is as if we were colouring a statue and someone approached and censured us, saying that we did not apply the most beautiful pigments to the most beautiful parts of the image, since the eyes, which are the most beautiful part, have not been painted with purple but with black, we should reply justifiably 'Don't expect us, friend, to paint the eyes so fine that they will not be like eyes at all, nor the other parts. But observe whether by assigning what is proper to each we render the whole beautiful.' (Plato, *Republic*, IV 420C)[58]

According to both these passages, one aspect of colour in art is very clear: there are correct colours to be used in painting and these colours are not necessarily the most beautiful ones in the eyes of the beholder. The difference between the schoolmaster and Sophocles is that, for the former, artistic convention, the blackness of the god's hair, the redness of the boy's cheeks, outweighs the poetic traditions praised by Sophocles. Whilst this story may have been told as an illustration of the pedantry of a schoolmaster next to a great poet, it nevertheless suggests that there were traditions of colour use in poetry which were not followed in art. Both Ion of Chios and Plato appear to be saying that art had its own strict guidelines for the use of appropriate colours; if these were not applied, then the work was unsuitable as art.[59]

[57] Fr. 8 in von Blumenthal; trans. in D. A. Russell and M. Winterbottom (eds.), *Ancient Literary Criticism* (Oxford, 1972), 4–5.

[58] Trans. P. Shorey, Loeb edition (New York and London, 1930).

[59] They also illustrate the problems in translating Greek

A link between form and colour is hinted at in the idea that the right colour must be used for the particular purpose of making something look like what it is supposed to be. According to Plato, each part of a statue has its proper colour, which may not be the 'most beautiful' colour when considered in the abstract, but is nevertheless suitable for the purpose for which it is employed. This fitness of colour seems based upon its truth to nature; it is the natural, the true colour of the part. In life, eyes are not purple but black; therefore it is the true colour of eyes, black, not the most beautiful colour, purple, which should be used to paint the most beautiful part of the body.

This aspect of the rightness of colours in painting is used as a simile by Plato in the *Republic* to explain why Homer and Hesiod are at fault in their creation of false stories: 'When anyone images badly in his speech the true nature of gods and heaven, [it is] like a painter whose portraits bear no resemblance to his model'.[60] In a similar image, one which recurs frequently in Byzantium, he wrote:

Painters, when they wish to produce an imitation, sometimes only use red, sometimes some other colour, and sometimes mix many colours . . . employing each colour, I suppose, as the particular picture demands it. In just this way we too shall apply letters to things, using one letter for one thing . . . Just as in our comparison we made the picture by the art of painting, so now we shall make language by the art of naming, or of rhetoric.[61]

This link between choosing a colour and choosing the right word to make the picture or the language suggests again that colour relates to true form: as words make up language, so colour makes up the picture and the object. This is why the proper colours have to be used in art, and it goes some way to explaining the intensity of the Classical debate on mixing and on pure colours.[62]

From the time of Simonides, and probably earlier, poetry, literature, and painting were considered parallel activities, sharing a common function and purpose.[63] Painting had a greater impact on Greek culture than sculpture or the other figurative arts. An entire body of technical and critical texts indicates a widespread interest in the topic; painting was the only representational art to be incorporated into general education. In literature, the description of paintings developed its own rhetorical genre, and picture/poem equations became a commonplace of the Classical world. It was within this context that philosophers debated the nature and value of art and of colour within art. Plato took the attitude that painting was fundamentally a representative art whose

colour words into English. John Gage, 'A "Locus Classicus" of Colour Theory: The Fortunes of Apelles', *JWarb* 44 (1981), 1–26, suggests that the Sophocles story may illustrate the Greek awareness of the discrepancy between colour perception and colour terminology; I would argue that Greek colour perception and colour terminology work together.

[60] *Republic*, II 377E. [61] *Cratylus*, 424E–425B.

[62] In *Republic*, 586B–C, Plato uses colours in describing pleasure and pain and plays on the word καθαρὸς for pure pleasures and colours.

[63] E. Keuls, *Plato and Greek Painting* (Leiden, 1978), 42 and n. 23.

chief function was to imitate, copy, and reproduce visible aspects of some physical objects in the same way as the sculptor or carpenter. What the sculptor and the painter created was not a three-dimensional replica but something which 'looked right'; the painter may have had to employ distortion through shading and colour to obtain a suitable result. This last depended on empirical judgement and the painter's limited control over the available colours. Plato's criticisms were aimed at those who wished merely to produce a superficial emotive copy with no desire to seek for a deeper meaning; he took a similar attitude to drama and poetry when they were seen to appeal merely to the irrational and unworthy. The painter's art is not 'truth' but a copy of a copy of the truth.[64] I will go on to argue that Byzantine philosophical attitudes to art pushed this belief a step further.

Just how far philosophical speculations about the nature and mixture of colour had any practical application for artists or those who wrote about art is unclear. Ancient authors writing about art and artists can be divided into five major groups: the compilers of tradition like Pausanias and Pliny who tend to record rather than criticize; the literary analogists like Cicero who used art for stylistic comparisons with literature; the moral aestheticians who exalted the 'ideal' and evaluated art on the basis of its influence on human morality and spiritual awareness; the professional critics, actual artists commenting on their fellows, of whom the only major surviving source is Vitruvius; and those providing the 'popular' appreciation of art, who describe it, emphasizing its realism and its value.[65] This last group perhaps represents the view of the patron and the artist, and is typified in works such as the *Imagines* of Philostratus which calls painting 'imitation by the use of colours'.[66] Art criticism concentrated on the professional aspects of form and design, the moral worth, and the popular, marvellous, and magical qualities of art.

Professional criticism concentrated on objective problems of form and design; it is not known how an artist would explain the 'content' and 'form' of their work. From the other forms of criticism, it is possible to obtain views on how questions such as these were seen, and how form was thought to convey the desired qualities of art.

[64] *Republic*, X. Where R. C. Lodge, *Plato's Theory of Art* (New York, 1975), 234, suggests that the Greeks saw paintings merely as coloured drawings, Plato's emphasis on the need to get the colouring right indicates that this is not necessarily so.

[65] R. L. Gordon, 'The Real and the Imaginary: Production and Religion in the Greco-Roman World', *Art History*, 2 (1979), 5–34 notes the tendency of scholars to impose their own frame of reference on the understanding and use of art in the ancient world through the dismissal of this category of art appreciation and the imposition of structure by titles such as Pliny's 'Chapters on the History of Art'.

[66] ζωγραφία δὲ ξυμβέβληται μὲν ἐκ χρωμάτων. The *Imagines* are a very sophisticated version of art description, concerned extensively with literary style, but they link to descriptions of art going back as far as Homer and forward into the Byzantine ekphrastic tradition. Despite this, they display Gordon's 'popularist' attitudes—concern with realism and myth. See R. H. Webb, 'The Transmission of the *Eikones* of Philostratos and the Development of Ekphrasis from Late Antiquity to the Renaissance', Ph.D. Thesis (University of London, 1992).

From the archaic period on, sculpture was painted, usually in simple washes of primary (in the modern artistic sense) colours: red, white, black, yellow, blue, green. Limestone statues tended to be totally painted; marble ones had perhaps some clothing, together with the hair, eyebrows, lips, and eyes, picked out. Inlays of ivory, gold, and silver in the statues of the gods were common, and of glass, coloured stones, and other metals in less important works, emphasizing the attraction of sparkle, gleam, and brightness, and the concern to emphasize wealth and value. Architecture was also brightly painted, though there is much debate as to the extent and nature of this. It is probable that even those areas of temples which were not painted had a coloured wash applied as a weather shield and to tone down the blinding glare of white marble.[67] Bright textiles in a range of hues, especially purple, seem popular in literature of all kinds and on statues.[68] Emphasis on the rich saturation of colour is made clear by the 'thrice-dipped' adjective which authors such as Homer frequently apply to cloth in place of a colour name.

Greek painting seems to have been similarly bold. In the early periods, it was essentially two dimensional, using a limited range of colours, red, black, blue, green, white, yellow, applied in flat, undifferentiated washes with no attempt at modelling in light and shade. This developed in the fifth century when greater emphasis was placed on 'naturalism' and there may have been more mixing of colours. Little survives from the Classical period, and there are no known copies of the works of famous painters. However, recent excavations at Vergina have produced valuable evidence. Here, all the rich tombs contain painted decoration in a variety of bright, warm, and muted colours including Pompeian red, shades of blue, yellow and green, white and mauve. Comparisons have been made with Roman copies of Greek work at Herculaneum, but, as yet, not enough is accessible to say much more about the colours.[69]

Stories about the works of the famous painters abound, usually concerned with the realism of the art work. Colour is barely mentioned in these, though the account of Pausias' ox in its shades of black indicates that colour could be used skilfully and effectively.[70] Later paintings of the Hellenistic period seem to have employed a greater range of shades, as the Alexander mosaic and the wall-paintings of Pompeii suggest. Tones of pink, red, green, and blue applied less brightly seem to have been increasingly popular. The first-century BC critic, Dionysius of Halicarnassus, remarked:

In ancient paintings the scheme of colouring was simple and presented no variety in the tone; but the

[67] I. D. Jenkins and A. P. Middleton, 'Paint on the Parthenon Sculptures', *BSA* 83 (1988), 183–207, examine the role of washes/varnishes.

[68] Vitruvius, *De Architectura*, VII 13, places emphasis on bright colouring with a wide range of hues, with particular reference to textiles.

[69] M. Andronicos, *Vergina* (Athens, 1987).

[70] *Natural History*, XXXV 126.

line was rendered with exquisite perfection, thus lending to the earlier works a singular grace. This purity of draughtsmanship was gradually lost; its place was taken by a learned technique, by the differentiation of light and shade, by the full resources of the rich colouring to which the works of later artists owe their strength.[71]

How far Dionysius was adopting the familiar literary convention of bemoaning the Good Old Days is not certain. Aristotle and Vitruvius both point out that drawing is more important than colour and that brilliant colours are no substitute for craftsmanship.[72]

Many of the elements of Roman art are derived from Greek art, with the variations inevitable in transposition. Roman statues were painted: the Prima Porta Augustus was discovered vividly painted in reds, browns, yellows, pinks, and blues. These colours seem to have dominated the painting of marble sculptures at least into the third century AD. There is an increasing use of coloured marbles, which were introduced into Rome in the first century BC, and the wide range of coloured stones employed indicates a desire for polychromy. Paint was used to re-create the effect of variegated marbling, often in bolder and more striking colours. Certain stones were felt to be appropriate for certain subjects, though it is not clear how important the colour was in this.[73] A liking for bright and primary colours is apparent in the paintings of all four phases at Pompeii, where the palette remains consistent, but is manipulated in a variety of ways.[74] The colours of Roman wall-painting are essentially those detailed in Chapter 2.[75]

Both wall and floor mosaics employed a range of colours. At first, wall mosaics were essentially shell and pumice, but by the time of those at Pompeii, glass and marble chips were popular, adding qualities of brightness and a wider range of colours. Floor mosaics were regarded as a different and more functional art form. This means that stone rather than glass tended to be used, restricting the range of colours available. However, where possible, bright colours were favoured, as is the case in many North African floor mosaics.[76]

A NOTE ON THE FOUR-COLOUR PALETTE

Literature records a difference between the simple (ἁπλόος or *austerus*) colours and the *florides*, but it is no longer clear what these were. The technical problems present in mak-

[71] Dionysius of Halicarnassus, *De Isaeo. Iudic.*, 4, trans. K. Jex-Blake and E. Sellers, *The Elder Pliny's Chapters on the History of Art* (London, 1896; repr. 1968), xxxi.

[72] Aristotle, *Poetics*, 1450[b]; Vitruvius, *De Architectura*, VII 5.

[73] D. Strong and A. Claridge, 'Marble Sculpture', in D. Strong and D. Brown (eds.), *Roman Crafts* (London, 1976), 204–5.

[74] See R. Ling, *Roman Painting* (Cambridge, 1991), who describes the colours of the four styles and how they alter in his tracing of the development of Roman painting. He also provides some excellent colour plates.

[75] See ibid. ch.10, esp. 207–9.

[76] Roberts, *Jeweled Style*, describes the emphases placed by Late Antique writers on bright, varied colours in both literature and art.

ing colours and creating consistent hues make the dominance of primary colours unsurprising. The unstable nature of pigments may influence the variations in philosophical colour theories, and be reflected in Plutarch's comment that mixing 'provides conflict, conflict produces change, and putrefaction is a kind of change'.[77]

This may provide some explanation for the pervasive tradition of the four-colour palette. Cicero and Pliny record that the great painters of the Greek past used only four main colours: 'Ex albis Melino, e silaciis Attico, ex rubris Sinopide Pontica, ex nigris atramento'[78]—Melian white, Attic yellow (or ochre), Sinopic red, and black called *atramentum*. From these, all other colours were mixed. The absence of blue in this palette has caused much debate: without blue, none of the colours in the blue–green band can be mixed; and it is undeniable that blue was used as a pigment throughout Greek art.[79]

It is suggested that the origins of the four-colour palette go back to the philosophical elemental tetrads which invariably omit blue. However, it should be noted that Empedocles (c.492–432 BC), the first to whom the doctrine of the four colours of the elements is attributed, nowhere mentions it in the surviving fragments of his works, and in Fragment 23 talks of the polychrome ($\pi o\lambda v\chi\rho\omega s$) nature of a painter's palette.[80] It is not until the first and second centuries AD that there is a consensus of opinions relating to the basic colours and elements. The unification of the four colours and the elements was a late development, more or less contemporary with the growth of belief in the four-colour palette. The theme of the four-colour palette may instead be aimed towards fifth-century painters as an indication of the development towards chiaroscuro in their style and as a symbol of the superior simplicity of the ancients as against the ostentation and showiness of the contemporary Roman age. Pliny describes the way in which Apelles used dark varnish to tone down his brighter colours, and suggests that Apelles may have had a stage in his career of using bright colours and then have employed a more restricted palette. Consequently the late restriction to four colours may have been due to Pliny's and Cicero's conflation of two strands of tradition. Though this palette would severely restrict mixing, this was in any case not a favoured practice of the time.

Blue is omitted from the palette therefore in an aesthetic sense, not a physical one, for although it and colours of its range appear constantly in Greek painting, this is only in touches for shading or for certain select and often sacred objects.[81]

[77] *Quaestiones Conviviales*, 725C.

[78] *Natural History*, XXXV 50.

[79] Examples are cited by Bruno, *Form and Colour*: the painted tombs at Kazanlak and Lefkadia; and by Gage, 'Colour Theory and Apelles', 4–5.

[80] Gage, 'Colour Theory and Apelles', 3.

[81] See Gage, 'Colour Theory and Apelles', and *Colour and Culture*, ch. 2. Alternatively, Bruno, *Form and Colour*, 85–6, suggests that the Greeks may have had a black pigment, atramentum, capable of giving blue if diluted enough or of imparting a bluish tinge—as carbon blacks do in Byzantine wall-paintings. Consequently terms for blue and

However, the four colours making up the palette, white, red, yellow, and black, are essentially the primary colours of Democritus and Plato (taking yellow in place of shining) which suggests that the idea of a palette is not related to actual painterly practice, as is frequently assumed, but to ideas about the nature of colour and the black–white linear scale, on which every colour is made up of black and white.

This debate over the four-colour palette provides a final example of the division between Classical and modern perceptions of colour and its use. From my survey of the artistic use of colour, it is apparent that much attention was paid to the use of bright colours in painting and sculpture, and to the use of gleaming, precious materials. There appears to have been an artistic convention over when and for what purpose it was appropriate to use which colours, a convention somewhat different to the literary attitude to colour. Colour was an essential part of art, appearing on every surface, even those—notably sculpture—where its application seems abhorrent to the modern viewer accustomed to neoclassical austerity.

It is not new to say that Classical colour words are imprecise with relation to hue and therefore are more concerned with other colour qualities; it is new to apply this know-ledge to colour use and the understanding of attitudes to colour in the ancient world. The evidence put forward in this chapter shows clearly that Byzantine traditions of colour, if they derive from any sort of Graeco-Roman heritage, are based on a founda-tion involving not the modern concern with hue, but the Classical ideas about the nature of vision, including emphasis on brightness and a linear colour scale, on which colours are perceived as forming a continuum between black and white. Such a rereading of Classical colour perceptions in contrast to modern ones provides a necessary framework for any understanding of Byzantine colour use.

black might well overlap, as is the case with κυάνεος. Blue may well be an early synonym for black in Latin. See André, *Étude sur les termes de couleur*, 162–71. J. J. Pollitt, *The Ancient View of Greek Art* (New Haven, Conn., 1974), 111, attacks the Ciceronian version of the four-colour palette.

CHAPTER 4

Colour Words in Byzantium

So far, my study of colour in art has pursued two lines of approach. In the first two chapters, I examined colour in art in a literal sense: the use of colours in works of art, the ways in which those colours were made, and the limitations that this placed on actual artistic practice. I also introduced the concept that the use of colour, and certainly its perception within a specific culture, was conditioned by the conceptions of that culture. I illustrated this by contrasting modern ideas about the nature of colour with Classical Greek ones, suggesting that the difference in ideas about colour influenced attitudes to it. The Greeks were not colour blind; rather they were interested in and attracted to a different aspect of colour from that which prevails upon us. What I intend to do now is push the examination of this difference and how it might influence the perception of art a stage further. By narrowing my focus and concentrating on the Byzantine world, both Classical Greek and modern attitudes to colour can be used as sounding-boards for the Byzantines. What are Byzantine perceptions of colour in contrast to both ours and those of the Classical Greeks?

To answer this question, I will use Byzantine writings about colour in three different ways. First, I will look at Byzantine writings on the nature of colour and will explore Byzantine colour vocabulary. In Chapter 5, a study of depictions and descriptions of the rainbow will provide an example against which our modern perceptions can be set. Finally, in Chapter 6, I will contrast two Byzantine descriptions of the same monument but from different dates.

THE BYZANTINE VIEW OF COLOUR

As in the Classical world, it is Byzantine philosophical writings that provide much of the evidence for Byzantine beliefs about the nature of colour. Differences between Classical and Byzantine philosophies owe much to the influence of Neo-Platonism, perhaps the most significant branch of philosophical thought in Byzantium. Neo-Platonist, and after this, Byzantine, thought passed over many of Plato's mathematical and political interests, his concern with the theory of Forms and the early dialogues' search for ethical definitions. Instead, a division between Logic and Ontology was

achieved. Significantly, the *Timaeus*, with Plato's exposition on colours, was one of the most important dialogues retained in the Neo-Platonist and Christian world. Iamblichus regarded it as the key to Plato's work dealing with physics; it was also seen as crucial in discussions of the form, immortality, and destiny of the soul. Porphyry wrote a commentary on it; the Christian Proclus felt that it was one of the two Neo-Platonic texts (the other being the *Chaldean Oracles*) that should not be withdrawn as harmful to the uninstructed and wrote a massive commentary on it.

The influence of Neo-Platonism on art is significant in the area of colour perception. Plotinus has been regarded as the founder of aesthetics through his discussions of beauty. In *Enneads*, I 6 and V 8 he emphasizes the visual nature of beauty: symmetry, light, colour, and the brilliance of shining materials. He also places a new emphasis on the artist and spectator, and the effects of luminosity, colour, and brilliance. Light and brightness act as a bridge between the terrestrial and celestial, an aspect later developed by Christian theologians. Colour is described in terms of form: the forms which reach the eye are somehow the colours of the objects and colours are the primary constituents of form in matter.[1] Plotinus takes colours to be both the objective feature of bodies and a form of light. It is in this context that he sees that good colour produces visible beauty and that simple beauty of colour comes by the shaping and mastery of darkness in matter through the presence of light.[2] Fire is the most beautiful of 'bodies' and all other things take the form of colour from it. Colour is a form of light;[3] it is the most appropriate colours which are the most beautiful, and the true colours, together with true details, make the work real.[4] Light and colour together are the primary visible feature of objects.

In the third century, Alexander of Aphrodisias and Germinus retained the Neo-Platonic system, and the work of Philoponus attacked Aristotle at various points, including Aristotle's understanding of vision.[5] Though there are no manuscripts of the *Enneads* earlier than the twelfth century, several of the fourth- and fifth-century Fathers

[1] Plotinus, *Enneads*, II 8 35. See also E. K. Emilsson, *Plotinus on Sense-Perception: A Philosophical Study* (Cambridge, 1988), esp. 52 and 72. Plotinus' theories of vision are close to those of Plato—see e.g. *Enneads*, II 4.

[2] *Enneads*, I 6 1.

[3] *Enneads*, II 4 5: the eye has the form of light and 'directs its gaze at the light and at colours, which are lights'—'χρόας φῶτα ὄντα'. See also ibid. I 6 2.

[4] Ibid., II 8 1. See also A. Grabar, 'Plotin et les origines de l'esthétique médiévale', *CahArch* 1 (1945), 15–34; C. Walter, 'Expressionism and Hellenism: A note on Stylistic Tendencies in Byzantine figurative art from Spätantike to the Macedonian "Renaissance"', *REB* 42 (1984), 265–87, dis-

cusses Plotinus in relation to art, noting his definition of it as having the capacity to signify rather than act as imitation. Colour, in describing reality metaphorically and literally, encompasses both aspects.

[5] In his *Commentary* on Aristotle's *Meteorology* (on 372ᵃ), Alexander describes a colour scale between black and white based on proportions of these. Philoponus criticized Aristotle's statement in *De Anima* that the act of vision, actualized visual faculty, was itself coloured, in a manner of speaking. R. Sorabji, 'John Philoponus', in R. R. K. Sorabji (ed.), *Philoponus and the Rejection of Aristotelian Science* (London, 1987), 26–30.

copied from them and further sections are found in the tenth-century *Souda* lexicon and in the works of the thirteenth-century scholar, Nicephoros Gregoras. Colour theory, however, seems not to have been discussed with reference to art.

The other side of the Byzantine philosophical coin is Christianity. For a time, Christianity struggled to displace Classicism, believing it to be pagan and pernicious. Gradually a form of synthesis developed, using some aspects of Classical philosophy and rejecting others.[6] The early Fathers favoured Plato but did not ignore Aristotle; his influence is found in Arianism, Nestorianism, and Monophysitism, amongst others. That Aristotle was so influential is the result of several factors: the heretical Origen and his followers were Platonists; it was the task of Christian theology to make tight distinctions and careful definitions and the tools for this were better provided by Aristotle than by Plato; as these tools were used by heretics, so Christians had to adapt the same weapons.

The sixth-century monk Leontius seems to have been the first theologian able to express dogma in Aristotelian terms and still remain Orthodox. Maximus the Confessor and John of Damascus were also influenced. On the whole, however, the theology of the Greek Middle Ages went back less to the philosophers than to the range of commentaries and anthologies of their works; these anthologies again provide a Neo-Platonic influence. Strenuous efforts were made to reconcile the Neo-Platonic tradition with Christianity. Synesius, Pseudo-Dionysius, Nemesius, who is referred to by John of Damascus, and who cites a wide range of Classical and Late Antique philosophers from Plato to Chrysippus, Porphyry, and Galen, were all fourth-century users of Classical philosophical traditions. In the fifth century, Aeneas of Gaza took a very pagan outlook. In the sixth and seventh centuries, Philoponus, Stephanus, Maximus Confessor, John Klimacus, and others all incorporated aspects of Classical philosophy in their work to varying extents. During the period of Iconoclasm, Germanos, Nicephoros, Theodore Studites, and John of Damascus used it in their arguments; the very concept of Iconoclasm owed much to the ideas of Plato and Aristotle on imitative and natural images. Byzantine interest in the physiological aspect of optics was essentially that laid out in Aristotelian physics, and Classical writings were copied throughout the Byzantine era.[7] Indeed, traces of Classical philosophy can be found in almost every writer from the ninth century on. Because of this, it is possible to say that the Classical tradition of colour and its perception was not lost or replaced by Christian thinking; rather it became overlain with the ideas and tenets of the faith. This, in turn,

[6] This issue of the conflict and conflation of Christian and pagan thought is discussed in many works, e.g. L. Reynolds and N. G. Wilson, *Scribes and Scholars* (London, 1968); N. G. Wilson, 'The Church and Classical Studies in Byzantium', *AntAb* 16 (1970), 68–77 and refs.; A. M. Cameron, *Procopios* (London, 1985).

[7] For details, see K. Vogel, 'Byzantine Science', *Cambridge Medieval History*, 4: 2 (Cambridge, 1967), 282–3.

led to a development in ideas about the relationship between colour and form, mould‑ing these ideas to a Christian purpose through Christian imagery.

How far the influence of Classicism went beyond a superficial knowledge is unclear. In the case of colour perception, I am not sure how important this is as an issue. To a certain extent, Classical philosophy acted as a part of the background of educated Byzantines (at whatever level of education) as a part of their heritage. The ideas and conceptions filter down in some way, even if the Plato of the Byzantines is the Neo‑Platonic philosopher of myths (the *Timaeus*) rather than the teacher of dialectic. What does seem to have existed is the continuation of awareness of the philosophical tradition and the continuing acceptance of some of the ideas set out in it.[8] The Classical heritage of Byzantium is reflected in the continuation of Classical attitudes towards colour, but these were not deliberately sustained as a fossilized relic of the idealized past. They represent a real issue of perception that was developed over time to fit the particular concerns of Byzantium. The fundamental ideology of Byzantium was Christian: Classicism only existed through its absorption into Christianity. The key element in all this is language, for both Classical Greeks and Byzantines shared a common language.

BYZANTINE COLOUR VOCABULARY

To what extent does Byzantine colour vocabulary differ from the Classical? Are colour words used differently? The glossary compiled in Chapter 3 offers a comparative foil for that given below. The glossary of Byzantine colour terms is a means of examining the language and the meanings of that language employed by those who wrote about art. This is not a search for the colour vocabulary which may have influenced painters, an essentially profitless task, but an attempt to see how writers used colour words: it is the viewer of art's perceptions which concern me, not the artist's.

A Brief Glossary of Byzantine Colour Terms

The sources for this glossary of Byzantine colour terms are the sixth‑century lexicon of Hesychius and those of Photios (ninth century) and the *Souda* (tenth century).[9] In

[8] Byzantine philosophy is not highly regarded on the whole by scholars who tend to see it as a parroting of Plato, Aristotle, and Plotinus with a Christian bias. The Byzantines, even Psellos and his associates, are perceived as commentators rather than thinkers and dismissed accord‑ingly. This is an unfair judgement: philosophy to the Byzantines was not what it is to us. It seems to have been con‑cerned with questions, terminology, and the systematic dis‑cussion of Late Antique issues, particularly Neo‑Platonism.

[9] Hesychius of Alexandria, *Lexicon*, ed. K. Latte (Hauniae, 1953), 2 vols.; Photios, *Lexicon*, ed. R. Porson (Leipzig, 1828), and ed. C. Theodorides (Berlin and New York, 1982), *A–Δ* only pub.; *Suidae Lexicon*, ed. A. Adler (Leipzig, 1928, 1931, 1933, 1935, 1938), 5 vols.

addition, the lexica of Du Cange[10] and of Kriaras[11] serve as standard references for Byzantine Greek.[12] Such a glossary will not be able to convey every nuance present in the texts, but will provide a guide to aspects otherwise not explicit in a one-word English translation.

ἁλουργός Universally πορφύρεος or sea-purple (Hesychius, Photios, *Souda*).
 Imperial purple (Du Cange).
 Souda expands with a few references to examples of use.

γλαυκός λευκός, κυάνεος (*Souda*, Photios).
 'Fear' and 'strong' (Hesychius).

ἐρυθρός τό μέλαν (Du Cange, *Souda*).
 πυρρός in one form or another (Hesychius, Photios, Du Cange).
 κόκκινος, red (*rubens*) (Du Cange).
 Photios notes it as made from madder. Du Cange and Kriaras note its use in describing imperial writing.

κόκκινος Dyed φοῖνιξ and colour in own right. Made from grain (Hesychius).
 Red (*rubor*), *minium* (Du Cange).
 Kriaras notes a consistent meaning in the Classical and medieval periods. References are usually to its derivation.

κυάνεος μελανός (Hesychius, Photios, *Souda*), especially in relation to Poseidon who is called μελανόθριξ (Hesychius, Photios, *Souda*) or πορφυρόθριξ (Photios, *Souda*).
 Hesychius also records it as κύανος: θαλάττιον ὕδωρ and as the perceived colour of the sky (οὐρανοειδής). He says it is also used for Moors and Ethiopians.

λευκός Radiant, shining (Hesychius, *Souda*).
 Souda notes it as the colour penetrating the eyes.
 λευκός is also used in connection with good luck.

μέλας The colour distinguished logically from white (*Souda*).
 βάθος (Hesychius, Photios).
 Black (*atramentum*) (Du Cange).

ξανθός Fire (Hesychius, Photios, *Souda*).
 Also good and χλωρός (Hesychius).
 Photios notes it in relation to hair.
 Yellow (*flavus*) (Du Cange).

[10] C. Du Fresne and D. Du Cange, *Glossarium ad Scriptores Mediae et Infirmae Graecitatis*, 2 vols. (Lyons, 1688).

[11] E. Kriaras, Λεξικὸ τῆς μεσαιωνικῆς Ἑλληνικῆς δημώδους γραμματείας 1100–1669, A–K (Thessaloniki, 1968–85, incomplete).

[12] Additional references are from: G. W. H. Lampe, *A*

πορφύρεος Stirred up—ταράσσεται (Photios, Hesychius).

 Death, ὁ μέλας, and deep (Hesychius).

 Purpureus (Du Cange).

πράσινος χλωρός (Hesychius, Photios).

 The colour of garden vegetables (Hesychius) especially of leeks (Photios).

 Souda and Du Cange note it as the alternative Circus faction to οἱ βένετοι.

πυρρός ὁ ξανθός (Photios, *Souda*).

ὑάκινθος ὑπομελανίζος (Hesychius, *Souda*).

φαιός μέλας (Hesychius).

 Colour between black and white (Photios, *Souda*).

φοῖνιξ ἐρυθρός; πυρρός (Photios, Hesychius).

χλωρός From 'green shoots' comes 'green' and χλωρός; ὠχρός is also derived from this (*Souda*).[14]

 Hesychius relates it to trees and gives ὠχρότης.

 Du Cange cites the fourth horse of the Apocalypse.

ὠχρός χλωρός (Hesychius).

 Fear, weakness, sickness, change (*Souda*).

Byzantine Definitions of Colour

The word used for 'colour' itself in both Byzantine and Classical accounts is usually χρῶμα, but ἄνθος is also a common term. This can be translated as 'flower' or 'bright colour', or as 'brightness' and 'lustre'. That such a word should mean 'colour' indicates the strength of qualities such as brightness and saturation in the perception of colour.[15] In Greek thought, χρῶμα was related to χρώς, skin, that is, to form and surface, and to movement and change, which can be related to the shifting nature of colour. This shifting aspect is perceived as one of the qualities of colour, a positive part of the nature of colour.[16]

Χρῶμα is defined by the *Souda* lexicon, the anonymous tenth-century scholarly encyclopaedic collection, as 'what is in bodies, like black and white and everything in between them'.[17] The lexicon describes how the eye perceives colour, in a way which

Patristic Greek Lexicon (Oxford, 1961); E.A.Sophocles, *Greek Lexicon of the Roman and Byzantine Periods* (New York, 1887).

[14] The Greek is virtually untranslatable: χλωρός: ἀπὸ τοῦ χολὴ χλοερὸς καὶ χλωρός, ἀπὸ τούτου δὲ τὸ ὠχρός.

[15] J. Gage, 'Colour in History: Relative and Absolute', *Art History* 1 (1978), 106 and n. 10.

[16] See e.g. Aristotle, *Meteorologica,* III 4 375ᵃ.

[17] *Suidae Lexicon*, ed. Adler, iv. 828. Chroma is also related to sound and some form of musical scale.

seems to follow Classical ideas about the movement of objects through the diaphanous to the eye, and states that 'colour (χρῶμα) in appearance is what is visible and vision receives this'.[18] In other words, the *Souda* defines χρῶμα/colour as what makes objects visible to sight. The implication is that nothing would be visible without colour.

The *Souda* also describes the arrangement and mixing of colours. Under the entry φαιόν, there is a long passage on the nature of colour, a passage which, in many respects, echoes Plato on the nature of colours:

Some colours are simple, others, like black and white, opposites. Some of them are mixed like those between [black and white], and these are made by such a mixture with each other of opposites. Of these, some like yellow [ξανθός] are close to white and others like blue [κυάνεος] are close to black. The rest of them are between them like red [ἐρυθρός] and grey [τὸ φαιόν]. And so it is in the case of tastes. The opposites are simple like sweet and bitter and the rest mixed and between . . . [A passage on taste follows] It is not always the case that the between [colours] are mixed, for the mixed are between, but not opposite, as is the case with colours because of grey [φαιός] being mixed in between. However, red [ἐρυθρός] or green [πράσινος] do not completely come [or, come not at all—οὐ πάντως] from a mixture of opposites but are said to be between, as participating in neither of the limits [i.e. black and white].[19]

This text ascribes the description of the nature of tastes to Plato, Aristotle, and Galen; the assignation of tastes to planets is said to be Plato's. This last is more probably derived from a Neo-Platonic commentary on Plato. The passage on colours reads like a garbled version of the description in Plato's *Timaeus*.[20] Both Plato and the *Souda* take black and white as the two poles from which all other colours come and between which all other colours are arranged. However, where Plato had red and shining as his two other primaries, the *Souda* replaces shining with green (πράσινος).

This concept of the mixing of colours may be what Patriarch Photios referred to when he commented in a homily that 'today when, mixing the white with the black, out of which colours the natural constitution of the eye is wrought, you have filled with your bodies the voids of this wondrous place, forming as it were the socket of the eye'.[21] Mango interprets this as a laboured simile saying that Hagia Sophia might be called the eye of the universe, which is especially apt on a day when the contrasting garments of the population form the white and black (i.e. pupil) of the eye, of which the empty church is the socket. More simply, it may also be a reference to the making of colour by the mixing of black and white, and the filling of voids in the terms laid down by

[18] τὸ γὰρ ἐν τῇ ἐπιφανείᾳ χρῶμα τοῦτό ἐστι τὸ ὁρατόν, καὶ τοῦτο αἱ ὄψεις ἀντιλαμβάνονται (*Suidae Lexicon*, iv. 828). [19] Ibid. iv. 828–9.
[20] *Timaeus*, 65–7 (taste) and 67–8 (colour).
[21] *Homily*, VII 2, The Annunciation, Φωτίου Ὁμιλίαι ed. B. Laourda, ch 1 n. 8 (Thessaloniki, 1959), 74. ὅτε τὸ λευκὸν τῶν χρωμάτων οἱονεὶ τῷ μέλανι κερασάμενοι, ἐξ ὧν ἡ τῶν ὀμμάτων φύσις διαποικίλλεται, τοῖς ὑμετέροις σώμασι τὰ κενὰ τοῦδε τοῦ θεσπεσίου χώρου, καθάπερ ὀμμάτων κοῖλα μορφοῦντες, ἀνεπληρώσατε. Trans. in C. Mango, *The Homilies of Photios* (Cambridge, Mass., 1958), 140.

Democritus in the fourth century BC.[22] A similar attitude is present in the remark of the fifteenth-century writer, George of Trebizond, that Aristotle says that virtue is the mean and vice each extreme, and 'virtus enim non ut fuscus color ex nigro et albo, sed ut neutrum extremorum, in mediocritate collocatur'.[23] This Aristotle does not say, but it coincides with Byzantine ideas.

Other Byzantine texts deal specifically with the nature of colour. The Nestorian Christian Job of Edessa, who wrote in Syriac in the ninth century, provided another account in his *Book of Treasures*.[24] This description looks to the other major Classical tradition of the nature of colour, that of Aristotle.[25] Job wrote that the eye possessed in itself the two principal colours together with the addition of grey or some other colour. These colours in the eye created a certain affinity between the eye and outside colours which enables the eye to receive these colours. Colour itself, in Aristotelian fashion, was a *summum genus* of which there were six genera. These were whiteness and blackness, the 'universal, true and first' genera, and four others, redness, saffron-yellowness, greenness, gold-yellowness. These are genera only in a relative sense and are subdivided into species which are subdivided into individual colours. Whiteness is subdivided, for example, into the whiteness of the swan and of snow, green into verdigris and leek.[26] It is perhaps significant that the secondary colours are not specific hues but bands of colour.

A third description of the nature of colour comes in Michael Psellos' *De Omnifaria Doctrina*, dating to the eleventh century.[27] Psellos claims that his passage on colour is based on Plato and that Plato says that effluences (ἀπόρροιαι) are sent from bodies to the eyes. After his version of the effluences theory, Psellos adds that the same colours do not necessarily appear to the same people but according to the different mixtures in their eyes. For example, to those with phlegm around the membranes of the eyes, things seem less white, and so to others in different ways according to the differences of their mixtures. This seems rather more like a Byzantine version of Classical colour theory, and echoes the remarks of the *Souda*, than the actual Classical theories themselves. Psellos' views again emphasize the shifting nature of colour and yet suggest that colour itself is

[22] E. A. James, 'Colour Perception in Byzantium', Ph.D. thesis (University of London, 1989), 294; J. Gage, *Colour and Culture* (London, 1993), 44.

[23] *Comparationes Philosophorum Aristotelis et Platonis* (1456?). I am grateful to Ruth Webb for this reference.

[24] Job of Edessa, *Book of Treasures*, Syriac text ed. and trans. A. Mingana (Cambridge, 1935), Discussion III, ch. 3, 130–8. Job was a Nestorian who left an account of natural science as taught in Baghdad around 817. Arab sources make it clear that he was a key figure in the translation of Greek—especially Aristotle and Galen—into Syriac. His

sources for the *Book of Treasures* include Aristotle, Galen, Hippocrates, and several Persian and Indian writers.

[25] Mingana cites specifically *De Sensu*, 3–4.

[26] Job provides a table of these. Apart from those quoted above, black divides into raven and pitch, red into vermillion and minium, saffron-yellow into wax and orpiment, and yellow into citron and gold. Job also says that the colours are closely linked to the humours and notes that a mixture of red and white makes saffron-yellow. How far different categories of colour affects mixing is unclear.

[27] Ch. 64, Περὶ χρωμάτων. PG 122, 728C.

stable and changes in it are due to people's perceptions. This double perception of colour is a theme which recurs throughout Byzantine colour perception.

The glossary of Byzantine colour words suggests several points of contact with Classical colour vocabulary. Several terms remain consistent: ἐρυθρός is still red, φαιός still grey. A continuing concern with qualities of colour other than hue alone is apparent. In the case of πορφύρεος, two lexica provide 'stirred-up' as a meaning. In this instance, scholia on Homer offer a similar definition.[28] In several cases, these Homeric scholia also suggest that πορφύρεος and μέλας are synonymous.[29] Ὠχρός maintains links with 'fear'. Κυάνεος is very definitely related to the sea and the sky but all three Byzantine sources stress its sense as 'dark', indicating its brightness value, rather than its hue, which suggests the Classical usage. Black and white are seen as opposites, and white is tied very closely to qualities of light.

A survey of a range of Byzantine texts, both secular and religious, of different periods and genres, reinforces this suggestion that Classical and Byzantine colour vocabularies are very similar.[30] For example, λευκός and μέλας are found in texts at all levels of literary style from the fourth to the fourteenth centuries. Πορφύρεος is used in texts as diverse as the seventh-century *Chronicon Pascale* (described by Browning as an example of literary koine[31]) to the twelfth-century *Alexiad* of Anna Comnena, a high-class Atticizing text. The fairly low level Greek of the eighth-century *Chronicle* of Theophanes shares terms such as κόκκινος with Procopios, writing in the sixth century, as do the *Alexiad* and low level texts from the twelfth century. The New Testament contains a range of perhaps six colour terms, covering the colours red, white, green, and purple.[32] The Book of Revelation has a rather wider range of words, but adds only black to this list. In the hagiographical texts I examined, terms for 'white' and 'black' predominate; other terms are few and far between. Romanos the Melode, who died after 555, adds purple, πορφύρεος, to this list, used almost invariably with

[28] *Scholia Graeca in Homeri Iliadem*, ed. H. Erbse (Berlin, 1969–88), 7 vols., Bk. *E*, 83a; Bk. *Ξ*, 16, a, b, c. Scholia notes tend to refer to syntax, morphology, etymology, and to paraphrase words and phrases, rather than to offer definitions. Comments also need to be understood very clearly within the textual context as they frequently draw their conclusions from the text. As far as remarks on colours within Homeric scholia go, I have found that colours are only occasionally given values, and these are interpreted by the scholiast from the text. Colour words are glossed but rarely analysed or translated in a framework outside that of either the text or of scholia practice. Ruth Webb's detailed study of scholia up to the Renaissance relating to the *Imagines* of Philostratos supports these findings in more detail, R. H. Webb, 'The Transmission of the *Eikones* of Philostratos and the Develop-ment of Ekphrasis from Late Antiquity to the Renaissance', Ph.D. thesis (University of London, 1992).

[29] See e.g. *Scholia* ed. Erbse, Bk. *E*, 83a. Elsewhere, πολιός is described as synonymous with λευκός: Bk. *K*, 334.

[30] Details of this survey are provided in the appendix.

[31] R. Browning, 'The Language of Byzantine Literature', in S. Vryonis (ed.), *Byzantina kai metabyzantina*, i. The *'Past' in Medieval and Modern Greek Culture* (Malibu, 1978), 103–33. Definitions of style are made explicit by I. Ševčenko, 'Levels of Style in Byzantine Literature', *Akten der XVI Byzantinistenkongress Vienna 1981*, I: i (*JÖB* 31: 1) (Vienna, 1981), 289–312.

[32] λευκός, κόκκινος, χλωρός, ξύλος, πορφύρεος; πυρρός for sky.

reference to royalty.[33] The early sixth-century *Akathistos* hymn has only λαμπρός. Medical texts not unexpectedly use terms within the white, black, red range for complexions, yellows and greens for urine, and a mixture of both for humours.[34]

Epigrams from all periods devoted to works of art offer a valuable source of colour vocabulary. Here again, many terms are shared with Classical colour vocabulary, but employed in a very different context, that of Christian images. Perhaps the most striking aspect, however, is just how infrequently these texts actually employ colour terms and the limited range that appear: λευκός, ὠχρός, ἐρυθρός, μέλας and πορφύρεος seem to predominate.[35]

On the other hand, Byzantine colour vocabulary also reveals differences from the Classical. The *Book of Ceremonies*, compiled in the tenth century at the behest of Constantine VII Porphyrogenitus, mixes 'traditional' terminology with what must be Byzantine developments. As in Procopios and Malalas, πράσινος is the colour of the Green faction, and βένετος of the Blues, and clothes in both these colours are worn when appropriate. But the *Book of Ceremonies* also contains terms such as τυρεα, ῥοής, derived in a similar manner to ῥούσιος, and ἀληθινός. Ῥούσιος is used of the Red circus faction and is probably a transliteration of the Latin, *russus*. Both the Classicizing Theophylact Simocatta (late sixth century) and the more plebeian Malalas use κυάνεος and χλωρός as alternatives for Blues and Greens, and even curse tablets offer καλλάϊνος, derived from the Latin *callinus*, for Blue,[36] suggesting that colour vocabulary does not easily fall into appropriate literary styles. In other words, non-Classical terms are found in high-style texts and Classical terms in low level works: style and genre do not appear conclusively to govern colour vocabulary.

Most striking is just how few colour words are used in texts from all periods in whatever genre or level of style. Neither 'literary' nor 'other' texts make many references to colour and what words are used cover a small range of colours. There seems little difference in the use of colour terms, though slightly more in the actual words employed, between high and low level texts. To focus on historical writings, Procopios uses about ten colours, reflected in several different words.[37] Of the terms listed in my Classical glossary, Procopios uses all but γλαυκός. Anna Comnena uses eleven colour words, including three 'purple' terms and two red.[38] The *Chronicon Pascale* has six, including

[33] See e.g. Kontakion 5, Joseph, strophes 15 and 19; Kontakion 39, strophe 11 on the Magi.

[34] The 7th-cent. doctor, Paul of Aegina, for example, uses λευκός, μέλας, ἐρυθρός, πυρρός, ξανθός, χλωρός almost exclusively (*Paulus Aegineta*, ed. I. L. Heiberg, (Leipzig–Berlin, 1921–4), 2 vols.).

[35] Λευκός, for example, is the term most commonly employed by Manuel Philes. I am grateful to Henry Maguire

for reminding me of the significance of epigrams and for his helpful suggestions and references in examining them.

[36] See A. Cameron, *Circus Factions. Blues and Greens at Rome and Byzantium* (Oxford, 1976), 13 and n. 2.

[37] Procopios' main colour words are: ἀλουργίδος, ἐρυθρός, κυάνεος, λευκός, μέλας, ξανθός, πορφύρεος, πολιός, φαιός, φοῖνιξ; plus χλωρός, ὠχρός.

[38] Anna Comnena's main colour terms are: ἀλουργός,

ξανθός, but not ἐρυθρός. Malalas has a basic range of about thirteen, which contains ῥούσιος for 'red', two types of purple and variants for the Blues and the Greens of the Hippodrome.[39] Many authors use compound colour words, such as Malalas' ὑπόξανθος and Theophylact Simocatta's rather more Classicizing κροκινίζουσος.[40] Such words are secondary, rather than primary colour words; they are devised to fit particular circumstances and their relation to colours has to be enforced.

As ever, a major problem is posed in the translation of these words. The French translator of the *Book of Ceremonies* translates the word λευκός as 'blanc', assuming it to be simply a hue term:[41] a case can be made for it as 'bright' or 'gleaming', reflecting a different colour value. In the same text, is something different meant in the cases where the author uses λευκός and where ἄσπρος is used, both of which translate as 'white'?[42] Do ἐρυθρός and κόκκινος both mean 'red', or is one used as a different shade of red, crimson perhaps, or is it used in particular contexts? Is, for example, πορφύρεος, taken by us to be the word *par excellence* for imperial purple, really that? Are other 'purple' words used in this context and what other contexts is πορφύρεος used in? Whether different colour words carry different significances is, at present, virtually impossible to judge. Though the vocabulary remains fairly consistent, there may perhaps be some sort of pattern as to which colours it is appropriate to mention in what sort of text: the nature of a romance might allow for more colours than, say, a hagiography.

Vocabulary is not everything. As I will go on to illustrate in subsequent chapters, context and perception—the ways in which colours and colour words were used—are also significant. All Byzantine authors, at whatever literary level they write, use more words reflecting brilliance and qualities of light than they do 'colour' words: this suggests a perceptual difference between 'them' and 'us'.

The tradition of Byzantine accounts of the nature of colour is to maintain and emend Classical colour theory. Byzantine colour words similarly maintain and extend the Classical vocabulary. By both, colour is conceived of as a combination of dark and light elements; a group of four primaries is proposed; colour is not defined extensively in terms of its hue, but with regard to both brilliance and saturation. This continuity with

βένετος, ἐρυθρός, κόκκινος, λευκός, μέλας, ξανθός, πορφύρεος, φαιός, φοῖνιξ.

[39] This comprises: ἀληθινός, ἄσπρος, βένετος, γλαυκός, κυάνεος, λευκός, μέλας, ξανθός, πολιός, πορφύρεος, πράσινος, χλωρός, ῥούσιος.

[40] Theophylact Simocatta, *Historiae*, ed. C. de Boor (Leipzig, 1887), VII 11 5.

[41] *Book of Ceremonies*, ed. and trans. A. Vogt, *Le Livre des cérémonies* (Paris, 1935), 2 vols.; see e.g. ch. 1. 9; ch. 1. 19, and *passim*. H. Granger-Taylor, *Purple and Gold: Textiles and Clothing of Classical Antiquity* (Philadelphia, forthcoming),

and A. Muthesius, *History of the Byzantine Silk Industry* (Vienna, forthcoming), should provide valuable information about costume and colour; A. Muthesius, 'Crossing Traditional Boundaries: Grub to Glamour in Byzantine Silk Weaving', *BMGS* 15 (1991), 326–65, offers some preliminary pointers.

[42] e.g. λευκός and ἄσπρος are used for the emperor's chlamys (e.g. at ch. 20 and ch. 26), and for the emperor's divitision (e.g. ch. 46): should these be understood as the same garment, and if not, how do they differ?

the Classical heritage suggests that the Classical colour scale and the use of light and dark/black and white elements continued to be seen as pertinent in Byzantium. As significantly, these texts suggest that the function of colours is to distinguish things, that colour is an element in the definition of being.

THE USE OF COLOUR IN BYZANTINE LITERATURE: A CASE STUDY

The survey above of Byzantine colour vocabulary is not meant to be exhaustive, but rather to demonstrate the range of colour words and their presence in texts of different levels of literary sophistication. In contrast, in an analysis of two very different Byzantine literary texts, I will examine the ways in which colour is used, how colour vocabulary operates: where, how, and how often colour words are used. Only by understanding the vocabulary of colour can descriptions of colour in art be comprehended and com‑ pared and an extra dimension added to our understanding of how art was seen and appreciated in Byzantium.

I intend to compare two works, the *Chronographia* of Michael Psellos, dated to the late eleventh century, and the epic poem, *Digenes Akrites*, the date of which is unclear. The text is ascribed variously to 940–1040, to the tenth century in part and the rest later, or to the reign of Constantine IX (1042–55).[43]

The style of these pieces is very different. The *Chronographia* is a 'literary', Atticizing piece in the tradition of high‑style Byzantine literature; *Digenes Akrites*, an epic arising from a mixture of popular tradition and middle‑ranking culture, is the nearest equiva‑ lent to a readily accessible 'popularist' work available from this period. The differences in style and intention of the two works are enough to give a sample of two levels of perception and the use of colour and colour words at two different levels.

Colour in the Chronographia

The *Chronographia*[44] presents an account of court history from an author, Michael Psellos, who regarded himself as both a philosopher and a statesman.[45] He was influential at court under a succession of emperors between Michael V (1041–2) and

[43] By, respectively, G. Huxley, 'Antecedents and Context of *Digenes Akrites*', *GRBS* 15 (1974), 317–38; H.‑G. Beck, *Geschichte der Byzantinischen Volksliteratur* (Munich, 1971), 63–97; J. Mavrogordato, *Digenes Akrites* (Oxford, 1956). The 1992 International Symposium, 'Byzantine Heroic Poetry: New Approaches to *Digenes Akrites*', held in London, offered no consensus on the issue: R. Beaton and D. Ricks (eds.), *Digenes Akrites: New Approaches to Byzantine Heroic Poetry* (Aldershot, 1993).

[44] Greek text: Michel Psellos, *Chronographie*, ed. and trans. E. Renauld (Paris, 1967). English trans. by E. R. A. Sewter, *Fourteen Byzantine Rulers* (London, 1984).

[45] For a biography of Psellos see J. M. Hussey, 'Michael Psellos', *Speculum*, 10 (1935), 81–90, and 'The Revival of Learning in Constantinople in the Eleventh Century', D.Phil. thesis (University of Oxford, 1932); C. Zervos, *Un philosophe neoplatonicien du XIme siècle, Michel Psellos: sa vie, son œuvre, ses lettres, son influence* (Paris, 1920).

Nicephoros Botaniates (1078–81), and was also a major figure in the so-called literary and intellectual 'renaissance' of the eleventh century.[46] He was 'professor' of rhetoric at the so-called university of Constantinople when it was refounded in 1045. As a professional intellectual, he wrote philosophy, poetry, theology, history, literary criticism, orations, and alchemical and theological works.[47] Psellos was also a skilful rhetorician in an age where rhetoric was an essential means of communication for the élite. 'Just as Plato through the *Timaeus* combines theology with physical science, so I write philosophy by means of rhetoric and fit myself to both through use of both', for 'learning is divided into two parts, the one is composed of rhetoric, the other is concerned with philosophy'.[48]

The *Chronographia* displays aspects of both. It is a history of the reigns of the emperors from Basil II (976–1025) to Michael VII (1071–8), concentrating on the emperors and those around them rather than the events of each reign. Psellos' education is apparent throughout the work. His Greek is complex: he writes in a high Atticizing style, emphasizing archaisms. The vocabulary and forms of the Classical period dominate in a Byzantine variation. Psellos notes Demosthenes, Isocrates, Aelius Aristides, Thucydides, Plato, Plutarch, Lysias, and Gregory of Nazianzus as the greatest influences on his style. Classical allusions abound, including, besides these, Homer, Hesiod, and the Stoic authors.[49] In other words, Psellos was well aware of Classical colour vocabulary at the highest level and, in the tradition of high style Byzantine literature, was prepared to use it in a Classicizing manner.

Both the *Chronographia* and *Digenes Akrites* use colour words in the main to describe people and clothing. Psellos, however, uses Classical terms throughout the *Chronographia*. Πορφύρεος (purple) is used most frequently in describing the robes of the emperor and, in one instance, those of spiritual power.[50] Φοῖνιξ is also used for robes, but those of the empress rather than the emperor; this suggests the possibility of a symbolic use of colour, one shade being appropriate for the emperor and another for the empress. Φοῖνιξ is also used to describe blushing.[51]

Psellos' descriptions of people concentrate on their skin, hair, height, and bearing. Skin of both women and men is always white if these individuals are being portrayed

[46] For which see J. M. Hussey, *Church and Learning in the Byzantine Empire 867–1185* (Oxford, 1937); P. Lemerle, 'Le Gouvernement des philosophes' in *Cinq études sur le XIe siècle byzantin* (Paris, 1977), 193–248; and various articles in *Travaux et Mémoires*, 6 (1976).

[47] Psellos' own account of his learning is in *Chronographia*, VI 36–46.

[48] The first quotation is in *Bibliotheca Graeca Medii Aevi*, ed. K. Sathas (Paris, 1870), 476, and cited in G. A. Kennedy,

Classical Rhetoric in Christian and Secular Tradition from Ancient to Modern Times (Chapel Hill, NC, 1980), 168; the second, *Chronographia*, IV 41.

[49] E. Renauld, *Étude de la langue et du style de Michel Psellos* (Paris, 1920); Browning, 'The Language of Byzantine Literature'; B. P. McCarthy, 'Literary Reminiscences in Psellos' *Chronographia*', *Byzantion*, 15 (1940–1), 296–9.

[50] *Chronographia*, I 10 19; I 31 18; III 15 19; IV 52.

[51] Ibid., III 15 35; III 21 9; III 19 9.

in a favourable light.[52] They almost always have hair which is yellow (ξανθός) or auburn (πυρράζων).[53] The Empress Zoe is described as having a radiant white skin, and Constantine Monomachos has pure white (λευκός) skin.[54] This use of 'white' for the skin of both men and women contrasts sharply with Classical usage, where only women have white skin and darkness is a sign of manliness and heroism. White-skinned men are effeminate; dark-skinned women are ugly.[55] Not so in Byzantium, where, as *Digenes* suggests, white skin is for Byzantines, especially the beautiful, and dark skin for outsiders, particularly Ethiopians.[56]

Descriptions of favoured individuals also concentrate uniformly on another aspect. In Psellos, Michael IV is described as being in the 'bloom' of youth with a 'dazzling and glorious colour'.[57] Zoe has a radiant (λαμπρός) white skin. Constantine Monomachos' head is 'like the sun in its glory, so radiant was it'. His hair is compared to the rays of the sun and his body to translucent crystal.[58] Constantine Ducas as a baby has hair like the sun.[59] Similar emphases are seen in other descriptions from this period such as Christopher of Mitylene's account of Constantine IX, which compares his skin to pearls and his hair to gold, and elsewhere in Psellos' writings.[60]

The fullest account of beauty in the *Chronographia* is that of the empress Zoe. Psellos describes her as being very beautiful, with large eyes, imposing brows, golden hair, and a radiant white skin.[61] He also says that she retained her looks in old age, remaining unwrinkled.[62] This description has been seen as matching up with the woman portrayed in the imperial panel in the south gallery of Hagia Sophia and labelled 'Zoe' (Plate 39).[63] Such a belief overlooks Psellos' style of description. His account of his daughter, Styliane, in the eulogy he composed on her early death provides a full account of those features which he felt it necessary to describe.[64] The eulogy also describes them in such a way as to suggest an idealized portrait, and thus to indicate what the Byzantines regarded as the ideals of beauty. Psellos' description begins at the top and works its way down, as rhetorical canons decree. Styliane's head was neither too long

[52] *Chronographia*, VI 126; VI 151.

[53] Ibid. ξανθός: VI 20; VII 12; πυρράζοντος:VI 126.

[54] Ibid. VI 6.

[55] See E. Irwin, *Color Terms in Greek Poetry* (Toronto, 1974), 112–16, 129–35; C. Rowe, 'Conceptions of Colour and Colour Symbolism in the Ancient World', *ErYb* 41 (1972), 355; and J. J. Winkler, 'Lollianus and the Desperadoes', *JHS* 100 (1980), 155–81.

[56] In hagiographies and demonologies, the devil and demons often appear as black and/or Ethiopian. See R. P. H. Greenfield, *Traditions of Belief in Late Byzantine Demonology* (Amsterdam, 1988). [57] *Chronographia*, III 18.

[58] Ibid. VI 126–7. [59] Ibid. VII 12.

[60] *Die Gedichte des Christophoros Mitylenaios*, ed. E. Kurtz (Leipzig, 1903), no. 54. Michael Psellos, *In Mariam Sclerenum*, ed. M. D. Spadaro (Catania, 1984), lines 134–6.

[61] *Chronographia*, VI 6. [62] Ibid. VI 158.

[63] Notably N. Oikonomides, 'The Mosaic Panel of Constantine IX and Zoe in St. Sophia', *REB* 36 (1978), 219–32, who argues from Psellos' description that the head of Zoe cannot possibly be that of a 64-year-old woman. On the theme of reality in Byzantine portraiture see I. Spatharakis, *The Portrait in Byzantine Illuminated Manuscripts* (Leiden, 1976).

[64] εἰς τὴν θυγατέρα Στυλιανὴν πρὸ ὥρας γάμου τελευτήσασαν, in K. Sathas, *Bibliotheca Graeca Medii Aevi* v (Paris, 1876), 62–87. A. Leroy-Molingen, 'Styliané', *Byzantion*, 39 (1969), 155–63, says a little on the theme.

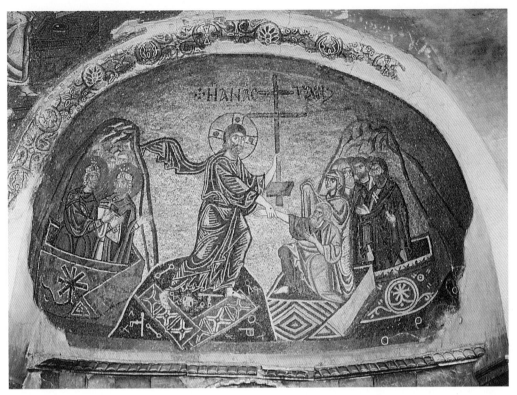

PLATE 1. The Anastasis mosaic, Nea Moni (*c*.1049–55)

PLATE 2. The robe of John the Baptist, Deesis mosaic panel, Hagia Sophia, Istanbul (after 1264). This detail of the robe reveals how pure colours are laid down in strips, creating one impression when seen from close to and another when seen from a distance (compare with Plate 16)

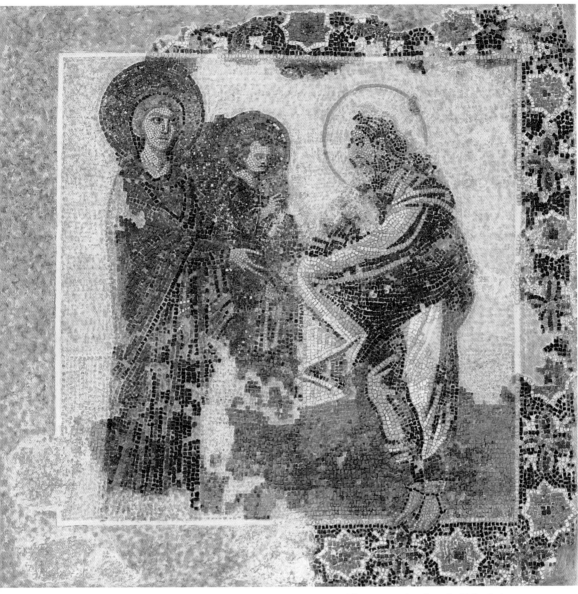

PLATES 3 and 4. The detail of the Virgin's face from the mosaic of the Presentation from the Kalenderhane Camii in Istanbul (seventh century) makes it appear crude and caricatured; from a distance, the colours blend into a coherent whole

PLATES 5 and 6. In contrast with Plates 3 and 4, the face of the Virgin from the Koimesis panel in the Kariye Camii, Istanbul (dedicated 1321), is modelled with harsh colours, particularly olive green, and white high-lights

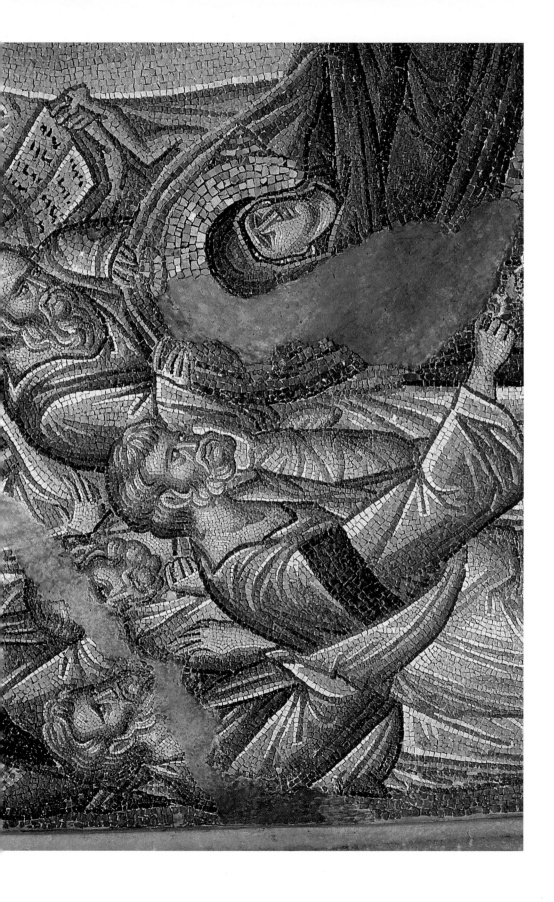

PLATES 7 and 8. The orb held by the Archangel
Michael from the apse mosaic at the Panagia
Angeloktistos, Kiti, on Cyprus (sixth or seventh cen-
tury) shows how mosaic could be modelled in three
dimensions. The mosaicist achieves the illusion that the
archangel's fingers are positioned behind the orb

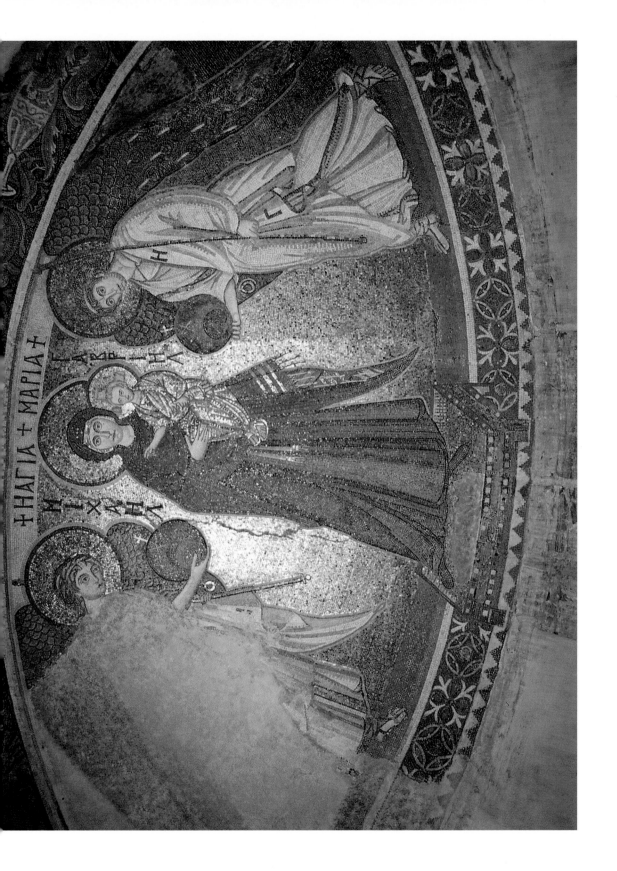

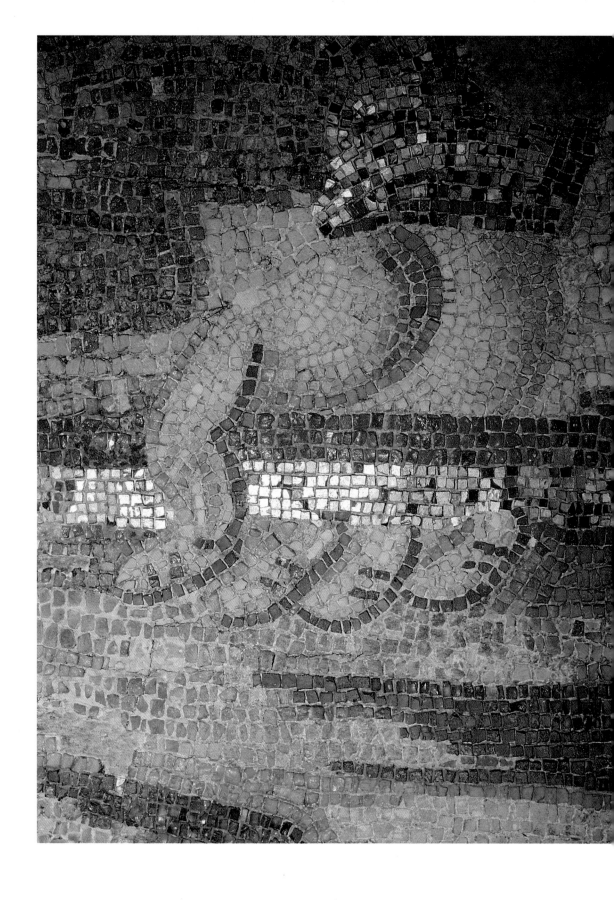

PLATES 9 and 10. The archangel from the vault of the apse, Hagia Sophia, Istanbul (dedicated 867). When seen from a distance, the eye makes sense of apparently random patternings and colours. Note how the thumb is outlined in green and the archangel's wing seems to consist of reds and golds

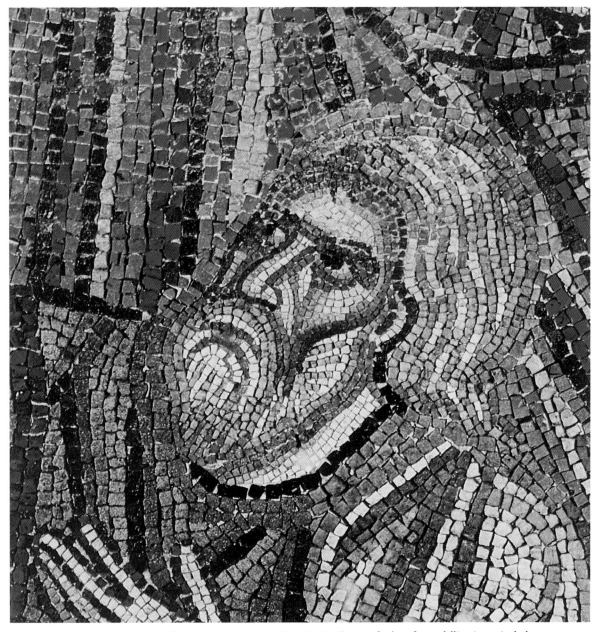

PLATES 11 and 12. Adam, from the Anastasis, Nea Moni. The use of colour for modelling is particularly apparent where Adam's head meets Eve's robe. In a colour reproduction, the distinction between the two is clearly delineated; it is far less apparent in black and white, showing how far modelling uses colour rather than outline

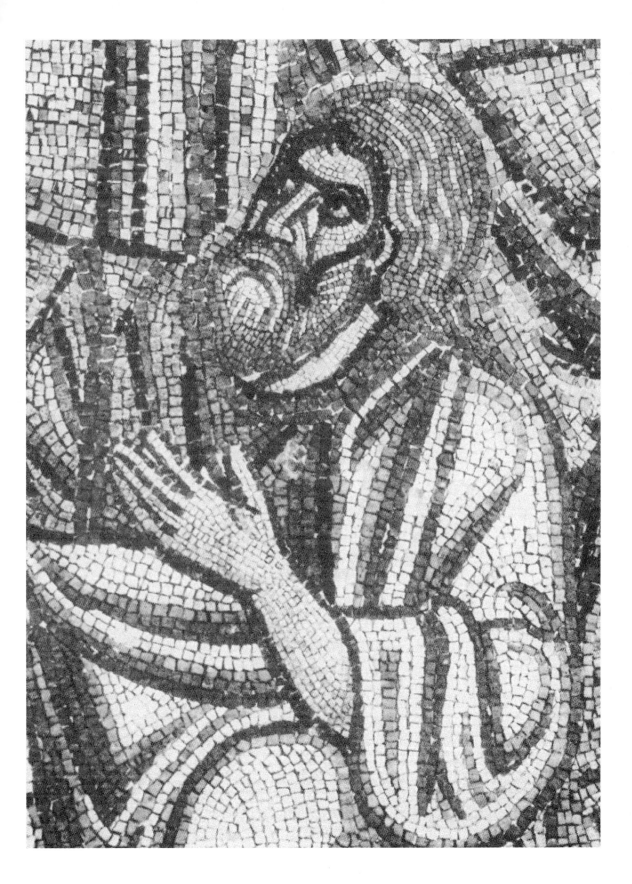

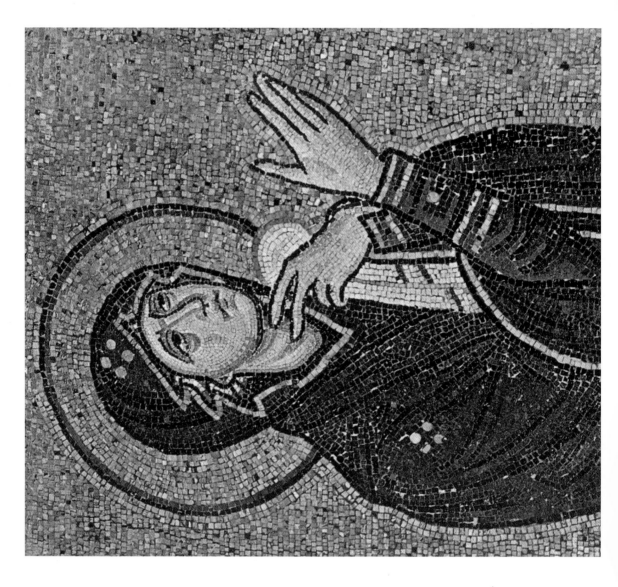

PLATE 13. The Virgin at the Crucifixion, Daphni
(c. 1100) displays the chequerboard technique of model-
ling along the right side of her jaw, with dark and light
cubes placed next to each other. In this mosaic, the use of
a very restricted range of colours serves to hold the com-
position of the picture together

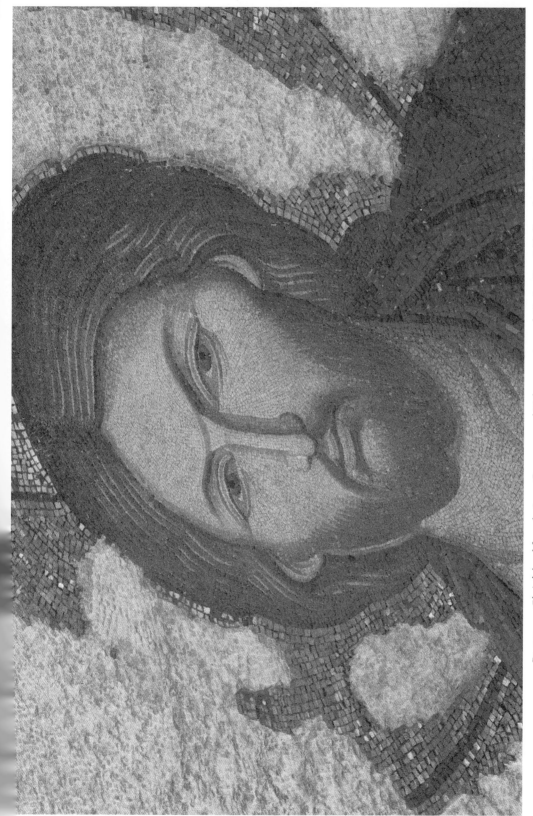

PLATE 14. Christ's head from the Isaac Comnenos and Melane mosaic panel, Kariye Camii (dedicated 1321). The chequerboard effect is even more pronounced here than in Plate 13. The viewer is unable to step back far enough to lose it because of the narrowness of the narthex in which the mosaic is positioned

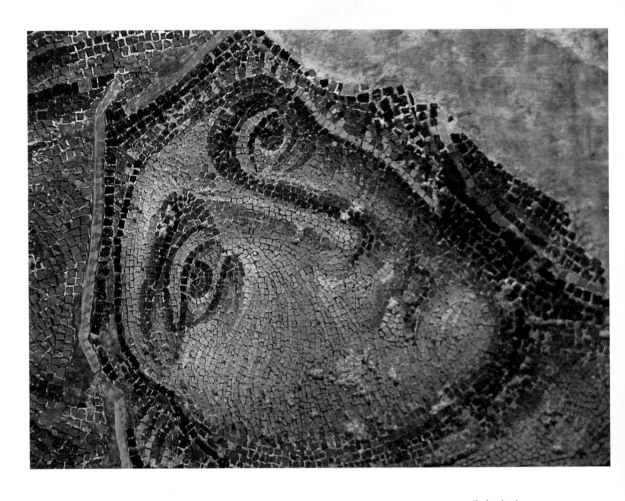

PLATE 15. A detail of the head of the Virgin from the Deesis mosaic panel, Hagia Sophia, Istanbul (after 1264), shows how tesserae are laid in a pointillistic fashion to blend colours at a distance (as Plate 16 demonstrates)

PLATE 16. The Deesis mosaic panel, Hagia Sophia, Istanbul (after 1264)

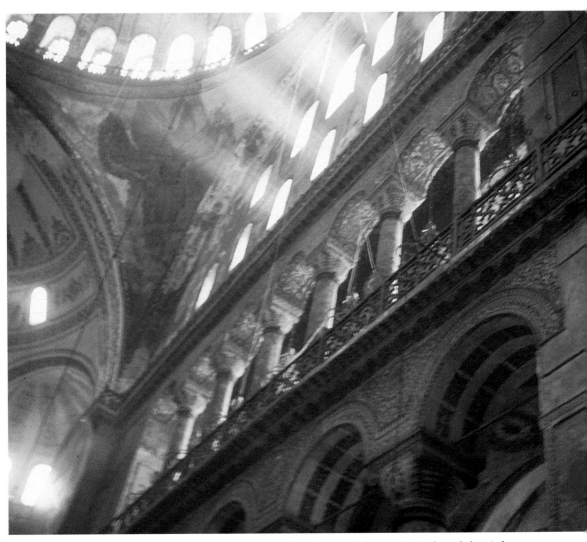

PLATE 17. Interior view of Hagia Sophia, Istanbul (built 532–7), light streaming in through the windows

PLATE 18. In this detail from the apse mosaic in the church of the Panagia Angeloktistos, Kiti (sixth/seventh century), the uneven surface of the apse is clear, particularly to the right of the inscription. The use of silver tesserae for the halo of the archangel also serves to create a spectacular light effect

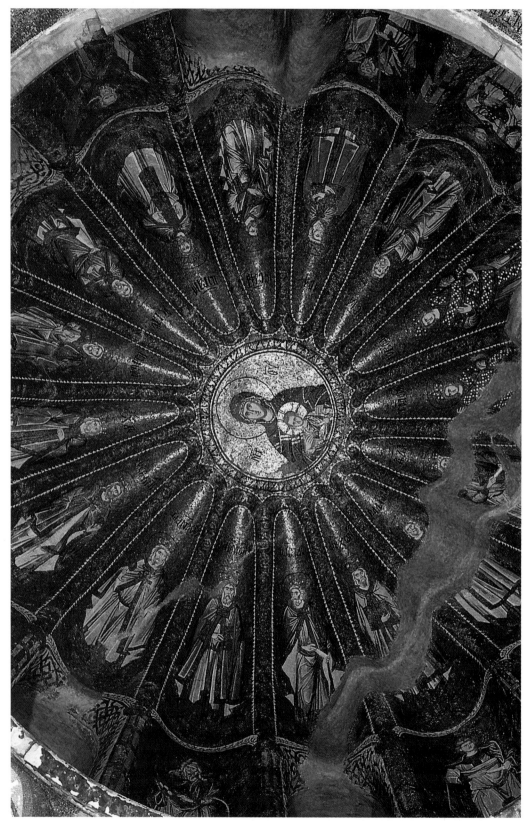

PLATE 19. Virgin, Child, and the Ancestors of Christ, north dome of the inner narthex of the Kariye Camii (dedicated 1321). The fluting of the dome helps to collect and channel light from eight windows below the rim up into the segments of the dome to the centre

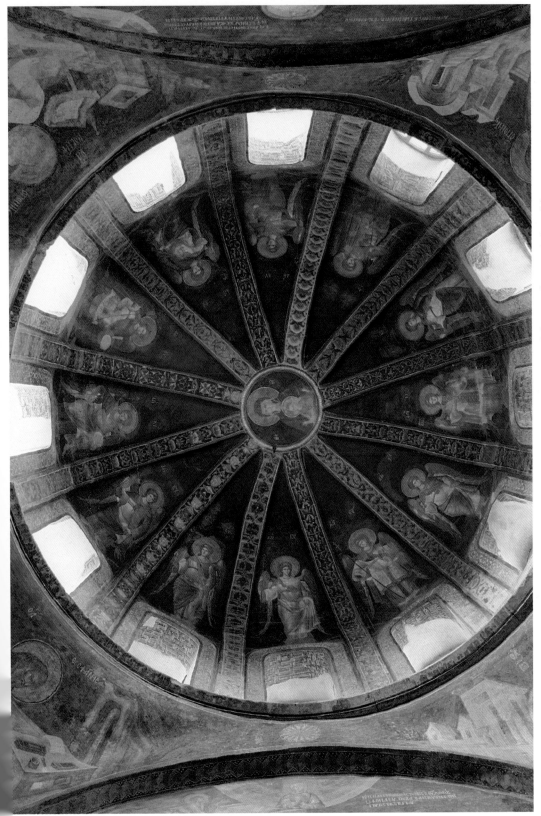

PLATE 20. Light is used differently on painted surfaces. In the painted dome in the parecclesion of the same church, the use of more windows creates the feeling of the dome standing on a circle of light, compensating for the lack of reflection

PLATE 21. Detail of the narthex mosaic panel, Hagia Sophia, Istanbul (ninth century), set above the west door and visible only when the viewer cranes the neck. This detail shows how the tesserae, particularly those in the gold background, are laid in alternate rows with gaps between

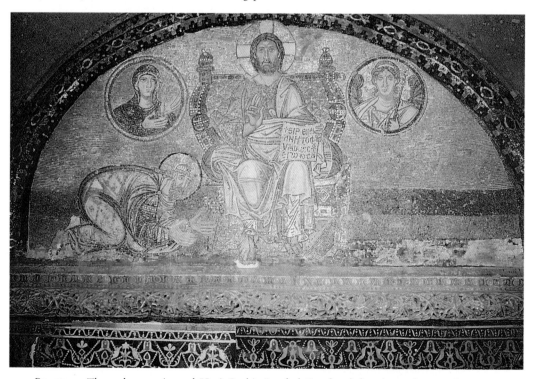

PLATE 22. The narthex mosaic panel, Hagia Sophia, Istanbul. Seen from below, the gaps between the tesserae merge into a continuous whole

PLATE 23. In the gold background of the apse mosaic of Hagia Sophia, Istanbul (dedicated 867), the silver tesserae are inserted unevenly and so shine out clearly to enhance the gleaming effect

PLATE 24. In contrast to the apse mosaic, the gold background of the Deesis mosaic panel in Hagia Sophia (perhaps after 1264) is laid in a ripple effect, almost like carpet pile. This style of background is seen in Late Antique floor mosaics and in the floor mosaics of the Great Palace. Its effect in a wall mosaic is to catch light and create a sensation of gleaming and of movement

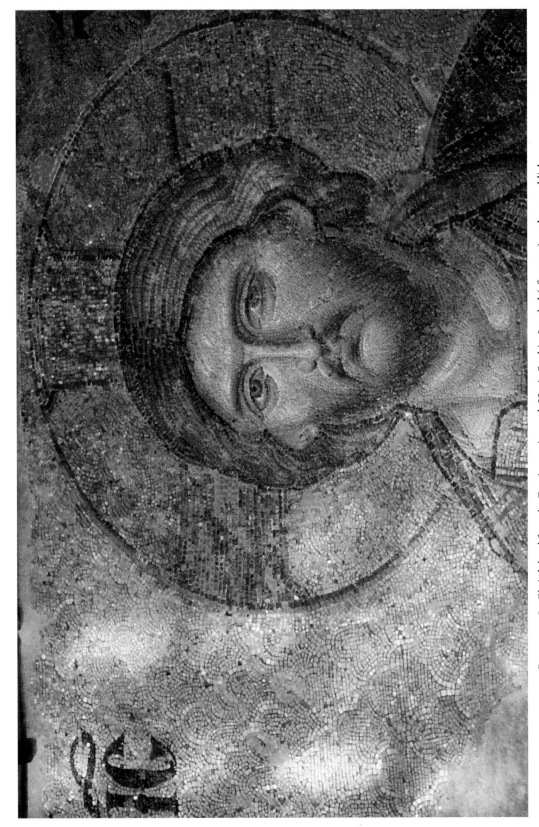

PLATE 25. In Christ's head from the Deesis mosaic panel, Hagia Sophia, Istanbul (after 1264), real external light strikes across the panel from the top left and is reflected by the mosaicist in the shadow line drawn in tesserae across Christ's neck

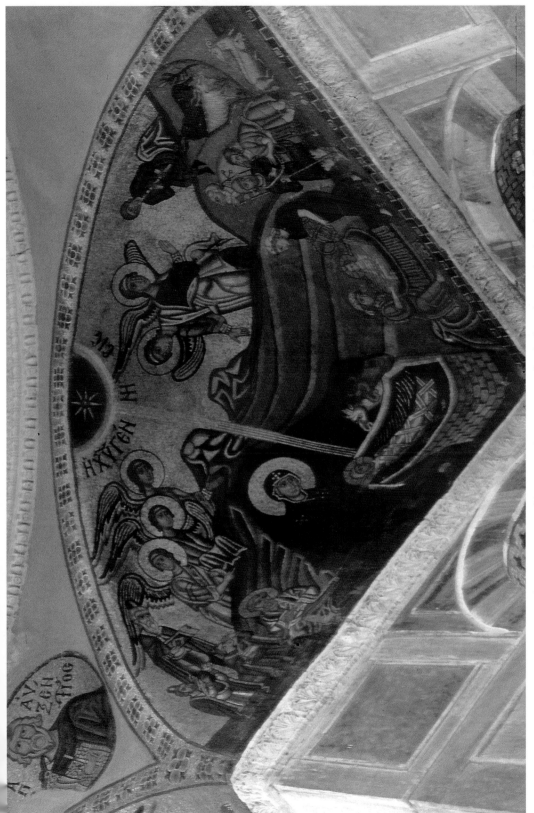

PLATE 26. In this representation of the Nativity from Hosios Loukas (early tenth century), colour chains of red and blue run round the edge of the picture, unifying the pictorial space

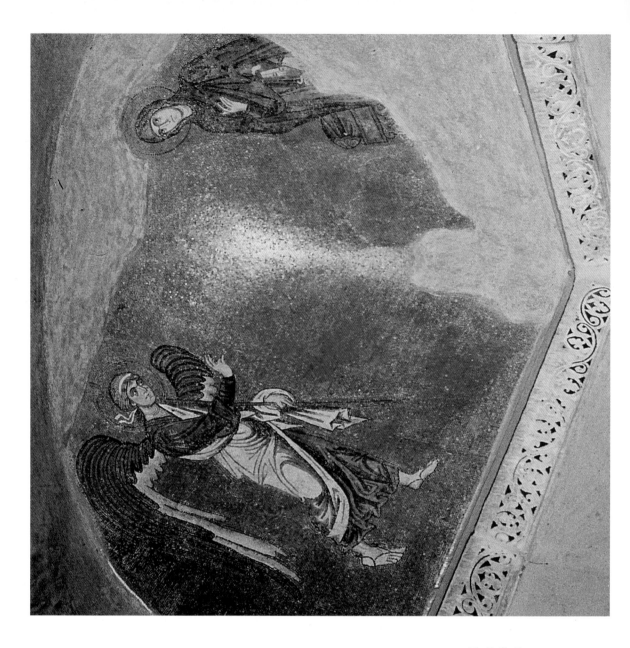

PLATE 27. The curve of the squinch and the use of gold tesserae collect external light in a pool between the Virgin and the Archangel Gabriel in the Annunciation mosaic at Daphni (c.1100)

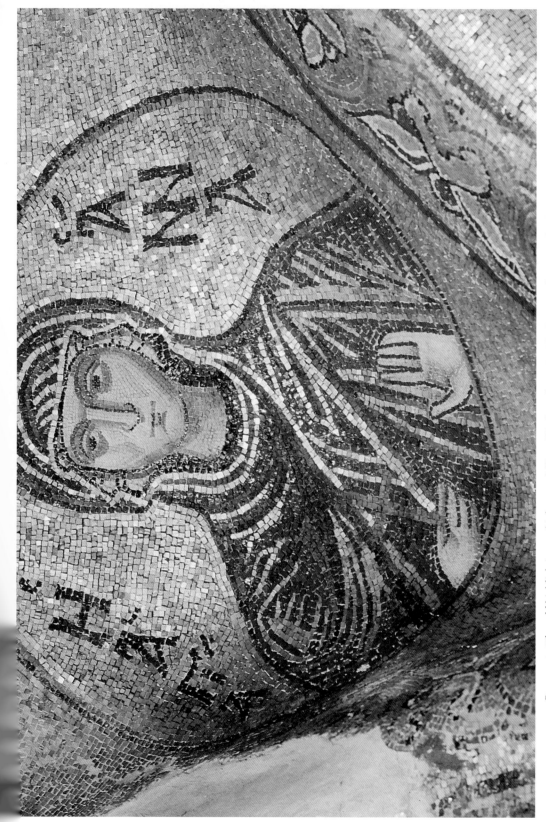

PLATE 28. The gold highlighting on this bust medallion of St Anne from Nea Moni serves to bring out details of the figure

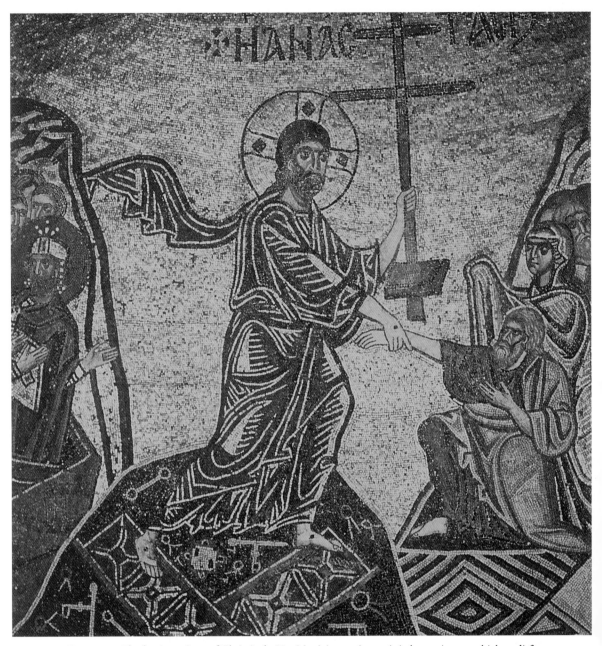

PLATE 29. The dominant figure of Christ in the Nea Moni Anastasis mosaic is thrown into even higher relief through the use of chrysography

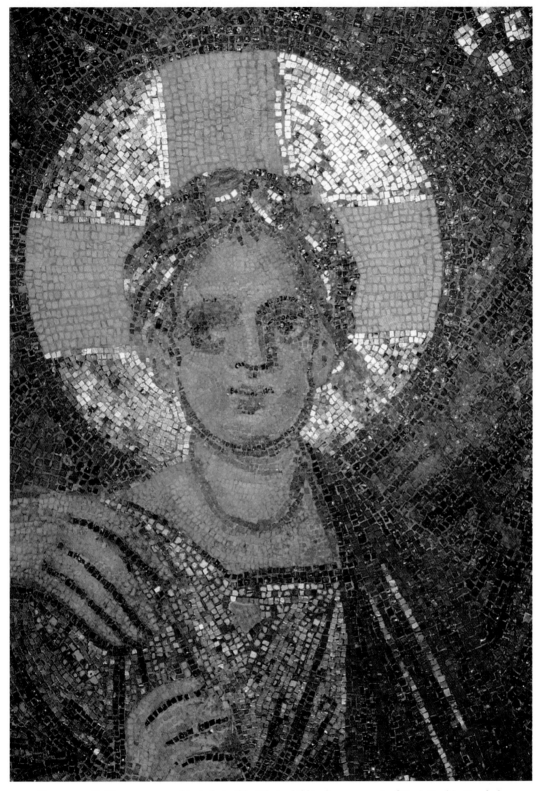

PLATE 30. Gold tesserae are used in the hair of the Christ child in the apse mosaic of Hagia Sophia, Istanbul, as a highlighting device

PLATE 31. Dirt and cleaning may affect a mosaic: John the Deacon from the apse, St Catherine's monastery, Mt. Sinai (sixth century)

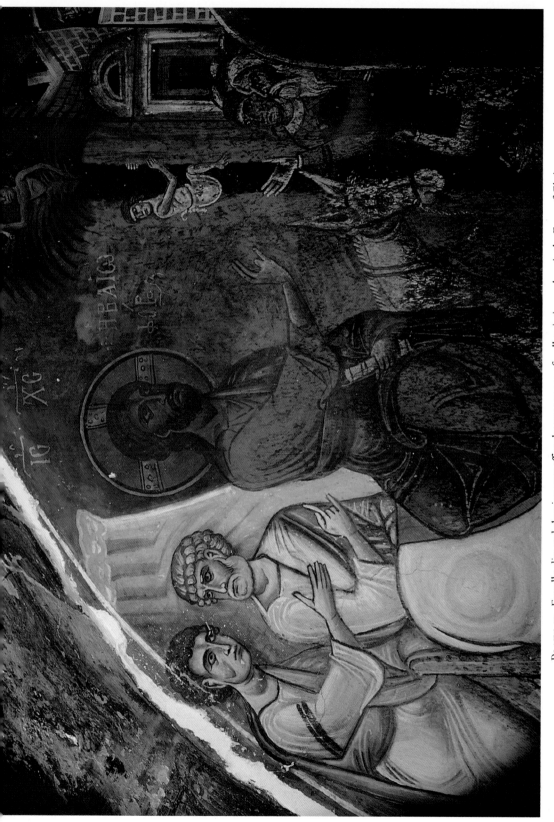

PLATE 32. Equally, dirt and cleaning may affect the appearance of wall-painting, as here in the Entry of Christ into Jerusalem, Asinou, Cyprus (1103–7)

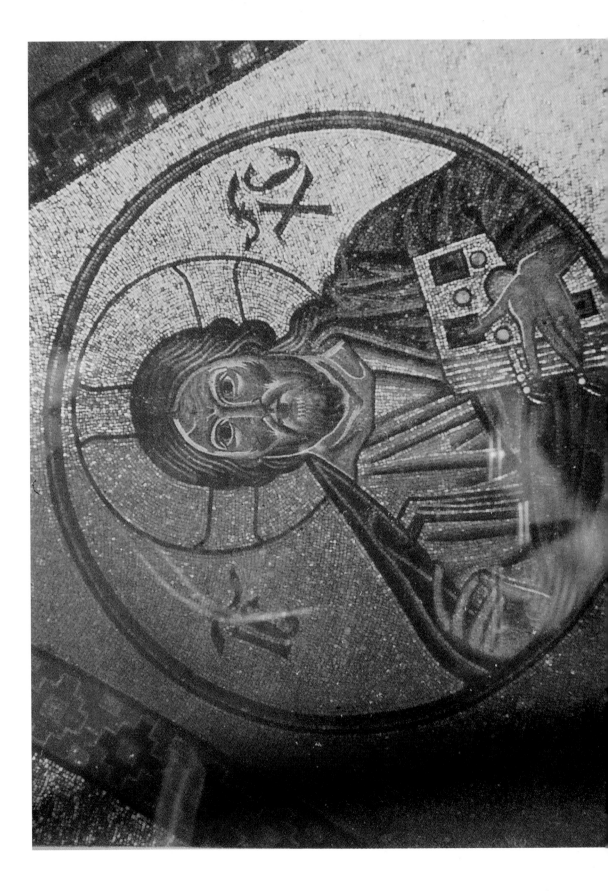

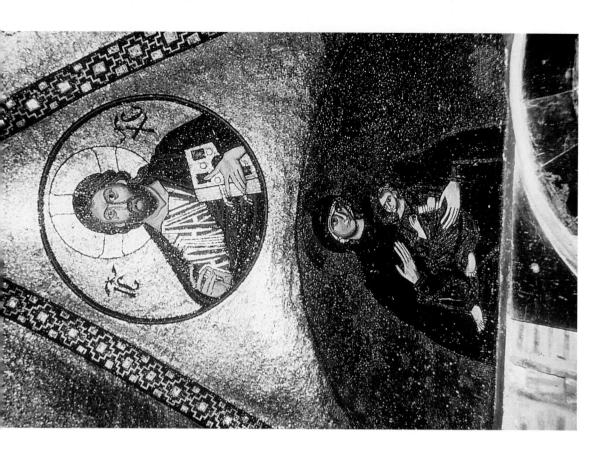

PLATES 33 and 34. Opposite, the reproduction used by Demus of the bust of Christ to illustrate 'reverse highlighting'. Hosios Loukas (early tenth century) Right, the bust of Christ at Hosios Loukas as it appears now

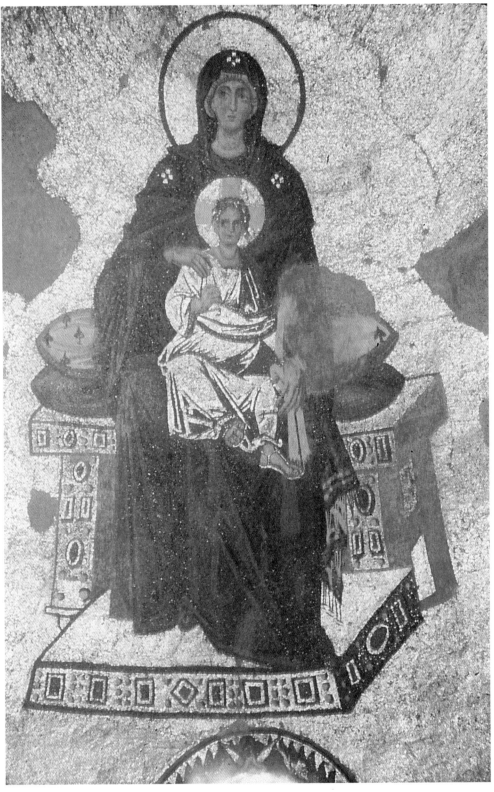

PLATES 35 and 36. The mosaic of the Virgin in the apse of Hagia Sophia, Istanbul (dedicated 867). Seen from two different angles, the colours seem to change

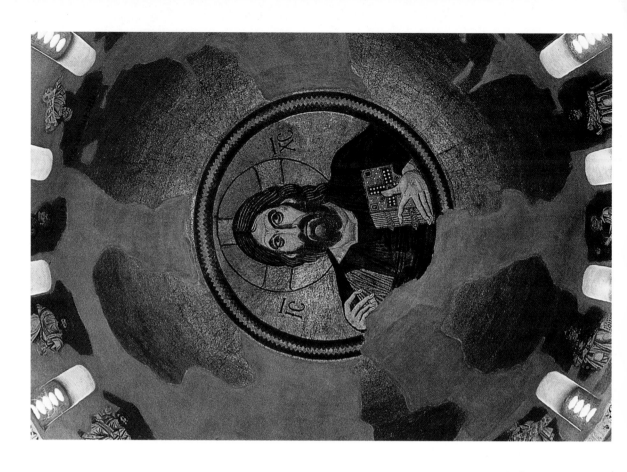

PLATE 37. The Pantocrator mosaic from Daphni, Greece (c.1100). The gold of the Gospel book is balanced by a gold patch on Christ's robe, below his right hand, a patch which has no figurative significance

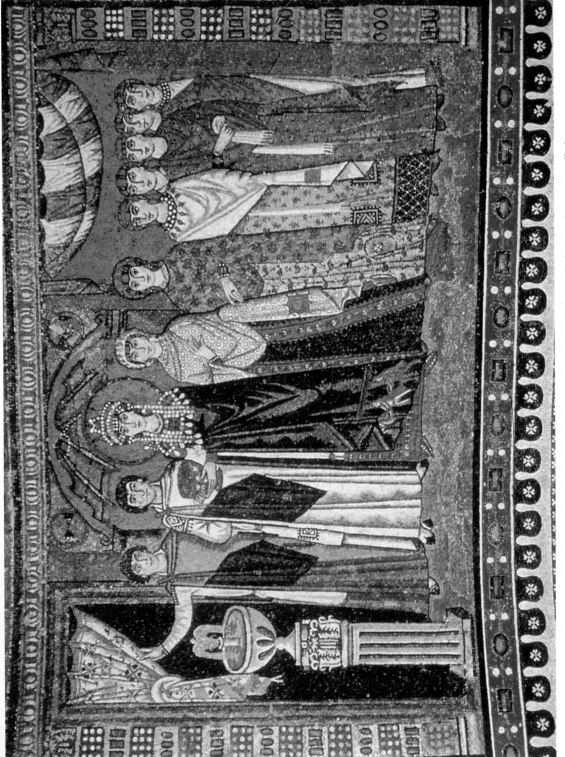

PLATE 38. Theodora and her suite, San Vitale, Ravenna (c.547). The balance of colours in the mosaic pulls the eye from right to left across the scene

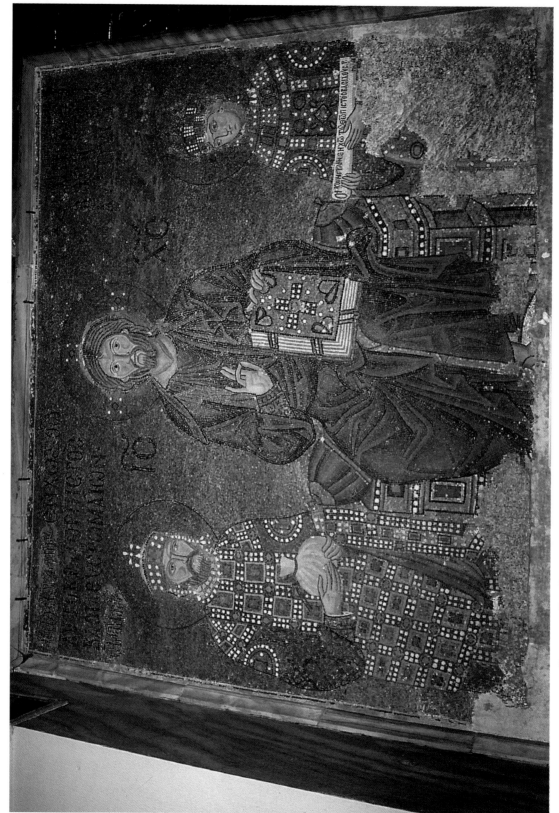

PLATE 39. Zoe, Constantine IX Monomachos, and Christ, Hagia Sophia, Istanbul (1028–42). The vivid blue of Christ's robe emphasizes his central position, whilst the use of gold and of pink and green jewellery in the imperial robes of the other two figures provides a symmetrical framing

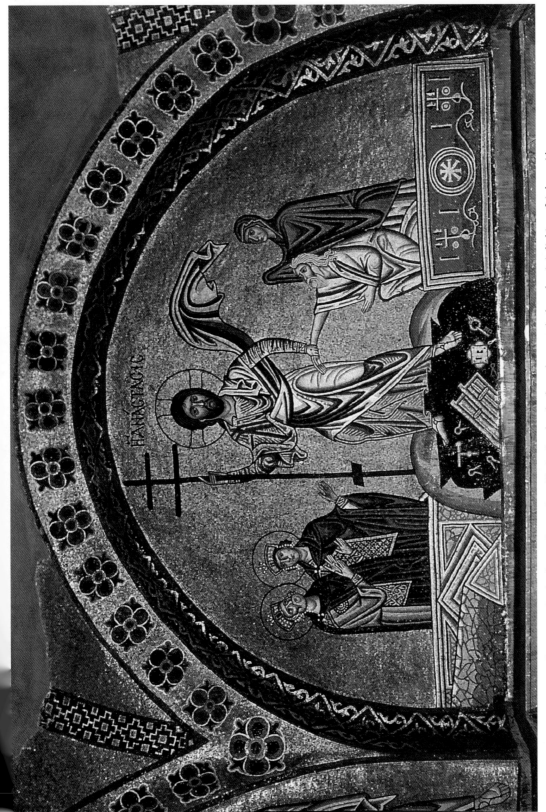

PLATE 40. In the Anastasis mosaic at Hosios Loukas (early tenth century), the colouristic linking of Adam with Christ in terms of actual hue, creates a dynamic pictorial axis (in contrast to Plate 1). Eve is linked colouristically both to Adam, who is alongside her, and across the scene to David, thus stabilizing it horizontally

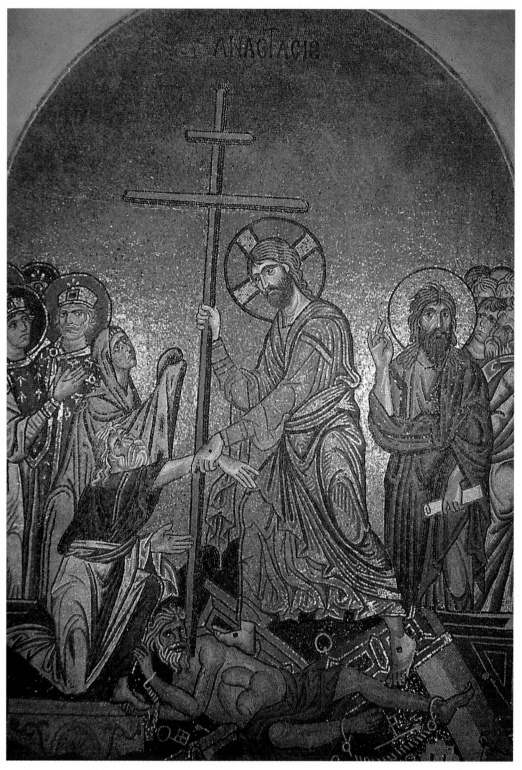

PLATE 41. In the Anastasis mosaic from Daphni (*c*.1100), the scene is again balanced on either side of Christ by the use of blue in the robes of the kings and Adam and in the robe of John the Baptist to the viewer's right. Adam's white robe causes him and Christ to form an appropriate diagonal axis of bright colours across the picture

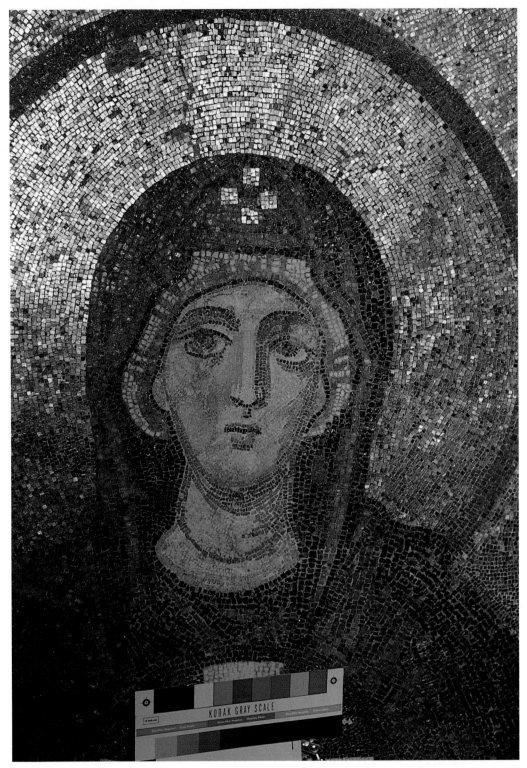

PLATE 42. This comparison between the Virgin from the apse of Hagia Sophia, Istanbul (dedicated 867), and a photographer's colour scale illustrates the problem of matching descriptions with actual colours in Byzantine art

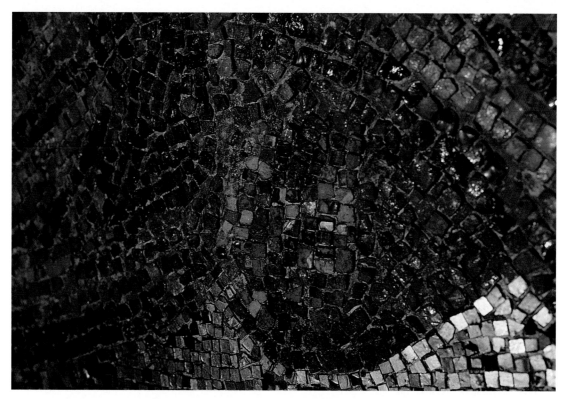

PLATES 43 and 44. In these two close-ups of tesserae from Hagia Sophia, Istanbul, Plate 43 is the Virgin's right foot and Plate 44 the archangel's left foot. In both cases, it is possible to see tesserae from which red paint has flaked off. The different materials from which the tesserae are made are employed to create different effects

PLATE 45. Coloured glass from the Pantocrator monastery (Zeyrek Camii) in Istanbul (*c.*1136). It raises the question of how far the making of such glass was influenced by the West

PLATE 46. The side of the Virgin's throne, apse mosaic, Hagia Sophia, Istanbul (dedicated 867); the use of stone along the leg of the throne creates an effect of shading and dimensionality, contrasting with the brilliant glass tesserae alongside

PLATE 47. Damage to the apse mosaic of Hagia Sophia, Istanbul (dedicated 867), showing the layers of plaster on the brickwork, the setting bed for the gold background tesserae, and the clamps used to hold the whole work together. The cushion on the throne is in the top left of the picture

PLATE 48. The seventh-century Presentation mosaic from the Kalenderhane Camii has been removed from that building. This picture shows it in cross-section, revealing the uneven surface and the layers of plaster

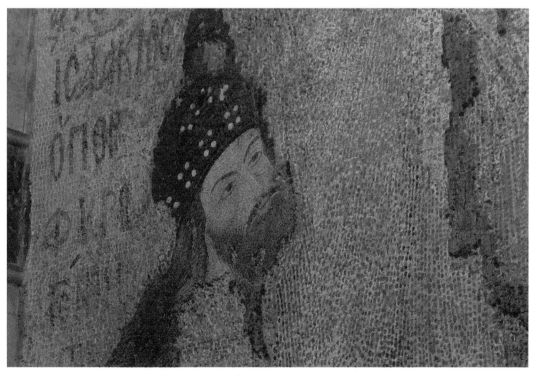

PLATE 49. Underpainting of the plaster bed of mosaics is visible in this detail of Isaac Comnenos in the Isaac Comnenos and Melane mosaic panel in the Kariye Camii (dedicated 1321)

PLATES 50–3. Underdrawings for wall-painting in various stages
PLATE 50. A sketch made directly on to a brick wall: St Peter from the Chrysostomos monastery, Cyprus (twelfth century)

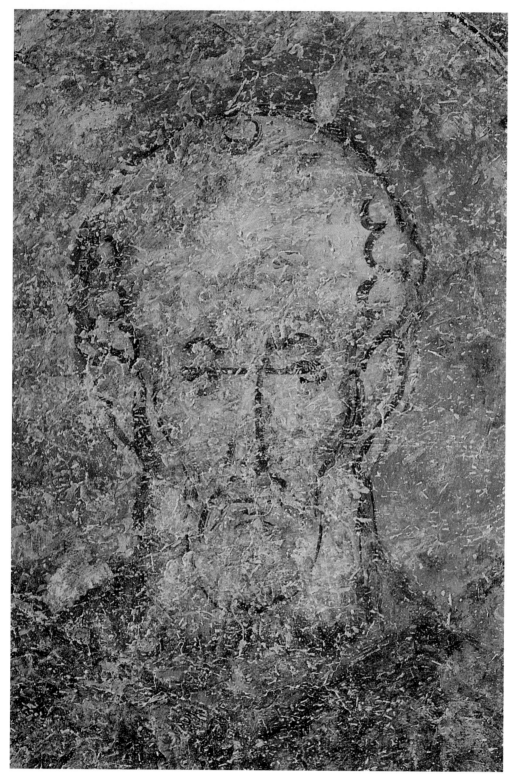

PLATE 51. A more detailed underdrawing on plaster for the head of an unidentified monastic saint from the SW pier of the SW recess of the Chrysostomos monastery

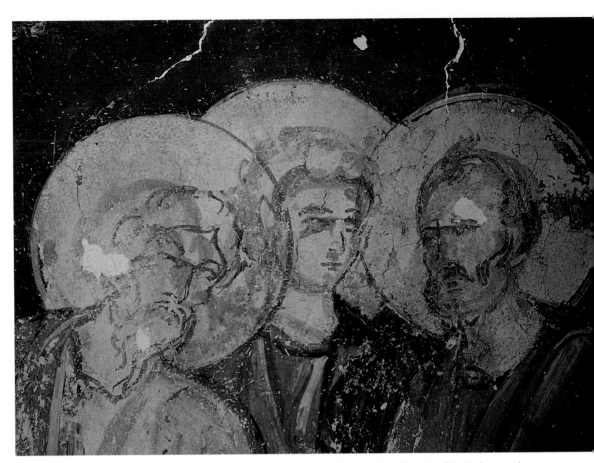

PLATE 52. Heads in monochrome, from the Communion of the Apostles, Church of the Holy Apostles, Perachorio, Cyprus (twelfth century)

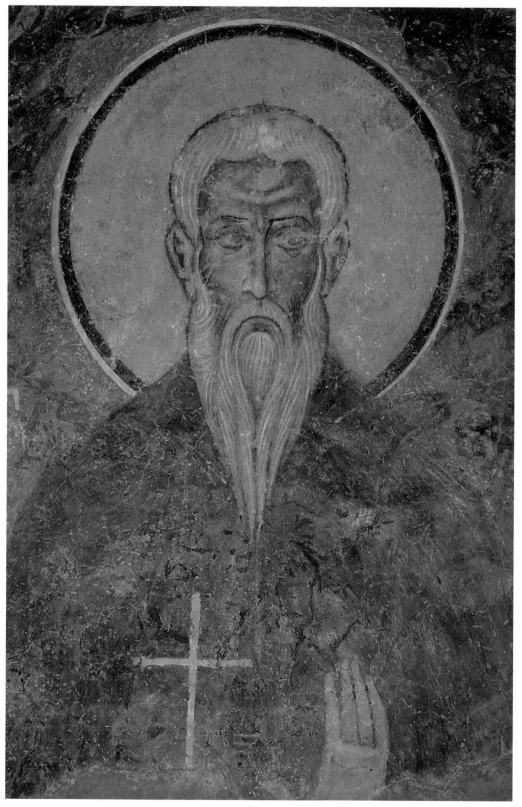

PLATE 53. The finished product: the head of St Xenophon in the NW recess, Chrysostomos monastery

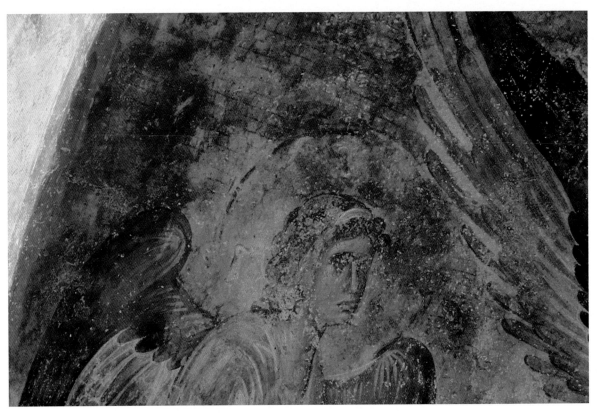

PLATE 54. This detail of the wall-painting of the Hospitality of Abraham from Sopoćani in Serbia (c.1263–70) shows the use of a gold-leaf background painted to resemble gold tesserae

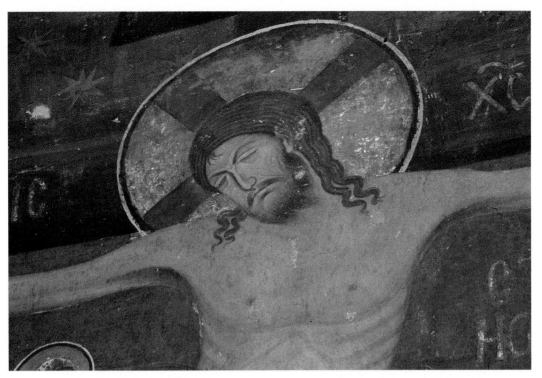

PLATE 55. Another use of gold leaf in wall-painting. Here, it is used on the haloes, the inscriptions, and on the stars in the background for added brilliance and reflection of light. It is also a statement of wealth. Crucifixion, Church of the Virgin, Studenica, Serbia (*c*.1207)

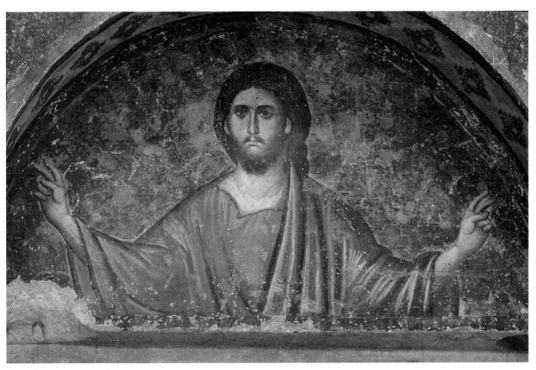

PLATE 56. In this painting of Christ above the west door at Sopoćani (*c*.1263–70), the extensive gold-leaf background has discoloured through age and the decay of the glue used to attach it to the wall

PLATE 57. A cross-section of painted plaster from the small thirteenth-century painted chapel at Baladan, Turkey, showing the different layers of plaster and paint

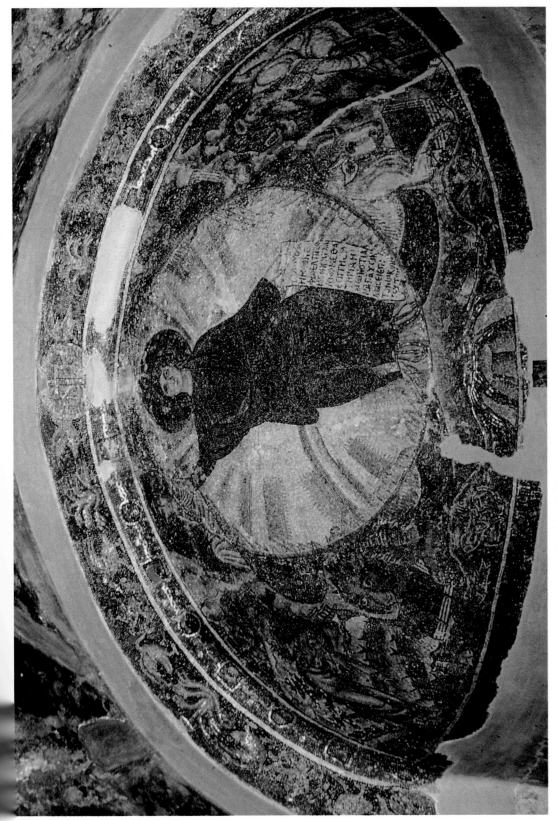

PLATES 58–61. A collection of rainbows

PLATE 58. Naturalistic rainbows: the Maiestas Domini mosaic in the apse of Hosios David, Thessaloniki

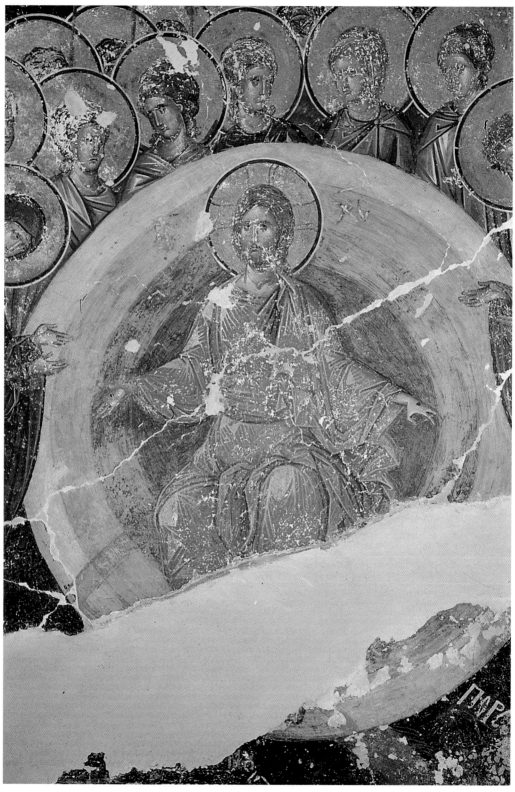

PLATE 59. Non-naturalistic rainbows: a red rainbow: Christ in Glory at the Last Judgement, from the wall-painting in the parecclesion of the Kariye Camii (dedicated 1321)

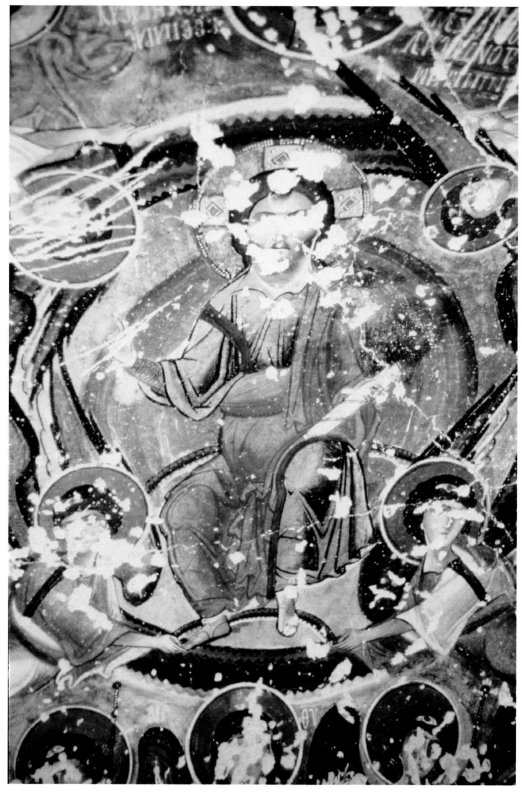

PLATE 60. A yellow rainbow: Christ in Glory, wall-painting from Chapel 23, Karanlık Kilise, Cappadocia (c.1050)

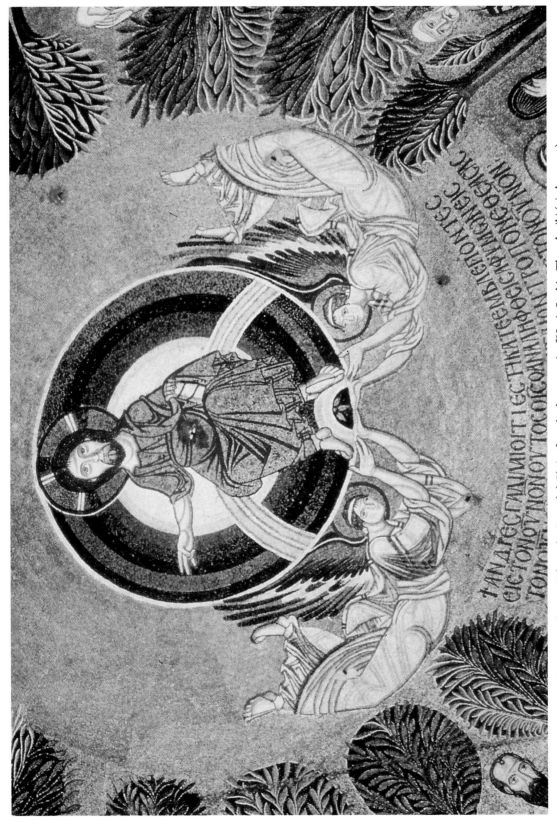

PLATE 61. A grey rainbow: the Ascended Christ, from the dome mosaic of Hagia Sophia, Thessaloniki (ninth century)

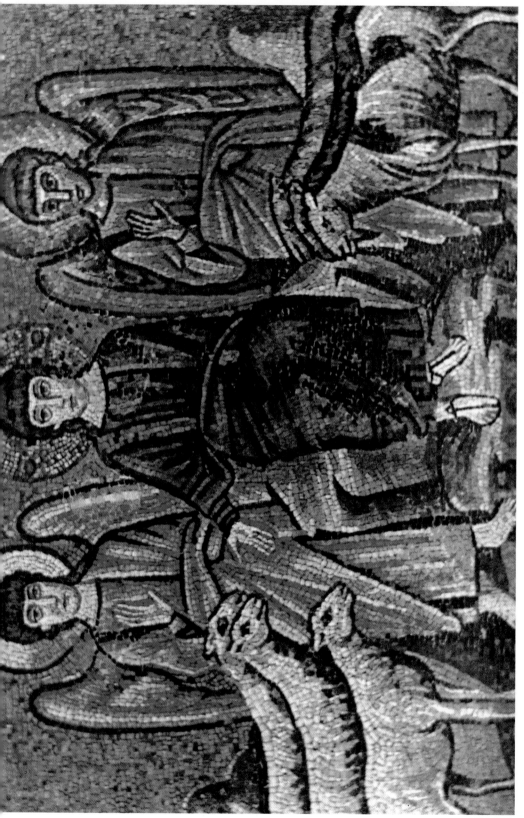

PLATE 62. Colour symbolism is contextual in Byzantine art. In this representation of the separation of the sheep from the goats from Sant' Apollinare Nuovo, Ravenna (early sixth century), the angel with the goats is coloured blue and the one with the sheep red

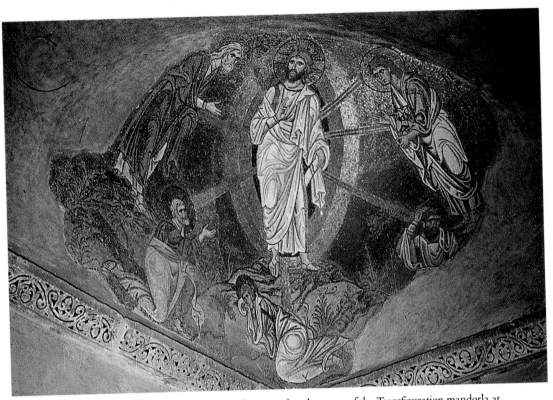

PLATE 63. The 'divine darkness' of God portrayed as the centre of the Transfiguration mandorla at Daphni (c.1100)

PLATE 64. Ernest Hawkins at work in the Kariye Camii

nor too broad, her eyebrows were not too arched or too long; nor did they meet in the middle, but were divided by the width of her nose. They were made very black by the whiteness of her forehead. Her eyes shone like stars—much emphasis is laid on this characteristic. They were almond shaped and guarded by her eyelids. The black iris and the white of the eye brought out the unmixed beauty of the two colours. Her nose was slender and straight, a boundary between her cheeks, her mouth was red, but not too red, and her teeth were like pearls or a row of crystal. The white and red formed a polychrome harmony. Her cheeks were round and white with red, like roses, in the middle, and her hair, yellow (ξανθός) and gold in colour, shone.

This description of Styliane is, in essence, a stylized, extended version of the description of Zoe. All the features of both are visible in the imperial panel, with the exception of the Empress's hair, which has been lost in the alterations to the face. Zoe has arched, defined black brows, separated by a line indicating the width of the nose. The irises of her eyes are black on a white background and the eyelids are accentuated. Her skin is white and her cheeks rounded with red centres, whilst her mouth is also red. However, the descriptions of both Zoe and Styliane cited above indicate that much of this representation belongs to convention rather than necessarily reflecting reality. Zoe's face shows the 'correct' physical characteristics for beauty. Certainly the colours used in description and in works of art alike reflect the same qualities and conventions. Portraits of people in literature and in art seem concerned with the same aspects: the eyes, the clear definition of physiognomy, geometric precision.

In his account of the joint reign of Zoe and Constantine IX Monomachos, Psellos retells a significant story about colour and art. The empress, a pious woman, had an image of Christ made, embellished with bright metal, which appeared to be almost living.[65] This image was known as the Antiphonetes. She prophesied the future from it and got into the habit of asking it questions and favours. If it turned ὠχριακῶς then she would go away disappointed but if it went πυρρακίζων with its halo 'lustrous with a beautiful radiant light', then she would tell the emperor and prophesy the future.

This seems to be a very clear use of a specific colour word in a sense beyond that of hue. Ὠχρός is translated 'yellow' but its essential meaning is 'pale' with particular emphasis on 'pallid' and 'wan', in contrast to χλωρός which is pale in the sense of 'young' and 'fresh'. It is frequently used in negative contexts as a colour term in Byzantium. It is the colour of Judas' complexion in Constantine Rhodios' account of the Betrayal mosaic in the church of the Holy Apostles.[66] This negative aspect, with the

[65] *Chronographia*, VI 66–7, entitled Περὶ τοῦ Ἀντιφωνητοῦ.

[66] Constantine Rhodios, *Description des œuvres d'art et de l'église des saints apôtres à Constantinople*, ed. E. Legrand (Paris, 1896), line 891.

emphasis on pallor, rather than yellow, seems to be the implication of ὠχρός with regard to the Antiphonetes image. Πυρρός, on the other hand, tends to be employed as a positive term, conveying 'fire' and 'flame', again not a hue as such, but a quality. The Antiphonetes image, when πυρρός, shines splendidly. Fire is a spiritual element discussed at some length by Pseudo-Dionysius.[67] In Psellos' *De Operatione Daemonibus*,[68] air spirits are white and fire, indicating purity and life. The two words are not simply used in the context of 'yellow' and 'red' but rather 'pale' and 'fiery'. Further, these two definitions are underlain by other, symbolic concepts. But it should be stressed that this symbolic 'meaning' is not a fixed, unchanging meaning. In this instance, ὠχρός carries a negative significance and χλωρός a positive one; there are other cases where ὠχρός is used in a positive sense, in, for example, Manuel Philes' epigram on John Chrysostom.[69]

The colour change of the Antiphonetes image reflects a change in its meaning. This is made obvious by Zoe's reaction, and more subtly indicated by the actual colours involved in the change.[70]

The term 'Antiphonetes' has been interpreted in various ways. Though it might be expected that the word means something like 'speaking image', Mango translates it as 'guarantor', a legal term, which he explains through the legend about the image given in a letter, allegedly from Pope Gregory II, concerning the Chalke Gate image of Christ.[71] Mango manages to identify this image as the image of the Chalkoprateia, the Antiphonetes.

However, the iconography of the image gives no real clue to its meaning.[72] Despite the arguments of Mango, I think it can be proposed, at least in the case of Zoe's image, that 'speaking image' is a more plausible rendition of the term, and that this is supported by an awareness of the meaning behind the colour terms. It is the change in

[67] See below, Ch. 7.

[68] *PG* 122, 818–75. K. Svoboda, *La Démonologie de Michel Psellos* (Brno, 1927). It has been suggested that this work is not actually by Psellos; see A. Kazhdan and A. W. Epstein, *Change in Byzantine Culture in the Eleventh and Twelfth Centuries* (Berkeley, Los Angeles, and London, 1985), 138.

[69] Manuel Philes, *Carmina*, ed. E. Miller (Paris, 1855), i. 34, no. 73.

[70] This concept will be explained and supported more fully in Ch. 7.

[71] This story is essentially that Theodore the merchant took the image of Christ at the Tetrastyle as his surety on two ventures; the image worked miracles for him (C. Mango, *The Brazen House* (Copenhagen, 1959), 142–8).

[72] Mango cites the figure of Christ Antiphonetes from Nicaea, a full-length figure in gold and blue tunic, holding a closed Gospel book in the left hand and blessing with the right, which he dates to between 1025 and 1028, though he would like it to be forty years later and inspired by Zoe's image. He also mentions a 14th- or 15th-cent. fresco on the south-east pier of the nave of St Demetrius, Thessaloniki, showing Christ seated on a throne with an open Gospel book in his left hand (*Brazen House*, 146–8). Other Antiphonetes images include a fresco in the church of the Panagia tou Arakou, Lagoudera, Cyprus, a 14th-cent. steatite icon now in Padua Cathedral treasury (I. Kalavrezou-Maxeiner, *Byzantine Icons in Steatite* (Vienna, 1985), 210, no. 135), and some undated copper coins which Philip Grierson suggested may be dated to Zoe's reign and may represent the Antiphonetes (Seminar at the Institute of Classical Studies, London, 1988). On the iconography of Christ Antiphonetes, see A. Kazhdan and H. Maguire, 'Byzantine Hagiographical Texts as Sources on Art', *DOP* 45 (1991), 15–16 and plates 23–31.

colour that speaks to Zoe and which indicates the nature of the message of the icon. The icon itself is not a guarantor, though it does respond; in this example, the colour conveys the meaning or message of the image. Colour acts as an indicator; the image speaks through its colour.

This concern with the symbolic 'meaning' of colour is apparent elsewhere in Psellos' writings, and indicates a definite perception of the nature and role of colour. In his alchemical works, colour acts as an indicator of substance in the making of precious stones and, of course, gold. He shows an interest in Aristotle's theory of the four elements and provides a version of the *iosis* process.[73] The emphasis, he is at pains to make clear, lies on getting the metal to the correct colour—ξανθός is an indicator of gold, a process he calls accurately ξάνθωσις. Elsewhere he says that the only quality of gold that copper has is the colour, for gold is without mixture and shines with a brilliant light.[74]

Throughout the *Chronographia*, references to colour are used sparingly but in a way we would consider natural—descriptions of people, art works, notably buildings, and objects. But the primary consideration is not automatically hue and much emphasis is placed on the use of colour words to convey aspects of brightness. In this respect, colour terms are sometimes employed to convey symbolic aspects. Psellos' description of the nature of colour is essentially Classical, deriving from Plato, and much of his colour use is similar to that of the Classical period, in terminology, description, and metaphor.

Colour in Digenes Akrites

Digenes Akrites,[75] in contrast, is an epic poem consisting of a narrative cycle of some 3,000–4,000 lines describing the parentage, education, exploits, marriage, and death of its eponymous hero. Five metrical versions of the poem exist, together with one prose and one Russian text. In addition, the so-called 'Akritic cycle' of ballads contribute further details about the hero.

The poem is a romance. It is set on the Euphrates frontier in a time of peace. There

[73] For Psellos' alchemical texts see *Catalogue des manuscrits alchimiques grecs*, vi. *Michel Psellos*, ed. J. Bidez (Brussels, 1928), especially the *Épître de Psellos à Cerulaire sur la chrysopée*, esp. sects. 9–12, pp. 36–9.

[74] *Reproche à Cerulaire d'avoir faire de l'alchimie*, lxvi, in *Catalogue*, ed. Bidez, vi. 76–81. There has been much debate as to how much Psellos really knew about alchemy and whether he had knowledge beyond that of a few phrases culled from the theory and practice of the ancients. His writings suggest that whilst it is probable that he never worked in a laboratory himself, there is no reason to believe that he did not

have a clear awareness of the aims and methods employed.

[75] The version I am using is *Digenes Akrites*, ed. and trans. J. Mavrogordato (London, 1956) which is based extensively on the Grottaferrata text with additions from the other sources. It seemed unnecessary to deal with the textual complexities for the purposes of this study. I have followed Mavrogordato's consecutive numbering of lines within the edition as a whole. D. Ricks, *Byzantine Heroic Poetry* (Bristol and New York, 1990), is a bilingual edition of the Escorial *Digenes Akrites*, a version which survives as a late 15th-cent. manuscript. The range of colour terms is virtually identical.

are no obvious historic personages; the emperor Basil seems a mythologized version of Basil II, there are hints of the Paulician rebellion and a background of Arab raids. Arab and Byzantine seem to coexist on good terms, however. Digenes himself is a fusion of Christian and Moslem and the Arabs are only once presented as villains; the whole tone of the poem shows a lack of fanaticism and political concern.[76] Like the *Iliad*, it is a composite piece, a rewriting of different facts and aspects not necessarily related in time and place. Digenes' exploits are also vague but the poem provides details of his everyday life. Details are convincing and it is possible to build up from them a picture of life for a Byzantine magnate on the frontier in the tenth/eleventh centuries. It is not a history. The poem deals exclusively with rural life. Cities are seldom mentioned, no one goes to Constantinople (which plays no part in the narrative), geography is vague. Digenes himself is essentially a symbolic hero acting within a symbolic setting, a composite fictional prototype whose skills, interests, attributes, and concerns are those of the rural Byzantine nobility.[77]

The several versions of the poem tell the same story, but with variations in length, style, and language. Two, according to Beaton, appear to be the direct witnesses of the original poem, though how closely either approximated to the original is unknown.[78] Of these two, the Grottaferrata edition, which is the one discussed here, may be the earliest. This text provides a simple, clear narrative. As far as can be told through the rewriting, the language is that of the *koine* or even vernacular in basic style, using several words that are not in standard dictionaries or which are derived from other languages. However, some pretensions to a literary education are apparent, notably in the frequent allusions to Achilles Tatius and Heliodorus, and in an acquaintance with rhetorical literature, though expressed in a non-Atticizing manner.[79] The author's knowledge of past history is restricted to biblical heroes and to Alexander the Great as popular hero. Beaton's conclusion is that *Digenes* was written in Constantinople by a moderately educated individual working within a generation of the defeat at Manzikert in 1071.[80] The author's overriding purpose was to preserve something of the heroic frontier days through linking them with the literary precedents of Homer and the Hellenistic narratives, whilst at the same time writing the earliest work whose language could be described as Modern Greek.

[76] Shown in the essays of Gregoire, typified by the collection of articles in H. Gregoire, *Autour de l'épopée byzantine* (London, 1975).

[77] C. Galatariotou, 'Structural Opposition in the Grottaferrata *Digenes Akrites*', *BMGS* 11 (1987), 29–68; H. F. Graham, '*Digenes Akrites* as a Source for Frontier History', *Actes du XIVe congrès international des études byzantines, Bucharest 1971* (Bucharest, 1975), 321–9.

[78] R. Beaton, *The Medieval Greek Romance* (Cambridge, 1989), 29.

[79] See Browning, 'The Language of Byzantine Literature'.

[80] Beaton, *Medieval Greek Romance*, 46. See also R. Beaton, 'Was *Digenes Akrites* an Oral Poem?', *BMGS* 7 (1981), 7–28, and '*Digenes Akrites* and Modern Greek Folk Song: A Reassessment', *Byzantion*, 51 (1981), 22–43.

As in Psellos, so in *Digenes*, colour is most frequently employed in descriptions of clothing. Here, however, a wider range of colours is employed. In the fight between the Amazon Maximo and Digenes, she wears a yellow silk (ὁλόσηρον καστόριν)[81] tabard and a green (πράσινος) turban sprinkled with gold.[82] He has a scarlet (κόκκινος) cap and a blue (βένετος) spear, and his horse is δαγάλον—perhaps 'chestnut'.[83] The Amazon's horse is black (μαυρός). Other garments include the gold-sprinkled violet (ὄξεος) and deep purple-white (λευκοτρίβλαττος) tabard of the Arab Emir, a very rich garment, and Digenes' scarlet (κόκκινος) singlet adorned with gold and precious stones.[84]

Descriptions of people in both texts follow the same conventions, but adapt them to the particular requirements of the piece. Again, virtue is fair. Digenes and his wife are both fair skinned and blond, and his father, the Emir, an Arab, is also blond (ξανθός). In this last case, pains are taken to explain that the Emir is not black (μέλας) as the Ethiopians are.[85] This use of fairness in both Psellos and *Digenes* and its contrast with Classical conventions, suggests a new standard Byzantine convention of beauty. Digenes himself, however, is given the best of both worlds. He is white skinned and ruddy of face, but, despite his hair, his brows are dark black (κατάμαυρος).[86]

Digenes places much emphasis on the concept of gleaming objects, brilliance, and shine. Going into battle, the hero and his armaments gleam and glitter, Digenes 'flashes like the sun'. Digenes' wife has a face like snow which is coloured πορφύρεος. She is called 'sun-beautiful' (ἡλιόκαλος) and a variety of other epithets are used, containing the word sun. She 'shines with light'.[87]

The flashing qualities of colour are also made apparent in two major descriptive passages. In the invocation to May, emphasis lies on the gleaming effect of nature and the reflection of colours:

> Circling their wings the peacocks in the flowers
> Flashed back the hue of flowers in their wings
>
> (VI 2486–7)[88]

Here the author puns on ἄνθος, meaning both 'flower' and 'colour'.

This interest in dazzling the spectator is found again in the account of Digenes' palace, a 'dwelling bright and marvellous'. The description is in two parts, concerning

[81] This is Mavrogordato's tentative translation. He notes that all that is really known of the meaning of καστόριν is the *Souda*'s 'a sort of colour', *Digenes Akrites*, ed. Mavrogordato, 207, note to lines 3197–8.

[82] *Digenes*, VI 3197–8.

[83] As translated by Mavrogordato (VI 3177–80).

[84] *Digenes*, IV 1201.

[85] Ibid. I 33.

[86] Ibid. IV 1178.

[87] Ibid. VI 2490–7.

[88]
> οἱ ταῶνες τὰς πτέρυγας κυκλοῦντες
> εἰς τὰ ἄνθη,
> ἀντέλαμπον τῇ τῶν ἀνθῶν ἐν ταῖς
> πτέρυξι χρόᾳ

the garden and the palace respectively.[89] The flowers of the garden are described in colour terms: deep purple (πορφυρόβαφος) and milky (γάλακτος), but they also flash and gleam.[90] The palace is bright and the marbles glistening (ἀστράπτος). They shine and throw gleams of light. The mosaics are gold.

Parallels can be drawn between the description of the palace and garden and the invocation to May, and Achilles Tatius' description of a garden in *Leucippe and Clitophon*.[91] Links with Longus' *Daphnis and Chloe* and Meliteniotes' allegorical poem, Τὸ Σοφρυσυνή are also apparent. This is not surprising: the Greek novels were popular in Byzantium—Tatius, for example, is mentioned in the *Souda* and by Thomas Magister.[92] However, the descriptions in *Digenes* are not by any means a simple copy. The Greek novels tend to use colour sparingly for descriptions of people (the conventional white for skin, yellow for hair, and black for eyebrows), clothing, and occasionally in descriptions of nature. Rather than use a specific colour word, the preference, particularly in Achilles Tatius, is for comparative phrases ('as dark as a negro's skin' or the 'flower of beauty' in the eyes of a painted Andromeda is comparable to a violet).[93] *Digenes* employs actual colour terms more frequently.

In *Digenes*, colour is emphasized very much in terms of gleam and its flashing qualities. The hues described are bright and unsaturated. Colours are used to create an impression of richness, hence the frequent use of gold and πορφύρεος. Characters are dressed lavishly to underline their importance—only heroic characters are so described, including Digenes' only 'worthy' enemy, Maximo. There is a remarkable similarity in the appearances of the heroes, doubtless according to literary convention, and Digenes and his wife are both described in a very similar fashion. Weapons, horses, and armaments, the important things in life, are all given colour descriptions. The grandeur of Digenes' palace is emphasized through its description in terms of gold and glitter.

The colour vocabulary of the poem reflects its dual nature. Alongside Classical terms such as ξανθός and ὠχρός and the Classical description of people, are terms like λευκοτρίβλαττος and βένετος which are essentially non-Attic, Late Antique, or Byzantine technical terms. Λευκοτρίβλαττος appears in the *Book of the Eparch*[94] in defining types of silk cloth, cloth which is either scarlet or purple.[95] Τρίβλαττος

[89] *Digenes*, VII 3309–410.

[90] Ibid. VII 3334–6.

[91] *Leucippe and Clitophon*, I 15. For example, in comparison with the two lines of *Digenes* quoted above, Tatius writes 'between the brilliance of the flowers and the hues of the peacocks, whose plumage seemed itself to consist of very flowers': ἀντέλαμπε δὲ ἡ τῶν ἀνθέων θέα τῇ τῶν ὀρνίθων χροιᾷ καὶ ἦν ἄνθη πτερῶν.

[92] T. Hägg, *The Novel in Antiquity* (Oxford, 1983) details

the survival of Greek novels in Byzantium. Psellos himself said that even highly educated people debated as to whether Achilles Tatius or Heliodoros was the better author.

[93] *Leucippe and Clitophon*, IV 5 and III 7 respectively.

[94] *The Book of the Eparch*, trans. E. H. Freshfield (London, 1970), part IV, 236–8, on silk merchants. The book is dated to *c*.895.

[95] These are the definitions in the lexica of Du Cange and Kriaras.

technically means 'three times dyed', by which a richer colour was obtained.[96] Βλαττίον originally meant purple, but came to be applied to any precious textile. It comes from the Latin *blatta*, a clot of blood or a moth. Βένετος is also a late word. No self-respecting Atticizing writer would use it except for describing the Blue circus faction.[97] It is perhaps derived from the Latin *venetum*, though the origin of the names of the factions is unknown. Malalas says it is so-called after the province Venetia, subject to Rome, from where blue dye was obtained.[98] Either way, it is an indication of the literary level of *Digenes*. The terms καστόριν and δαγάλον are even closer to the vernacular. Mavrogordato translates the latter 'chestnut', but admits to uncertainty and an inability to find the word anywhere else.[99] As for καστόριν, the *Souda* notes it as 'a kind of colour' and no scholar has been able to be any more precise.

Where Psellos uses λευκός and μέλας, *Digenes* while not abandoning these employs, apparently interchangeably, ἄσπρος and μαυρός, both of which are the primary Modern Greek terms for these colours, suggesting a Byzantine vernacular origin for these. Neither is a Classical term.[100]

The Classical elements of the poem are further apparent in comparisons with earlier epics. The same concerns with glitter and gleam are reflected in works from Homer to the *Argonautica* of Apollonius Rhodius and Nonnus' *Dionysiaca*. Although the palace of Digenes is comparable with those of the Classical novel, this sort of description with its emphases on gleam and precious metals is also essentially an epic convention.[101] Descriptions of people derive from similar conventions in the colours regarded as most fitting and beautiful. So, although *Digenes* is not a high literary piece, many of the conventions of literary colour use are apparent. This may be because the author had a greater knowledge of literature than is generally allowed for; equally, the oral elements surviving in Greek epic poetry may have been overlooked. It is most probable that these similarities exist because this was the way that 'everyone' described their heroes, a universal topos of literary and oral culture. This universality suggests not a common, unthinking, banal expression, but a means of description perceptually valid enough to have become a commonplace: because a certain expression is a topos, this does not render it a false aspect of perception.

[96] R. Pfister, 'Teinture et alchimie dans l'Orient hellénistique', *SemKond* 7 (1935), 48, calculates that 12,000 murex were needed for 1.4 grammes of purple and 1.2 grammes of dye for every 100 grammes of wool.

[97] As is the case with Procopios, for example.

[98] John Malalas, *Chronicle*, VII 176.

[99] He says his translation is based on Legrand, who provides no authority for it (*Digenes*, 206, note to line 3178).

[100] Also bay (βάδεας); chestnut (δαγάλον); or white

(ἄσπρος); and weapons are called blue (βένετος) and gold or Arabian-green (πρασινοαραβατικός). Mavrogordato wonders how a spear can be blue, but this is because he emphasizes hue rather than value. The use of this adjective for damascened blades is commonplace in much heroic literature as a means of describing the sheen.

[101] See Nonnus, *Dionysiaca*, XVIII 67–87, for a description of a palace that foreshadows later descriptions of churches.

From this study, it is possible to draw some conclusions about Byzantine colour vocabulary. It is perhaps surprising that the nature of colour vocabulary in *Digenes* and in the *Chronographia* should be so similar. The two texts diverge most in their specific colour vocabulary, the actual words used, not the way in which they are used, though, here again, there are many more consistencies rather than inconsistencies. Both texts reflect their genre in their choice of colour vocabulary, the one keeping to the high tradition of Byzantine letters, the other conflating oral tradition and literary education. Psellos' colour vocabulary is strictly Classical. The *Digenes* text uses Classical and non-Classical terms almost interchangeably, suggesting that both are familiar to the audience.

In perception of colour, however, they are very similar. Both stick to the same formula for personal descriptions, both use colour sparingly, and both emphasize value above hue. In both texts, this is achieved through detailing qualities of light-bearing, of glitter, gleam, and reflection. This sort of description occurs far more in *Digenes*, as one would expect in a work of the imagination. Both use colour to illustrate moral aspects. In *Digenes*, colour underlines wealth and attractiveness; in the *Chronographia*, these qualities are apparent, but more subtle points are also made, as the example of the Antiphonetes image illustrates. Buildings in both are described similarly, stressing the qualities of reflectance. The emphasis placed on this quality elsewhere in these works suggests that this is a topos, but one which reflects an actual form of perception. Without a grounding in 'reality', a topos of this nature loses much of its effectiveness.

These similarities in colour use in two works of a similar period but greatly differing nature and style imply that the perceptions recorded in both as to the use of colour can be seen as generally applicable within Byzantium at this time. It seems that there are links with the Classical tradition, links made obvious by Psellos, but apparent also as a basic level of perception in *Digenes*. Consequently, in looking at descriptions of works of art, it should be possible to identify aspects of those accounts which relate to the norms of Byzantine colour description and colour vocabulary, rather than identifying these as automatically being specific to the appreciation of art.

CHAPTER 5

The Colour of the Rainbow[1]

A N understanding of the vocabulary of colour opens up the issue of how colour is seen and described. The next stage is to examine surviving works of art and the ways in which they are described, to see how language and image meet. A representation familiar to both modern and Byzantine perceptions is the rainbow. Through a study of the rainbow, it is possible to compare our own perceptions with what we can apprehend of Byzantine perceptions, and to examine some of the problems inherent in our understanding of the nature and role of colour in Byzantium. Continuity between ourselves and the Byzantines is usually regarded as elusive, to be traced, for example, through the use of texts available in both cultures. This is a more direct link. The rainbow is a phenomenon known, described, and depicted both now and by the Byzantines. Depictions and descriptions of the rainbow also offer the opportunity to examine in more detail the question of colour symbolism, the signification of colour within a picture, a theme which has been touched on but not yet explored in this book.

We see the rainbow through the eyes of Isaac Newton.[2] We are taught that, in physical terms, the rainbow is caused by the division of white light into the colours of the spectrum, seven very specific colours, red, orange, yellow, green, blue, indigo, and violet. These seven hues are accepted as the absolute colours of the rainbow and dominate our descriptions of it. So-called 'rainbow colours', stripes of bold saturated colours in almost any combination, though usually featuring red, orange, and blue, and more rarely yellow or green, are used as a design for objects as various as knitted garments and shoelaces. Rainbow motifs are very popular in our culture, ranging from pale pastel versions on greetings cards to bolder plastic window stickers. The object is defined as a rainbow by its colours, by the incorporation of versions of the Newtonian seven at any level of brightness or saturation. Its form is irrelevant: bootlaces and cards with multicoloured bands ending in pale hearts are defined alike as portraying rainbows because of the multiplicity of hues involved.[3]

[1] A shorter version of this chapter which did not discuss colour symbolism has appeared in *BMGS* 15 (1991),66–94.

[2] For a general study of the rainbow and its composition, C. B. Boyer, *The Rainbow* (London and New York, 1959).

For the rainbow in art generally, see J. Gage, *Colour and Culture* (London, 1993), ch. 6.

[3] The work of T. Klika typifies this attitude to the rainbow. His rainbows are essentially pastel hue bands wrapped

We also use rainbows in a symbolic way. It appears, for example, as a hippy manifestation: 'Everybody is a rainbow. You are a rainbow, man [*sic*]'[4] and

> Our planet, safe
> Circled by
> The Rainbow of Promise.[5]

Here the rainbow is a vague nebulous miasma. Elsewhere, the concept is of the rainbow as a universal sign of peace, unity, and environmental concern, apparently derived from the idea of unity in diversity.[6] Within our culture, however, we almost always use rainbows in the form of bands of different hues. We recognize a rainbow as such by its hues and its resemblance to a 'real' rainbow.

Byzantine representations of the rainbow also fall into two categories, naturalistic and non-naturalistic.[7] Naturalistic rainbows are those which, by our definition, display the expected rainbow colours, in bands of two, usually three, and occasionally four, hues. These colours may be red and green, as is the case with the Covenant of Noah shown in the sixth-century manuscript of the Book of Genesis now in Vienna;[8] red, green, and gold, as in the same scene from an Octateuch dated to *c*.1150 in the Topkapı library, where the gold band also serves to delineate the rainbow from the green background;[9] red, gold, and silver at San Marco in the rainbow in the mosaic of the Flood;[10] red, yellow, green, and dark blue in a seventh-century icon from Sinai showing Christ enthroned as the Ancient of Days and Incarnate Logos;[11] green, red, white, and blue-purple in the Maiestas Domini apse mosaic of Hosios David, Thessaloniki, dated to almost anywhere between the fifth and seventh centuries (Plate 58).[12]

Non-naturalistic rainbows are those which are represented by a single or double band of one basic colour appearing in an arc shape. They may be red, as is the case in

round a variety of unlikely objects. See T. Klika, *10,000 Rainbows* (New York, 1983).

[4] Ibid. 3.

[5] M. B. Klika, ibid.

[6] As with the logo of organizations such as Greenpeace. D. H. Lawrence uses the rainbow in the book of the same title as a sign of hope. The legends and stories surrounding it see it as a mysterious path leading to better things, notably a crock of gold.

[7] I have not included so-called 'rainbow patterns', when rainbow hues are used in an abstract pattern, as in the border of the Pantocrator mosaic at Daphni, in this study. This is because it is our hue-oriented perception of the rainbow that describes them as such and I am not certain how applicable such a definition would be in Byzantium.

[8] Vienna, Nationalbibliothek, cod. theol. gr. 31, fo. 3ᵛ.

[9] Topkapı Sarayı Lib. MS G. I. 8. I am grateful to John Lowden for showing me this example.

[10] Other rainbows are found in the Noah Covenant scenes at the Cappella Palatina and Monreale, both naturalistic. That at Monreale appears non-naturalistic in close-up, but naturalistic from a distance, a clever use of optical effects. However, I have not included these and only mention San Marco because of the debate as to how much the decoration of these monuments owes to the East and how much to the West.

[11] Icon B16 in K. Weitzmann, *The Monastery of St. Catherine at Mt. Sinai: The Icons*, i (Princeton, NJ, 1976), 41–2 and pl. XVIII.

[12] For the story of the discovery of this mosaic and an account of its interpretations, see J. Snyder, 'The Meaning of the "Maiestas Domini" in Hosios David', *Byzantion*, 37 (1967), 143–52.

the twelfth-century Christ in Glory fresco at Lagoudera and Ascension fresco from St Nicholas Kasnitze, Kastoria, and in the Last Judgement at the fourteenth-century Kariye Camii (Plate 59). At Torcello, the Christ in Majesty in the late twelfth-century Last Judgement mosaic sits on two gold bands and the Ascension mosaic at San Marco (late twelfth century) has red and gold bands. At the Karanlık Kilise, Göreme (c.1050), the Ascension fresco rainbow begins with a black border, then a yellow-orange band, and then a dark band. From this a 'dog-tooth' pattern goes out into the bottom band which is white, perhaps representative of silver. There is a similar rainbow at Christ's feet (Plate 60).

Blue may also be used. In the ninth-century Khludov Psalter, the rainbow is portrayed as bands of blue in both Christ in Glory and Ascension scenes, similar in nature to the representations of emanations of light in the Transfiguration scenes of the same manuscript.[13] Where the mandorla is blue or silver, as is the case in most of these examples, the rainbow is marked off from it by darker—blue or black—borders and often appears brighter. A Georgian enamel plaque from the eleventh-century Khakhuli triptych representing Christ in judgement seated on the rainbow pictures the rainbow as alternating bands of dark and light blue, divided by gold.[14] The rainbow in the thirteenth-century Last Judgement from the church of the Ascension, Mileševa, is also blue.

Variations on the theme of blue include a blue-grey rainbow in the Ascension fresco from the eleventh-century church of St Sophia, Ohrid, and silver-grey representations in the late ninth-century Ascension mosaic from Hagia Sophia, Thessaloniki (Plate 61), and at Peć, in the Ascension from the twelfth/thirteenth-century Church of the Holy Apostles.

So, in our terms, the colours of non-naturalistic rainbows are either red or blue, with the addition of gold or silver, and omitting entirely the colours in the green area of the spectrum. These single or double bands of colour are very different from our modern multi-hued representations of rainbows, which in their emphasis on 'rainbow colours' attempt to echo the naturalistic. The question then arises as to why there are two very different Byzantine portrayals of the rainbow, one of which is, to modern perceptions, stylized and schematized to such an extent as hardly to represent a rainbow at all.

In pictorial terms, the Byzantine rainbow appears to have two separate functions: in Noah scenes as the sign of God's Covenant, and in Christ in Glory scenes. In the former, rainbows are inevitably naturalistic; in the latter, they tend to be non-naturalistic.

[13] e.g. the picture of Christ in Glory before an iconophile patriarch, fo. 22 on Ps. 23; the Ascension scenes of fo. 46 (Ps. 46) and fo. 55 (Ps. 56). Fo. 14 (Ps. 17) shows an Anastasis in which the divine light is shown similarly.

[14] No. 56 in *Medieval Cloisonné Enamels at the Georgian State Museum of Fine Arts* (1984), 52.

Textual sources provide further information about Byzantine perceptions of the rain-bow. Accounts such as that in the *Souda* lexicon and in Michael Psellos' *De Omnifaria Doctrina* describe how the rainbow is formed and what its colours are. The *Souda* describes how the dampness of the cloud is made many-coloured by the sun's rays, like a bow, and the sun's rays are bent back from the damp clouds. Of the colours, it says that green (χλωρός) in the rainbow is a sign of air, red (πυρρός) of spirit, and black (μελανίζος) of water.[15] Psellos' account begins with a description of the form of the rainbow and how it is made: there is a bow in the shape of part of a circle, made by the sun's rays reflecting on to clouds, though it occasionally appears at night.[16] It is three coloured. The first zone is red (φοῖνιξ), the second green (πράσινος) and the third purple (ἁλουργός) which is glossed as ὑπερπορφύρεος.

Both the *Souda*'s and Psellos' colour terms cover the same range of colours. Φοῖνιξ and πυρρός describe reds; πράσινος and χλωρός are both greens; and purple, ἁλουργός, or, as Psellos calls it, ὑπερπορφύρεος together with μελανίζος, 'dark-coloured', are very similar. The rainbow colours of the *Souda* and Psellos are essentially red, green, and purple-black, to use the conventional translations. An equally valid translation might be to focus instead on brightness and saturation, as the studies of Byzantine colour vocabulary (and the Homeric scholia) suggest. The colours can then be seen as bright, less bright, and dark.

These two Byzantine accounts of the rainbow follow closely that of Aristotle. Aristotle said that the rainbow was green (πράσινος), red (φοῖνιξ) and purple (ἁλουργός), the three colours that no mixing can create.[17] He justifies these colours as primary colours on mystical, philosophical, arithmetical, and experimental grounds.[18] Yellow (ξανθός), is secondary to the primary colours and lies between purple and green. It is caused by the contrast of colours, not through reflection: Aristotle is less than clear as to how it forms part of the rainbow. Other colours can appear through the mixing and juxtaposition of the basic three.

Aristotle also writes lengthily about how and why the rainbow appears in the sky. The phenomenon is produced by a reflection of the sun's rays which takes place under certain conditions of cloud formation and is a sign of varying weather condi-tions, notably rain. The colours are due to the weakening of our sight by reflection, which takes place in three stages. In the first, the bright light of the sun reflected in the dark medium of water appears red; further weakening of the sight produces other colours.[19]

[15] *Suidae Lexicon*, ed. A. Adler (Leipzig, 1928–38), 666.
[16] *De Omnifaria Doctrina*, ch. 106. PG 122, 749C–752A.
[17] *Meteorologica*, 372ᵃ7.

[18] *De Sensu*, 439ᵇ21–440ᵃ6; *Meteorologica*, 375ᵃ4–20; *De Caelo et Mundo*, 268ᵃ7–23.
[19] *Meteorologica*, 374ᵇ–375ᵇ.

Later philosophers expanded on Aristotle and gave a range of colours covering the bands of purple, yellow, green, blue, and red.[20] There are, however, never more than four or five bands of colour in the rainbow. In some cases, the terms given appear to duplicate themselves. This is less a case of either/or than of two words which seem to have the same hue connotations conveying different colours. Alexander of Aphrodisias followed Aristotle in describing the colours as red ($\phi o \hat{\iota} \nu \xi$), purple ($\dot{a} \lambda o \nu \rho \gamma \acute{o} s$), green ($\pi \rho \acute{a} \sigma \iota \nu o s$) and yellow ($\xi a \nu \theta \acute{o} s$).[21] His contribution was of major importance in establishing Aristotle's three colours as the orthodox view in the Late Antique and early Byzantine period. Philoponos and Olympiodoros both appear to defend the Aristotelian version of how the rainbow is made, and Olympiodoros notes it as having three colours.[22] Ptolemy, on the other hand, may have believed in seven colours, but if this is so, his description belongs to the lost first book of the *Optics*.[23]

Other Byzantine accounts of the rainbow also follow Aristotle. These include the section under $\mathring{\iota} \rho \iota s$ in the lexica of Hesychius of Alexandria[24] and of Photios[25] and the description in the Syriac text of Job of Edessa.[26] Aristotle is clearly the Late Antique and Byzantine world's Newton: it is from his description of both colours and formation of the rainbow that all later Greek accounts appear to derive. His primary rainbow colours form the basis of the colours cited in descriptions or employed in works of art. Red, blue, purple, and yellow are the most important rainbow colours; other colours are essentially variations on this theme, at varying levels of brightness.

These descriptions of the rainbow come in works aiming to describe and explain physical phenomena. It is from this tradition that naturalistic rainbow depictions in art and text must stem. Although non-naturalistic rainbow colours are incorporated into these accounts, all textual references emphasize the multicoloured nature of the rainbow.

[20] Poseidonios describes the rainbow as having the same colours as those proposed by Aristotle, with the addition of blue ($\kappa \upsilon \acute{a} \nu \epsilon o s$). Cited in Diogenes Laertius, *Vitae*, VII 152. Aetius' range of rainbow colours consists of purple ($\dot{a} \lambda o \nu \rho \gamma \acute{o} s$ and $\pi o \rho \phi \acute{\upsilon} \rho \epsilon o s$), red ($\phi o \hat{\iota} \nu \xi$), green ($\pi \rho \acute{a} \sigma \iota \nu o s$), and yellow ($\xi a \nu \theta \acute{o} s$). See Aetius, *Compendium*, detailed in K. Reinhardt, *Poseidonios* (Munich, 1921), 165 n. 2, and O. Gilbert, *Die meteorologischen Theorien des griechischen Altertums* (Leipzig, 1907), 604–18. Stobaeus also has a section on the rainbow. He gives red ($\phi o \hat{\iota} \nu \xi$), purple ($\dot{a} \lambda o \nu \rho \gamma \acute{o} s$ or $\pi o \rho \phi \acute{\upsilon} \rho \epsilon o s$), blue ($\kappa \upsilon \acute{a} \nu \epsilon o s$), and green ($\pi \rho \acute{a} \sigma \iota \nu o s$) as the colours of the rainbow, saying that they are made by different effects of light from the sun and with rain. *Ἐκλογαί ἀποφθέγματα ὑπόθεσις*, ed. C. Wachsmuth (Berlin, 1884), XXX VI 238–42.

[21] In *Meteorologica*, 139 33–5. Elsewhere in this work (157 25–9), $\dot{a} \lambda o \nu \rho \gamma \acute{o} s$ is dropped.

[22] For Alexander, see his *De Anima*, trans. and commentary A. P. Fotinis (Washington, DC, 1979). Olympiodoros lists the same colours as Alexander, with the exception of $\xi a \nu \theta \acute{o} s$. See H. Durbeck, *Zur Charakteristik der griechischen Farbenbezeichnungen* (Bonn, 1977), nn. 27, 45.

[23] Suggested in A. Lejeune, *Euclide et Ptolémée, deux stades de l'optique géométrique grecque* (Université de Louvain recueil des travaux d'histoire et de la philologie, 3ᵉ série, 31ᵉ fac, 1948), 27–8 and n. 5. See also Gage, *Colour and Culture*, 60 and n. 136.

[24] Hesychius of Alexandria, *Lexicon*, ed. K. Latte (Hauniae, 1953), ii. 374.

[25] Photios, *Lexicon*, ed. R. Porson (Leipzig, 1823), 98.

[26] Job of Edessa, *Book of Treasures*, Syriac text ed. and trans. A. Mingana (Cambridge, 1935), 5th discourse, ch. 6, 208–10. Job describes three rainbow colours: date-red, made from heat and watery cold; green, a mixture of heat and humidity; and yellow or saffron, formed of a mixture of red and white.

It is from other sources that an explanation of the non-naturalistic rainbow must be sought.

In the Bible, the rainbow is mentioned in four places. In Genesis, it is an essential expression of the covenant of God with Noah after the Flood.[27] It appears in the vision of Ezekiel, where the prophet, seeing the Lord in glory, declares 'Like the appearance of the bow that is in the cloud on the day of rain, so was the appearance of the bright-ness round about. This was the appearance of the glory of the Lord.'[28] This aspect of glory is echoed in Revelation where in his vision of heaven, the prophet sees one seated on the throne round which was a rainbow that looked like an emerald ($\sigma\mu\alpha\rho\acute{\alpha}\gamma\delta\iota\nu\sigma$),[29] and later, a mighty angel wrapped in a cloud with a face like the sun and legs like fire and a rainbow over his head.[30] The rainbow also appears in Ecclesiasticus (Sirach): 'Look upon the rainbow and praise him that made it; Exceeding beautiful is the brightness thereof. It compounds the heavens round about with a circle of glory.'[31] A little later, it is used as part of the description of one of the heroes of the book: 'As the rainbow giving light in clouds of glory.'[32]

These accounts share a common theme. The perception of the rainbow is a mani-festation of light and a sign of divine glory, especially that seen through visions. Little interest is shown in a multiplicity of hues. That the rainbow is multicoloured is regarded as worthy of mention; what these colours are is not. The nearest thing to a colour description is the comparison in Revelation to a precious stone, but there is nothing to suggest that hue, rather than other qualities of a precious stone, such as its brilliance, is being referred to here. Emphasis instead is placed on the brightness of the rainbow and its relation to light and brilliance. It is linked explicitly with fire and the sun.

Scenes with rainbows depicted in Byzantine art (except perhaps Noah scenes) emphasize the glory of God, an aspect made clear in all the biblical examples. They are joined in the use of the rainbow by artistic representations of the Ascension, which are the most common source of rainbows. In one sense, this is surprising since the rainbow is not mentioned in the New Testament account. However, the words of the two angels to the Apostles at the Ascension: 'This same Jesus . . . will come in the same way as you saw him go into heaven,'[33] make it clear that the Ascension and the return of Christ in glory at the Second Coming could be closely related. Consequently, the Ascension could be depicted in the same way as the Second Coming, using the imagery of Revelation and of Old Testament prophecies, including the rainbow.[34] Ascension

[27] Gen. 9: 13.　　[30] Rev. 10: 1.　　[33] Acts 1: 10.　　[34] As at Bawit, for example, where the Glory in the apse
[28] Ezek. 1: 28.　　[31] Ecclus. 43: 11–12.　　　　　　could be either an Ascension or a Christ in Glory scene. I am
[29] Rev. 4: 3.　　[32] Ecclus. 50: 7.　　　　　　　　　grateful to Jill Storer for advice on this whole issue.

homilies place much emphasis on the Ascension as a festival of light;[35] the rainbow is merely one aspect of this.

Biblical exegeses that mention the rainbow reiterate this image of brilliance. Commenting on Genesis, Procopios of Gaza in the fifth century writes about the creation of the rainbow without mentioning its colours, concentrating firmly on its aspect as a sign and discussing whether or not it existed prior to the Flood.[36] The fourth-century patriarch, John Chrysostom, notes it only as the perpetual bond of God's promise.[37] Other commentaries on Genesis mention it within this context or ignore it.

Gregory of Nazianzus (d. *c.*390) in his Commentary on Ezekiel,[38] writes that the rainbow indicates peace and the covenant between God and man. However, the fifth-century bishop of Cyrrhus, Theodoret, describes it as light in a circle like a bow, and notes that it is seen by day in the clouds. This brief nod in the direction of observation is followed by a disquisition on the theological significance of the rainbow.[39]

Commentaries on the Apocalypse follow a similar line. Oecumenius in the sixth century notes a difference between the perceptible rainbow of many colours and the σμαράγδειος (?emerald-like)[40] spiritual rainbow. The former is formed as a physical phenomenon through the reflection of light from the clouds; the latter exists as a sign of virtue around the throne of God, a point which serves as a launching pad for a disquisition about the virtues of the stone σμάραγδος.[41] Elsewhere, he uses the multi-coloured rainbow as a symbol of the multifarious virtues of the angels.[42] In both accounts, however, he stresses the close relationship between the rainbow and light. Andreas of Caesarea in the sixth century writes with reference to Revelation 4: 2–3 that the rainbow is emerald-like and appears many-coloured (ποικίλος) and brightly coloured (ἄνθος) to the wonder of the ranks of angels. On 10: 1 he notes the shining nature of the angel, and the bright, many-coloured effect of the rainbow. He links the rainbow with the sun and light and brilliance.[43] Arethas of Caesarea in the tenth century says in his *Commentary* that the Apocalyptic rainbow is like the rainbow in the clouds made from the shining rays of the sun. Both of these rainbows are

[35] See e.g. the Ascension homilies of Gregory of Nyssa, *PG* 46, 689; John of Damascus, *PG* 96, 843; and Leo the Philosopher, *PG* 107, 113.

[36] Procopios of Gaza, *Commentary on Genesis*, verse 13, *PG* 87, 300.

[37] John Chrysostom, *Homily on Ch. IX of Genesis*, XXVIII, *PG* 53, 254.

[38] Gregory of Nazianzus, *Commentary on Ezekiel*, *PG* 36, 665B.

[39] Theodoret, *Commentary on Ezekiel*, *PG* 81, 836C.

[40] σμάραγδος is usually translated as 'emerald'. However,

LSJ suggests that this is probably incorrect, and that the term is used of several green stones. The whole issue of the words and colours used for stones is a complex one, affected as it is by our emphasis on the colour of the stone and the probable lack of such emphasis originally.

[41] *The Complete Commentary of Oecumenius on the Apocalypse*, ed. H. C. Hoskier, University of Michigan Studies, Humanistic series, vol. xxiii (Ann Arbor, Mich., 1928), 69–70. I am grateful to Jill Storer for this reference.

[42] Ibid. 120–1.

[43] Andreas of Caesarea, *Sermon X* 4, *PG* 106, 253B.

described as multicoloured (ποικίλος). That round the throne of God signifies the goodness of God, 'the being like the sun': those that achieve good works will similarly be made shining. This rainbow is σμάραγδος green in colour, rather than ἴασπις, which is the colour of the stone interpreted as jasper. In the section of his commentary dealing with Revelation 10: 1, Arethas concentrates on the effects of the glory and unapproachability of light.[44]

Of these writers on scripture, Arethas is the only one who seriously engages with Classical theories on the formation of the rainbow. As his Classical learning is well known, this may be a deliberate choice on his part. It may be that other commentators believed either that this Classical aspect was irrelevant in direct relation to scripture, or that such details were unnecessary in an account of the rainbow. What was important in this context was not the rainbow's hue and how that was made, but its qualities of light and what these signified. In all these passages, it is light that is emphasized, with or without reference to the rainbow, paralleling the pictorial representation of these scenes, which may or may not contain a rainbow.

In scriptural terms, therefore, the rainbow is something other than the physical phenomenon described elsewhere. Oecumenius touches on this difference; Philo, writing in the first century AD, explains it in some detail. He discusses Genesis 9: 13–17 in *Questions and Answers on Genesis* and mentions the placing of the rainbow.[45] He says that the rainbow of Genesis is not the earthly rainbow but the 'bow of God', something very different. The earthly rainbow does not have a special separate nature but is an appearance of the sun's rays in moist clouds, a phenomenon which does not happen at night or when the sun is not out. The bow, on the other hand, is a symbol of the invisible power of God, which is in the air and affects the density of the air and rain. Arethas of Caesarea supports this. He says that the divine, single-coloured rainbow is called by the same name as the human, multicoloured one to remind humanity of the disunity of many coming together in unity in the imitation of God.[46]

This theme of the divine and human rainbows representing unity and disunity is represented in a letter of Basil of Caesarea (d. 379) on the difference between the substance and the person.[47] In this, he uses the colours of the rainbow to illustrate the unity in disunity of the Trinity: the three colours of the rainbow consist of one object, just as the three persons of the Trinity consist of one God. He describes the rainbow and its colours in essentially Aristotelian terms, but calls it a 'reflecting brilliancy'. This emphasis on qualities of brightness and gleaming is apparent in his colour words: γλαυκός, usually translated as grey or green, but also meaning gleaming; ἠλέκτρινος,

[44] Arethas, *Commentary on the Apocalypse*, PG 106, 568D.

[45] Book II, 64. What survives of this section has been translated as a Loeb Classical Library text, 1953.

[46] Arethas, PG 106, 568D.

[47] Basil, *Letter* 38, PG 32, 333C–335C.

a shiny gold and silver compound; πυραυγής, fiery, but with emphasis on the shimmering effect of fire; and πορφύρεος, purple, but a word covering hues from yellow and green to red and purple.[48]

It is this concept of the 'bow of God', the divine rainbow, which is portrayed by the non-naturalistic rainbow. In art, the non-naturalistic rainbow appears overwhelmingly in scenes like the Ascension, the Last Judgement, and Christ in Glory, where it forms part of the manifestation of the glory of the Lord upon which Christ sits and rests his feet. In these scenes, he usually sits on one rainbow and places his feet on another, often identical, one. It has been suggested that these act as a signifier of heaven and earth, based on Isaiah 66: 1, 'heaven is my throne and earth my footstool'.[49] Whilst this may be so for cases where only one rainbow is depicted, the use of the same rainbow for both throne and footstool in the majority of cases suggests that this is not so, unless one believes that heaven and earth, this world and the next, would be represented by the same sign. The rainbow is not proposed as a sign of heaven in any exegetical text that I have seen. Rather, in all of these scenes, the rainbow is not a manifestation of physical phenomena, nor a part of the Old Testament covenant between God and man, nor even a schematic reference to these things, but a manifestation of divine light reflecting the glory of Christ; the rainbows are seen particularly in holy visions, a further indica-tion of their unworldly nature.

Clues about the nature of the non-naturalistic rainbow are provided in the meteoro-logical accounts by their emphasis on the character of the rainbow as being both light and made by light. This theme of the rainbow as light is made very clear in the theological writings cited above. So instead of being defined simply in hue terms, an additional quality, that of light, is perceived as significant.

I have already suggested that Byzantine writing about colour and the Byzantine use of colour words demonstrates a belief in colour as a form of light. This is not a belief in white light divisible into component spectral colours, but a perception of a fundamental element of colour being its light-bearing quality.[50] This is apparent in descriptions of works of art with their emphases on aspects such as the glowing or shiny nature of colours rather than their hues, in the nature of Classical and Byzantine Greek colour

[48] πορφύρεος is generally taken as being the colour of the dye obtained from the murex, and thus as purple.

[49] This is proposed by Weitzmann in his description of the Sinai icon of Christ as the Ancient of Days mentioned above, where there is one naturalistic rainbow and one non-naturalistic rainbow: *Monastery of St. Catherine at Sinai*, i. 41–2.

[50] In contrast to the view of J. L. Opie, 'Some Remarks on the Colour System of Medieval Byzantine Painting', *Acts of the 16th International Byzantine Congress, Vienna 1982*, ii. 5

(*JÖB* 32/5) (Vienna, 1982), 85–91. Opie argues that the most important manifestation of colour as light was the reconstitution of white light through the use of comple-mentary and contrasting colours. This assumes that the Byzantines were aware of the division of white light into colours of the spectrum and, indeed, that they conceived of light as white, beliefs which this study of the rainbow do not support. Opie's findings seem largely based on a reading of Pliny, whose works do not seem to have been known in Byzantium.

vocabulary, and in the Byzantine concept of a colour scale running from bright/light to dark.[51]

Light imagery and symbolism is a constant feature of theological and mystical writings, above all in that of the fifth/sixth-century theologian, Pseudo-Dionysius. His influence on aesthetics lies in his belief in light as the primary creative force and analogue of the divine. He wrote that divine matter was best conveyed by incongruous images which are more likely to elevate souls than by comparisons with precious materials which would 'probably induce men to err, since they would be induced to believe that there are in the heavens brilliant essences like gold, or men fashioned of light, brilliant and beautifully dressed, emitting rays of harmless fire'.[52] As has already been mentioned, he also suggests that on a physical level, the light of the distant heavens was also darkness, a darkness defined as the 'inaccessible light' of God.[53]

In the *Divine Names*, Pseudo-Dionysius lists light as one of the names given to God and as an image of good.[54] The *Celestial Hierarchy* talks of God as the source of light: 'material lights are images of the outpouring of an immaterial gift of light'.[55] Pseudo-Dionysius associates light and life, light and the immaterial—the sun is the visible image of divine goodness which all material things desire.[56] Again in the *Celestial Hierarchy*, fire is used as a symbol of the divine[57] and fire is used in the colour descriptions of the heavenly beings.[58] Here, Pseudo-Dionysius stresses colour as light materialized, developing a Christian metaphysics of light. Colour is the most material aspect of light, accident rather than substance. Good is a translucent metaphysical quality; light is a symbol of spirit, and colour images are like angels, mirrors, things of the spirit with a sacramental and metaphorical divine dimension.[59] The heavenly and the physical are perceived as complementary and Pseudo-Dionysius' colour imagery, with its emphasis on the sparkle of metals, especially gold and silver, and concentration on bright colours, illustrates this. His aesthetic is based on proportion and splendour and the symbolic expression of the ideal—Plato out of Plotinus.[60]

[51] Apparent for example in Pseudo-Dionysius, *Celestial Hierarchy*, XV 1, PG 3, 336C; John Chrysostom, *Ad Theodorum Lapsum*, I 11, PG 47, 292; John of Damascus, *De Fide Orthodoxa*, I 4, PG 94, 797B–800C.

[52] *Celestial Hierarchy*, II 8, PG 3, 157A. Οἰηθήσονται γὰρ, χρυσοειδεῖς καὶ στίλβοντας ἄνδρας εἶναι, καὶ λαμπρὰν φοροῦντας ἐσθῆτα, καὶ πυρώδεις δίχα καύσεως καὶ ἀβλαβῶς εἶναι.

[53] *Epistle*, V, PG 3, 1073.

[54] *Divine Names*, PG 3, 697C. Trans. and commentary, C. Luibheid, *Pseudo-Dionysius—The Complete Works* (London, 1987), 74.

[55] *Celestial Hierarchy*, I 3, PG 3, 121D. καὶ τῆς ἀΰλου φωτοδοσίας εἰκόνα, τὰ ὑλικὰ φῶτα. See also I 1 121A. *Complete Works*, 146. E. Benz, 'Die Farbe in der Christlichen Vision', *ErYb* 41 (1972), 265–323, looks at colour visions as a reflection of divine magnificence, though his emphasis is predominantly Western.

[56] *Divine Names*, IV 4–6, PG 3, 697B–701B. This text deals with light as an aspect of defining God and the relationship between spiritual light and darkness.

[57] *Celestial Hierarchy*, IV 2, PG 3, 189A–192A.

[58] Ibid., XV 1–7, PG 3, 328A–336C.

[59] See e.g. *Celestial Hierarchy*, XV 1, PG 3, 328A–C.

[60] J. Gage, 'Gothic Glass: Two Aspects of a Dionysian Aesthetic', *Art History*, 5 (1982), 36–57.

Such attitudes are found throughout Byzantine theological writings; in the fourth century, John Chrysostom, for example, describes the kingdom of heaven as one of light and splendour.[61] Some four centuries later, John of Damascus uses the sun and its brightness as a means of describing the three persons of the Trinity and regards the angels as secondary, spiritual lights.[62] Hesychast beliefs stress the significance of light as a manifestation of the divine to which believers should make their way.[63] Light, according to the fourteenth-century Hesychast theologian, Gregory Palamas, is God's power.[64] Both the Hesychasts and writers of Transfiguration homilies generally treat light as a key element in the deification of Christ.[65]

Hence it is hardly surprising that the rainbow, one of the visible indicators of glory and divine light, according to scriptural and exegetical texts, should be employed in scenes expressing these concepts. Expositions on the Transfiguration make very similar points about divine light.[66]

So these depictions of the rainbow represent a planned iconographic expression of divine light and glory, with deliberately chosen consistent colours. If rainbows are seen as symbols of divine glory and light, then the colours used to depict them should underline this meaning.

In Byzantine art history, colours have been treated as iconographic elements rather than as symbols. The basis for this seems to be Demus' statement that 'basic colours were more or less fixed by iconographic rules', citing as examples, presumably from his own observation, since no further reference is provided, the white robes of Christ at the Transfiguration, his blue and gold robes in any scene before the Crucifixion, and purple and gold robes in any scene after the Resurrection, together with the blues and purples worn by the Virgin, the blues and beiges of St Peter's robes, and the light greens and blues of the robes of St Paul.[67] Thus, colour is perceived as a means of representing and identifying a figure. However, many Byzantine art historians have also noted that colour varies. Mouriki details how, at Nea Moni, St Peter's robes vary in colour, with various combinations of white, violet, olive, grey, and dark blue.[68] This is a common enough phenomenon for Mouriki to say, with Mathew and Gage,

[61] *Ad Theodorum Lapsum*, I 11, *PG* 47, 292.

[62] *De Fide Orthodoxa*, I 4; II 31. *PG* 94, 797B–800C. Chapter 7 (885C–900A) looks at fire and at the four elements.

[63] Symeon the New Theologian and Gregory Palamas both conceive of light in this way.

[64] Gregory Palamas, *The Triads*, exerpts trans. N. Gendle (New York and Toronto, 1983), I. iii. 22; II. iii. 8.

[65] J. A. McGuckin, *The Transfiguration of Christ in Scripture and Tradition* (New York, 1986) quotes several examples.

[66] Gregory Nazianzenus, *Oratio*, 40 6, *PG* 36, 363–6;

John of Damascus, *Oratio de Transfig.*, *PG* 96, 545–76, are among various of the Fathers who comment in this way. See, further, McGuckin, *Transfiguration in Scripture and Tradition*.

[67] O. Demus, *Byzantine Mosaic Decoration* (London, 1948), 90 and n. 61. This evidence is cited by, among others, G. Mathew, *Byzantine Aesthetics* (London, 1963), 121; S. Runciman, *Byzantine Style and Civilisation* (London, 1975), 119; D. Mouriki, *The Mosaics of Nea Moni on Chios* (Athens, 1985), 240.

[68] Mouriki, *Nea Moni*, 240 and n. 2.

that facial features, pose, and attributes are as important as colour for iconographic indicators.[69]

Such a view presents different problems. It assumes that colour iconography should work through hue, rather than realizing that, as Byzantine colour perception focuses also on other qualities, these might be recognized in Byzantine colour iconography: so the various hues of St Peter can be seen as belonging to the same saturation or brightness range. It overlooks Byzantine statements about the importance and significance of colour. In the concluding chapter of this book, I shall show that, for the Byzantines, colour was the primary definition of form, that forms were defined by their colour, and that this colour has to be the 'true' colour. If this is so, then colour iconography cannot be the haphazard array it has been treated as.

The colours of the non-naturalistic rainbow go some way to illustrating the diversity of colour iconography in Byzantium. In this instance, a variety of colours from grey and blue to red and yellow are used to represent the rainbow. It may be that the choice is random and unpremeditated, though this would be unique in an art so carefully calculated and tied to theology; it may be that a symbolic rather than simply identificatory force is at work.

In anthropological terms, colours can be seen as semiotic codes or informational systems.

Everywhere, both as terms and concrete properties, colours are engaged as signs in vast schemes of social relations: meaningful structures by which persons and groups, objects and occasions, are differentiated and combined with cultural orders . . . It is not, then, that colour terms have their meanings imposed by the constraints of human and physical nature; it is that they take on such constraints in so far as they are meaningful.[70]

This semiological view holds that signifiers (the colours) are associated with tacit signifieds (the thing symbolized), following the model of the relationship between sound and memory in language. This approach has been proposed by, among others, Freud, Lévi-Strauss, and Turner.[71] This standard approach to symbolism applies a structural model to symbols, suggesting that symbols work similarly and are organized rather like a code which can be cracked, or a language which can be deciphered. A symbol essentially has one meaning, or a limited range of meanings.

[69] Ibid.; Mathew, *Byzantine Aesthetics*, 121; J. Gage, 'Colour in History: Relative and Absolute', *Art History*, 1 (1978), 108. See also H. Buchthal, 'Notes on Byzantine Hagiographical Portraiture', *GBA* 62 (1963), 81–90. I am grateful to Henry Maguire for this reference.

[70] M. Sahlins, 'Colors and Cultures', in J. L. Dolgin, D. S. Kemmitzer, and D. M. Schneider (eds.), *Symbolic Anthropology: A Reader in the Study of Symbols and Meanings* (New York, 1977), 165–80, esp. 167.

[71] e.g. in S. Freud, *Introductory Lectures on Psycho-analysis* (London, 1963); C. Lévi-Strauss, *The Raw and the Cooked* (London, 1969); V. Turner, *The Forest of Symbols* (Ithaca, NY, 1967). D. Turton, 'There's No Such Beast: Cattle and Colour Naming among the Mursi', *Man*, 15 (1980), 320–38, examines colour terms among the Mursi and shows how in this cultural context, cattle colours and the configuration of cattle colours are used as the referent for categories of colour.

Sperber, on the other hand, proposes a more flexible model.[72] His cognitive approach holds that symbolic interpretation is not a matter of decoding, but of improvisation, an improvisation that rests on an implicit knowledge. In this way, symbolism participates in the construction of knowledge, rather than acting simply as an instrument of social communication: a symbol is not a code word denoting a specific object, but it is used flexibly to express different things. As an escape from the structuralism of semiotics, Sperber offers a space for symbolism to be relative and defined by context: 'the notion of a symbol is not universal but cultural, present or absent, differing from culture to culture or even within a given culture.'[73] In other words, a symbol only 'works' within its own cultural context, and further, it need not have one consistent 'meaning' within that culture. The 'meanings' of the symbol are reliant wholly on its specific context at each time of use. This is how I understand Byzantine colour symbolism to work, though the very belief in a system of symbolism must be structuralist to a certain extent. To synthesize both points (as Sperber suggests is possible),[74] Byzantine colour symbolism is structured around the concept of colour as more than just hue, and which colour is used in which context depends upon that context.

In the case of the Byzantine rainbow, the naturalistic and non-naturalistic rainbows are both perceived and represented differently. The different colours used indicate this difference and reflect the significance of the rainbow in its particular context. The context of the non-naturalistic rainbow was identified as a representation of the glory of God: the colours used to portray it must, in this context, be significant of that aspect. In another context, their significance can be different. Red, as used in the non-naturalistic rainbow, is a sign of divine glory. Used in the robes of Eve in scenes of the Anastasis, its significance, judging from Byzantine texts about both Eve and the Anastasis, cannot be the same. In this case, red may reflect its Graeco-Roman use as an indicator of fertility, linking neatly to the concept of Eve as the 'mother of all living'.[75] Christ's white robes at the Transfiguration are not just an iconographic guide for the identification of Christ, but also bear a significance within Byzantine culture, and a significance which is not necessarily the same as that held by Adam's white robes in the Anastasis.[76] Whether the art historian can then go on to work out what those significances might be is another story.

[72] D. Sperber, *Rethinking Symbolism*, trans. A. L. Morton, (Cambridge, 1975).

[73] Ibid. 50. Sperber demonstrates this contextuality through the example of the use of butter among the Dorze of Ethiopia: see esp. 53–9 and 138. He even goes so far as to say that 'symbolism is, in large part, individual' (87). Sperber also raises the question of whether symbols ever 'mean' anything, saying that the interpretation of symbols is not an interpretation of their meanings (85).

[74] Ibid., esp. ch. 3.

[75] Gen. 3: 20.

[76] On the one hand, white clothing can be interpreted as a sign of purity as Plutarch, *Quaestiones Romanorum*, XXVII, suggests; on the other, Winkler argues that pure white is as unhealthy as pure black (J. J. Winkler, 'Lollianus and the Desperadoes', *JHS* 100 (1980), 162).

The selection of colours is not random and motiveless. All those colours used in the rainbow convey the same idea or association. Because colour is conceived less as hue and rather more as reflections of light and darkness on a black–white scale, then its relation to this scale provides its hue. However, meaning is provided not by the position on this colour scale alone, but by context. Blue in the rainbow can only mean divine light because of the known significance of the rainbow; in the scene of the angels and the sheep and the goats at Sant' Apollinare Nuovo, the significance of the colour is altered from the usual simple association with divinity to an almost negative divine figure, the angel with the goats (Plate 62).[77] In the Transfiguration scenes at St Catherine's, Sinai, and Daphni, blue is closely linked with black, and through this with divinity: the negative theology of Pseudo-Dionysius describes the divine darkness of the unapproachable light of God (Plate 63).[78] In contrast, devils are always shown as black. Purple is both a sign of royalty and of sinful luxury. Nicholas Mesarites in his account of the Pantocrator mosaic in the Church of the Holy Apostles in Constantinople, describes how Christ's robe is coloured blue and red 'warning all by the hand of the painter not to wear brilliant clothing or to seek purple'.[79] On the other hand, wool is common and available to all: 'however, when it is dipped in the dye of the sea (murex), it is called purple. Once it takes up this name, it becomes something which is fitting to be used exclusively by kings ... [the purple] transcends the common character *because of the dignity of him who uses it*'.[80] Hue in itself has no fixed significance: it is not the defining element of Byzantine colour symbolism.[81]

Further, the concept of an organized colour (hue) symbolism seems not to have been of great importance in Byzantium. It does not feature in the type of texts where it might be expected, such as descriptions of precious stones, either as stones or in their use in biblical descriptions, notably the Heavenly Jerusalem of the New Testament and the High Priest's clothing of the Old,[82] nor in the Late Antique *Oneirocritica* of Artemiodoros; nor do texts on the rainbow pay much attention to it. The clearest

[77] On this theme see also E. Kirschbaum, 'L'angelo rosso e l'angelo turchino', *Rivista di archeologia cristiana*, 17 (1940), 209–48.

[78] *Epistle*, I, PG 3, 1065A; *Epistle*, V, PG 3, 1073A.

[79] Mesarites, 'Description of the Church of the Holy Apostles in Constantinople', text, with translation and commentary by G. Downey, *Transactions of the American Philosophical Society* NS 47: 6 (1957), XIV 8. 870. On purple as a symbol of luxury and distinction, see C. Rowe, 'Conceptions of Colour and Colour Symbolism in the Ancient World', *ErYb* 41 (1972), 359–60.

[80] Sixth Session of the Seventh Ecumenical Council, citing Athanasius' *Letter* to Eupsychius. Mansi, 317E–320D, 138–9, in D. J. Sahas, *Icon and Logos: Sources in Eighth Century Iconoclasm* (Toronto, 1986). Ἀλλ' ὅταν τῇ ἐκ τῆς θαλάττης προσομιλήσῃ βαφῇ πορφύρα λέγεται καὶ τῆς προσηγορίας ἀμειθομούσης καὶ τῆς χρήσεως κατ' ἐξαίρετον βασιλεῦσι μόνοις ἁρμόττειν λαχούσης ... φεύγει γὰρ τὴν κοινότητα διὰ τὸ τοῦ χρωμένου ἀξίωμα. John of Damascus uses a very similar phrase, *First Treatise on the Divine Images*, commentary, PG 94, 1264B.

[81] For additional supporting evidence for the 'context is all' argument see L. Brubaker, 'Byzantine Art in the Ninth Century: Theory, Practice, and Culture', *BMGS* 13 (1989), 58–60.

[82] Michael Psellos' *De Lapidibus*, PG 122, 888–900, deals with the first two concepts; Epiphanius of Cyprus, *De XII Gemmis Liber*, PG 43, 293B–304D with the last.

examples are texts such as Basil the Great's comparison of the colours of the rainbow to Christ: blue represents his heavenly realm, red the Passion, and green, his work on earth; or John Malalas' sixth-century account of the colours of the circus factions.[83] The Classical tetrads linking colours with the elements, seasons, signs of the zodiac, and so on appear also in patristic works, but in specifically sacred contexts. Jerome explains the four colours of the vestments of the High Priest by reference to elemental significance, as does Philo.[84] Gregory of Nyssa (d. after 394) says that such a perception may not necessarily be true, but this is irrelevant since it leads to a contemplation of virtue.[85] Cosmas Indicopleustes, writing in the early sixth century, also associates these colours with the four elements.[86] In the tenth-century Book of Ceremonies, some sort of hierarchy of colours is suggested in the different colours ascribed to the garments of various officials up to the level of emperor, though the actual details and meanings of these is never explicitly stated.[87] This is not to say that hue had no significance but to emphasize the changeable nature of that significance.

The issue of colour symbolism is one of the areas where East and West seem to diverge. In the West, colour symbolism, even if unfixed, is made far more explicit: colours tend to be equated with meanings more than in the East. Gage quotes Innocent III in the thirteenth century as describing black as the colour of penance and mourning and therefore suitable for clerical vestments during Advent and Lent.[88] Pastoureau provides a lexicon of colour for the West and notes that colour references in Western literature tend to be either emblematic or taxonomic.[89] He tabulates colours with virtues and vices; red, for example, is a sign of chastity or courage, or alternatively of cruelty and anger.[90] This outlook is clear in attitudes to the rainbow, within which context green and red are seen as symbols of destruction by flood and fire.[91] Western rainbows appear different enough to warrant their own study.[92] In the East, this explicit symbolism is a

[83] Malalas, *Chronographia*, 7 4; ed. L. Dindorf (Bonn, 1831), 174–7.

[84] Jerome, *Epistle*, 64 18; Philo, *Vita Mosis*, II 118. Tertullian, on the other hand, regarded this sort of comparison as idolatrous.

[85] *Life of Moses*, II 191; *PG* 44, 388C–389A.

[86] *Christian Topography*, ed. and trans. by W. Wolska-Comus; *Topographie chrétienne*, ii (Paris, 1970), v. 35. 63 merely says that the four colours of ὑάκινθος, πορφύρεος, κόκκινος, and βύσσος represent the four elements. His account of the tabernacle, v. 22–4. 43–9, and of the High Priest's vestments, v. 45–7. 75–9, makes little reference to either colours or their symbolism.

[87] In my opinion, the *Book of Ceremonies* does not provide an adequate guide to the colours of court costume since there is little standardization of vocabulary, as I have already indicated. In addition, I am not convinced that the *Book* provides

an accurate account rather than a somewhat idealized one of what actually happened at the Byzantine court (and if it does, how long is this account valid for?). For these reasons, a comparison between the *Book of Ceremonies*, Pseudo-Codinos, and artistic representations of court costumes seems fraught with more problems than solutions. On the problems inherent in using the *Book of Ceremonies*, see M. McCormick, 'Analysing Imperial Ceremonies', *JÖB* 35 (1985), 1–20. [88] Gage, 'Colour in History', 107.

[89] M. Pastoureau, *Figures et couleurs: étude sur la symbolique et la sensibilité médiévale* (Paris, 1986).

[90] Ibid. table I, 40.

[91] Gage, 'Colour in History', 107, makes this point and relates it to Gregory the Great. However, it is not correct to extend this automatically to Byzantium, since it does not appear to be a feature of any Byzantine source.

[92] For example, they tend to be two or three coloured. See

late feature; examples tend to be from after 1204, and may well derive partially from Western influences.[93]

A single-band rainbow is almost invariably red. It is possible to see red as a colour indicative of light, not necessarily that of pure divinity in the sense in which white is used,[94] but light in the sense that Pseudo-Dionysius uses it. It is the sign of fire—'the red [Apocalyptic horse] is the power and sweep of fire'[95]—and the 'word of God seems to honour the depiction of fire above all others'.[96] Fire and light are seen to be related concepts. The *Souda*'s entry under ἶρις makes this point. In art, red is the colour of the angel shepherding the sheep in the scene representing the parable of the sheep and the goats at Sant' Apollinare Nuovo in Ravenna. In the Mausoleum of Galla Placidia, it forms the heart of the stars on the blue ceiling; and in the Paris Psalter, red is the colour of the heavens from which God's hand emerges in the scene depicting the prayer of Isaiah.[97] Red is also significant in other contexts of aspects such as life and blood.[98] Red is the one colour consistent in every literary description of the rainbow where colour is used and in all naturalistic depictions of rainbows.

Non-naturalistic rainbows which are not red are predominantly blue and grey/silver. This also suits the concept of the rainbow as light, for blue, next to gold, is the colour of divine light.[99] John of Gaza described a painting of the universe in a bath house in Gaza. This had at its centre a gold cross set against three concentric circles of blue: he called these circles an image (τύπος) of the Trinity and the heavenly sphere.[100] Christ's mandorla in the Transfiguration is generally in shades of blue and silver, as is the case at Daphni, or blue as in the manuscript associated with John Cantacuzenos.[101] The mandorla represents the immaterial light of divine visions and the presence of the divinity. In early Christian art, its use is restricted to the Transfiguration and to the miraculous appearance of God in the Old Testament.[102] The similarities in colour and

P. Dronke, 'Tradition and Innovation in Medieval Western Colour Imagery', *ErYb* 41 (1972), 69–70.

[93] This use of colour symbolism is found, for example, in a 15th-cent. ekphrasis describing an icon of the Virgin and Child by John Eugenikos in *Anecdota Nova*, ed. J. E. Boissonade (Paris, 1844), 335–40. See also the quotation in G. Galavaris, 'The Stars of the Virgin', *Eastern Churches Review*, 1 (1966–7), 369.

[94] In writings on the Transfiguration, for example (see above, n. 65), or as Pseudo-Dionysius uses it in, for example, *Celestial Hierarchy*, XV 8, PG 3, 337A, where whiteness is 'the gleam of . . . kinship with the light of God'.

[95] Ibid. PG 3, 337B. [96] Ibid. XV 2. PG 3, 328C.

[97] Paris Gr. 139, fo. 435ᵛ.

[98] Pliny, *Natural History*, XXX 98–9, says that red is

significant in this way. On the symbolism of red in the Classical world, see Rowe, 'Conceptions of Colour', 357–8. This aspect of red seems to be a general cultural referent: see Sahlins, 'Colors and Cultures'.

[99] P. Reutersward, 'What Colour is Divine Light?', in T. B. Hess and J. Ashbery (eds.), 'Light, from Aten to Laser', *Art News Journal*, 35 (1969), 108–27; Gage, 'Colour in History', 110–11.

[100] John of Gaza, *Ekphrasis*, τοῦ κόσμικου πίνακος, I 41–4. Text in *Johannes von Gaza und Paulus Silentarius*, ed. P. Friedländer (Leipzig, 1912), 137–8.

[101] Paris Gr. 1242, fo. 92ᵛ.

[102] On these themes, see A. Grabar, 'The Virgin in a Mandorla of Light', in K. Weitzmann (ed.), *Studies in Honor of A. M. Friend jr.* (Princeton, NJ, 1955), 305–11.

context of rainbow and mandorla underline their association in meaning. But at Sant'
Apollinare Nuovo, in the scene of the parable of the division of the sheep and the goats
referred to above, blue is used for the angel shepherding the goats, a negative use of the
colour. Context here defines significance.

Gold (probably represented in some cases by yellow) is another means of represent-
ing divine light. Gold is the most precious metal, the paradigm of purity. It is employed
as a sign of light and divinity by St Basil and Pseudo-Dionysius.[103] Gold does not rust,
decompose, or wear and can be beaten to the fineness of air. Gold was used to invoke
the transcendental nature of the Incarnate Christ. Gold and red also seem related in
significance. Gold tesserae are frequently bedded on red ground, as is the case at Nea
Moni and the Kariye Camii, whilst other tesserae are put on plaster painted the same
colour. Gold thread is often wound round a red core. Clearly, practical reasons play
some part in this (a red background makes gold tesserae appear deeper and more glow-
ing), yet there may be some further significance. The colour scales of the *Souda* lexicon
and of Psellos both place red and yellow together; $\xi\alpha\nu\theta\delta\varsigma$ and $\pi\upsilon\rho\rho\delta\varsigma$ convey both
'yellow' and 'red'.[104]

Desire for fixed order, for a scheme into which everything fits neatly, is a legacy of
nineteenth-century scholarship and the 'scientific' cast of mind, in which nothing is
valid unless defined and categorized. But Byzantium was a society in which multiple
references and associations were keenly appreciated, and limitations of category
avoided. The Byzantines knew, for example, that the devil is recorded both as an
angel of light and as 'the great serpent'. Possession by demons was essentially random:
entirely innocent people could be possessed, not through moral failings but through a
lack of caution. Demons could take any form; evil was recognizable through its
deeds.[105] As for good, 'the Son of Man is coming at an unexpected hour' in an
unknown form.[106] If good and evil were so random in appearance, how could the
colours used to represent them be any more settled?

In the same way, the rainbow is both light and colour; the hue, as far as this is
analysed in Byzantium, is seen as a product of reflection, and less important than
the aspect of light. That no one set of colour terms or uniform system of representa-
tion exists is not surprising. The rainbow is not perceived in such uniform hue
terms in Byzantium, but in terms of glory and brilliance. 'The beauty of the carving
is extraordinary, and wonderful in the appearance of the cavities which, overlaid

[103] *Celestial Hierarchy*, II 3, *PG* 3, 141B. See A.
Stojakovic, 'Jésu-Christ, source de la lumière dans la
peinture byzantine', *CahCM* 18 (1975), 271 and n. 9.

[104] *Suidae Lexicon*, ed. A. Adler (Leipzig, 1928-38),
φαιός, 709-10; Michael Psellos, *De Omnifaria Doctrina*, 64,

PG 122, 728C.

[105] See C. Mango, 'The Devil', *BBBS* 13 (1987), 47;
J. B. Russell, *Satan: The Early Christian Tradition* (Ithaca,
NY, 1981); C. Mango, 'Diabolus Byzantinus', *DOP* 46
(1992), 215-24. [106] Luke 12: 40.

with gold, produces the effect of a rainbow, more colourful than the one in the clouds.'[107]

So there is no overwhelming consensus as to the specific colours of the rainbow, though the hues associated with it do all fit into the same basic colour bands. For the naturalistic rainbow, Aristotle's three bands, red, green, and purple, are echoed in a variety of vocabulary by most of the sources. The *Souda's* ἶρις definition suggests an alternative reading in terms of brightness, a reading which suits the three bands as well, if not better, than one based on hue. Most texts, both secular and religious, are content to call the rainbow 'many-coloured' and expand on the nature of its formation from light. Where the rainbow is represented in a non-naturalistic way, the colours employed are significant of light and divinity. However, it is clear that context—in this case the rainbow as a sign of divine glory—is more important than the hue in defining the meaning. The three major rainbow colours are linked with the elements, by the *Souda* for example, and on a religious allegorical level, the significance in both pagan and Christian terms of the number three is well known.

Where they do exist, accounts of the rainbow concentrate on aspects that are, to us, unexpected. The rainbow as a sign of God's covenant, according to Genesis, is virtually ignored in surviving exegeses: its colours are put to little use; and it is not considered a portent—perhaps indicating how firm a grip this particular natural explanation held—or an omen. It tends to act almost exclusively as a minor natural phenomenon and a sign of glory. More important than colour is light, in both art and literature.

Modern emphases on the rainbow lie with the representation of its hues: Byzantine accounts and depictions appear incomplete, a demonstration of perceptual and artistic failure on this level. To regard these as schematic is the result of our own hue-based perceptions. Instead, it is necessary to accept a fundamental difference in Byzantine perceptions of colour, and a fundamental difference with regard to the use of colour in art. What I have begun to do here is to stress the perception of colour as the defining and formative element for the Byzantines in art, perhaps the single most important aspect of art, and consequently to emphasize the importance of issues such as colour symbolism and iconography in defining the nature of that art. A meaning is conveyed by a group of colours which seem totally unrelated otherwise, and the shades of meaning involved are not clear to us now. The broad symbolism is maybe explicable, not through relating hue usages but by examining Byzantine attitudes to the theme. An organized

[107] Nicholas Mesarites, 'Account of the Usurpation of John Comnenus "the Fat"', in A. Heisenberg (ed.), *Die Palastrevolution des Johannes Comnenus* (Würzburg, 1907), 44; trans. in C. Mango, *Art of the Byzantine Empire* (Toronto, 1986), 229, the description of the palace of the Mouchroutas.

form of colour (hue) symbolism does not seem to exist. Further, in emphasizing the significance of brilliance, a new dimension to Byzantine art is opened up in both stylistic and interpretative contexts. Whereas Byzantium is often conceived as a static world, its handling of colour suggests unexplored subtlety.

CHAPTER 6

The Rhetoric of Colour

The Church of the Holy Apostles

HAVING discussed the vocabulary of colour and the use of that vocabulary in descriptions of surviving images where we can relate the word to the actual hue, I intend to turn now to considering the use of colour in two highly rhetorical texts. Certain attitudes to, and perceptions of, colour have been established as intrinsic aspects of Byzantine attitudes to colour: how do these influence descriptions of works of art? Furthermore, those aspects of the colours used in a work of art which are considered significant enough to be noted and detailed by authors offer, in turn, a means of appre-hending what the Byzantines considered the role of colour in art to be.

The two texts considered here describe the same monument, the Church of the Holy Apostles in Constantinople. They thereby provide the opportunity to see the same building from two different perspectives and to compare and contrast those views.

Detailed descriptions are all that survive of the church, since the building was destroyed by the Turks after 1453. The original foundation was the work either of Constantine the Great or of Constantius II in the fourth century. Procopios notes a sixth-century rebuilding by Justinian, and provides a comprehensive account of the architecture and plan.[1] The Holy Apostles was the most important church in the city after Hagia Sophia, not only because of its size and dedication, but also through its function as the burial place of the emperors between the fourth and eleventh centuries, as well as its extensive collection of relics. Sources provide sundry brief remarks on the refurbishments of the church by Justin II and Basil I, but the most extensive descrip-tions are found in the poem of Constantine Rhodios[2] and the prose narrative of Nicholas Mesarites.[3]

Rhodios' work was written at some point between 931 and 944 at the request of the emperor, Constantine VII Porphyrogenitus.[4] It is divided into two sections: an

[1] Procopios, *Buildings*, I 9–24.

[2] For the text of Rhodios, see E. Legrand (ed.), *Description des oeuvres d'art et de l'église des Saints Apôtres de Constantinople* (Paris, 1896). An English translation for the Belfast Byzantine Texts series is now in process.

[3] Trans. and commentary by G. Downey, 'Description of

the Church of the Holy Apostles in Constantinople', *TAPS* NS 47: 6 (1957), 859–918.

[4] See G. Downey, 'Constantine the Rhodian: His Life and Writings', in K. Weitzmann (ed.), *Late Classical and Medieval Studies in Honor of A. M. Friend jr.* (Princeton, NJ, 1955), 215–16.

introduction and systematic narration of the seven wonders of Constantinople, together with a brief, generalized account of some of the other marvels of the city; and a description of the Church of the Holy Apostles. This begins with a complex, confusing account of the architecture and plan of the building and goes on to describe the mosaics, commencing with representations of Christ, the Virgin, and the Apostles, and then twelve narrative scenes from the life of Christ in chronological order. Seven of these scenes are called *thauma* to balance the seven wonders of the first part. The work breaks off abruptly in the middle of the Virgin's lament for Christ at the Crucifixion.

Mesarites wrote his work between 1198 and 1203, and dedicated it to Patriarch John X Camaterus. The text consists of forty-three prose chapters and starts by placing the church topographically within the city. The account of the plan and architecture is less detailed than that of Rhodios, and Mesarites moves swiftly in to his description of the mosaics. He deals with twenty-two scenes in no particular order before concluding with a look at the sarcophagi of the famous in the church, a return to the forecourt of the church and an encomium to the Patriarch.

This textual evidence has been most frequently employed by scholars to analyse the patterns of mosaic development and the evolution of iconographic cycles in the Byzantine church.[5] The texts have been used as archaeological documents for the reconstruction of art works rather than as literary texts about art. Consequently, the crucial issue for art historians has been whether the texts describe the same set of mosaics or whether alteration on a major or minor scale took place in the intervening two hundred years or so. Debate centres on the discrepancies in the two accounts, both in subject-matter and style, felt by some to reflect a difference in fact as well as in perception.[6] This debate is essentially irrelevant to my argument. It is not necessary to establish what colour the mosaics were at a particular time, but to deal with how two different authors perceived them. The nature of the argument, however, demonstrates a considerable misunderstanding of the nature of Byzantine descriptions of art, a point to which I shall return later. On the issue of the relationship between the two sets of mosaics as described, I am prepared to follow the conclusions of Epstein. She feels that both accounts are essentially of a late ninth-century cycle, with eleventh- or twelfth-century

[5] For which, see O. Demus, *Byzantine Mosaic Decoration* (London, 1948); E. Kitzinger, 'Mosaics', *Encyclopaedia of World Art*, 10 (1965), cols. 341–9; R. S. Cormack, 'Ninth century monumental painting and mosaic in Thessaloniki', Ph.D. thesis (University of London, 1968); R. Krautheimer, 'A Note on Justinian's Church of the Holy Apostles in Constantinople' in his *Studies in Early Christian, Medieval and Byzantine Art* (New York and London, 1969), 197–201.

[6] As argued by O. Demus, *The Mosaics of San Marco in Venice*, i (Chicago, 1984), 234–41. Demus spends much time on comparing the mosaics of San Marco with the descriptions of Rhodios and Mesarites, but there is no definite reason to believe that San Marco reproduces its supposed prototype with any real accuracy: this would make it unique among medieval churches.

additions a possibility, and that differences in content and nature are attributable to changes in literary style.[7]

This issue of style is a key element in the discussion of these texts. Byzantinists have tended to believe that literary style obscures accuracy of description and access to perceptions. However, style itself is a means of expressing perception and what is written about colour says much about its use and appreciation. Both texts describe the same monument and much the same set of mosaics. This means that it is possible to compare perceptions of colour: how the authors see it, where and how they differ in their perceptions, and why.

The nature of colour perception in the texts is best approached through a summary description of its employment. Both texts reveal an apparent paucity in colour terms and their employment. This is not unexpected; Byzantine texts, as we have seen, are not particularly concerned to describe colour.

Rhodios' description contains few specific colour words. The most significant part of his poem in this sense is the section describing the different coloured marbles employed in the building of the Holy Apostles (lines 641–74). The building is beautiful because of the light-bearing nature of the stones and metals (lines 645–6). These stones are rose-coloured ($\dot{\rho}o\delta\acute{o}\chi\rho\omega s$), white-purple ($\lambda\epsilon\upsilon\kappa o\pi o\rho\phi\acute{\upsilon}\rho\epsilon os$), green ($\pi\rho\acute{a}\sigma\iota\nu os$) and like leaves, spotted like dragons' scales, sardonyx, and snow-coloured ($\chi\iota o\nu\acute{o}\chi\rho\omega s$). Throughout this passage, words like $\pi o\lambda\acute{\upsilon}\chi\rho\omega s$ and $\pi o\iota\kappa\acute{\iota}\lambda os$, meaning 'multicoloured', recur time and again, suggesting that this aspect of colour is highly favoured. Terms such as gold-gleaming ($\chi\rho\upsilon\sigma\alpha\upsilon\gamma\acute{\eta}s$) and translucent ($\delta\iota\alpha\upsilon\gamma\acute{\eta}s$) are common and serve to emphasize the effect of light on marble, in particular the gleaming play of that light. This emphasis on light is maintained throughout the poem with frequent references to the 'light-bearing' sun, moon, and stars, notably in the Virgin's lament (lines 946–81). The marbles are compared with flowers and at lines 694–6, these are scattered on 'numberless shoots of light' and then comparable with stars.

Elsewhere, Rhodios' account of the mosaics ignores all artistic aspects of the events taking place, with the exception of the Transfiguration where, as the Gospels say, mention is made of Christ's luminous white garments and shining face, and in the Betrayal, where the countenance of Judas is described as pallid ($\dot{\omega}\chi\rho\acute{o}s$) (line 891). Rhodios compares Christ, the Apostles, and the Virgin to the sun, stars, and moon (lines 737–41) and notes how the dome is covered with a mixture of gold and glass down to the multicoloured marbles.

[7] A. W. Epstein, 'The Rebuilding and Redecoration of the Holy Apostles in Constantinople: A Reconsideration', *GRBS* 23: 1 (1982), 79–92.

Mesarites seems to share Rhodios' admiration of chromatic diversity. In chapter XIII 2, he states that the church 'fills the sight with the beauty of its colours and by the gold-en gleam of its mosaics'. His account of the mosaics begins with a description of the Pantocrator noting (ch. XIII 8) how its lines 'are not plain, but . . . please the senses and impress the mind by their varied colours and the brilliance of the gold and the brightness of their hues'. This concern with reflectance and brilliance is apparent throughout. The description culminates in the colour of the Pantocrator's robe which is blue (κυάνεος) and gold (ch. XIV 8). There is, Mesarites says, a good and biblical reason for these colours: to reveal by example the ostentation of purple (πορφύρεος), scarlet (κόκκινος) and blue (ὑάκινθος), the latter colour of a different nature from κυάνεος since it carries overtones of the precious stone called ὑάκινθος. This contrasts with Rhodios' simpler account of this scene, which merely mentions Christ 'depicted like the sun'.[8]

Mesarites uses the same colours, red, purple, and gold, in his account of the Communion of the Apostles (ch. XV), a range which serves to create an effect of splendour. Emphasis is also placed on the glistening aspect of the gold and coloured stones. The Transfiguration (ch. XVI) stresses the role of light with its comments on Christ's garb, and, in the Crucifixion, Christ wears a grey (φαιός) garment, a 'sign of suffering and burial' (ch. XVII 2). Other uses of colour come in chapter XX 2 6, Luke preaching at Antioch, where the white healthiness of the Antiochenes is con-trasted with the yellow (ὠχρός) diseased pallor of others.[9] In the scene of the women at the tomb (ch. XXVIII), the same word, ὠχρός, is used to describe the shocked colour of the women, on their discovery of the angel and the empty tomb.

In chapter XX, the colours of the head-dresses of the Saracens and Persians are described. These are scarlet (κοκκοειδής), white (λευκός), and sky-coloured (οὐρανόχροιος). The red blood of Christ, visible in the Doubting of Thomas, is com-pared to the ink used by the emperors as 'the true confirmation of their commands' (ch. XXXIV 7). In similar style, while writing about the tombs of the famous, Gregory of Nazianzus is described as buried in a fiery-coloured (πυρρακίζουσα) sarcophagus because he was fiery (πυρράκης) with spiritual beauty (ch. XXXVIII 4).

Mesarites also stresses the glittering nature of the walls and columns of the church where the stone is cut so finely that 'the wall seems to be covered with many-coloured woven cloths' (ch. XXXVII). However, unlike Rhodios, he places little overall emphasis on the marbles.

[8] Rhodios, line 737.
[9] Downey, 'Description of the Church of the Holy Apostles', 875 n. 4 suggests that this reference to the Antiochenes is an attempt to enhance their dignity as Christians as opposed to their later reputation.

In both texts, the actual colour vocabulary is not extensive. Little overall attention within the context of such long and detailed pieces is actually paid to the colours of the works of art. Reading them from the perspective of modern hue-based perceptions, the first conclusion is that colour is an unimportant aspect of description. Reading from a Byzantine perspective (in so far as that is possible), a very different picture can be obtained, for, within each text, several contrasting ideas of colour are apparent, used to provide several different results.

Rhodios' colour words indicate a concern with polychromacity, apparent in his use of terms such as white-purple, and with combinations of shades and their resemblance to nature. His emphasis lies with the shifting, inconstant, and transient nature of colour; his interest is luminosity. He is not concerned to record hue, 'redness'. Just as Classical theories of perception do not see colour as a property of light but hold that light affects and alters colour,[10] so too for the Byzantines.

Rhodios' passage describing the marbles is very close in content and style to Paul the Silentiary's sixth-century account of Hagia Sophia.[11] It is not a copy, however: Rhodios' poem is much shorter and uses different colour words, and, moreover, seems to have been written for a different purpose.[12] Both place much emphasis on the origin of the marbles, a means of displaying the topography of the Byzantine world and reinforcing the myth of Empire, but Paul is far more concerned with glitter (617) whilst Rhodios also emphasizes chromatic diversity and colour combinations:

> 640 εἴτ' Ἀνθέμιος, εἴτ' Ἰσίδωρος νέος,
> ὕλαις ἀπείροις μαρμάρων πολυχρόων
> καὶ λαμπρότησι τῶν μετάλλων τῶν ξένων
> ἐπενδύσας τε καὶ καλῶς συναρμόσας,
> ὁποῖα νύμφην κροσσωτοῖσι χρυσέοις
> 645 ἢ παστάδα χρύσαυγον ὡραϊσμένην
>
> 650 ἐκ μὲν Φρυγίας συνάγων μακροὺς στύλους,
> καὶ Δοκιμίου κίονας ῥοδοχρόους,
> ἐκ Καρίας δὲ λευκοπορφύρους πλάκας,
> ἐκ δ' αὖ Γαλατῶν κηρομόρφους συνθέτας,
>
> Rhodios, 640–5 and 650–4[13]

[10] J. Gage, 'Colour in History: Relative and Absolute', *Art History*, 1 (1978), 104–30.

[11] 'Ekphrasis', in *Johannes von Gaza und Paulus Silentiarius*, ed. P. Friedländer (Leipzig-Berlin, 1912), 227–56.

[12] On the function of Paul's poem, see R. Macrides and P. Magdalino, 'The Architecture of Ekphrasis: Construction and Context of Paul the Silentiary's Ekphrasis of Hagia Sophia', *BMGS* 12 (1988), 47–82; for Rhodios', see Downey, 'Constantine the Rhodian'.

[13] 'Either Isidore or Anthemius prepared the church, clothing it with boundless forests of many-coloured marbles and the brightness of foreign metals, clothing it and putting it together finely like a bride with golden tassels or a gold-gleaming bridal chamber made beautiful with flashing

as against

λοξοτενεῖς φαίνουσα, καὶ ὁππόσα Λύδιος ἀγκὼν
ὠχρὸν ἐρευθήεντι μεμιγμένον ἄνθος ἑλίσσων·
ὅσσα Λίβυς φαέθων, χρυσέωι σελαγίσματι θάλπων,
χρυσοφανῆ κροκόεντα λίθων ἀμαρύγματα τεύχει
ἀμφὶ βαθυπρήωνα ῥάχιν Μαυρουσίδος ἄκρης·
ὅσσα τε Κελτὶς ἀνεῖχε βαθυκρύσταλλος ἐρίπνη
χρωτὶ μέλαν στίλβοντι πολὺ γλάγος ἀμφιβαλοῦσα
ἔκχυτον, ἧι κε τύχηισιν, ἀλώμενον ἔνθα καὶ ἔνθα·
ὅσσα τ' Ὄνυξ ἀνέηκε διαυγάζοντι μετάλλωι
ὠχριόων ἐρίτιμα, καὶ Ἀτρακὶς ὁππόσα λευροῖς
χθὼν πεδίοις ἐλόχευσε καὶ οὐχ ὑψαύχενι βήσσηι,
πῆι μὲν ἅλις χλοάοντα καὶ οὐ μάλα τῆλε μαράγδου,
πῆι δὲ βαθυνομένου χλοεροῦ κυανώπιδι μορφῆι·
ἦν δέ τι καὶ χιόνεσσιν ἀλίγκιον ἄγχι μελαίνης
μαρμαρυγῆς, μικτὴ δὲ χάρις συνεγείρετο πέτρου.

Paul, 632–46[14]

Terms such as 'Dokimios' are semi-technical terms indicating a particular sort of marble, of a particular colour. Dokimion marble, for example, came from Turkey and was white and mottled.[15]

Descriptions of marble in literature developed from the essentially topographical accounts of authors such as Statius in the first century to the more metaphorical accounts of Choricius of Gaza in the fifth century and Paul the Silentiary himself in the sixth.[16] They not only describe the church interior, but also make claims about the extent and glories of the empire. Rhodios maintains this tradition. In both Paul's and Rhodios' poems, the emphasis falls on iridescence, shine, and gleam. In Rhodios' account, there is a feeling of luxuriance and of the dynamics of colour. The writing is meticulously precise, with much use of simile and metaphor. In his concern for multicoloured effects, Rhodios' account seems also to indicate a slow alteration in colour perception,

signals. . . . From Phrygia they brought together tall pillars and rose-coloured capitals of Dokimios and white-purple slabs from Caria.'

[14] 'There is a wealth of porphyry stone . . . besprinkled with little bright stars . . . The glittering crocus-like stone which the Libyan sun, warming it with its golden light, has produced . . . that of glittering black upon which the Celtic crags deep in ice have poured here and there an abundance of milk; the pale onyx with glint of precious metal . . . It has spots resembling snow next to flashes of black so that in one stone various beauties mingle' (trans. C. Mango, The Art of the Byzantine Empire (Toronto, 1986),

85–6).

[15] R. Gnoli, Marmora Romana (2nd edn., Rome, 1988,) describes and illustrates the various types of marble used in the Roman and Byzantine periods. All of Rhodios' examples are identified in this book. See also D. Strong and A. Claridge, 'Marble Sculpture', in D. Strong and D. Brown (eds.), Roman Crafts (London, 1976), 204–5.

[16] J. Onians, 'Abstraction and Imagination in Late Antiquity', Art History 3 (1980), 1–24, suggests that the sort of description comparing marble to flowering meadows, rivers, etc., represents a difference and greater range in perception for the spectator.

forming part of a gradual shift away from the Classical emphasis on colour as brilliance towards a more modern appreciation of colour simply in hue terms: the difference between Rhodios' 'rose-coloured capitals' and Paul's 'glittering crocus-like golden stone', perhaps.

It has been said that Rhodios is merely writing within the traditions of the so-called 'ekphrasis' or description of a work of art, and that passages such as this account of the marbles are merely topoi, rhetorical devices designed to show off the poet's skill and Classical knowledge. This raises several issues. Though ekphrasis may be simply and broadly defined, in the words of the second-century AD rhetorician, Hermogenes of Tarsus, as a description of 'persons, deeds, times, places, seasons and many other things',[17] and as being vivid and full of detail, this barely touches on its complex nature. Classical and Late Antique rhetorical handbooks make it clear that ekphrasis is less a genre in itself than a technique employed in writing.[18] As such, it contains standard attributes of rhetoric such as emotionalism, paradox, cliché, paraphrase, quotation, allusion, and the use of topoi or stock themes; it does not translate into 'a description of works of art'.[19]

Ekphrasis does not aim to describe a monument as an art historian might; instead, its purpose is to 'turn listeners into spectators'.[20] It is used as a rhetorical device in order to build up descriptions, describing emotions and attitudes for the listener, who is also a viewer, to put next to the object. Within the description, the subject-matter is retranslated and re-enacted for the listener/reader to experience within the context of their own perceptions.[21] This may lead to omission, distortion, obscurity, and confusion, but is unlikely to result in deliberate falsehood, dead language, and incomprehensibility, particularly if the subject is still in existence. 'Rhetoric' is not, and should not be seen as, a term of condemnation; it is a means used by the Byzantine author to achieve an end through the informed and relevant employment of various techniques.[22]

[17] *Progymnasmata*, 10, ed. H. Rabe (Leipzig, 1913), 22. Γίνονται δὲ ἐκφράσεις προσώπων τε καὶ πραγμάτων καὶ καιρῶν καὶ τόπων καὶ χρόνων καὶ πολλῶν ἑτέρων. Quoted in H. Maguire, 'Truth and Convention in Byzantine Descriptions of Art', *DOP* 28 (1974), 114.

[18] For ekphrasis as a technique not a genre, see L. James and R. Webb, '"To Understand Ultimate Things and Enter Secret Places": Ekphrasis and Art in Byzantium', *Art History*, 14 (1991), 1–17.

[19] On the nature of ekphrasis, see Maguire, 'Truth and Convention'; H. Maguire, *Art and Eloquence in Byzantium* (Princeton, NJ, 1981); Macrides and Magdalino, 'Architecture of Ekphrasis'; James and Webb, 'Ekphrasis and Art in Byzantium'. L. Brubaker, 'Perception and Conception: Art, Theory and Culture in Ninth Century Byzantium', *Word and Image*, 5 (1989), 19–32, notes the differences in Byzantine perception expressed in the ekphrastic tradition.

The image of the 'distorting mirror' of Byzantine literature and rhetoric was introduced by C. Mango, 'Byzantine Literature as a Distorting Mirror', in *Byzantium and its Image* (London, 1984).

[20] Nicholas Rhetor, *Progymnasmata*, περὶ ἐκφράσεως, ed. J. Felten (Leipzig, 1913), 68. ἢ δὲ πειρᾶται θεατὰς τοὺς ἀκούοντας ἐργάζεσθαι. These arguments are laid out more fully in James and Webb, 'Ekphrasis and Art in Byzantium'.

[21] Textual criticism studies make the relationship of author and reader through the sending and receiving of images based on a shared code of communication clear. See e.g. S. R. Suleiman and I. Crosman (eds.), *The Reader in the Text* (Princeton, NJ, 1980). In this context, there is the added dimension of the existence of the actual image and its 'real' and 'created' perceptions of both author/spectator and auditor/spectator/reader.

[22] For the importance of rhetoric in Byzantine education,

The relationship between visual and verbal in Byzantium is less one of commentary than of parallel function and physical accompaniment.[23] Ekphrasis is conceived as running parallel to art. It aims to articulate things which cannot be seen with physical eyes, stating explicitly what is implicit in the image for the Byzantine viewer: as Mesarites says, it is necessary to 'look at things [in the church] with the eyes of sense and to understand them with the eyes of the spirit'.[24] Ekphrasis offers a way in to this understanding. Only thus is it possible to 'understand the ultimate things and to enter the secret places'.[25]

Basil the Great said 'that which the spoken narrative presents through hearing . . . silent painting shows through imitation'.[26] That the ekphrasis as a style permitted variants on the same subject is immediately apparent in a comparison of the works on the Holy Apostles. Rhodios and Mesarites frequently say 'you will see' or instruct the reader/viewer/auditor to learn or look. The medieval spectator was impressed not only by precious metals but also by the craft workers' power to turn them into images: the listener who was also spectator respected not only the writer's skill and learning but, further, their ability to turn both skill and learning into images. There is no reason why these works should not have been understood by the 'average' Byzantine audience any more than Shakespeare should not be understood by the 'average' modern audience.

Consequently, when Rhodios talks of colours in a style resembling that of Paul the Silentiary, he is subscribing to literary convention but, within that, he uses it to describe the perceptions of his own time, perceptions which are not automatically identical to Paul's. For example, Paul tends to see art objects as a part of architecture (lines 682 on); Rhodios does not. Mesarites' differences within the genre result from a further development of perception.[27] Both Rhodios and Mesarites, however, and indeed all writers using the technique of ekphrasis, use colour as a means, not simply of describing what is there, but of penetrating to the secret places, as a part of the ekphrastic technique.

Mesarites says (ch. XIII 2), echoing Plato, that beauty is perceived by the sight as colour and by the mind as a form of geometry. He uses colour in three major ways, and in all of these Classical influences are apparent. There are times when colour is mentioned simply in hue terms, though this is usually overlain with concern for the gleaming effect (the Communion of the Apostles) or with concern for literary metaphor (the emperor's signature, Gregory's sarcophagus), and is almost invariably, as in the

see R. Webb, 'A Slavish Art? Language and Grammar in Late Byzantine Education', *Dialogos*, 1 (1994), 81–103.

[23] Macrides and Magdalino, 'Architecture of Ekphrasis', are at pains to stress the relationship on many levels between Paul the Silentiary's work and the actual monument of Hagia Sophia. Similar perceptions are also found in R. S. Cormack, *Writing in Gold* (London, 1985), esp. ch. 2.

[24] Mesarites, ch. XII.

[25] Ibid.

[26] Basil, *Homily*, 19, On the Holy Forty Martyrs, PG 31, 509A. Ἃ γὰρ ὁ λόγος τῆς ἱστορίας διὰ τῆς ἀκοῆς παρίστησι, ταῦτα γραφικὴ σιωπῶσα διὰ μιμήσεως δείκνυσιν. Philostratus expressed a similar idea, *Imagines*, I, saying that poets and painters φορὰ γὰρ ἴση ἀμφοῖν ἐς τὰ τῶν ἡρώων ἔργα καὶ εἴδη.

[27] Epstein, 'Rebuilding', 82–3.

examples cited above, underlain with symbolism. Symbolism is sometimes employed in a very obvious way; a colour is mentioned and then a reason for this colour provided, as is the case with the Pantocrator's robes and the garment of the crucified Christ.

The colour vocabulary of both Rhodios and Mesarites is basically Classical, but in their love of the multi-coloured, both authors are only too happy to create new terms or bring to the fore rarely used colour words. These compounds act as secondary colour terms. Rhodios uses white ($\lambda\epsilon\upsilon\kappa\acute{o}s$), in compound with $\chi\rho o\iota\acute{a}$ 'colour'; the bulk of his colour words are made up of this sort of compound. He has three terms for 'red', of which the $\dot{\epsilon}\rho\upsilon\theta\rho\acute{o}s$ version is used in compound form, and three for 'blue'. The basic blue of Classical texts is, of course, $\kappa\upsilon\acute{a}\nu\epsilon os$, and the shortage of words for 'blue' has already been noted, so Mesarites' three are striking. None of his colour words is unexpected except for the unusual $o\dot{\upsilon}\rho\alpha\nu\acute{o}\chi\rho o\iota os$, though there is a parallel for this in Hesychius' $o\dot{\upsilon}\rho\alpha\nu o\epsilon\iota\delta\acute{\eta}s$.[28] Mesarites' text may possibly provide another indication of a gradual linguistic development towards the Modern Greek concern with hue in its colour terms. A similar alteration is apparent in Modern English when compared with Anglo-Saxon.[29]

Even when a word is used within the context of hue, it is clear that other qualities such as luminosity, reflection, brilliance, and glitter are of more concern. In these texts, a colour word is never used in the context of hue alone without some other meaning behind it. Just as the interest in brightness is apparent in the practical context of the production of mosaics: the angling and aligning of tesserae; the study of optics for the best light effects; the emphasis on the glittering effect that mosaic can create, so also the language of Byzantine literature expresses these concerns.

There is also much evidence for the metaphysical appreciation of light. Such a concept may derive ultimately from the negative theology of the fifth/sixth-century theologian Pseudo-Dionysius, touched upon in the previous chapter. Expressing the concept of God as darkness and the association of light and life, light and the immaterial, Pseudo-Dionysius stressed colour as light materialized, beyond which is the transcendent darkness of God which remains hidden from all light and concealed from all knowledge.[30] 'The divine darkness is that "unapproachable" light where God is said to live.'[31]

This perception of divine light seems to lie behind both Rhodios' and Mesarites' descriptions of the Transfiguration, with their emphases on the light-bearing garments

[28] See $\kappa\upsilon\acute{a}\nu\epsilon os$ in the glossary to Ch. 4.
[29] See N. F. Barley, 'Old English Colour Classification: Where Do Matters Stand?', *Anglo-Saxon England*, 3 (1974), 15–28.
[30] *Epistle*, I, *PG* 3, 1065A; trans. C. Luibheid, *Pseudo-*

Dionysius—The Complete Works (London, 1987), 263.
[31] *Epistle*, V, *PG* 3, 1073A, and Luibheid, *Complete Works*, 265. $\dot{o}\ \theta\epsilon\hat{\iota}os\ \gamma\nu\acute{o}\phi os\ \dot{\epsilon}\sigma\tau\grave{\iota}\ \tau\grave{o}\ \dot{a}\pi\rho\acute{o}\sigma\iota\tau o\nu\ \phi\hat{\omega}s,\ \dot{\epsilon}\nu\ \hat{\phi}\ \kappa\alpha\tau o\iota\kappa\epsilon\hat{\iota}\nu\ \dot{o}\ \Theta\epsilon\grave{o}s\ \lambda\acute{\epsilon}\gamma\epsilon\tau\alpha\iota.$

of Christ. Mesarites' account also succeeds in suggesting that the union of God and man in the transfigured Christ was productive of darkness, a phenomenon beyond comprehension (ch. XVI 7). The change in colour of divine light is intriguing: in representations of the Transfiguration, as at St Catherine's monastery, and at Daphni, the mandorla of Christ is dark at the centre, growing lighter as it moves outwards and, where it touches the apostles' robes, they change colour (Plate 63). Something of this is conveyed by Mesarites.

Homilies on the Transfiguration describe it as a feast of light, emphasizing the splendour of light and reflecting the glory of the transfiguration and the relationship between God and man in Christ—'he is the light on high and he is that light revealed in flesh'.[32] Origen wrote 'since there are even degrees among white things, his garments became as white as the brightest and purest of all white things, that is light'.[33] This connection between white, purity, and light is highly significant. Lights act as symbols of life and hope both in metaphor and in daily life; the emphasis placed on them is thus hardly surprising.[34]

In medieval perception, symbols were believed to be objective and to reflect faithfully various aspects of the universe seen as widely and deeply meaningful.[35] In the medieval world, symbols represented events and facts and led to the metaphysical world that could be encompassed by faith and theology. Within Byzantium, symbols seem to have operated in a variety of ways. There could be the hidden meaning behind the scene visible only to the initiate—Moses and the brazen serpent prefiguring Christ; the imagery associated with an object—the vine—and so on. In depicting Christianity, Byzantine art was forced to apprehend and convey ideas and concepts that are not easy to portray: divinity; God made man. By the period of these texts, this form of symbolism had become increasingly conventionalized. Colour as symbol is consequently loaded with metaphysical meaning, much of which can only be guessed at and all of which alters with context. Nevertheless, as a part of art, colour could not be 'meaningless' and random in its use.

[32] Clement of Alexandria, *Excerpts from Theodotus*, 4–5, *PG* 9, 656A–D. See J. A. McGuckin, *The Transfiguration of Christ in Scripture and Tradition* (New York, 1986) for translations of the Patristics on the Transfiguration. For Clement, see 149–50. The role of Hesychasm in influencing attitudes towards divine light and so possibly the pictorial colour of light is another important but underdeveloped field.

[33] Origen, *Commentary In Matthaeum*, 12 36–43, *PG* 13, 1059–86, and McGuckin, *Transfiguration*, 157.

[34] See Macrides and Magdalino, 'Architecture of Ekphrasis', 73. They cite Malalas' story of how lights were lit

through Constantinople to reassure people as to the well-being of the emperor. In the ekphrasis of Paul the Silentiary, light descriptions culminate in the image of Hagia Sophia as a divine light guiding humanity.

[35] G. B. Ladner, 'Medieval and Modern Understanding of Symbolism: A Comparison', *Speculum*, 54 (1979), 223–56; M. D. Chenu, 'The Symbolist Mentality', in J. Taylor and L. K. Little (trans.), *Nature, Man and Society in the Twelfth Century. Essays on New Theological Perspectives in the Latin West* (Chicago, 1968), 99–148. I am grateful to Martin Kauffmann for this reference. And also Pseudo-Dionysius, *Celestial Hierarchy*, II, *PG* 3, 136.

In Mesarites' account, colour 'symbolism' tends to be overt and covert in its use. The description of the Pantocrator's robes emphasizes the ostentation of purple, frequently employed as a sign of arrogance in the Classical Greek world, but a sign of power in the Roman and Byzantine ages, and of scarlet and ὑάκινθος-blue.[36] In contrast to these stand gold and κυάνεος-blue. The value of gold as the purest and highest of the metals[37] is underlined by its use as a representation of divine light in haloes and backgrounds, and its possession of the essential qualities of reflectance and brilliance. We have already seen how divine light could also be pictured as blue.[38]

So here, the description of Christ clothes him in the spiritual holiness of light rather than in earthly splendours—in this case, costly dyes and precious stones. This, I feel, is the distinction between the two types of blue mentioned by Mesarites. Cost is an indication of regard; lapis lazuli (which may be the translation of the noun ὁ κύανος) was the rarest and most expensive pigment known to the Byzantines. There is no evidence for lapis being used in tesserae, so the use of κύανος may reflect simply the common word for 'blue', but by suggesting the concept of value it is also symbolically significant. Deeper symbolic meanings such as the significance of red and gold draperies and the blue and purple of the upper room (ch. XV 3) beyond their immediate costly and visual effect can only be surmised.

That red could be used to denote some aspect of divinity and light has already been discussed.[39] Here, I would like to add Gregory of Nyssa's remark that the redness of blood and wine bore a eucharistical significance.[40] The Classical and Roman links of red with life, blood, and magic[41] may also lie behind Mesarites' description of Gregory's tomb as fire-coloured, and the parallel drawn between the colour of Christ's blood and the emperor's signature on official documents. This link also hints at the belief in the emperor as Christ's deputy on earth, a key issue in Byzantine ideology.

Symbolism in language also seems to have a part. The compound 'heaven-coloured' (οὐρανόχροιος) suggests a sense based on the meaning of ὁ οὐρανός and the connotations we might assume this as having. Indeed, it may well be correct to make these sorts of inferences although the context of the word, the colour of the head-dresses of the Saracens and Persians, and the shortage of terms generally describing the colour of the sky imply that its meaning is not necessarily so obvious. It seems that in the cases of blue (κυάνεος) and green (πράσινος), colour, rather than the actual object ('sky', 'leek') has become the dominant meaning of the words: they are invariably used as colour adjectives and not as substantives.[42]

[36] For an ostentatious use of purple in the Classical world, see Aeschylus, *Agamemnon*, 910–11, 920–8.

[37] See A. J. Hopkins, *Alchemy, Child of Greek Philosophy* (New York, 1934), 37, 69, 96–7, on this theme.

[38] See above, Ch. 5.

[39] See above, Ch. 5.

[40] *Commentary on the Song of Songs*, 4, PG 44, 845A–C.

[41] See above, Ch. 5.

[42] On this division of colour terms, see B. Berlin and P.

For other words such as ὠχρός and χλωρός, other aspects seem prevalent. As in Psellos' account in the *Chronographia* of the Antiphonetes image,[43] so in both texts dis‑cussed here, ὠχρός, 'pale, yellow', is used in a negative context: Judas at the betrayal,[44] the frightened women at the tomb. It carries very strongly the element of 'pallid' or 'wan', pale in a sense opposed to the pale of χλωρός, meaning 'fresh', 'green', as was made clear in the glossaries of Classical and Byzantine colour words.[45]

Alexander Kazhdan's study of the use of colour in the works of the twelfth–thirteenth‑century author, Nicetas Choniates, offers a contrasting view of Byzantine colour perception.[46] Kazhdan notes that a broad range of colours and shades is used in eleventh‑ and twelfth‑century painting, but that written sources tend to mention only a limited set of 'traditional' colours which allow only standard formulaic descriptions. Skilled authors could manipulate this range and, by providing stereotypes in fresh combinations and new perspectives, could give the colours new life. Whiteness, he claims, is a positive quality, indicative of goodness and purity, but 'if whiteness is good‑ness and purity, then to be multicoloured is to be impure, bad, corrupt'.[47] Kazhdan argues that the reason why Byzantine authors were unwilling to push back the boundaries of chromatic convention was an ingrained aversion to this sort of diversity, not an inability to perceive different colours: 'if a Byzantine reader came across a multi‑coloured description, he would not simply find it strange and unfamiliar; he would probably assume that he should adopt a negative attitude to the object or person so described.'[48] This, however, is clearly not the case indicated by the descriptions of the church of the Holy Apostles, nor even by Paul the Silentiary, nor, indeed, by Byzantine authors in general. Byzantine texts tend to contain multicoloured descriptions rather than otherwise. Literary and artistic evidence suggest very clearly that two of the qualities especially prized in Byzantine colour combinations were colours in contrast and association: as John Mauropous put it, beauty is created when 'two contrasting colours are wonderfully blended together'.[49]

As I argued with reference to the rainbow, it is not the colour or range of colours as

Kay, *Basic Color Terms, Their Universality and Evolution* (Berkeley, Calif., 1969).

[43] *Chronographia*, VI, 66.

[44] R. Mellinkoff, 'Judas' Red Hair and the Jews', *Journal of Jewish Art*, 9 (1982), 31–46, explains how the hatred felt towards the Jews and the betrayer of Christ was reflected by the portrayal of Judas. He was usually depicted in profile, bearded, with a dark or no nimbus, yellow robes, and a money bag. In the West, he was often given red hair—an interesting negative use of red. The use of ὠχρός may reflect something similar.

[45] Though what is important in these cases is the context;

in other instances, ὠχρός is used with a more positive sense, for example, in Manuel Philes' epigram on John Chrysostom, no. 73 in E. Miller (ed.), *Manuelis Philae, Carmina* (Paris, 1855), i. 34; and by John Mauropous on Basil, *PG* 120, 1135‑6. I am again indebted to Henry Maguire for these references.

[46] A. Kazhdan with S. Franklin, *Studies in Byzantine Literature of the Eleventh and Twelfth Centuries* (Cambridge, 1984), ch. 7. [47] Ibid. 258. [48] Ibid. 259.

[49] Epigram 100 in P. de Lagarde and J. Bollig (eds.), *Johannis Euchaitarum Metropolitae Quae Supersunt* (Berlin, 1882).

such which creates the impression, but the meaning behind the terms, the ideological frame of reference within which they operate. White need not automatically be pure. Purple is not always a symbol of imperial dignity. If purple is put into a negative context as Mesarites employs it in his description of the Pantocrator, then it will fulfil a negative function, which is striking because unusual. It does not take on a negative aspect for all time and in all places. As John of Damascus rephrased the image of the fourth-century Church Father, Athanasius: 'Purple cloth by itself is a simple thing, and so is silk, and a cloak is woven from both. But if a king should put it on, the cloak receives honour from the honour given to him who wears it': the significance of the purple colour depends on the context of its use.[50] The same is true in using many colours. Choniates' use of colour is a sign of his skill as a writer but he plays cleverly with the meanings of those colours within a thought-world where the 'meanings' of colours are not fixed. It is not so much the hue that is significant as its relative lightness or darkness. There is no organized colour 'symbolism'; rather the 'meaning' of the colour depends above all on the context in which it is used. Considering the unstable nature of manufactured colours, this should not surprise us.

Aristotle in the *Poetics* wrote 'the reason why people enjoy seeing pictures is that the spectators learn and infer what each object is—this, they say, is so-and-so; while if one has not seen the thing before, the pleasure is produced not by the imitation but by the execution, the colour or some such cause'.[51] This attitude is that of the ekphrases discussed here, with their emphasis on narrative, realism, and truth to nature. Together with this goes the power of imagination, ἡ φαντασία, emphasized respectively by Theodore Studites, 'imagination [is considered] a receptacle of an image, because the two have in common [the transmission] of resemblances',[52] and John of Damascus in *De Fide Orthodoxa*.[53] Imagination was perceived by the Greeks as a form of seeing, and the ekphrasis was an obvious vehicle for its display. Colour is used in these pieces to convey this idea, as a means of enabling the imagination to perceive the object described, as a crucial element in turning listeners into spectators. It is used in the creation of a picture in a particular way, a way which modern perspectives fail to appreciate. The ekphrasis emphasizes the relationship of the writer and the reader/auditor, who were both viewers, to art, literary tradition, and each other: the study of colour is one way of approaching this relationship.

[50] John of Damascus, *First Treatise on the Divine Images*, commentary, PG 94, 1264B. Ὥσπερ λιτὸν ἡ κογχύλη καθ᾽ ἑαυτὴν, καὶ ἡ μέταξα, καὶ τὸ ἐξ ἀμφοῖν ἐξυφασμένον ἱμάτιον· ἂν δὲ βασιλεὺς τοῦτο περίθηται, ἐκ τῆς προσούσης τῷ ἠμφιεσμένῳ τιμῆς, τῷ ἀμφιάσματι μεταδίδοται.

[51] *Poetics*, 1448b15.

[52] *Letter to Naukratios*, Epistle, 2 36, PG 99, 1220B. φαντασία δὲ δόξειέ τις εἰκών· ἰνδάλματα γὰρ ἀμφότερα.

[53] *De Fide Orthodoxa*, II 17, PG 94, 933.

CHAPTER 7

The Perception of Colour in Byzantium

TWO major points about Byzantine colour perception are apparent. The first is that the concept of 'colour' in Byzantium had an importance and significance which has been hardly grasped by art historians; and the second is that Byzantine colour symbolism and iconography worked in ways totally beyond modern conventional descriptions. A key element in Byzantine colour perception is the relationship between colour and brightness. The concern with brightness as the essential quality in art has been expressed in the case studies. It is a pervasive feature of writings on art.

AN APPRECIATION OF COLOUR

How are colours perceived in Byzantine writings generally? In the fourth century, Eusebius writes about the 'dazzling appearance' of the church at Tyre.[1] Gregory of Nazianzus in his account of the church at Nazianzus emphasizes the beauty of light.[2] Gregory of Nyssa demonstrates a delight in the combination of colours and in translucent beauty and natural beauty which seems conceived primarily in terms of colour: 'the river glows like a ribbon of gold drawn through the deep purple of its banks.'[3] Chief among the qualities of beauty for Gregory are variegated colours apprehended through sight, the highest sense. Simple colours also are beautiful, but he values them especially in combination: 'blue is interwoven with violet and scarlet mingled with white and among them are woven threads of gold; the variety of colours shine with a remarkable beauty.'[4]

This appreciation of colour is apparent throughout the Byzantine period. A sixth-century Syriac text describing the cathedral of Edessa talks of the building being

[1] *Ecclesiastical History*, X 4 43, PG 20, 849.

[2] *Orat.* XVIII 39, PG 35, 1037.

[3] *Letter*, 20, PG 46, 1081A, quoted by G. Mathew, 'The Aesthetic Theories of Gregory of Nyssa', in G. Robertson and G. Henderson (eds.), *Studies in Memory of D. Talbot Rice* (Edinburgh, 1975), 218. οἷόν τις ταινία χρυσῆ διὰ βαθείας ἀλουργίδος ὑποστίλβει.

[4] *Life of Moses*, 194, PG 44, 389D–391A. Ὑάκινθος μὲν πορφύρῳ συμπλέκεται. Τὸ δὲ τῆς κόκκου ἐρύθημα τῇ βύσσῳ μίγνυται. Πᾶσι δὲ τούτοις τοῦ ἐκ χρυσίου νῆμα συγκατασπείρεται· ὡς ἐκ τῆς πολυειδοῦς ταύτης τῆς βαφῆς, μίαν τινὰ συγκεκραμένην ὥραν ἐκ τοῦ ὑφάσματος ἀπαυγάζεσθαι. Gregory's contribution to aesthetics lies particularly in making pagan tradition acceptable and in placing the sensuous aspect of perception in a Christian context. Whatever is beautiful on whatever scale is so because it participates in the supreme beauty, God. Mathew, 'Aesthetic Theories'; H. Cherniss, 'The Platonism of Gregory of Nyssa', *University of California Publications in Classical Philology*, 11: 1 (Berkeley, Calif., 1930), 1–92.

'spangled' with gold mosaic 'like the shining stars of the firmament' and admires the variegated colours;[5] Juliana Anicia's church of St Polyeuctos is described in a sixth-century epigram as having 'walls clothed in marvellous metallic veins of colour like flowering meadows'.[6] Similarly, Procopios in the *Buildings*,[7] and the sixth-century ekphraseis of Choricius[8] and of Paul the Silentiary on Hagia Sophia emphasize these aspects. Paul's description concentrates on aspects such as iridescence and the shining, gleaming qualities, conveying a sense of luxuriance and elation:

The roof is compacted of gilded tesserae from which a glittering stream of golden rays pours abundantly and strikes men's eyes with irresistible force. It is as if one were gazing at the midday sun in spring when it gilds each mountain top.[9]

His writing serves to illustrate the dynamism of colour through its concern with flowing, changing effects: not a new aesthetic of colour, but an attitude apparent in Greek literature as far back as Homer.

The seventh-century poet, George of Pisidia, wrote 'How could anyone who sees the peacock not be amazed at the gold interwoven with sapphire, at the purple and emerald green feathers, at the composition of the colours in many patterns, all mingled together but not confused with one another?'[10] This same appreciation of variegation is displayed by a range of writers in a range of styles, from the author of the eighth- or ninth-century *Narratio* of St Sophia to Theodore Studites and John of Damascus, both writing in the eighth century.[11] Photios in his description of the ecstatic motion and richness of Hagia Sophia continues this tradition into ninth-century writings,[12] a tradi-

[5] Trans. in A. Palmer, 'The Inauguration Anthem of Hagia Sophia in Edessa: A New Edition and Translation with Historical and Architectural Notes and a Comparison with a Contemporary Constantinopolitan Kontakion', *BMGS* 12 (1988), 131.

[6] *Greek Anthology*, I 10 60–3.

τοῖχοι δ' ἀντιπέρηθεν ἀμετρήτοισι κελεύθοις
θεσπεσίους λειμῶνας ἀνεζώσαντο μετάλλων,
οὓς φύσις ἀνθήσασα μέσοις ἐνὶ βένθεσι πέτρης
ἀγλαΐην ἔκλεπτε, θεοῦ δ' ἐφύλασσε μελάθροις.

[7] *Buildings*, I 27–49; 54–65.

[8] *Laudatio Marciani*, I 17; II 28. *Choricii Gazae Opera*, ed. R. Foerster (Leipzig, 1929), 7, 35.

[9] *Ekphrasis*, in *Johannes von Gaza und Paulus Silentarius*, ed. P. Friedländer (Leipzig–Berlin, 1912), 227–56.

Χρυσεοκολλήτους δὲ τέγος ψηφῖδας ἐέργει,
ὧν ἄπο μαρμαίρουσα χύδην χρυσόρρυτος ἀκτὶς
ἀνδρομέοις ἄτλητος ἐπεσκίρτησε προσώποις.

φαίη τις Φαέθοντα μεσημβρινὸν εἴαρος ὥρηι
εἰσοράαν, ὅτε πᾶσαν ἐπεχρύσωσεν ἐρίπνην.

(668–72)

[10] George of Pisidia, *Hexaemeron*, 1245–50, *PG* 92, 1245–9. Quoted in H. Maguire, *Earth and Ocean. The Terrestrial World in Early Byzantine Art* (London, 1987), 39.

Ὅπως ἰδών τις τὸν ταὼν μὴ θαυμάσοι
τὸν χρυσὸν ὡς σάπφειρον ἐμπεπλεγμένον,
καὶ τὴν πτερωτὴν ἐν σμαράγδῳ πορφύραν,
τὰς πολυμόρφους συνθέσεις τῶν χρωμάτων,
ὅλας ἀσυγχύτους τε καὶ μεμιγμένας;

[11] For the *Narratio*, see C. Mango, *The Art of the Byzantine Empire* (Toronto, 1986), 96–102; Theodore Studites in, for example, the *Second Refutation of Iconoclasm*, 17, *PG* 99, 361B–C; John of Damascus in *Homily on the Dormition*, II, *PG* 96, 724A. I am grateful to Jill Storer for this reference.

[12] *Homily*, X 5 (trans. C. Mango, *The Homilies of Photios* (Cambridge, Mass., 1958), 185).

tion which can also be seen in the sermons of Leo VI: 'a boundary, as it were, made of a stone of a different colour, surrounds the white surface, and by slightly varying the spectacle, makes the white translucence . . . even more agreeable.'[13] It is also apparent in tenth-century writings such as Theophanes Continuatus and the *Vita Basilii*.[14] It is surely into this context of brightness that John Geometres' description of the green marble columns of the church of St John Studion as 'white' belongs.[15] Michael the Deacon's twelfth-century account of Hagia Sophia emphasizes the brightness and flashing nature of the gold decoration and the variegated colouring.[16] Even the Iconoclasts in the eighth century show an attraction towards glitter, while denying that the scintillation of divine light can be reproduced: the forged letter of Eusebius to Constantia says 'who would be able to draw with dead and inanimate colours . . . the glittering and sparkling scintillations which are so very precious and glorious'.[17]

These examples serve to focus attention on the Byzantine concern with colour primarily in the context of qualities like gleam and shine, and a belief in colour as an essential indicator of form, reinforced by the perception of light in colour terms. This is very different from the denunciation of colour by early Christian writers such as Tertullian and Hermas. The latter sees white as the colour of divine light and blessedness, which surpasses and transfigures the variegated colours confined to earthly existence. It is a negation of the multiplicity of this life for the simple radiance of the celestial. A similar attitude is found in Gnostic tradition, where gold shares the purity of white. It is true that Proclus and the *Prolegomena to Platonic Philosophy* see ποικίλος as the common characteristic of all undesirable forms of art.[18] Such a denunciation of colour is far commoner in the West:[19] there are virtually no examples of it in Byzantium. In Byzantium, if colour is condemned or seen as sinful, it is only because this is indicated by the context. Colour itself as a concept reflects too many crucially impor-tant issues of form and reality to be denounced.[20]

[13] *Sermon*, 28 (Mango, *Art*, 202).

[14] Continuatus on the artistic work of Theophilus, III 42–44, and V 84 for *Vita Basilii*, in edn. of I. Bekker (Bonn, 1838), 139–48 and 326.

[15] John Geometres, poem 96, *PG* 106, 943B. The Greek is λευκός. I am indebted to Henry Maguire for this reference.

[16] Trans. in C. Mango and J. Parker, 'A Twelfth Century Description of Hagia Sophia', *DOP* 14 (1959), 233–46.

[17] *Sixth Session of Seventh Ecumenical Council*, Mansi 313C (trans. in D. J. Sahas, *Icon and Logos: Sources in Eighth Century Iconoclasm* (Toronto, 1986), 134); *PG* 20, 1545A–1548A. τίς οὖν τῆς τοσαύτης ἀξίας τε καὶ δόξης τὰς ἀπο-

στιλβούσας, καὶ ἀπαστραπτούσας μαρμαρυγὰς οἷός τε ἂν εἴη καταχαράξαι νεκροῖς καὶ ἀψύχοις χρώμασι . . .

[18] Proclus, *Commentary: Plato: Timaeus*, ed. A. J. Festugière (Paris, 1966–8), 1 46 7–47; 14 49 20–51; *Prolegomena*, 14–15.

[19] As Bernard of Clairvaux does. See P. Dronke, 'Tradition and Innovation in Medieval Western Colour Imagery', *ErYb* 41 (1972), 52.

[20] On this theme, Gregory the disciple and hagiographer of Lazaros Galesiotes (d. 1053) finds six different tinges of 'brightness' for different types and levels of spirituality. See A. Kazhdan and H. Maguire, 'Byzantine Hagiographical Texts as Sources on Art', *DOP* 45 (1991), 2 and n. 8.

COLOUR, FORM, AND THE IMAGE

I now intend to examine what can be called the Byzantine 'ideology' of colour: the area in which these attitudes and approaches to colours can be seen as part of a pattern of thought and perception, the ideas that lie behind the Byzantine approach to colour.[21]

The most significant of these concepts is a link between colour and form. Alchemical beliefs have already been noted as demonstrating such a link quite clearly in the estimation of colour as the standard indication of the transmutation of matter. Michael Psellos made the same point in a literary fashion, conveying additionally a suggestion of the way in which the image was deemed to represent the prototype: 'the letter reflected you, just as an icon reproduces through colours the living form of the prototype'.[22] Colours create the animate form.

Gregory of Nyssa made the point more explicitly:

In the art of painting, the material of the different colours fills out the representations of the model. But anyone who looks at the picture that has been completed through the skilful use of colours does not stop with the mere contemplation of the colours that have been painted on the tablet; rather he looks at the form which the artist has created in colours.[23]

This illustrates the essential relationship perceived between colour and form. From the Byzantines' accounts of their art, it is clear that the 'reality' of the object portrayed was what mattered.[24]

The fourth-century patriarch, John Chrysostom, wrote 'who the emperor is, and who the enemy, you do not know exactly until the true colours have been applied, making the image clear and distinct'[25] for 'as long as somebody traces the outline as in a drawing, there remains a sort of shadow; but when he paints over it brilliant tints and lays on colours then an image emerges'.[26] The image is not present and identifiable until

[21] E. A. James, 'Colour Perception in Byzantium', Ph.D. thesis (University of London, 1989), ch. 6; J. Gage, *Colour and Culture* (London, 1993), 47–8.

[22] *Michaelis Pselli Scripta Minora*, ed. E. Kurtz and F. Drexl (Milan, 1936–41), V II 138.

[23] *First Sermon on the Song of Songs*, PG 44, 776A. Ὥσπερ δὲ κατὰ τὴν γραφικὴν ἐπιστήμην ὕλη μέν τίς ἐστι πάντως ἐν διαφόροις βαφαῖς ἡ συμπληροῦσα τοῦ ζῴου τὴν μίμησιν· ὁ δὲ πρὸς τὴν εἰκόνα βλέπων, τὴν ἐκ τῆς τέχνης διὰ τῶν χρωμάτων συμπληρωθεῖσαν, οὐ ταῖς ἐπιχρωσθείσαις τῷ πίνακι βαφαῖς ἐμφιλοχωρεῖ τῷ θεάματι· ἀλλὰ πρὸς τὸ εἶδος βλέπει μόνον, ὃ διὰ τῶν χρωμάτων ὁ τεχνίτης ἀνέδειξεν.

[24] R. Cormack, '"New Art History" vs. "Old History": Writing Art History', BMGS 10 (1986), 223–31; R. Macrides and P. Magdalino, 'The Architecture of Ek-phrasis: Construction and Context of Paul the Silentiary's Ekphrasis of Hagia Sophia', BMGS 12 (1988), 47–82.

[25] *In dictum Pauli, nolo vos ignorare*, 4, PG 51, 247D. ποῖος δέ ἐστιν ὁ βασιλεὺς, καὶ ποῖος ὁ πολέμιος, οὐ σφόδρα ἀκριβῶς οἶδας ἕως ἂν ἐλθοῦσα τῶν χρωμάτων ἡ ἀλήθεια τρανώσῃ τὴν ὄψιν καὶ σαφεστέραν ποιήσῃ.

[26] John Chrysostom, *Epistola ad Hebraeos, Homily XVII*, 2, PG 63, 130A. Ἕως μὲν γὰρ ἂν ὡς ἐν γραφῇ περιάγῃ τις τὰ χρώματα, σκιά τίς ἐστιν· ὅταν δὲ τὸ ἄνθος ἐπαλείψῃ τις, καὶ ἐπιχρίσῃ τὰ χρώματα, τότε εἰκὼν γίνεται. John of Damascus, *On the Holy Images*, III PG 94, 1361D, quotes this and comments on it. Ignatios the Deacon's *Life* of the Patriarch Tarasios (written after 843) also uses this image: Ignatius the Deacon, *Vita Tarasii Archepiscopi Constantinopolitani*, ed. I. A. Heikel (Helsinki, 1891).

colour is added.[27] Mango notes the play on words in this passage, with the sketch representing the shadow, i.e. the Old Testament, and the true colours truth, i.e. the New Testament.[28] The type (σκιά) equals the preliminary sketch (σκιαγραφία) which foreshadowed reality (ἀλήθεια): that painting was thought to be completed by the addition of colours is strongly implied in patristic literature by the use of verbs such as σκιαγραφέω, and in the opposition of εἰκών to σκιαγραφία. As significant is the emphasis on colour for defining true form. If colour is an indication of reality, then it must be true to the perception of that reality. It is colour, particularly brilliant colour, that makes the image recognizable and proper, giving it its resemblance to life. But the colour has to be the true colour, as Chrysostom says, a point made clear by the alchemical texts. Here, as has already been explained, the change in the nature of a sub-stance is illustrated through its change in colour. If the colour is right, then the substance is what it purports to be; but the colour transformation, especially in *iosis*, has to follow a particular order, for false colours can deceive: Gregory of Nyssa noted that there are those who 'because of their fine colour pick the false flower instead of the true one'.[29] Indeed, one can 'sketch in the character of evil with muddy colours'.[30]

Colour is seen as a touchstone of accuracy and of truth in art and in the representa-tion of the prototype. In the eighth century, John of Damascus called Melchisedek the σκίασμα of Christ, the underpainting preceding the coloured picture.[31] This sort of analogy is also made by Cyril of Alexandria (d. 444) and by the seventh-century patriarch Germanos among others, suggesting a continual use and reuse of these ideas about colour.[32] It is not until the colours are put together that the true likeness is gained, which on a spiritual level must be Christ. It is through colour that the imitation of Christ is achieved. 'Art can convey by colours the prayers of the soul'.[33] In many ways, this is a continuation of the Classical view on form and colour, the view of Plato and Aristotle. But combined with Byzantine thinking about the image and the nature of the image, it has enormous significance—the significance of definition itself.

The role of colour in making the image lifelike is stressed in a variety of Byzantine

[27] Kazhdan and Maguire make several important points about the significance of the underdrawing for likeness, though they underplay the significance of colour in defining form and likeness. However, they conclude that images with-out colour were considered incomplete by the Byzantines, Byzantine Hagiographical Texts', 8–9.

[28] Mango, *Art*, 48 n. 136. Cyril of Alexandria makes a similar point, *Epistle* 41, 21. See also H. Kessler, '"Pictures Fertile with Truth": How Christians Managed to Make Images of God without Violating the Second Command-ment', *Journal of the Walters Art Gallery*, 49: 50 (1991/2), 5–7. I am grateful to Henry Maguire for this reference.

[29] *Commentary on the Song of Songs*, 9, PG 44, 972C. τοῖς διὰ τὴν εὐχροιαν τὸ νόθον δρεπομένοις ἀντὶ τοῦ κρείττονος.

[30] Gregory of Nyssa, *On Perfection*, PG 46, 272B.

[31] *On the Holy Images*, III, PG 64, 1361D.

[32] See D. Sheerin, 'Line and Colors; Painting as Analogue to Typology in Greek Patristic Literature', *17th International Byzantine Congress, Washington 1986*, Abstracts of short papers (Washington, DC, 1987), 317–18.

[33] Agathius Scholasticus, epigram describing an image of the archangel, *The Greek Anthology*, I, 34. οἶδε δὲ τέχνη | χρώμασι πορθμεῦσαι τὴν φρενὸς ἱκεσίην.

texts. Asterius of Amasia (fourth century) said: 'I shall describe the painting to you. For we, men of letters, can use colours no worse than painters do'.[34] Some five centuries later, Photios also makes clear the concept of colour giving life to the image, creating reality and lifelikeness.[35] This reinforces the importance of the true colours. In his homily on the dedication of the image of the Virgin and Child in Hagia Sophia, he explains how a painting that is in agreement with religious truth contains the essence of the prototype, which is apprehended through sight. Colour is a part of this truth; it presents the 'real archetype'.[36] As the true colour must be used in art, so in speech: 'every word set apart from deeds, even if it is beautifully decked out, is like a lifeless icon which portrays a form blooming with paint and colour', as Gregory of Nyssa put it in the fourth century.[37] Words are only powerful in the context of deeds; colour is only powerful if used correctly.

This concept of the true likeness being conveyed through colour is expanded by an explicit linking of literature and art through colour: word (hearing) and sight made equivalent. Form created by colour is linked to words and speech. Gregory of Nyssa said 'he [the painter] wrought by means of colours as if it were a book that uttered speech'.[38] John of Damascus made the same point more explicitly four centuries later: 'form through colours is coupled with speech', and suggests that Christian painting and writing had the same end.[39] In the *Fount of Knowledge* (the *Dialecta*), he notes that likeness can be shown by colours and colour is a quality of all things.[40] Theodore Studites made a similar point: 'whatever is marked there [on the page] with paper and ink is marked on the icon with varied pigments.'[41] In the sixth session of the Seventh Ecumenical Council, it was recorded that 'that which the narrative declares in writing is the same as that which the icon (or image) does [in colours]'.[42]

[34] Letter describing a picture of the martyrdom of St Euphemia, ed. F. Halkin, *Euphémie de Chalcedonie* (Brussels, 1965), 4. φράσω σοι τὴν γραφήν· οὐδὲ γὰρ φαυλότερα πάντως τῶν ζωγράφων οἱ μουσῶν παῖδες ἔχομεν φάρμακα. For this last word, χρώματα is given as an alternative reading (trans. in Mango, *Art*, 38). Asterius actually mentions only two colour words, underlining the metaphorical meaning of the phrase.

[35] e.g. he notes that the Virgin's lips 'have been made flesh by the colour' (*Homily*, XVII).

[36] *Homily*, XVII (trans. C. Mango, *The Homilies of Photius*, Dumbarton Oaks Studies III (Cambridge, Mass., 1958), 286–96). See also Leo VI's description of a picture: 'you might say that this picture was not devoid of speech, for the artist has infused such natural colour and feeling into the faces . . . they are so coloured because of their awareness of what is being said' (Mango, *Art*, 204).

[37] Gregory of Nyssa, *On Virginity*, 23, PG 46, 405C. ἐπεὶ

καὶ πᾶς λόγος δίχα τῶν ἔργων θεωρούμενος, κἂν ὅτι μάλιστα κεκαλλωπισμένος τύχῃ, εἰκόνι ἔοικεν ἀψύχῳ, ἐν βαφαῖς καὶ χρώμασιν εὐανθῆ τινα χαρακτῆρα προδεικνυούσῃ.

[38] *Laudatio S. Theodori*, PG 46, 737D. πάντα ἡμῶν ὡς ἐν βιβλίῳ τινὶ γλωττοφόρῳ διὰ χρωμάτων τεχνουργησάμενος.

[39] *On the Holy Images* I 12, PG 94, 1265D. Ὅτι δὲ συνεζευγμένην οἶδε τῷ λόγῳ τὴν διὰ τῶν χρωμάτων μορφήν.

[40] Ch. 31, PG 94, 537A–540A. In this work, John says that colour cannot exist in itself but is found in substances. It is a quality of things (ch. 4).

[41] *First Refutation on the Holy Icons*, 10, PG 99, 340D–341A. καὶ ὃ ἐνταῦθα διὰ χάρτου καὶ μέλανος, οὕτως ἐπὶ τῆς εἰκόνος, διὰ ποικίλων χρωμάτων.

[42] *Sixth Session of the Seventh Ecumenical Council*, Mansi 232C, Sahas, *Icon and Logos*, 69. εἴτε γὰρ ἡ ἐξήγησις

The eighth-century patriarch, Nicephoros, broke the metaphor down still further. He defined γραφή as writing or description by means of letters, syllables, words, or by the art of painting with the help of colours.[43] Nicephoros suggested that the miniature painter and the calligrapher performed a similar function: the vivid presentation of Christ's teaching of salvation to the reader through the use of colours.[44] Similarly, according to the Patriarch Photios, 'writing' is defined as 'the same as painting'.[45] Both the lexicon of Hesychius and the *Souda* link γραφή with ζωγράφος, writing with painting.[46] Painting, ζωγράφος, contains the element ζωή, 'life'; it is this element that distinguishes it from γραφή, 'writing', and which incorporates the characteristic difference between writing and painting: colour, the element which gives life and form to the underdrawing (σκιαγραφία). The word 'colour' is frequently used in association with ζωγράφος, as if to suggest that painting might not be possible without colour. In all this, the Byzantine emphasis lies on the links between colour, speech, and words in creating a picture, the true picture, with colour being to the image what writing is to text.[47]

On one level, this can be seen as a play on words, a clichéd metaphor or topos. However, as I have already argued, clichés only become such because they encapsulate a pertinent, complex structure of thought particular to a given society.[48] That a figure of speech is a topos does not invalidate its meaning and sense. Though the equivalence of colour and word may appear to be too stereotyped to be of any significance, its existence and pervasive nature suggests this is not the case. If colour is equated with the word, then it must be because, on whatever level, it is felt to carry out a similar function: both serve to define and transmit meaning. As words are the codes of speech and writing, the building blocks, so similarly colour is conceived as the code for art in Byzantium. As the Seventh Ecumenical Council of 787 put it: 'Thus, as when we receive the sound of the reading with our ears, we transmit it to our minds, so by looking with our eyes at the painted [i.e. coloured] icon, we are enlightened in our

ἐγγράφως ἡμῖν δηλοῖ, τοῦτο καὶ ἡ ἀναζωγράφησις. Similarly Theodore Studites: as the Gospel writers had been able to 'write of Christ in words', so, he said, similarly 'icons are writing in gold'. *Refutio Poematon Iconomach.*, PG 94, 441–4.

[43] *Refutatio et Eversio*, fo. 213ʳ, in P. J. Alexander, *Patriarch Nicephoros of Constantinople* (Oxford, 1958), 251.

[44] *Apologeticus Pro Sacris Imaginibus*, ch. 61, PG 100, 748D: 'On the one hand, through calligraphic genius the teachings of divine history appear to us; on the other, by the excellence of painting, those same things are shown to us.'

[45] Photios, *Lexicon*, ed. C. Theodorides (Berlin and New York, 1982), 367.

[46] Hesychius, *Lexicon*, ed. K. Latte (Hauniae, 1953), i. 390; *Suidae Lexicon*, ed. A. Adler (Leipzig, 1928), i. 540. Similar references appear throughout a collection of unpublished scholia to Philostratos' *Eikones*. See R. Webb, 'The Transmission of the *Eikones* of Philostratos and the Development of ekphrasis from Late Antiquity to the Renaissance', Ph.D. thesis (University of London, 1992).

[47] Links with Classical theories are apparent in this view, as, for example, in the Platonic metaphor from the *Republic*, quoted in Ch. 3, which made the point about needing true colours.

[48] See also L. Brubaker, 'Perception and Conception: Art, Theory and Culture in Ninth Century Byzantium', *Word and Image* 5 (1989), 19–32.

mind.'[49] The visual and the verbal carry out a parallel, complementary function, described through ekphrasis.[50] When colour is used in a literary context to make statements about the nature of art and the image, we should expect to draw similar conclusions from its actual use in art.

This attitude is a key element in the definition of the image developed during the period of Iconoclasm. Both Iconophiles and Iconoclasts had a very similar view of the nature of the icon. Both could agree that because man was created in the image of God, then man as this image bore the nature of the archetype: the issue was whether man could then be portrayed in his divine image or whether this was the quality of human existence beyond the grasp of pictorial representation.[51] The Iconophiles based their definition of the image on the relationship between the original, the prototype, and the copy derived from it, believing them to be alike but different in essence, the image being an imitation of the true nature of the prototype. The Iconophile Patriarch Nicephoros defined the nature of images, saying that: 'an image is a likeness of an archetype which reproduces itself by way of resemblance the entire form of what is impressed upon it.'[52] Painting imitates by being like the archetype, and presents itself through line and colour, line being the underdrawing ($\sigma\kappa\iota\alpha\gamma\rho\alpha\phi\iota\alpha$) referred to above. Through the image, 'knowledge of the archetype draws near to us',[53] but it would be impossible to know the archetype if the icon did not present the subject authentically. Colour is one of the tools of this presentation, the most significant, since it is through colour that the image appears lifelike. Colour is the tool of $\zeta\omega\gamma\rho\alpha\phi\circ\varsigma$, writing in life, without which the icon would remain a $\sigma\kappa\iota\alpha\sigma\mu\alpha$, a shadow.[54]

The Iconoclasts, in the person of Constantine V, pushed this a stage further by asserting that a genuine image had to be identical in essence with that which it portrayed.[55] Consequently, an icon of Christ could not be identical in essence with Christ himself and was thus idolatrous. It was not possible to present the uncircumscribable in any material form, and so the Iconophiles were accused of establishing a new person of Christ separated from his divine essence.[56]

[49] *Sixth Session of the Seventh Ecumenical Council*, Mansi 220E, Sahas, *Icon and Logos*, 61. καὶ ἢ γὰρ διὰ τῆς ἀναγνώσεως ἐν τοῖς ὠσὶ δεχομένοι τὴν ταύτης ἀκρόασιν τῷ νοΐ παραπέμπομεν, καὶ τοῖς ὄμμασιν ὁρῶντες τὰς εἰκονικὰς ἀνατυπώσεις, ὡσαύτως νοερῶς αὐγαζόμεθα.

[50] L. James and R. Webb, '"To Understand Ultimate Things and Enter Secret Places": Ekphrasis and Art in Byzantium', *Art History*, 14 (1991), 1–17.

[51] See J. Pelikan, *The Christian Tradition*, ii. *The Spirit of Eastern Christendom 600–1700* (Chicago and London, 1974), ch. 3, esp. 95–6.

[52] Nicephoros, *Antirrheticus*, I 28, PG 100, 277A.

[53] Nicephoros, *Apologeticus*, ch. 62, PG 100, 749.

[54] Should comments about lifelike representations consequently be understood as a pun on ζωή?

[55] This is according to Patriarch Nicephoros, *Antirrheticus*, I 15, PG 100, 225.

[56] M. V. Anastos, 'The Ethical Theory of Images Formulated by the Iconoclasts', *DOP* 8 (1954), 151–60; id., 'The Argument for Iconoclasm as Presented by the Iconoclastic Council of 754', in K. Weitzmann (ed.), *Studies in Honor of A. M. Friend jr.* (Princeton, NJ, 1955), 177–88.

Both parties perceived colour as significant in the definition of form, and so in the definition of images and the reality of images. The Iconophiles declared that: 'pictorial representation is attained by colours'; the Iconoclasts that: 'the deceitful colouring of the pictures (ὁμοιωμάτων) . . . draws down the spirit of man from the lofty adoration of God'.[57] Throughout surviving Iconoclast texts and the Iconophile Council of 787, the phrase 'depiction with colours' (or variations on this theme) is used to refer to images, suggesting that colour was seen very much as a key element of the icon.[58] Patriarch Nicephoros' supposition was that creation, being circumscribable, could be pictorially represented. Matter such as pigments, which were products of creation, became the means by which the object assumed its material form. The most experienced artists used 'the brighter materials and the clearer colours, which colour the appearance [of the archetype] to the utmost, and are aesthetically appealing, and give glory to it, inasmuch as the image can be preserved to the truer [archetype]'.[59] For Nicephoros, the iconographic representation of Christ does not imply his circumscription. 'Thus one can say that the body is coloured, and not that one cannot talk about the body of colour nor of colour made corporeal.'[60] He accuses the Iconoclasts of failing to dis-tinguish between decoration (the materials of painting) and the content (subject-matter) of the icon and its archetype, calling them 'persecutors of colour (χρωματόμαχος), rather, persecutors of Christ (χριστόμαχος)'.[61] 'Colour' here is not significant merely as a useful word-play with 'Christ': it works as word-play because of the debate as to its role in the nature of the image. The image of the crucified Christ juxtaposed with the whitewashing of his image in the Khludov Psalter (fo. 67ʳ) makes the same point visually.[62]

Both parties defined icons in terms of colour, but interpreted differently the transience of colours; concern is with the spiritual potential and significance of colour. Both provided an interpretation of Gregory of Nazianzus' statement that: 'it is an injury to

[57] The first quotation is from Nicephoros, *Antirrheticus*, II 13, PG 100, 357C. γράφεται μὲν γὰρ ἄνθρωπος διὰ χρωμάτων καὶ ψηφίδων, ἂν οὕτω συνενεχθείη, καὶ ταῦτα ποικίλως καὶ πολυειδῶς σχηματιζόμενος. The second is from the epitome of the definition of the iconoclas-tic conciliabulum of 754, trans. in *Nicene and Post-Nicene Fathers*, series II (Michigan, 1975–80), xiv. 543.

[58] H. Hennephof, *Textus Byzantini ad Iconomachiam Pertinentes* (Leiden, 1969), passim. Henry Maguire suggested that the mandylion of Edessa might be seen as uncoloured, quoting the 9th-cent. *Narratio de Imagine Edessena* (PG 113, 425A) as describing it as being an image 'without colouring or painter's art'. See Kazhdan and Maguire, 'Hagiographical Texts', 8. Averil Cameron's account of the image describes the account of the 8th–9th-cent. bishop of Harran, Theodore

Abu Qurrah, which implies that the mandylion was coloured: A. M. Cameron, 'The History of the Image of Edessa: The Telling of a Story,' in *Okeanos: Studies for I. Ševčenko, Harvard Ukrainian Studies*, 7 (1985), 87–90. Icons of the mandylion are coloured, but the appearance of the actual mandylion and its perceived colour remains an interesting problem.

[59] Nicephoros, *Apologeticus*, ch. 53, PG 100, 725A.

[60] Nicephoros, *Antirrheticus*, III 35, PG 100, 429C.

[61] Nicephoros, *Prolegomena*, 282 7, in *Spicilegium Solesmense Complectens Sanctorum Patrum Scriptorumque Ecclesiasticorum Anecdota Haectam Opera etc.*, ed. J. B. Pitra (Paris, 1852–8), iv. 233–91.

[62] As Kessler, '"Pictures Fertile with Truth"', 56, suggests.

put faith in colours . . . colours, flowing, wash away':[63] the Iconoclasts interpreted this as meaning that which is in colours is easily washed away; the Iconophiles read it differently as a comment on morals rather than images. The Iconoclast emphasis on representation in colours serves to underline their belief in the earthly, material nature of images and the inability of images to convey the divine essence.[64] Rather than being life-like, as the Iconophiles claimed, colours were the reverse of lifelike. The Iconophiles were at pains to express how colours could be used to represent Christ: not his divinity, but his resemblance, as with man and the Creator.[65]

They claimed that material substances were fundamentally altered through the artist's actions. The Seventh Ecumenical Council quoted Athanasius on this issue: wool is common and available to all: 'however, when it is dipped in the dye of the sea, it is called purple. Once it takes up this name, it becomes something which is fitting to be used exclusively by kings . . . [the purple] transcends the common character, because of the dignity of him who uses it.'[66] Colour transcends the material as imparting spiritual concepts. The Council claimed that the Iconophiles did not seek to reproduce divinity with colours.[67] Nicephoros criticizes Iconoclastic emphasis on the symbol of the Cross as communicating Christ's Passion only in monochrome. Sacred forms, on the other hand, not only paint the Passion with colours and depict it in more detail, but also in a more speaking manner, a manner more honourable and worthy of praise than an image showing the Passion in an obscure fashion.[68] In other words, clarity is superior to the obscurity of the Cross, and this clarity is provided, in effect, by colour. A monochrome symbol is incomplete and less visible, an underdrawing in fact. John of Damascus, the most extreme of the Iconophiles, made the theological connotations of colour explicit: 'the Godhead not incarnate is colourless.'[69] However, the incarnate Christ, the Logos,

[63] *Moral Epics*, 31, PG 37, 912. Discussed at the Seventh Ecumenical Council, Mansi 297B; Sahas, *Icon and Logos*, 121. ὕβρις πίστιν ἔχειν ἐν χρώμασι . . . ἡ μὲν γὰρ ἐν χρώμασιν εὐχερῶς ἐκπλύνεται.

[64] Iconoclasts claimed that Theodore of Ancara said 'we have received the tradition to revitalise the notions about the saints; not however on icons with colours which are material but through virtue'. *Expositio Symboli*, I, PG 77, 1313–1432 and quoted in Sahas, *Icon and Logos*, 132; Mansi 312A, *Sixth Session of Seventh Ecumenical Council*. τὰς τῶν ἁγίων ἰδέας ἐκ ἐν εἰκόσιν οὐχ ὑλικῶν χρωμάτων ἀναμορφοῦν παρειλήφαμεν ἀλλὰ τὰς τούτων ἀρετὰς διὰ τῶν ἐν γραφαῖς περὶ αὐτῶν δηλουμένων οἷ ὃν τινας ἐμψίχους εἰκόνας ἀναμάττεσθαι δεδιδάγμεθα, ἐκ τούτου πρὸς τὸν ὅμοιον αὐτοῖς διεγειρούμενος ζῆλον. Also phrases such as 'the gaudiness of colours' and 'material colours' were anathematized: see Sahas, *Icon and Logos*, passim.

[65] Sahas, *Icon and Logos*, 77.

[66] *Sixth Session of the Seventh Ecumenical Council*, Mansi 317E–320D, Sahas, *Icon and Logos*, 138–9 citing Athanasius' *Letter* to Eupsychius. Ἀλλ' ὅταν τῇ ἐκ τῆς θαλάττης προσομιλήσῃ βαφῇ πορφύρα λέγεται καὶ τῆς προσηγορίας ἀμειβομένης, καὶ τῆς χρήσεως κατ' ἐξαίρετον βασιλεῦσι μόνοις ἁρμόττειν λαχούσης . . . φεύγει γὰρ τὴν κοινότητα διὰ τὸ τοῦ χρωμένου ἀξίωμα.

[67] Colour is unable to circumscribe the uncircumscrib-able, as Patriarch Nicephoros makes clear, *Antirrheticus*, II 12, PG 100, 356B–357A. The council itself makes this point, Mansi 244A–B, Sahas, *Icon and Logos*, 77.

[68] Nicephoros, *Antirrheticus*, III 35, PG 100, 429C.

[69] *On the Holy Images*, II 11, PG 94, 1293D. Εἰ δὲ Θεότητος τῆς ἀΰλου, καὶ ἀσωμάτου, καὶ ἀοράτου, καὶ ἀσχηματίστου, καὶ ἀχρωματίστου, εἰκόνα τις τολμήσει ποιῆσαι, ὡς ψευδῆ ἀποβαλλόμεθα. This works on two levels. First, only the incarnate God can be represented through colour, the non-incarnate being un-

has colour: 'we are not mistaken if we make the image of God incarnate, who . . . assumed the nature, feeling, form and colour of our flesh.'[70] Patriarch Nicephoros repeats the point, crucial for the Iconophiles, that something with a visible form can be inscribed.[71] Colour is that which makes form visible.

Such a belief seems to be behind the popular notion expressed by Gregory of Nyssa. He uses the figure of the human painter creating an image in comparison with God who 'paints the image [of man] with various colours according to his own beauty',[72] a work of imitation or mimesis. God, of course, according to Genesis I: 26–7, created man in his own image. This metaphor is echoed elsewhere and carried a stage further in the idea that man is himself a creative artist after God.[73] It is also possible to 'prepare the pure colours of the virtues, mixing them with each other according to some artistic formula for the imitation of beauty, so that we become as images of the image'.[74]

Part of this emphasis is the result of the belief, inherited from the Classical world and apparent in Classical philosophy, in the primacy of colour in sight and sight among the senses. Echoing Gregory of Nyssa, John of Damascus said: 'the first sense is sight and the organs of sight are the nerves of the brain and eyes. Now sight is primarily the perception of colour; with colour it discriminates the body that has colour and its size and its shape and its placing and the intervening space and number.'[75] Nicephoros also made this point: 'for we all know that sight is the most honoured and necessary of the senses.'[76] According to Nicephoros, visual representation was clearer and more distinct

circumscribable, but then, colour is the only way to represent God. And only the 'true colours' can do this.

[70] John of Damascus, *On the Holy Images*, II, 5.

[71] *Antirrheticus*, I 19, *PG* 100, 232C–233A; I 26, *PG* 100, 272B–C. Aristonicus in a scholion on Book 3 of the *Iliad* makes a similar point: black and white animals are a suitable sacrifice to Earth and the Sun, but Homer does not give the colour of the sacrifice to Zeus 'for we see the earth and the sun but we only imagine god' (H. Erbse, *Scholia Graeca in Homeri Iliadem* (Berlin, 1969–88), Bk. Γ, 103–4, p. 377); Erbse cites Eustathius of Thessaloniki's repetition of the scholion, *Eustathii Commentarii ad Homeri Iliadem at Odysseam*, ed. M. Devarius (Hildersheim, 1969), 388 37, and 390 6.

[72] *De Hominis Opificio*, 5, *PG* 44, 137A. Trans. in G. Ladner, 'The Concept of the Image in the Greek Fathers and the Byzantine Iconoclastic Controversy', *DOP* 7 (1953), 1–34. οἷόν τισι βαφαῖς τῇ τῶν ἀρετῶν ἐπιβολῇ πρὸς τὸ ἴδιον κάλλος τὴν εἰκόνα περιανθίσαντα. John of Damascus reverses it neatly, *On the Holy Images*, II 5, *PG* 94, 1288A–B.

[73] Basil of Seleucia, for example, says '[Man] . . . as if sitting on a throne, shows the image of the creator through the dignity of his works, imitating his master with his own

actions as with colours' (*Oratio*, I, *PG* 85, 36B). Ὡς ἐν θρόνῳ καθεζόμενος δείκνυσιν ἔργοις διὰ τῆς ἀξίας τὴν εἰκόνα τοῦ Κτίσαντος, τοῖς πράγμασιν ὡς χρώμασι τὸν πεποιηκότα μιμούμενος.

[74] Gregory of Nyssa, *On Perfection*, *PG* 46, 272B. Ἀλλὰ ὡς ἔστι δυνατόν, καθαρὰ τῶν ἀρετῶν τὰ χρώματα, κατά τινα τεχνικὴν μίξιν πρὸς ἄλληλα συγκεκραμένα, πρὸς τὴν τοῦ κάλλους μίμησιν παραλαμβάνειν, ὥστε γενέσθαι ἡμᾶς τῆς εἰκόνος εἰκόνα.

[75] *De Fide Orthodoxa*, II 18, *PG* 94, 933D–936A. Πρώτη αἴσθησις, ὅρασις. Αἰσθητήρια δέ, καὶ ὄργανα τῆς ὁράσεως, τὰ ἐξ ἐγκεφάλου νεῦρα, καὶ οἱ ὀφθαλμοί· αἰσθάνεται δὲ ἡ ὄψις, κατὰ πρῶτον μὲν λόγον, τοῦ χρώματος· συνδιαγινώσκει δὲ τῷ χρώματι, καὶ τὸ κεχρωσμένον σῶμα, καὶ τὸ μέγεθος αὐτοῦ, καὶ τὸ σχῆμα, καὶ τὸν τόπον ἔνθα ἐστίν, καὶ διάστημα τὸ μεταξύ, καὶ τὸν ἀριθμόν.

[76] Nicephoros, *Refutatio et Eversio*, fo. 273ᵛ. ἴσμεν γὰρ δήπου ἅπαντες ὅτι γε ὄψις τῶν αἰσθητηρίων τὸ τιμιώτατον καὶ ἀναγκαιότατον τρανέστερον. Quoted in Alexander, *Patriarch Nicephoros*, 211 and n. 3. Gregory Palamas in the *The 150 Chapters* similarly stressed the primacy of sight, and also the relationship between sight and colour: 'sight is formed from the manifold disposition of

than oral communication, for speech could be distorted and debated, but the impressions of pictorial representations were trustworthy.[77] On the other hand, the Iconoclasts sought to establish hearing as the key sense, expressing the sentiment of St Ambrose: 'everything we believe, we believe either through sight or through hearing ... Sight is often deceived, hearing acts as guarantee'.[78]

However, only the true colour can define or enlighten correctly and accurately. Gregory expands his image: 'As ... painters transfer the human form to their pictures by means of certain colours, applying to their work of imitation [μίμημα] the proper and corresponding tints, so that the archetypal beauty may be transferred exactly to the likeness, thus ... our Maker also ... paints the image [i.e. man] with various colours according to his own beauty.'[79] The image is seen here as an imitation of the prototype, as man is of God, but it is colour that is used as the medium to convey likeness, and that likeness is only perceived and recognizable through the 'proper' colours. This applies in both a pictorial and spiritual context. Byzantine authors writing in the thirteenth century about the strangeness of Latin religious art complained that the Westerners used the actual hair and garments of people, things which were not 'an image and symbol [τύπος] of the prototype', to adorn their images instead of 'colours and other materials—which serve as a kind of alphabet' to 'instruct us pictorially'[80] and act as image and symbol of the prototype—and uses the same image of colours and letters seen in Byzantine writing from the fourth century on. Gregory of Nyssa's elaborate metaphor comparing the mixing of colours with the nature of the soul and its creation by God[81] works as both the straight metaphor it appears to be and on a deeper level, where colour is the very sign of the transmutation and definition of form.

The paradox in all this appears in the practical issue of making the true colour: the difference between the concept of 'colour' as an essentially abstract idea of reality, and that of the actual pigments.

It is from these links of colour with spirituality and form that colour symbolism and iconography derive their impact. A society that defines form, reality, and truth in terms of colour must reflect these in its use of colour. Gregory of Nyssa again:

colours and shapes' (ch. 15). See Gregory Palamas, *The 150 Chapters*, trans. R. E. Sinkewicz (Toronto, 1988).

[77] Nicephoros, *Apologeticus*, ch. 63, *PG* 100, 749–52. Discussed in J. Travis, *In Defence of the Faith. The Theology of Patriarch Nicephoros of Constantinople* (Brookline, 1984), 48.

[78] Ambrose of Milan, *Commentary on St. Luke*, IV 5.

[79] Gregory of Nyssa, *De Opificio Homini*, V, *PG* 44, 137A. Ὥσπερ τοίνυν τὰς ἀνθρωπίνας μορφὰς διὰ χρωμάτων τινῶν ἐπὶ τοὺς πίνακας οἱ γραφεῖς μεταφέρουσι, τὰς οἰκείας τε καὶ καταλλήλους βαφὰς

ἀπαλείφοντες τῷ μιμήματι, ὡς ἂν δι' ἀκριβείας τὸ ἀρχέτυπον κάλλος μετενεχθείη πρὸς τὸ ὁμοίωμα· οὕτω ... πρὸς τὸ ἴδιον κάλλος τὴν εἰκόνα περιανθίσαντα. This is also quoted by John of Damascus, *On the Holy Images*, I, *PG* 94, 1296A.

[80] All these quotations form part of Symeon of Thessaloniki, *Contra Haereses*, XXIII, *PG* 155, 112B. ὡς γράμμασιν ἄλλοις, τῇ χρωματουργίᾳ καὶ λοιπῇ ὕλῃ εἰκονικῶς ἐκδιδάσκουσιν.

[81] *On the Soul and Resurrection*, *PG* 46, 73A–76B.

if we contemplate a painting and try to understand it, at first it is simply a material surface which by way of different patches of colour helps to fulfil the portrayal of a living reality. Yet what the beholder of the painting observes is what the colour technique itself helps to fulfil: he does not confine himself to admiring coloured masses on a surface, his perception moves only towards the form which the artist reveals by way of the colours. In precisely this way in the *Song of Songs*, we must not confine our gaze to the expressiveness of the colours in their material aspect, but perceive in the colours a kingly form, forming itself by means of pure thoughts. White, ochre, black, red, deep blue, or any colour—these are the expressions in their everyday usage; these are the mouth, the kiss, the unguents and wine, the names of the limbs, the couch and the maidens and all the rest. But the perception that is fulfilled through all these is blessedness, serenity, cleaving to God . . .[82]

Here, not only does Gregory express many of the recurrent themes of Byzantine colour perception—the emphasis on colour qualities, the manifestation of form and reality through colour, colour symbolism—but he indicates the belief that the divine meaning is the full integration of that cognitive process which begins with sensory perception. This differs from St Paul's perception of invisible divine realities through created things, and Pseudo-Dionysius' concept of visible beauty as a reflection of, and way towards, the unknown heavenly beauty. Gregory gives the viewer an active role as interpreter of colours and words to fulfil the reality of the object. Much that was most vital in Byzantine art came into being in an effort to apprehend and convey hidden meanings. Plotinus formulated the notion that the essential value of a work of art was its capacity to signify.[83] In the Byzantine period, the figurative arts gave primacy to significance; style could be copied in transposing signs, but this may well have been of secondary importance.[84] Colour played a part in this process, as Gregory makes clear. He treats art as something where images themselves carry meanings and where symbolic associations can be perceived in and through colours and colour images.

Through the attribution of symbolic qualities to materials and colours, the impulse came to enhance rather than deny surfaces, substances, and textures for the greater effect of light. Each medium had a distinctive technical aspect and symbolic reference: materials were in themselves iconological elements. Steatite was highly regarded because it was fire resistant and retained an unblemished appearance; that the colour was an integral part of the attractiveness of the stone is made clear by the use of only certain colours of steatite.[85] Paul the Silentiary celebrates the beauty of ivory which seems to

[82] *Commentary on the Song of Songs*, I, 1, *PG* 44, col. 776A–B (trans. by Dronke, 'Tradition and Innovation', 72).

[83] All of which represents a gradual departure from the Platonic tradition. See Ladner, 'The Concept of the Image'.

[84] C. Walter, 'Expressionism and Hellenism: A Note on Stylistic Tendencies in Byzantine Figurative Art from Spätantike to the Macedonian "Renaissance", *REB* 42

(1984), 276.

[85] I. Kalavrezou-Maxeiner, *Byzantine Icons in Steatite* (Vienna, 1985). The author also tries to link the preference for green to its use as an imperial colour as is shown, for example, by the Caesar's use of green ink and its use for the garments of the protovestiarius. Porphyry is another material with significant symbolic connotations.

have been rated on a level just below silver; it was a sign of luxury and an aesthetic ideal.[86] There seems to have been a definite hierarchy of metals. Christianity placed a special value on lustrous substances and materials resistant to physical decay. Yet, as the quotation from the Seventh Ecumenical Council makes clear ('when [wool] is dipped in the dye of the sea, it is called purple . . .'), symbolism is governed by context. Colour is form but that form can change—as alchemical science demonstrates.

The constituent parts of an image, whether or not they have meaning in themselves, may have some bearing on the meaning of a picture in totality, but a knowledge of the component parts of the picture, its origins, and subsequent transformations is needed to see this. In tracing colour perceptions, a continuity with the traditions of the Classical world is apparent, but an emended continuity in which Classical attitudes altered and were changed to suit the requirements of Christianity. Colour is apparent as an essential element in the definition of the true image of the prototype and a parallel image in terms of word and art, conveying the same meanings in both areas. In ideological terms colour is apparent as the property that defines form. It is the property that conveys the right image, for which only the 'true' colour will suffice, and thus has a conceptual significance of great weight. As such, it is the essential element of Byzantine art. It gives meaning to form. Colour is not significant in terms of its 'colours' alone; it is itself a symbol.

[86] A. Cutler, *The Craft of Ivory* (Washington, DC, 1985) elaborates this theme.

Conclusion

THIS book began by asking the questions: what do we see in looking at a Byzantine mosaic? What part does colour play in the viewing of a picture? To answer these questions, I explored the relationships between words used to describe colours in Byzantium and Byzantine works of art.

I also began with a description of the Anastasis mosaic at Nea Moni. This was straightforward enough, an account of what we see in the scene. This description has since been elaborated, firstly with the addition of the stylistic use of colour, the manipulation of hues, tones, and areas of brightness within the scene. To this, a detailed description of the actual mosaic colours, with accompanying colour chart could be added.

Then the question of perception arises: how was this seen? What was the significance of the colours? Byzantine colour words were shown to be imprecise in their relation to hues, emphasizing rather the qualities of brightness and glitter. They seemed to have no specific symbolic reference; instead, symbolism depended on context. Above all, however, colour was the defining feature of an image. Colour made the image complete, made it a likeness of the prototype; without colour, the picture was just a sketch, unfinished and unrepresentative. Within the picture, each element has its proper colours, its 'true colour', which makes it recognizable.

This does not contradict the belief that there is no colour symbolism in Byzantine art. Individual colours do not 'mean' something: blue does not equal divinity; purple does not equal royalty. The Virgin is portrayed in blue because it is the correct colour, and in the context of the Virgin, blue carries connotations of divinity. In a different context, these connotations might be different. Purple represents royalty in both a positive (used by emperors and in some representations of Christ) and negative fashion (used to indicate sinful luxury and worldliness).[1]

So, to return to the Anastasis mosaic, what we see is not only colour in a purely artistic sense (composition, technique) but an aspect of the picture with perceptual repercussions. Physical colour is used to model the scene but use of the 'true' colours makes the nature of the figures clear, modelling them in a spiritual dimension. The blue and gold of Christ's robes can be interpreted as colours of light, as in the case of the

[1] Similarly with the angels and the sheep and the goats from Ravenna; the blue angel is still an angel, but blue goes with a 'negative divinity' in this instance.

rainbow. Adam himself wears the 'garment of light' described in the sources, whilst the red of Eve's robe may relate not only to light but to Eve's position as the 'Mother of all living', the linking of red with blood and life.[2] Canonical texts stress the significance of light and light imagery in the Anastasis; the colours used in the scene re-emphasize this aspect. Eleventh-century representations of the Anastasis stress the resurrection and triumph of Christ, leading humanity out of darkness.[3] In its use of colour and light, the depiction of the scene at Nea Moni makes these very points. It is only by putting texts and images together that it becomes possible to understand the significance of the Anastasis and so gain access to the whole picture.

Ignatios the Deacon used the term 'colours' to make descriptions more lifelike and vivid, to heighten the viewer's response to a scene.[4] It is colour in Byzantium which stimulates the viewer; it is colour that makes the scene 'lifelike'. Colour is not a topic to be pushed into the category of 'style' or 'iconography' or 'the place of art in society': it is an essential element in understanding all of these. For the Byzantine, sight discriminated colour and colour defined form: as form was perceived as both mimesis and reality, so too was colour. Colour defined the true form; without an understanding of colour use and meaning, the image remained incomplete, a monochrome outline, God without the Incarnation.

[2] On the iconography of the Anastasis, see J. Storer, 'The Anastasis in Byzantine Iconography', M.Litt. thesis (University of Birmingham, 1986).

[3] See A. Kartsonis, *Anastasis: The Making of an Image* (Princeton, NJ, 1986), ch.8.

[4] Ignatios the Deacon, *Vita Tarasii Archiepiscopi Constantinopolitani*, ed. I. A. Heikel (Helsinki, 1891), 2–6, p. 415. L. Brubaker, 'Perception and Conception: Art Theory and Culture in Ninth Century Byzantium', *Word and Image*, 5 (1989), 20, discusses this passage in more detail.

Appendix

THIS appendix refers to sources cited in Chapter 4 which are not discussed in detail elsewhere in the book. Sources used in other chapters but not cited here clearly contributed also to the findings. They are listed as primary sources in the main bibliography. I make no apologies for the apparently random choice; my aim was to cover as much at different levels as possible. Because the pattern of the use of colour words seemed to remain fairly consistent between genres and levels of literacy, I hoped that a random selection would cause any differences to be thrown up. Short of reading through the whole of Byzantine literature, further developments might profitably await a database of Byzantine literature. The texts below are listed by type and within this by date.

PROCOPIOS, *Histories*, ed. H. B. Dewing, 7 vols. (London and Cambridge, Mass., 1914–40)

JOHN MALALAS, *Chronographia*, ed. L. Dindorf (Bonn, 1831).

THEOPHANES, *Chronographia*, ed. C. de Boor, 2 vols. (Leipzig, 1883–5).

Chronicon Paschale, ed. L. Dindorf (Bonn, 1832); translation and commentary, M. and M. Whitby (Liverpool, 1989).

THEOPHYLACT SIMOCATTA, *Historia*, ed. C. de Boor, revised P. Wirth (Stuttgart, 1972).

ANNA COMNENA, *Alexiade*, ed. B. Leib, with P. Gautier, 4 vols. (Paris, 1937–76).

JOHN KINAMOS, *Epitome*, ed. A. Meineke (Bonn, 1836).

EUPHÉMIE DE CHALCEDOINE, *Légendes byzantines*, ed. F. Halkin (Brussels, 1965).

Sancti Pachomii Vitae Graecae, ed. F. Halkin (Brussels, 1932).

JOHN MOSCHOS, *Pratum Spirituale*, PG 87, 3, 2852–3112.

Life of St Mary of Egypt, *PG* 87, 3, 3693–3726.

LEONTIOS DE NEAPOLIS, *Vie de Symeon le Fou, et vie de Jean de Chypre*, ed. A.-J. Festugière and L. Ryden (Paris, 1974).

Vie de Theodore de Sykeon, ed. and trans. A.-J. Festugière, 2 vols. (Brussels, 1970).

'Miracles of St Artemios', in *Varia Graeca Sacra*, ed. A. Papadopoulos-Kerameus (St Petersburg, 1909), 1–79.

Life of Michael the Synkellos, ed. and trans. M. B. Cunningham (Belfast, 1991).

La vie de St. Cyrille le Phileote, moine byzantin, ed. and trans. E. Sargologos (Brussels, 1964).

ROMANOS LE MÉLODE, *Hymnes*, ed. and trans. J. Grosdidier de Matons, 5 vols (Paris, 1964–81).

Der Hymnos Akathistos im Abendland, ed. G. G. Meersseman (Freiburg, 1958).

COSMAS INDICOPLEUSTES, *Topographie chrétienne*, ed. W. Wolska-Comus, 3 vols. (Paris, 1968–73).

Parastaseis Syntomoi Chronikai: Constantinople in the Early Eighth Century, ed. A. Cameron and J. Herrin (Leiden, 1984).

GAUTIER, P., 'Le Typikon du Christ Sauveur Pantocrator', *REB* 32 (1974), 1–145.

——'Le Typikon de la Theotokos Evergetis', *REB* 40 (1982), 5–101.

A Selection of Evergetis Texts Made for the Third Belfast Byzantine International Colloquium, ed. A. Kirby (Belfast, 1992).

APPENDIX

Le livre des cérémonies, ed. and trans. A. Vogt, 2 vols. (Paris, 1935).

PSEUDO-CODINUS, G. CODINUS, *De Officialibus Palatii*, ed. I. Bekker, J. Gretser, and J. Goar (Bonn, 1839).

PAUL OF AEGINA, *Paulus Aegineta*, ed. I. L. Heiberg, 2 vols. (Leipzig–Berlin, 1921–4).

The Greek Anthology, ed. and trans. W. R. Paton, Loeb Classical Library (Cambridge, Mass., and London, 1930–40).

JOHN GEOMETRES, *The Progymnasmata of John Geometres*, ed. A. R. Littlewood (Amsterdam, 1972).
—— *PG* 106, 812–1002.

CHRISTOPHER OF MITYLENE, *Die Gedichte des Christophoros Mitylenaios*, ed. E. Kurtz (Leipzig, 1903).

JOHN MAUROPOUS, *PG* 120, 1114–1200.

NIKOLAOS CALLICLES, *Carmi*, ed. R. Romano (Naples, 1980).

MANUEL PHILES, *Carmina*, ed. E. Miller (Paris, 1855).

Bibliography

I. PRIMARY SOURCES

Details are given of sources discussed in some detail. For other texts to which references are made, full bibliographical details are presented in the relevant footnotes.

Les Alchimistes grecs, ed. R. Halleux (Paris, 1981).

ARISTOTLE, *De Sensu*, Loeb edition (1935).

—— *De Anima*, Loeb edition (1935).

—— *Meteorologica*, Loeb edition (1952).

Catalogue des manuscrits alchimiques grecs, ed. J. Bidez, esp. vi. *Michel Psellus* (Brussels, 1928).

Collection des anciens alchimistes grecs, ed. M. Berthelot, 3 vols. (Paris, 1888).

CONSTANTINE RHODIOS, *Description des œuvres d'art et de l'église des saints apôtres de Constantinople*, ed. E. Legrand (Paris, 1896).

Digenes Akrites, ed. and trans. J. Mavrogordato (London, 1956).

DIONYSIUS OF FOURNA, Ἑρμηνεία τῆς ζωγραφικῆς τέχνης, ed. A. Papadopoulos-Kerameus (St Petersburg, 1909).

—— *The 'Painter's Manual' of Dionysius of Fourna*, trans. P. Hetherington (London, 1974).

HESYCHIUS OF ALEXANDRIA, *Lexicon*, ed. K. Latte (Hauniae, 1953).

JOB OF EDESSA, *Book of Treasures*, ed. and trans. A. Mingana (Cambridge, 1935).

JOHN OF DAMASCUS, *On the Holy Images*, I–III, *PG* 94, 1231–84; 1283–1318; 1317–1420.

—— *The Orthodox Faith*, *PG* 94, 789–1228.

—— *The Fount of Knowledge* (Dialectica), *PG* 94, 521–676.

MANSI, G. D., *Sacrorum Conciliorum Nova et Amplissima Collectio*, xiii (Florence, 1857).

MICHAEL PSELLOS, *Chronographie*, ed. and trans. E. Renauld (Paris, 1967); English trans. E. R. A. Sewter, *Fourteen Byzantine Rulers* (London, 1984).

—— *Bibliotheca Graeca Medii Aevi*, ed. K. Sathas, v (Paris, 1870).

—— *Michaelis Pselli Scripta Minora*, ed. E. Kurtz and F. Drexl (Milan, 1936–41).

—— *Catalogue des manuscrits alchimiques grecs*, vi. *Michel Psellos*, ed. J. Bidez (Brussels, 1928).

—— *PG* 122, 540–1185.

NICEPHOROS, PATRIARCH, *Discours contre les iconoclastes*, ed. and trans. M.-J. Mondzain-Baudinet (Paris, 1990).

NICHOLAS MESARITES, *The Description of the Church of the Holy Apostles at Constantinople*, ed. and trans. G. Downey, *Transactions of the American Philosophical Society*, NS 47: 6 (1957), 859–918.

PAUL THE SILENTIARY, *Johannes von Gaza und Paulus Silentarius*, ed. P. Friedländer (Leipzig–Berlin, 1812).

PHOTIOS, *Homilies*, ed. B. Laourda (Thessaloniki, 1959); trans. C. Mango, *DOS* 3 (1958).

—— *Bibliotheca*, partially trans. J. H. Freese (London and New York, 1920).

—— *Lexicon*, ed. R. Porson (Leipzig, 1823).

BIBLIOGRAPHY

PLATO, *Timaeus*, Loeb edition (New York and London, 1929).

PLOTINUS, *Enneads*, Loeb edition (New York and London, 1929).

PROCOPIOS, *Buildings*, Loeb edition (New York and London, 1971).

PSEUDO-DIONYSIUS, *The Celestial Hierarchy*, PG 3, 119–320.

—— *The Divine Names*, PG 3, 585–996.

—— *The Ecclesiastical Hierarchy*, PG 3, 369–584.

—— *The Mystical Theology*, PG 3, 997–1064.

—— *Pseudo-Dionysius: The Complete Works*, trans. C. Luibheid (London, 1987).

Scholia Graeca in Homeri Iliadem, ed. H. Erbse, 7 vols. (Berlin, 1969–88).

Suidae Lexicon, ed. A. Adler (Leipzig, 1928–38).

Textus Byzantini ad Iconomachiam Pertinentes, ed. H. Hennephof (Leiden, 1969).

THEOPHILUS, *De Diversis Artibus*, ed. and trans. C. R. Dodwell (London, 1961).

2. LEXICA

DU FRESNE, C., and DU CANGE, D., *Glossarium ad Scriptores Mediae et Infirmae Graecitatis* (Lyons, 1688).

KRIARAS, E., *Λεξικὸ τῆς μεσαιωνικῆς Ἑλληνικῆς δημώδους γραμματείας 1100–1669* (Thessaloniki, 1968–85), incomplete.

LAMPE, G. W. H., *A Patristic Greek Lexicon* (Oxford, 1961).

LIDDELL, H. G., SCOTT, R., and JONES, H. S., *A Greek–English Lexicon* (9th edn., Oxford, 1968).

SOPHOCLES, E. A., *Greek Lexicon of the Roman and Byzantine Periods* (New York, 1887).

3. SELECT BIBLIOGRAPHY OF SECONDARY SOURCES

This list is intended as a guide to the literature on colour and the perception of colour and art in the Classical and Byzantine worlds. It is not a comprehensive source of all material cited in the book, which will be found, fully referenced, in the notes to each chapter.

ALEXANDER, P. J., *Patriarch Nicephoros of Constantinople* (Oxford, 1958).

ANDRONICOS, M., *Vergina: The Royal Tombs and the Ancient City* (Athens, 1987).

ASTON, M., 'Gold and Image', in W. J. Shiels and D. Wood (eds.), *The Church and Wealth* (Oxford, 1987), 189–208.

BEARE, J. I., *Greek Theories of Elementary Cognition from Alcmaeon to Aristotle* (Oxford, 1906).

BECKWITH, J., 'Byzantium: Gold and Light', in T. B. Hess and J. Ashbery (eds.), 'Light, From Aten to Laser', *Art News Annual*, 35 (1969), 44–57.

BENZ, E., 'Die Farbe in der Christlichen Vision', *ErYb* 41 (1972), 265–323.

BERTHELOT, M. *Les Origines de l'alchimie* (Paris, 1885).

BORN, W. A., 'Purple' and 'Scarlet', *CIBA Review*, 4 (1937).

BOURAS, L., 'Working Drawings of Painters in Greece after the Fall of Constantinople', in *From Byzantium to El Greco*, catalogue of an exhibition of Greek frescoes and icons (London, 1987), 54–6.

BOYER, C. B., *The Rainbow* (London and New York, 1959).

BRILL, R. H., 'The Scientific Investigation of Ancient Glasses', *Eighth International Congress on Glass, 1968* (Sheffield, 1969), 47–68.

BROWNE, C. A., 'Rhetorical and Religious Aspects of Greek Alchemy', *Ambix*, 2 and 3 (1938 and 1948), 129–37 and 15–25.

BRUBAKER, L., 'Perception and Conception: Art, Theory and Culture in Ninth Century Byzantium', *Word and Image*, 5 (1989), 19–32.

—— 'Byzantine Art in the Ninth Century: Theory, Practice and Culture', *BMGS* 13 (1989), 23–93.

BRUNO, V. J., *Form and Colour in Greek Painting* (London, 1977).

BUCHTHAL, H., 'Notes on Byzantine Hagiographical Portraiture', *CBA* 62 (1963), 81–90.

BUCKTON, D., '"Necessity the Mother of Invention" in Early Medieval Enamels', *Transactions of the Canadian Conference of Art Historians*, 3 (London, Ont., 1985), 1–6.

CABELLI, D. E., and MATHEWS, T., 'Pigments in Armenian Manuscripts of the Tenth and Eleventh Centuries', *RevEtArm* 18 (1984), 33–47.

CHATZIDAKIS, M., 'Ek ton Elpiou tou romaiou', in *Studies in Byzantine Art and Archaeology*, Variorum reprints (London, 1972), no. 3 (in Greek).

CONNOR, C. L., 'New Perspectives on Byzantine Ivories', *Gesta*, 30 (1991), 100–11.

CORMACK, R. S., '"New Art History" vs. "Old History": Writing Art History', *BMGS* 10 (1986), 223–31.

CUTLER, A., 'The Mythological Bowl in the Treasury of San Marco at Venice', in D. Kouymjian (ed.), *Near Eastern Numismatics, Iconography, Epigraphy and History: Studies in Honor of George C. Miles* (Beirut, 1974), 235–54.

—— *The Craft of Ivory* (Washington, DC, 1985).

DACL 12 1, Mosaique.

DAVIDSON, G., 'A Medieval Glass Factory at Corinth', *AJA* 44 (1940), 297–324.

DAVIDSON-WEINBERG, G., 'A Medieval Mystery: Byzantine Glass Production', *JGS* 17 (1975), 127–41.

—— 'The Importance of Greece in Byzantine Glass Manufacture', *15th International Congress of Byzantine Studies 2B* (Athens, 1981), 915–18.

DE BRUYNE, E., *Études d'esthétique médiévale*, ii and iii (Bruges, 1946).

DEMUS, O., *Byzantine Mosaic Decoration* (London, 1948).

DIEZ, E., and DEMUS, O., *Byzantine Mosaics in Greece* (Cambridge, Mass., 1931).

DRONKE, P., 'Tradition and Innovation in Medieval Western Colour Imagery', *ErYb* 41 (1972), 51–107.

ECO, E., *Art and Beauty in the Middle Ages* (New Haven, Conn., 1986).

EDGERTON, S. Y., 'Alberti's Colour Theory: A Medieval Bottle without Renaissance Wine', *JWarb* 32 (1969), 109–34.

EPSTEIN, A. W., *Tokalı Kilise: Tenth Century Metropolitan Art in Byzantine Cappadocia, DOS* 22 (Washington, DC, 1986).

FELLER, R. L. (ed.), *Artists' Pigments: A Handbook of their History and Characteristics* (Cambridge and National Gallery of Art, 1986).

FORBES, R. J., *Studies in Ancient Technology*, i. *Alchemy*; iii. *Cosmetics and Paints*; iv. *Dyes and Dyeing* (Leiden, 1955); v. *Glass* (Leiden, 1957).

—— 'On the Origins of Alchemy', *Chymia*, 4: 1 (1953), 1–14.

FREESTONE, I. C., BIMSON, M., and BUCKTON, D., 'Compositional Categories of Byzantine Glass Tesserae', *Actes du 11 congrès (Basle, 1988) de l'association internationale pour l'histoire du verre* (Amsterdam, 1990), 271–80.

FROLOW, A., 'La Mosaique murale byzantine', *ByzSlav* 12 (1951), 180–209.

GAGE, J., 'Colour in History: Relative and Absolute', *Art History*, 1 (1978), 104–30.

—— 'A "Locus Classicus" of Colour Theory: The Fortunes of Apelles', *JWarb* 44 (1981), 1–26.

—— 'Gothic Glass: Two Aspects of a Dionysian Aesthetic', *Art History*, 5 (1982), 36–57.

—— 'Color in Western Art: An Issue?', *ArtB* 72 (1990), 518–41.

—— *Colour and Culture* (London, 1993).

GAISER, K., 'Platons Farbenlehre', in *Synusia: Festschrift für W. Schadewaldt* (Pfullingen, 1965), 173–222.

GALAVARIS, G., 'The Stars of the Virgin: An Ekphrasis of an Ikon of the Mother of God', *Eastern Churches Review*, 1 (1966–7), 364–9.

GARLICK, C., 'What Colour was the Greek Hyacinth?', *CR* 35 (1921), 146–7.

GERNET, L., 'Dénominations et perceptions des couleurs chez les grecs', in I. Meyerson (ed.), *Problèmes de la couleur*, Colloque, Paris 1954 (Paris, 1957), 313–26.

GETTENS, R. J., and STOUT, G. L., 'A Monument of Byzantine Wall-painting: The Method of Construction', *SCon* 3 (1957–8), 107–19.

—— and FITZHUGH, E. W., 'Azurite and Blue Verditer', *SCon* 11 (1966), 54–61.

—— KUHN, H., and CHASE, W. T., 'Lead White', *SCon* 12 (1967), 125–39.

—— FELLER, R. L., and CHASE, W. T., 'Vermillion and Cinnabar', *SCon* 17 (1972), 45–69.

GILBERT, O., *Die meteorologischen Theorien des griechischen Altertums* (Leipzig, 1907).

GIPPER, H., 'Purpur', *Glotta*, 42 (1964), 39–68.

GLADSTONE, W. E., *Studies on Homer and the Heroic Age*, iii (Oxford, 1858).

GNOLI, R., *Marmora Romana* (2nd edn., Rome, 1988).

GORDON, R. L., 'The Real and the Imaginary: Production and Religion in the Greco-Roman World', *Art History*, 2 (1979), 5–34.

GOTTSCHALK, H. B., 'The De Coloribus and Its Author', *Hermes*, 92 (1964), 59–85.

GRABAR, A., 'Le Succès des arts orientaux à la cour byzantine sous les Macédoniennes', *MunchJb* 5 (1951), 32–60.

—— 'The Virgin in a Mandorla of Light', in K. Weitzmann (ed.), *Studies in Honor of A. M. Friend jr.* (Princeton, NJ, 1955), 305–11.

—— 'Le Verrerie d'art byzantine au moyen âge', *MonPiot*, 57 (1971), 89–128.

HAHN, D. E., 'Early Hellenistic Theories of Vision and the Perception of Colour', in P. K. Machamer and R. G. Turnbull (eds.), *Studies in Perception: Interrelations in the History of Philosophy and Science* (Ohio, 1978), 60–95.

HALL, M. B., *Color and Meaning: Practice and Theory in Renaissance Painting* (Cambridge, 1992).

HANDSCHUR, E., *Die Farb- und Glanzwörter bei Homer und Hesiod, in den homerischen Hymnen und den Fragmenten des epischen Kyklos* (Vienna, 1970).

HARDEN, D. B., 'Ancient Glass II', *Archaeological Journal*, 126 (1969), 44–77.

—— 'Ancient Glass III: Post-Roman', *Archaeological Journal*, 128 (1971), 78–117.

—— et al., *Glass of the Caesars*, Catalogue (Milan, 1984).

HARDING, C., 'The Production of Medieval Mosaics: The Orvieto Evidence', *DOP* 43 (1989), 73–102.

HAWKINS, E. J. W., 'Further Observations on the Narthex Mosaics in St. Sophia at Istanbul', *DOP* 22 (1968), 153–61.

HILLS, J. G. P., *The Light of Early Italian Painting* (New Haven, Conn., and London, 1987).

HOPKINS, A. J., *Alchemy, Child of Greek Philosophy* (New York, 1934).

—— 'A Study of the Kerotakis Process as Given by Zosimus and Later Alchemical Works', *Isis*, 29 (1938), 326–54.

IRWIN, E., *Colour Terms in Greek Poetry* (Toronto, 1974).

JAMES, L., 'Colour and the Byzantine Rainbow', *BMGS* 15 (1991), 66–95.

—— and WEBB, R., '"To Understand Ultimate Things and Enter Secret Places": Ekphrasis and Art in Byzantium', *Art History*, 14 (1991), 1–17.

JENKINS, I. D., and MIDDLETON, A. P., 'Paint on the Parthenon Sculptures', *BSA* 83 (1988), 183–207.

JENKINS, M., *Islamic Glass: A Brief History*, Metropolitan Museum of Art Bulletin (Fall, 1986).

JENSSEN, V., and MAJEWSKI, L., Appendix to S. Boyd, 'The Church of the Panagia Amasgou, Monagri, Cyprus, and Its Wallpaintings', *DOP* 28 (1974), 329–45.

JOHNSON, R. P., 'Compositiones Variae from Cod. 490, Bibliotheca Capitolare, Lucca', *Illinois Studies in Language and Literature*, 23: 3 (1939).

KARTSONIS, A. D., *Anastasis: The Making of an Image* (Princeton, NJ, 1986).

KAZHDAN, A., *Studies on Byzantine Literature of the Eleventh and Twelfth Centuries* (Cambridge, 1984).

—— and Maguire, H., 'Byzantine Hagiographical Texts as Sources on Art', *DOP* 45 (1991), 1–22.

KESSLER, H. L., '"Pictures Fertile with Truth": How Christians Managed to Make Images of God without Violating the Second Commandment', *Journal of the Walters Art Gallery*, 49/50 (1991/2), 33–65.

KEULS, E. C., *Plato and Greek Painting* (Leiden, 1978).

KIRSCHBAUM, E., 'L'angelo rosso e l'angelo turchino', *Rivista di archeologia cristiana*, 17 (1940), 209–48.

KITZINGER, E., *Mosaics of Monreale* (Palermo, 1960).

—— 'Mosaics', in *Encyclopaedia of World Art*, 10 (1965), cols. 325–49.

—— 'The Role of Miniature Painting in Mural Decoration', in K. Weitzmann *et al.*, *The Place of Book Illumination in Byzantine Art* (Princeton, NJ, 1975), 109–21.

KOBER, A. E., *The Use of Color Terms in the Greek Poets to 146 BC* (New York, 1932).

KUHN, H., 'Verdigris and Copper Resinates', *SCon* 15 (1970), 12–36.

LADNER, G., 'The Concept of the Image in the Greek Fathers and the Byzantine Iconoclastic Controversy', *DOP* 7 (1953), 1–34.

—— 'Medieval and Modern Understanding of Symbols: A Comparison', *Speculum*, 54 (1979), 223–56.

LAFOND, J., 'Découverte de vitraux histoires du moyen âge à Constantinople', *CahArch* 18 (1968), 231–8.

LAURIE, A. P., *The Pigments and Methods of the Old Masters* (London, 1914).

LAZAREV, V. N., *Mosaiki Sofii Kievskoj* (Moscow, 1960).

LAZAREV, V. N., *Old Russian Murals and Mosaics* (London, 1966).

—— *Michajlovskie Mosaiki* (Moscow, 1966).

LEROY-MOLINGEN, A., 'Styliané', *Byzantion*, 39 (1969), 155–63.

LINDSAY, J., *The Origins of Alchemy in Graeco-Roman Egypt* (London, 1970).

LING, R., *Roman Painting* (Cambridge, 1991).

LODGE, R. C., *Plato's Theory of Art* (New York, 1975).

LOGVIN, G. N., *Kiev's Hagia Sophia* (Kiev, 1971).

LOUMAYER, G., *Les Traditions techniques de la peinture médiévale* (Brussels and Paris, 1920).

LOWDEN, J., 'Did Byzantine Artists Use an Iconographic Guide?', *Abstracts of Shorter Papers, 17th International Byzantine Congress, Washington 1986* (Washington, DC, 1987), 201.

—— *Illuminated Prophet Books* (London, 1988).

LUZZATO, L., and POMPAS, R., *Il significato dei colori nelle civiltà antiche* (Milan, 1988).

MACRIDES, R., and MAGDALINO, P., 'The Architecture of Ekphrasis: Construction and Context of Paul the Silentiary's Ekphrasis of Hagia Sophia', *BMGS* 12 (1988), 47–82.

MAFFEI, F. DE', *Icona, pittore e arte al concilio Niceno II* (Rome, 1974).

MAGUIRE, H., 'Truth and Convention in Byzantine Descriptions of Art', *DOP* 28 (1974), 111–40.

—— *Art and Eloquence in Byzantium* (Princeton, NJ, 1981).

—— 'The Art of Comparing in Byzantium', *ArtB* 70 (1988), 8–103.

MANGO, C., *Byzantium and Its Image* (London, 1984).

—— *The Art of the Byzantine Empire* (repr. Toronto, 1986).

—— 'The Monastery of St. Chrysostomos at Koutsovendis (Cyprus) and its Wall Paintings. Part 1: Description with the Collaboration of E. J. W. Hawkins and S. Boyd', *DOP* 44 (1990), 63–94.

—— and HAWKINS, E. J. W., 'The Apse Mosaics of St. Sophia at Istanbul', *DOP* 19 (1965), 113–52.

—— 'The Mosaics of St. Sophia at Istanbul: The Church Fathers in the North Tympanum', *DOP* 26 (1972), 1–42.

MARTIN, T.-H., *Études sur le Timée de Platon* (repr. Paris, 1981).

MATHEW, G., *Byzantine Aesthetics* (London, 1963).

—— 'The Aesthetic Theories of Gregory of Nyssa', in *Studies in Memory of D. Talbot-Rice* (Edinburgh, 1975), 217–22.

MATSON, F., 'Technological Study of the Glass from the Corinth Factory', *AJA* 44 (1940), 325–7.

MAXWELL-STUART, P. G., 'Studies in Greek Colour Terminology: 1, Glaucos; 2, Karapos', *Mnemosyne*, suppl. 65 (Leiden, 1981).

McGUCKIN, J. A., *The Transfiguration of Christ in Scripture and Tradition* (New York, 1986).

MEGAW, A. H. S., 'A Note on Recent Work of the Byzantine Institute in Istanbul', *DOP* 17 (1963), 333–72.

—— and HAWKINS, E. J. W., 'The Church of the Holy Apostles at Perachorio, Cyprus, and its Frescoes', *DOP* 16 (1962), 277–350.

MELLINKOFF, R., 'Judas' red hair and the Jews', *Journal of Jewish Art*, 9 (1982), 31–46.

MERRIFIELD, M. P., *Original Treatises in the Art of Painting*, 2 vols. (London, 1849).

MOURIKI, D., *The Mosaics of Nea Moni on Chios* (Athens, 1985).

MUGLER, C., *Dictionnaire historique de la terminologie optique des grecs* (Paris, 1964).

MÜLLER-BORE, K., 'Stilistische Untersuchungen zum Farbwort und zur Verwendung der Farbe in der älteren griechischen Poesie', *Klassische-Philologische Studien*, 3 (Berlin, 1922).

MUNRO, J. H., 'The Medieval Scarlet and the Economics of Sartorial Splendour', in N. B. Harte and K. G. Ponting (eds.), *Cloth and Clothing in Medieval Europe* (London, 1983), 13–70.

MUTHESIUS, A., 'Crossing Traditional Boundaries: Grub to Glamour in Byzantine Silk Weaving', *BMGS* 15 (1991), 326–65.

NEUBERG, H., *A History of Glass* (Paris, 1897).

NEWBOLD, R. F., 'Perception and Sensory Awareness Among Latin Writers in Late Antiquity', *ClMed* 33 (1981–2), 169–90.

NEWTON, R. G., 'Colouring Agents used by Medieval Glass Makers', *Glass Technology*, 19: 3 (1978), 56–60.

NORDHAGEN, P. J., 'The Mosaics of John VII (705AD–707AD)', *ActaIRNorv* 7 (1965), 121–66.

—— and L'ORANGE, H. P., *Mosaics* (London, 1966).

ONIANS, J., 'Abstraction and Imagination in Late Antiquity', *Art History*, 3 (1980), 1–24.

OPIE, J. L., 'Some Remarks on the Colour System of Medieval Byzantine Painting', *Acts of the 16th International Byzantine Congress, Vienna 1982*, ii: 5 (*JÖB* 32: 5, 1982), 85–91.

ORNA, M. V., and NELSON, R., 'Pigment Analysis of Some Byzantine Manuscripts at the University of Chicago', *10th Annual Byzantine Studies Conference Abstracts* (1984), 30.

OSBORNE, H., 'Colour Concepts of the Ancient Greeks', *British Journal of Aesthetics*, 8 (1968), 260–83.

PASTOUREAU, M., *Figures et couleurs. Étude sur la symbolique et la sensibilité médiévale* (Paris, 1986).

—— *Couleurs, images, symboles* (Paris, 1989).

PELLIZZARI, A., *I trattati attorno le arti figurative in Italia e nella Penisola Iberica dall'Antichista classica al riniscimente e al secolo XVIII* (Naples, 1915).

PFISTER, R., 'Teinture et alchimie dans l'orient hellénistique', *SemKond* 7 (1935), 1–59.

PHILIPPE, J., *Le Monde byzantine dans la verrerie* (Bologna, 1970).

Pigments et colorants de l'antiquité et du moyen âge: Colloque international du CNRS (Paris, 1990).

PLATNAUER, M., 'Greek Colour Perception', *CQ* 15 (1921), 153–62.

PLESTERS, J., 'Ultramarine Blue, Natural and Artificial', *SCon* 11 (1966), 62–91.

POLLITT, J. J., 'Professional Art Criticism in Ancient Greece', *GBA* 64: 2 (1964), 317–30.

—— *The Ancient View of Greek Art: Criticism, History and Terminology* (New Haven, Conn., 1974).

REINHARDT, K., *Poseidonios* (Munich, 1921).

REINHOLD, M., 'History of Purple as a Status Symbol', *Collection Latomus*, 116 (Brussels, 1970).

REUTERSWARD, P., 'What Colour is Divine Light?', in T. B. Hess and J. Ashbery (eds.), 'Light from Aten to Laser', *Art News Annual*, 35 (1969), 108–27.

ROBERTS, M., *The Jeweled Style* (London and Ithaca, NY, 1989).

ROOSEN-RUNGE, H., *Farbgebung und Technik frühmittelalterlicher Buchmalerei. Studien zur den Traktaten 'Mappae Clavicula' und Heraklius* (Munich, 1967).

ROWE, C., 'Conceptions of Colour and Colour Symbolism in the Ancient World', *ErYb* 41 (1972), 327–64.

RÜTH, U.-M., *Die Farbgebung in der Byzantinischen Wandmalerei der spätpaläologischen Epoche* (Bonn, 1977).

SAHAS, D. J., *Icon and Logos: Sources in Eighth Century Iconoclasm* (Toronto, 1986).

SCHÖNE, W., *Über das Licht in der Malerei* (Berlin, 1954).

SCHUHL, P./M., *Platon et l'art de son temps* (Paris, 1933).

SHEARMAN, J. K. G., 'Developments in the Use of Colour in Tuscan Painting of the Early Sixteenth Century', Ph.D. thesis (University of London, 1957).

SHEERIN, D., 'Line and Colors: Painting as Analogue to Typology in Greek Patristic Literature', Abstracts of short papers, *17th International Byzantine Congress Washington 1986* (Washington, DC, 1987), 317–18.

SHEPPARD, H. J., 'Alchemy: Origin or Origins?', *Ambix*, 17 (1970), 69–84.

SINGER, C., HOLMYARD, E. J., HALL, A. R., and WILLIAMS, T. I. (eds.), *A History of Technology*, ii (Oxford, 1956).

SPERBER, D., *Rethinking Symbolism*, trans. A. L. Morton (Cambridge, 1975).

STOJAKOVIC, A., 'Jésu/Christ, source de la lumière dans la peinture byzantine', *CahCM* 18 (1975), 269–73.

STORER, J., 'The Anastasis in Byzantine Iconography', M.Litt. thesis (University of Birmingham, 1986).

STRATTON, G. M., *Theophrastus and the Greek Physiological Psychology before Aristotle* (London and New York, 1917).

STRONG, D., and BROWN, D. (eds.), *Roman Crafts* (London, 1976).

STULZ, H., *Die Farbe Purpur im frühen Griechentum* (Stuttgart, 1990).

TALBOT/RICE, D. (ed.), *The Church of Hagia Sophia at Trebizond* (Edinburgh, 1968).

TARRANT, D., 'Greek Metaphors of Light', *CQ* NS 10 (1960), 181–7.

TAYLOR, A. E., *A Commentary on Plato's Timaeus* (Oxford, 1928).

TAYLOR, F. S., 'A Study of Greek Alchemy', *JHS* 50 (1930), 109–39.

—— 'The Alchemical Works of Stephanos of Alexandria', *Ambix*, 1 and 2 (1937 and 1938), 116–39 and 39–49.

THOMPSON, D. V., review of W. Theobald's edition of Theophilus, *De Diversis Artibus*, *Speculum*, 10 (1935), 438.

—— *The Materials and Techniques of Medieval Painting* (London, 1936).

UNDERWOOD, P. A., *The Kariye Djami*, 4 vols. (New York, 1966–75).

VECKENSTEDT, E., *Geschichte der griechischen Farbenlehre* (Paderborn, 1888).

VELMANS, T., 'Les Valeurs affectives dans la peinture murale byzantine du XIIIe siècle et la manière de les représenter', in *L'Art byzantine du XIIIe siècle: Symposium de Sopoćani 1965* (Belgrade, 1967).

VOGEL, K., 'Byzantine Science', *Cambridge Medieval History*, 4: 2 (Cambridge, 1967), 282–3.

WALLACE, F. E., 'Color in Homer and in Ancient Art', *Smith College Classical Studies*, 9 (1927).

WALTER, C., 'Expressionism and Hellenism: A Note on Stylistic Tendencies in Byzantine Figurative Art from Spätantike to the Macedonian "Renaissance"', *REB* 42 (1984), 265–87.

WEBSTER, T. B. L., 'Plato and Aristotle as Critics of Greek Art', *Symbolae Osloenses*, 29 (1952), 8–24.

WENZEL, M., 'Deciphering the Cotton Genesis Miniatures: Preliminary Observations Concerning the Use of Colour', *British Library Journal*, 13: 1 (1987), 79–100.

WESTERINK, L. G., *Anonymous Prolegomena to Platonic Philosophy* (Amsterdam, 1962).

WHITTEMORE, T., *The Mosaics of St. Sophia at Istanbul* (Oxford, 1933).

WHITTEMORE, T., 'A Portrait of the Empress Zoe and of Constantine IX', *Byzantion*, 18 (1946–8), 223–7.

WILSON, C. A., 'Philosophers, *Iosis* and Water of Life', *Proceedings of the Leeds Philosophical and Literary Society, Literary and Historical Section*, 19 (1984), 101–219.

WILSON, N. G., 'The Church and Classical Studies in Byzantium', *AntAb* 16 (1970), 68–77.

WINFIELD, D. C., 'Middle and Later Byzantine Wall Painting Methods: A Comparative Study', *DOP* 22 (1968), 63–139.

WINKLER, J. J., 'Lollianus and the Desperadoes', *JHS* 100 (1980), 155–81.

WOOD, D. M., 'Leo VI's Concept of Divine Monarchy', *Historical Series*, 1 (1964).

WRIGHT, F. A., 'A Note on Plato's Definition of Colour', *CR* 34 (1920), 31–2.

WUNDERLICH, E., *Die Bedeutung der roten Farbe im Kultur der Griechen und Römer, Religionsgeschichtliche Versuche und Vorarbeiten*, 20: 1 (Giessen, 1925).

YOUNG, S. H., 'Relations between Byzantine Mosaic and Fresco Technique: A Stylistic Analysis', *JÖB* 25 (1976), 269–78.

——'A Preview of Seventh Century Glass from the Kourion Basilica, Cyprus', *JGS* 35 (1993), 39–47.

4. POST-NEWTONIAN STUDIES ON COLOUR AND THE PERCEPTION OF COLOUR

BERLIN, B., and KAY, P., *Basic Color Terms, Their Universality and Evolution* (Berkeley, Calif., 1969).

BORNSTEIN, M. H., 'Influence of Visual Perception on Color', *AmAnth* 77 (1975), 774–98.

——'Name Codes and Color Memory', *American Journal of Psychology*, 89 (1976), 269–79.

CHEVREUL, M. E., *De la loi du contraste simultané des couleurs* (Paris, 1889).

CONKLIN, H., 'Hanunoo Color Categories', *South-Western Journal of Anthropology*, 11 (1955), 339–44.

——'Color Categorization', review of Berlin and Kay, *Basic Color Terms*, *AmAnth* 75 (1973), 931–42.

EVANS, R. M., *An Introduction to Color* (New York, 1948).

—— *The Perception of Color* (New York, 1974).

GIBSON, J. J., *The Senses Considered as a Perceptual System* (London, 1968).

GREGORY, R. L., *Eye and Brain* (3rd edn., London, 1979).

HEIDER, E. R., 'Universals in Color Naming and Memory', *Journal of Experimental Psychology*, 93 (1972), 10–20.

HELMHOLTZ, H. L. F. von, *Handbuch der physiologischen Optick* (1856), ed. and trans. J. P. C. Southall, *Treatise on Physiological Optics* (New York, 1962).

HICKERSON, N. P., review of Berlin and Kay, *Basic Color Terms*, *International Journal of American Linguistics*, 37 (1971), 257–70.

HILBERT, D. R., *Color and Color Perception* (Stanford, Calif., 1987).

KAY, P., and MCDANIEL, C. K., 'The Linguistic Significance of Meanings of Basic Color Terms', *Language*, 54 (1978), 610–46.

LUCY, J. A., and SCHWEDER, P. A., 'Whorf and his Critics', *AmAnth* 81 (1979), 581–615.

MCNEILL, N. B., 'Colour and Colour Terminology', *Journal of Linguistics*, 8 (1972), 21–33.

MUNSELL, A. H., *A Grammar of Color* (New York, 1900).

BIBLIOGRAPHY

NASSAU, K., *The Physics and Chemistry of Color* (New York, 1983).

NEUMAYER, A., review of W. Schöne, *Über das Licht in der Malerei* (Stuttgart, 1961), *ArtB* 37 (1955), 302–3.

NEWCOMER, P., and FAIRS, J., 'Basic Color Terms', review of Berlin and Kay, *Basic Color Terms, International Journal of American Linguistics*, 37 (1971), 270–5.

NEWTON, I., *Opticks: Or a Treatise on the Reflections, Refractions, Inflexions and Colours of Light* (4th edn., London, 1730).

OSTWALD, H., *Die Farbenfibel* (Leipzig, 1917).

PADGHAM, C. E., and SAUNDERS, J. E., *The Perception of Light and Colour* (London, 1975).

RAY, V. F., 'Techniques and Problems in the Study of Human Color Vision', *South-Western Journal of Anthropology*, 8 (1952), 251–60.

ROSSOTTI, H., *Colour* (London, 1983).

SAHLINS, M., 'Colors and Cultures', in J. L. Dolgin, D. S. Kemmitzer, and D. M. Schneider (eds.), *Symbolic Anthropology: A Reader in the Study of Symbols and Meanings* (New York, 1977), 165–80.

SEGALL, M. H., CAMPBELL, D. T., and HERSKOVITS, M. J., *The Influence of Culture on Visual Perception* (New York, 1966).

TEEVAN, R. C., and BIRNEY, R. C. (eds.), *Color Vision: An Enduring Problem in Psychology* (New York, 1961).

TURNER, V. W., 'Colour Classification in Ndembu Ritual', in M. Banton (ed.), *Anthropological Approaches to the Study of Religion* (London, 1966), 47–84.

TURTON, D., 'There's No Such Beast: Cattle and Colour-naming among the Mursi', *Man*, 15 (1980), 320–38.

WASSERMAN, G. S., *Color Vision: An Historical Introduction* (New York, 1978).

WHITELEY, W. H., 'Colour-words and Colour-values: The Evidence from Gusii', in R. Horton and R. Finnegan (eds.), *Modes of Thought* (London, 1973), 145–61.

WITKOWSKI, S. R., and BROWN, C. H., 'An Explanation of Color Nomenclature Universals', *AmAnth* 79 (1977), 50–7.

WRIGHT, B., and RAINWATER, L., 'The Meanings of Color', in J. Hogg (ed.), *Psychology and the Visual Arts* (London, 1969), 331–44.

YOUNG, T., 'On the Theory of Light and Colours', *Transactions of the Royal Philosophical Society* (1802), 12–48.

ZOLLINGER, Z., 'Human Colour Vision as an Inter-disciplinary Research', *Palette*, 40 (1972), 25–31.

General Index

Index of Greek Terms

157